Overview

# Timelapse

# Overview

# Timelapse

## How We Change the Earth

Benjamin Grant | Timothy Dougherty

TEN SPEED PRESS
California | New York

Imagery created in partnership with:

To future generations—
may you find this book
on a safer, smarter planet.
—BRG

To my parents—
for your endless support and
encouragement in all my endeavors.
—TXD

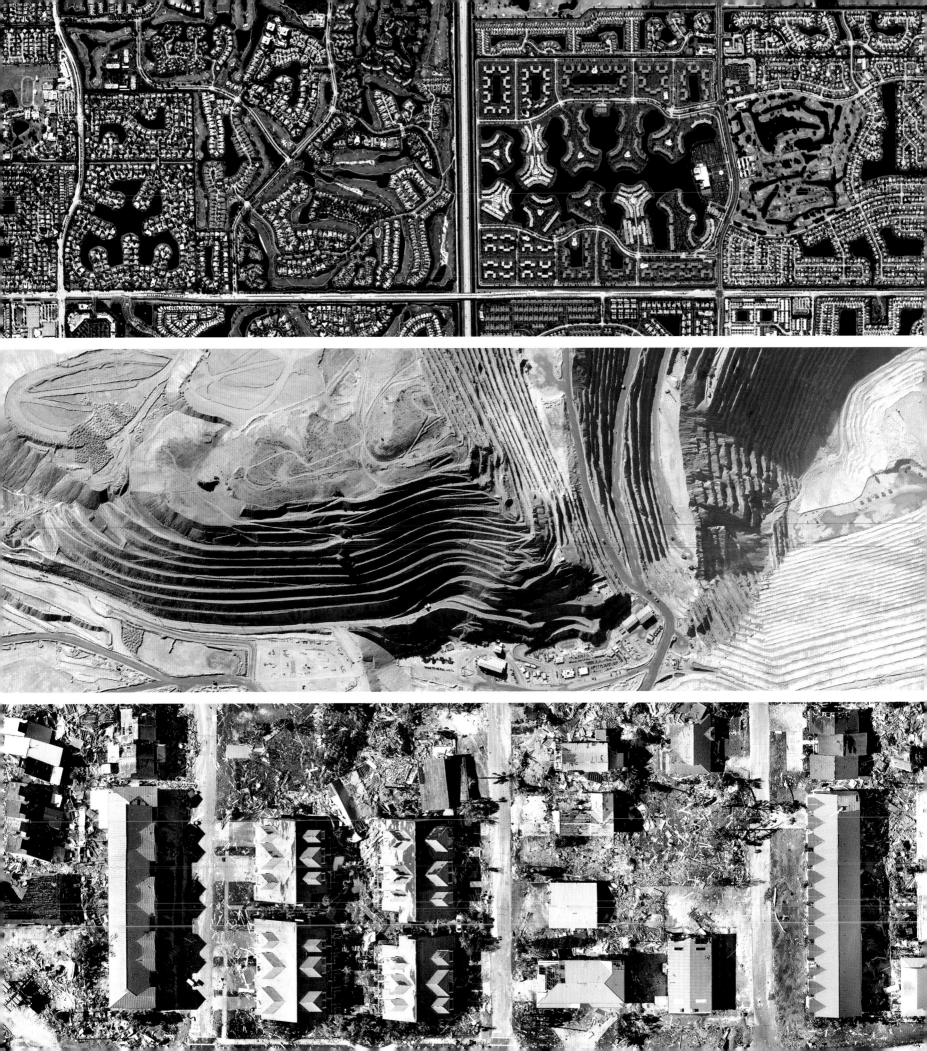

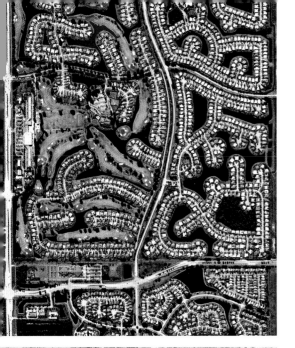

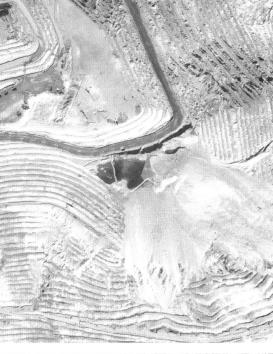

# Contents

# Introduction

We are living in a new era. There is a growing consensus among scientists that we have entered into a period of time in which human activity is now the dominant force upon Earth. There are more of us than ever before—our population has more than quadrupled in the last century, from 1.8 billion in 1920 to nearly 8 billion today. The utilization of Earth's natural resources to support and power all of the systems and activities of civilization has dramatically changed its air, water, and land. We are beginning to see that there are consequences for all of our actions. This book provides a visual perspective of that story, with the hope it will lead to greater awareness, better decisions, and a more sustainable future.

Since 2013, Overview has had the mission to inspire the Overview Effect—a feeling reported by astronauts who have had the opportunity to look back at Earth from outer space. From this distant vantage point, they experience a sensation of overwhelming awe and amplified appreciation for the planet we call home. When seen from space, Earth and our civilization seem simultaneously intriguing and unfamiliar. The abstract shapes, colors, and patterns inspire wonder at the planet's natural beauty and the impressive scale of the things we have created here. If we use this vantage point over different periods of time, we have the ability to see how things change. The stories in this book combine the scale afforded by satellite and aerial photographs with the element of time. This offers a powerful medium to observe and understand the massive scope of change that has taken place recently on Earth.

The rapid growth of our population and advancement of our technological capability have made modern

civilization not only possible, but incredible. We live in the most resource-abundant time ever because of our ability to invent and support our growing needs and expectations. And yet it seems we have not fully come to a consensus with how our actions are beginning to jeopardize the most essential element of human life—a healthy, stable planet. Simply put, our rapid growth and societal complexity has led to far-reaching exploitation of the planet's natural resources. The burning of fossil fuels for energy has released dangerous amounts of carbon dioxide into the atmosphere. Just as decades of scientific research predicted, the globe is indeed warming, and the climate is indeed showing signs of change.

Despite all the evidence of our impact and its consequences staring back at us, there is reason to be optimistic. The same scientists who predicted and continue to monitor global climate change have made it clear that it is not too late to adopt solutions that can both support our species and move us toward a more harmonious relationship with the planet. The combination of collective action, thoughtful policies, and technological innovation has the power to move us in a better direction.

All of these forces begin with, and are amplified by, awareness. Understanding how our choices impact the planet is an essential step if we hope to change course. The images and stories in this book provide a framework for thinking about how we have already impacted the planet and what is to come. It is only with that knowledge that we can build a vibrant civilization that grows, adapts, and operates in balance with the natural systems of our one and only home.

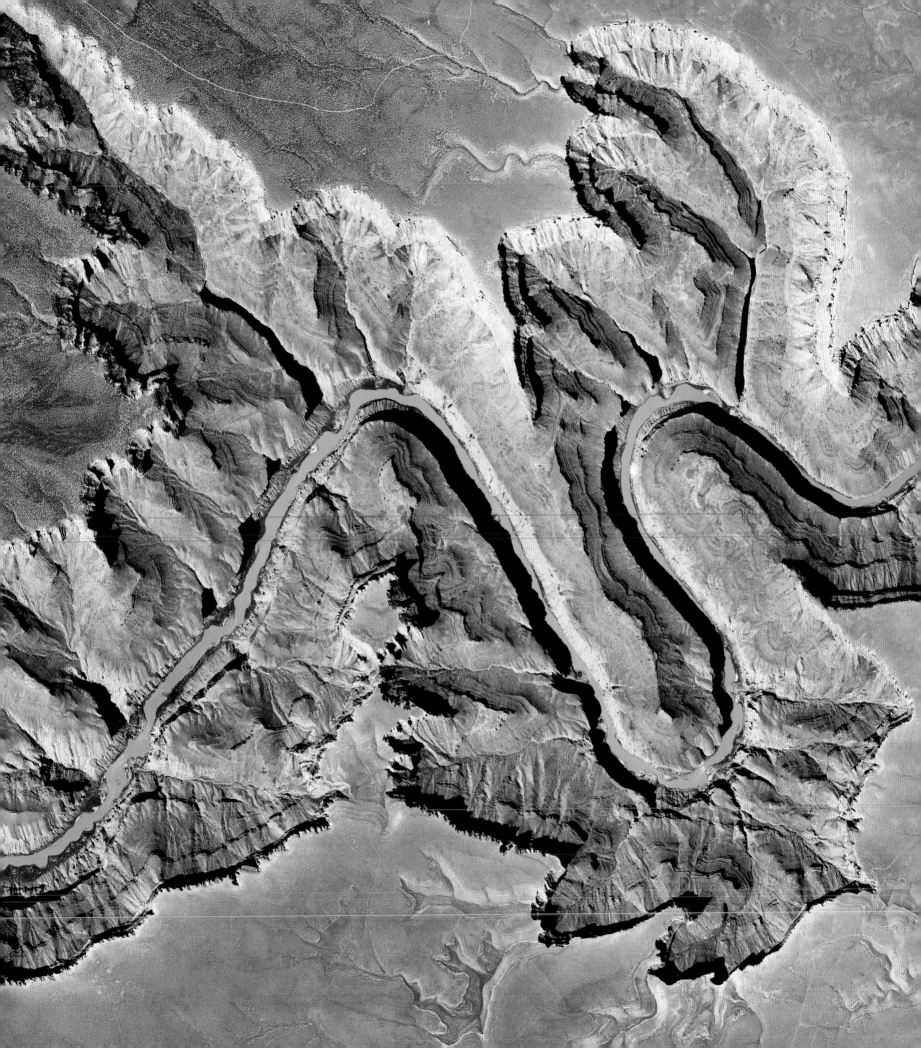

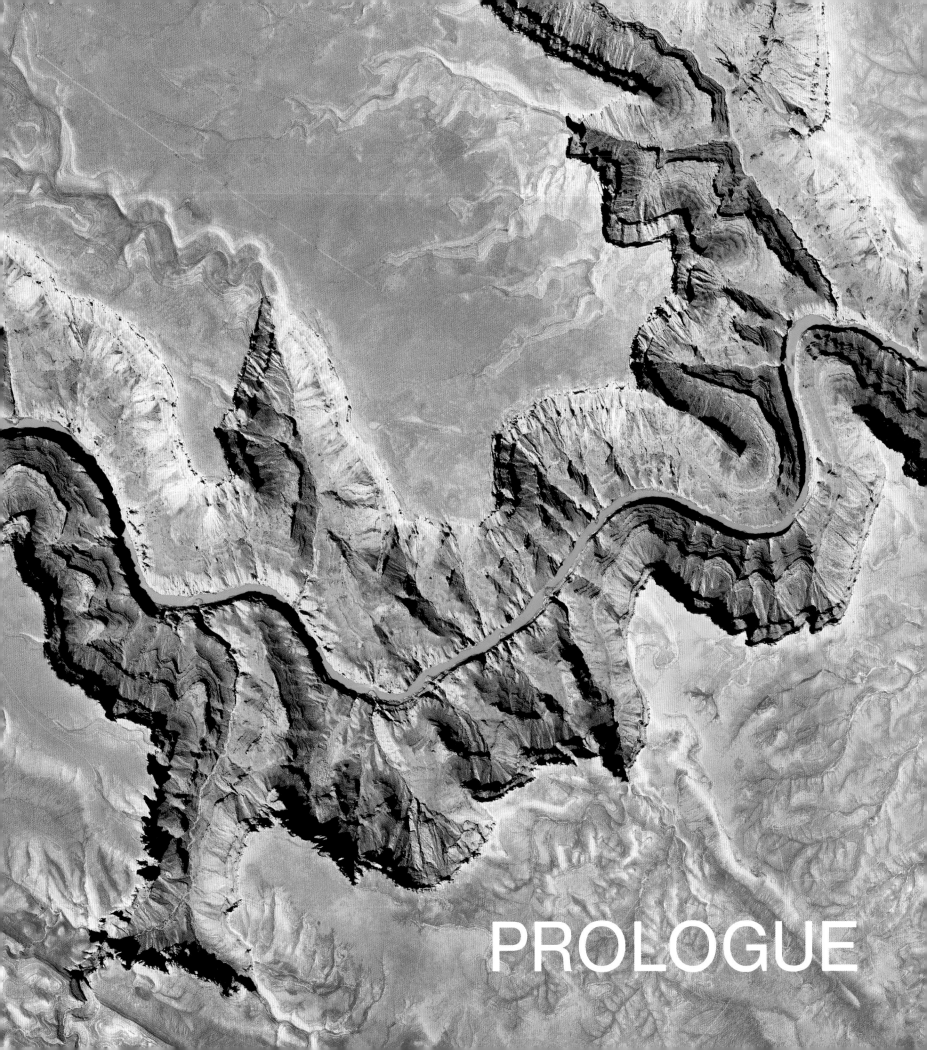

PROLOGUE

# The Past

In the grand history of life on Earth, humans have only just appeared. The planet has been in a state of constant evolution for billions of years, long before the dawn of humanity. Throughout Earth's past, geological forces have drastically altered its condition, with transformation taking place over eons. Water, in particular, has played a powerful role in this story, as a major force that continues to shape the planet and as the foundation of all life. Most of these water-dependent life-forms have come and gone over this long past—more than 99 percent of all species that have ever lived (roughly 5 billion) are believed to have gone extinct. We can look to the past and wonder at our place on this grand time line, yet the only certainty for our future has been constant all along: change.

PREVIOUS SPREAD
**Colorado River**
5 million years ago

———

The Colorado River and the trajectory of its current flow were formed roughly 5 million years ago. Due to tectonic activity, the Colorado Plateau continued to rise from 5 million until 2.5 million years ago, thereby shifting the direction of the river. With its new path, the river began to erode the area in present-day Arizona now known as the Grand Canyon. That canyon is situated just a few miles south of the river section captured in this Overview.

`36.417100°, -111.858300°`

OPPOSITE
**Andes Mountains**
45 million years ago

———

The Andes mountain range, seen here on the southern coast of Peru, stretches more than 4,300 miles (6,920 kilometers) down the west coast of South America from Venezuela to the top of Argentina. The range is the second tallest in the world and formed 45 million years ago as the Nazca and Antarctic tectonic plates moved under the South American plate—a geological process called "subduction."

`-14.631400°, -74.981000°`

**Timeline**

YA = YEARS AGO

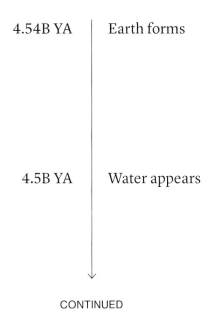

4.54B YA   |   Earth forms

4.5B YA   |   Water appears

CONTINUED

# Timeline

| | |
|---|---|
| 3.5B YA | Earliest forms of oxygen appear |
| 3.4B YA | Earliest photosynthesis by cyanobacteria |
| 850M YA | Earliest plants appear |
| 380M YA | Vertebrae and land animals appear |
| 252M YA | Major volcanic event in Siberia leads to mass extinction |

OPPOSITE

**Lake Natron**
1 million years ago

Formed roughly 1 million years ago by the movement of tectonic plates under Africa's Great Rift Valley, Lake Natron is a salt lake in northern Tanzania. The lake is shallow—less than 10 feet (3 meters) deep—and varies in width depending on its water level. The color of the water here is typical of saline lakes with high evaporation rates, in which salt-loving microorganisms thrive using photosynthesis to make their own food. A byproduct of this photosynthesis causes the lake's deeper water to turn bright red.

-2.348486°, 35.731660°

CONTINUED

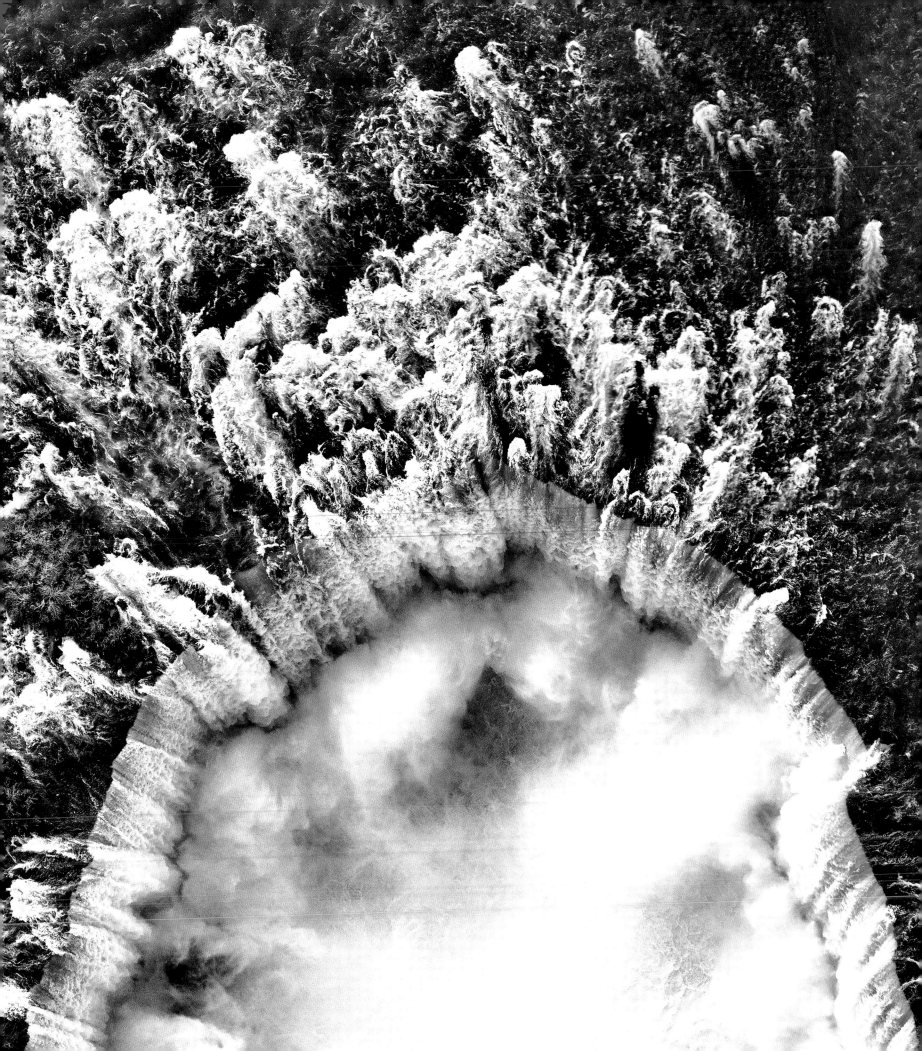

# Timeline

230M YA | Dinosaurs appear

200M YA | Mammals appear

175M YA | Continents form

100M YA | Flowering plants and rainforests appear

66M YA | Dinosaurs go extinct

CONTINUED

OPPOSITE

**Niagara Falls**
11,000 years ago
———

Niagara Falls is the collective name for three waterfalls that straddle the border between Ontario, Canada, and the United States. Horseshoe Falls is seen here. Believed to have formed at the end of the last ice age 11,000 years ago, the falls were created when glaciers released a large amount of water from the newly formed Great Lakes. This water carved a path en route to the Atlantic Ocean and dropped over the cliff face now known as the Niagara Escarpment. The falls have the highest flow rate of any waterfall in the world, with a vertical drop of more than 165 feet (50 meters).

43.077107°, -79.075506°

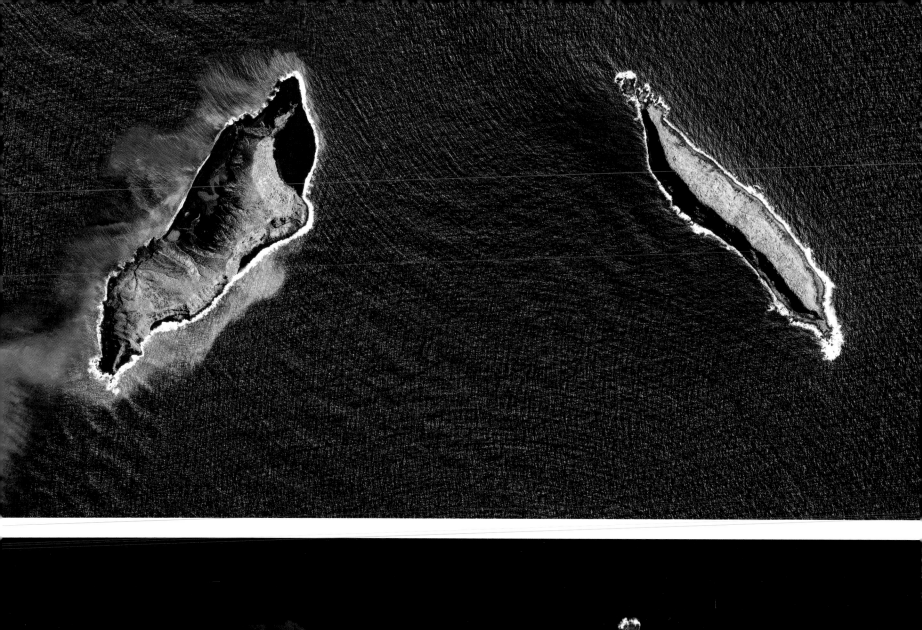
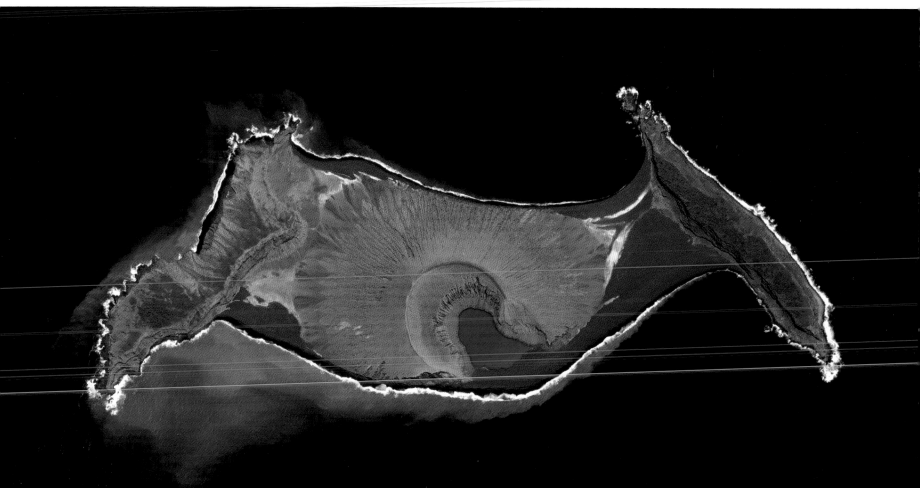

| | |
|---|---|
| 55M YA | Primates appear |
| 200,000 YA | First *Homo sapiens* in Africa |
| 45,000 YA | Humans settle in Australia |
| 16,000 YA | Humans settle in Americas |
| 12,000 YA | Agricultural Revolution / First permanent settlements |
| 5,000 YA | Civilizations form |

OPPOSITE

**Hunga Tonga–Hunga Ha'apai Formation**
2010 / 2019

———

Volcanic activity has produced new land on Earth for millions of years, and observing recent volcanic events helps us understand what has occurred throughout these millennia. At the time of this first Overview in 2010, Hunga Tonga and Hunga Ha'apai were volcanic islands separated by 1 mile (1.6 kilometers) of water in Tonga, a country comprised of 169 islands spread across Polynesia in the southern Pacific Ocean. In December 2014, an eruption produced new volcanic material that connected the two islands, thereby forming the combined landmass that is now called Hunga Tonga–Hunga Ha'apai.

-20.545347°, -175.393691°

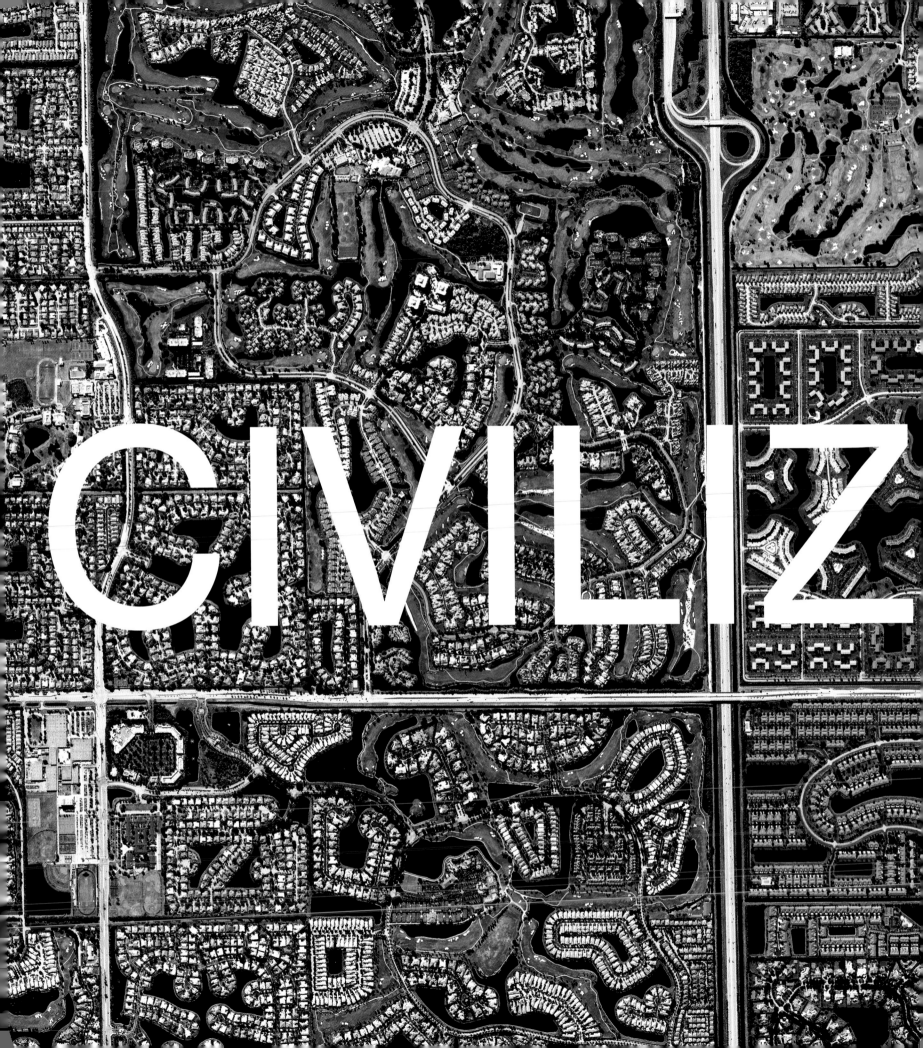

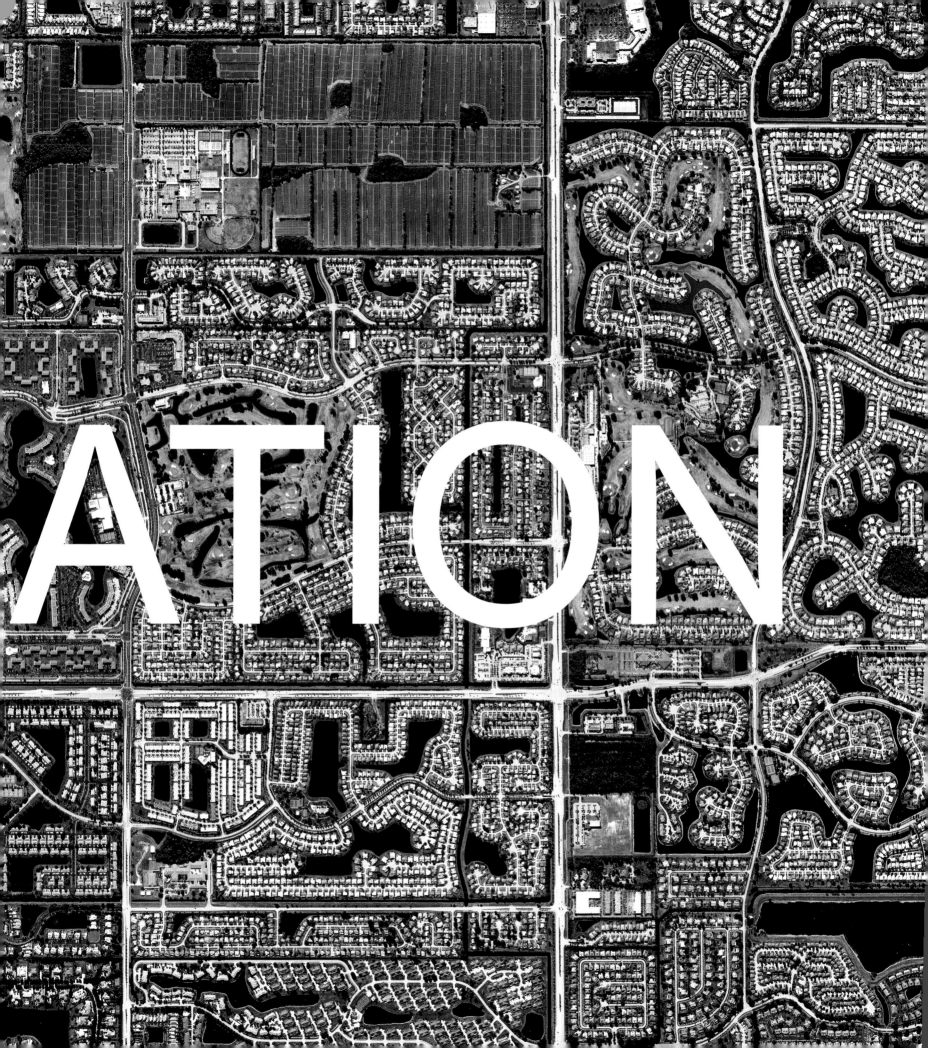

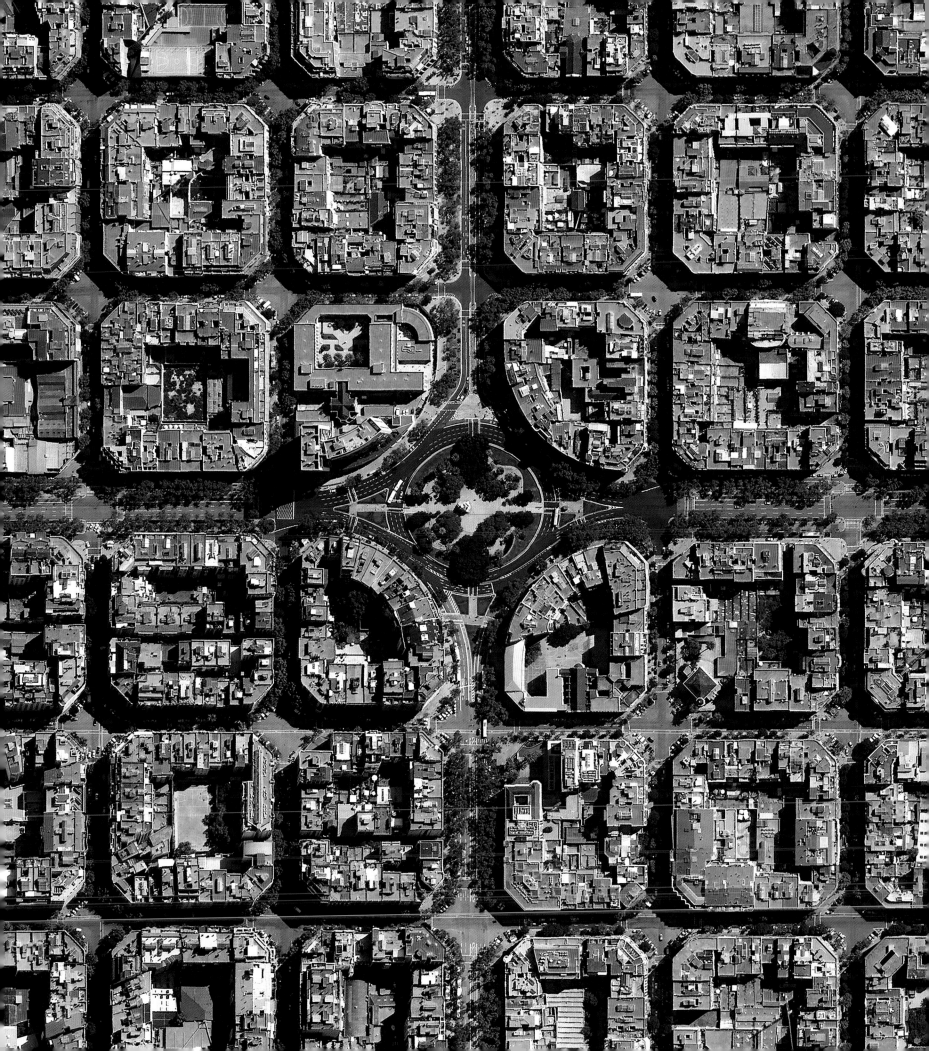

> **"What is the city but the people?"**
>
> —William Shakespeare

# Urbanization

Human beings have rapidly become an urban species. While we may pride ourselves on venturing to the farthest corners of the earth, more than 54 percent of us now live in cities. More than half the population has settled on only 1 percent of Earth's livable area. With 6.3 billion people expected to reside in urban areas by 2050 (65 percent of 9.7 billion people), cities represent not only what our civilization looks like now, but what we will see more of in the decades to come. In this chapter, you will observe this relatively recent trend of urbanization, the difference between deliberate urban planning and unplanned growth, and how the influx of people has shaped various cities around the world.

The growth of cities has enabled humanity to achieve some of its greatest feats. Urban centers were the first places where humans gathered for public discourse, commerce, and entertainment. City residents are attracted by the prospect of better jobs, health care, and education. The architecture we imagine and then build serves as hubs for human collaboration, productivity, and creativity. The infrastructure and services we can provide at scale in cities—housing, electricity, public transportation, water, and sanitation—are typically cheaper and less harmful to the environment than those same amenities when they are brought to a dispersed, rural population. Ultimately, the density that occurs in cities is a necessary challenge, as we must fit an exploding population into an already developed, complex world.

While living in cities has become the norm for most people, cities themselves are anything but the norm for the planet. With growing populations, cities sprawl outward, effectively expanding or repurposing what is man-made. Cities and their inhabitants drive the demand for more than two-thirds of the world's energy production, and that collective behavior leads to roughly 70 percent of global carbon emissions. With convenience in mind, cities have almost always been developed alongside major bodies of water (90 percent of the world's urban areas are built on coastlines). Paradoxically, as sea levels rise, our decision to settle near water may soon lead to large-scale inconvenience. The thoughtful expansion, modernization, and adaptation of cities will not be easy due to our growing population and ever-increasing complexity. Nevertheless, it is an essential challenge to solve if we want to shrink our carbon footprint and live in greater balance with the planet.

PREVIOUS SPREAD

**Boca Raton**
2010

Residential development, infrastructure, and golf courses are seen in Boca Raton, Florida. Many cities in the state contain master-planned communities that were often built on top of waterways in the latter half of the twentieth century, creating intricate designs that are visible from the Overview perspective. Boca Raton is home to roughly 100,000 residents.

26.386332°, -80.179917°

OPPOSITE

**Eixample District, Barcelona**
2012

Barcelona is one of the most densely populated cities in Europe, and Eixample, shown here, is its most populous district, with 92,000 people per square mile (36,000 people per square kilometer). With octagonal intersections, the city's grid opens to allow for greater visibility, increased sunlight, better ventilation, and more space for short-term parking. In 2017, Barcelona also began a 20-year initiative to plant new or denser avenues of trees that will unite a network of gardens across the city along major streets, thereby increasing surfaces that are more permeable to rain. The trees will also enable birds and insects to create and move across a seamless habitat.

48.858950°, 2.276848°

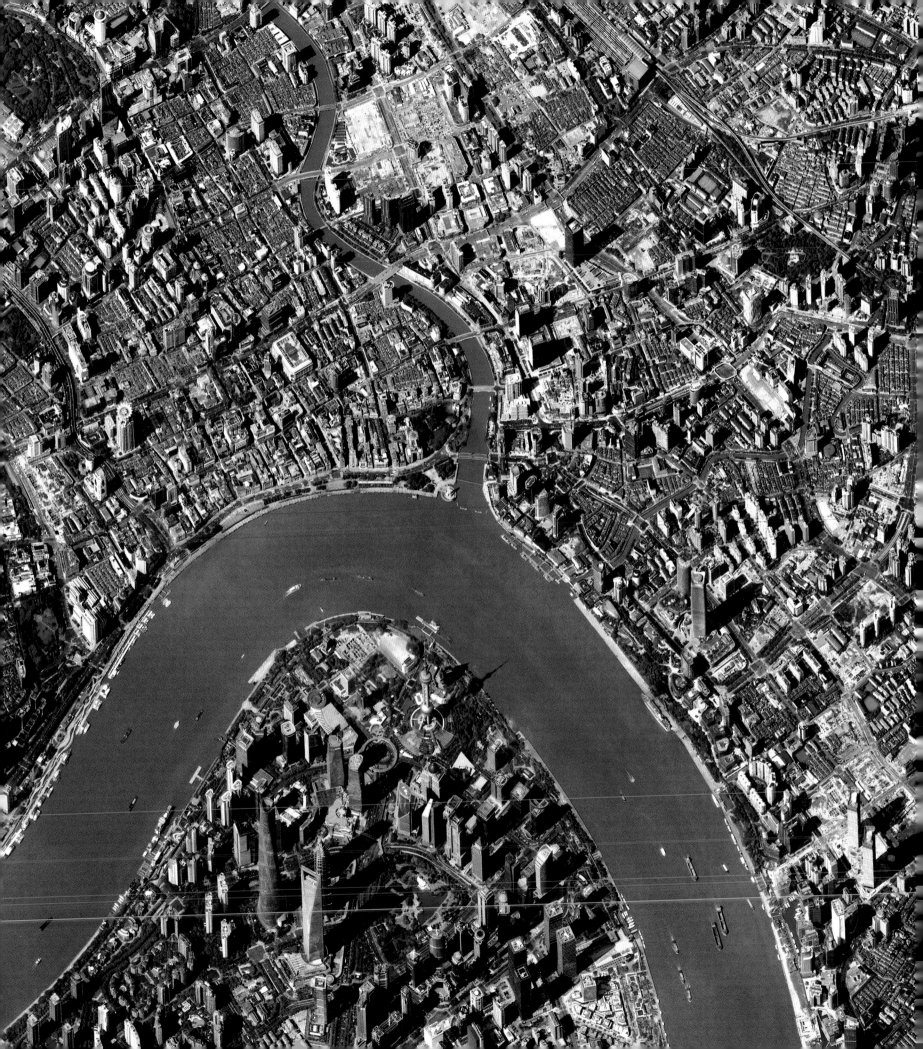

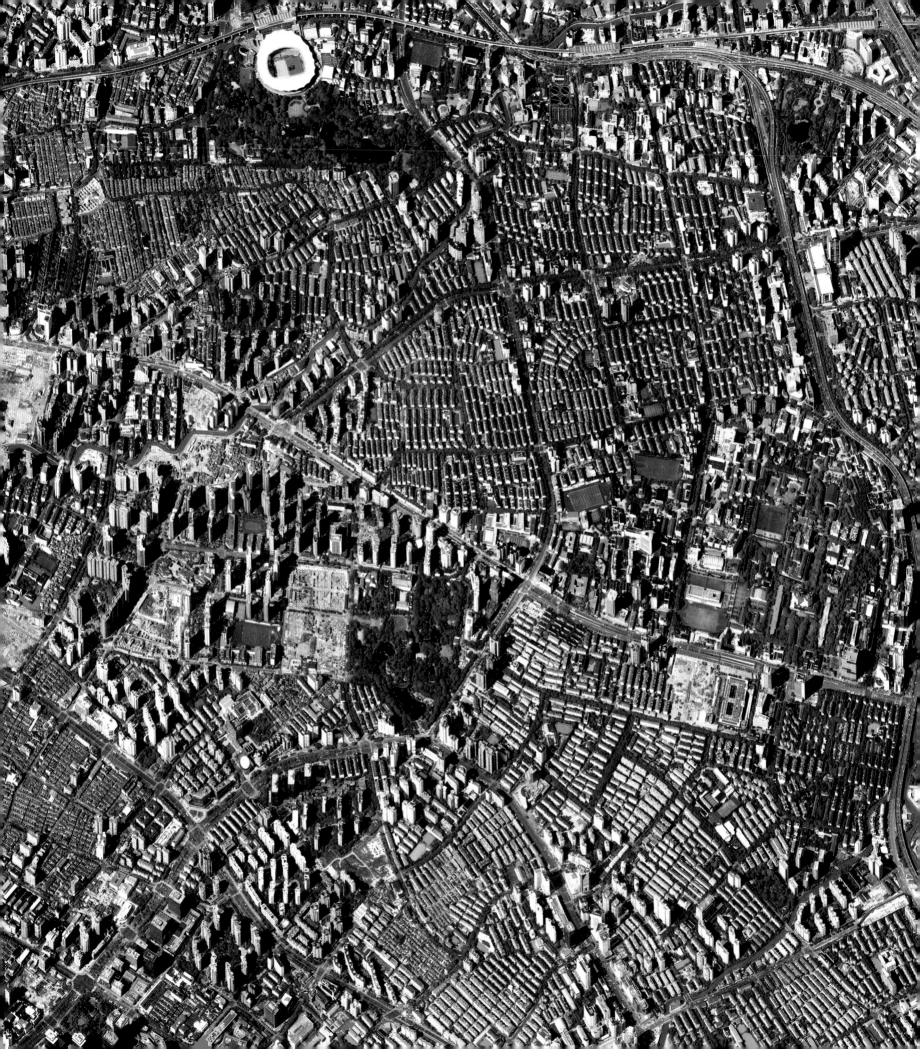

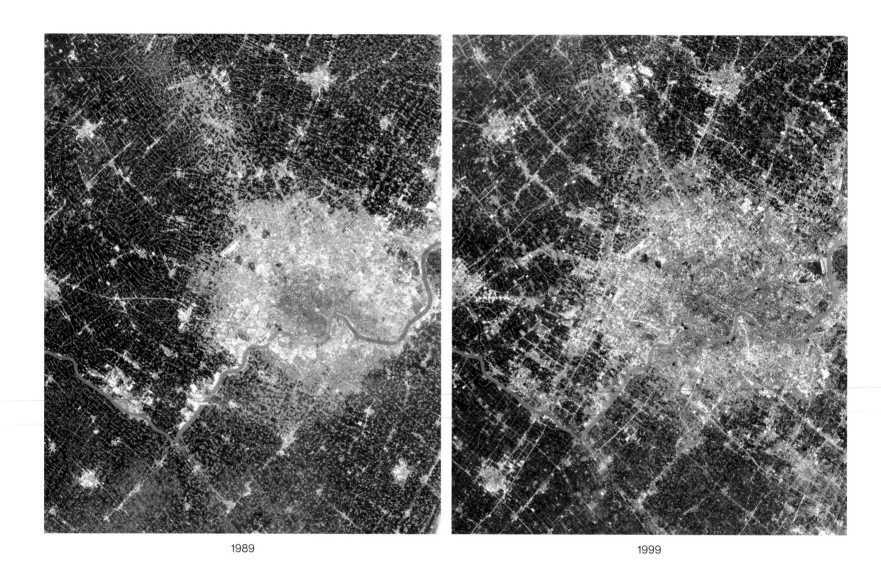

1989

1999

PREVIOUS PAGE

**Shanghai City Center**
2019

The Overview on the previous page shows Shanghai's Pudong New Area (bottom left) on one side of the Huangpu River and an area known as "The Bund" built on the other bank. These districts are home to some of the city's most recognizable skyscrapers as well as its financial center. Hongkou Football Stadium, China's first soccer stadium, which was constructed in 1999, is also clearly visible.

31.238916°, 121.497218°

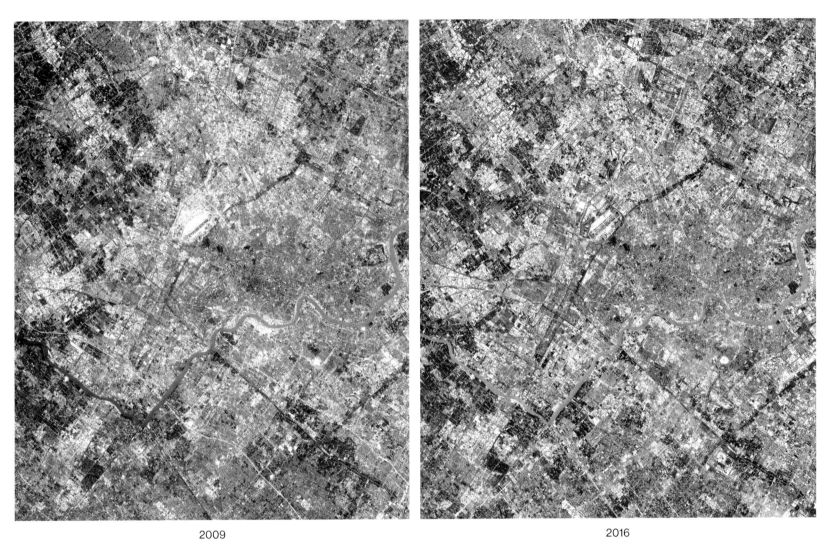

2009

2016

OPPOSITE AND ABOVE

**Shanghai Expansion**
1989–2016

Over the past few decades, the growth of Shanghai—and of many Chinese cities—has been staggering. The city has more than quadrupled in size since the early 1980s, when the Chinese government began opening the country up to foreign trade and investment. In 1984, Shanghai had 119 square miles (308 square kilometers) of urban area on the west bank of the Huangpu River; by 2014, it had expanded almost five times larger to an area of 503 square miles (1,303 square kilometers), effectively merging with the surrounding towns. Shanghai's urban area is currently about the size of Los Angeles, but its population (now upward of 24 million) is more than double that of LA.

31.224302°, 120.914889°

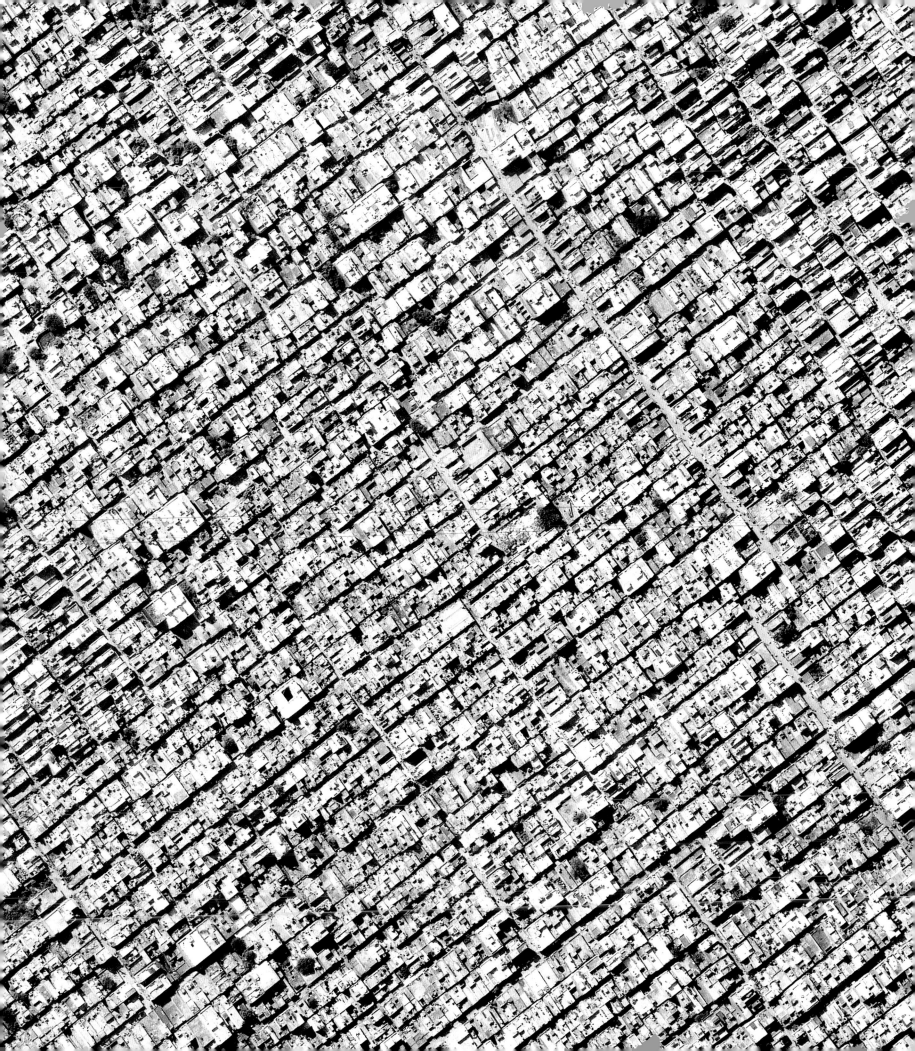

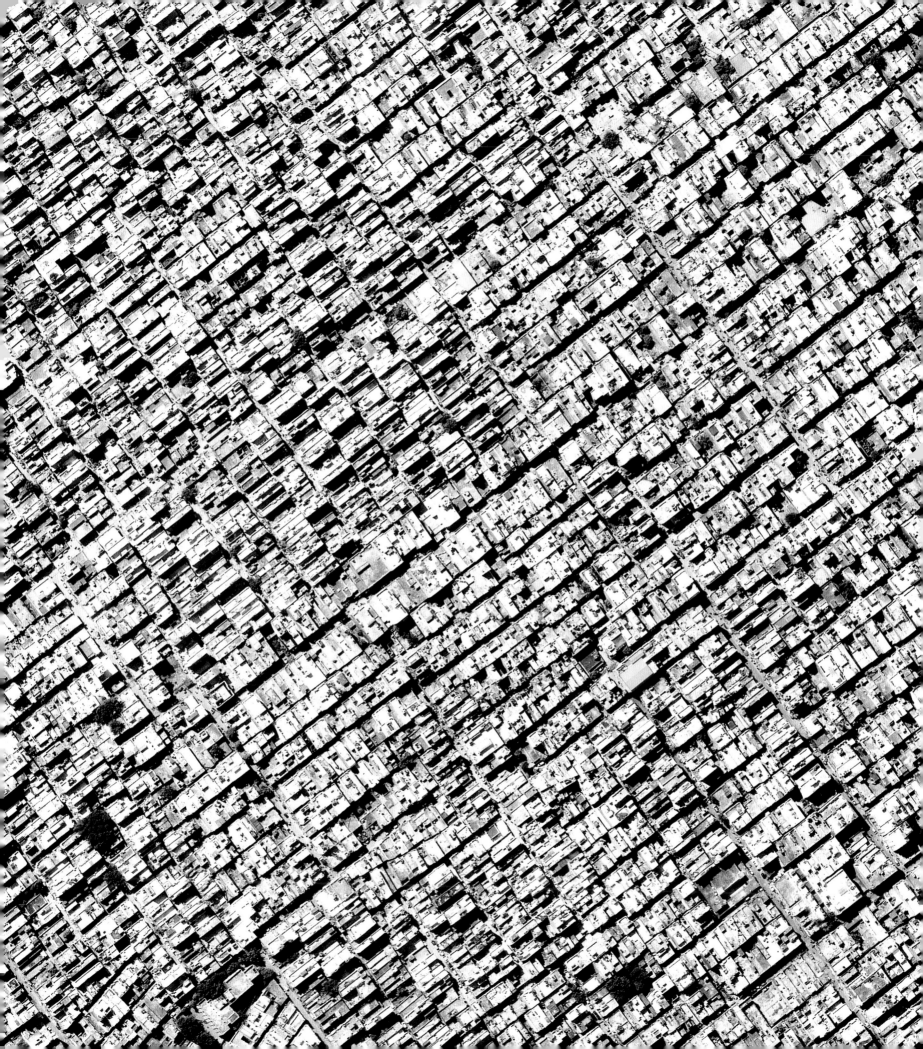

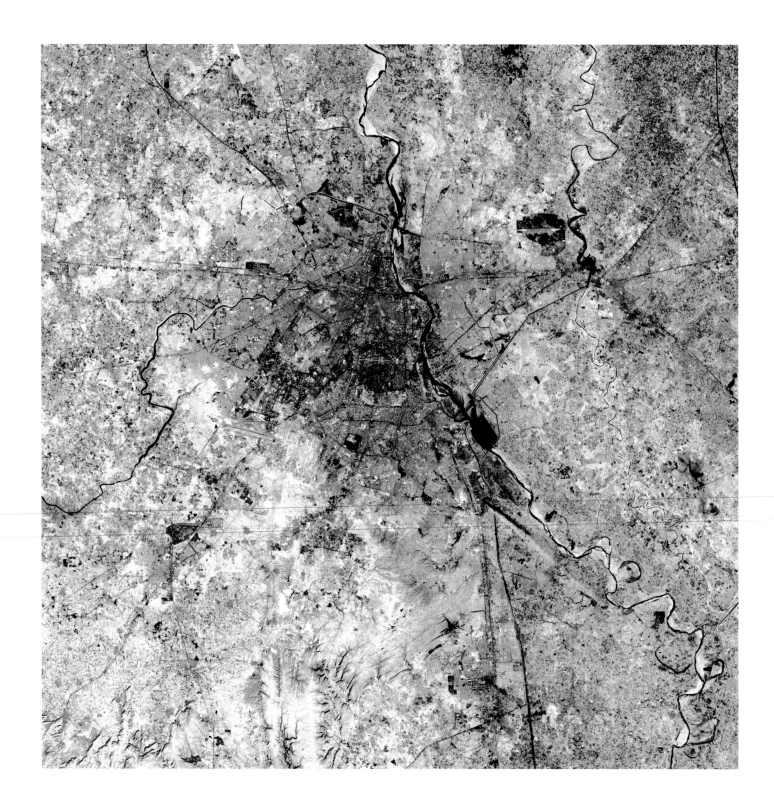

PREVIOUS PAGE

**Delhi Neighborhoods**
2018

———

Nearly half of Delhi's residents live in slums without basic infrastructure like electricity, running water, and sewage. The neighborhoods of Santosh Park and Uttam Nagar, both pictured in the Overview on the previous page, are home to some of the city's poorest people and contain its most built-up and densely populated land. Numerous studies have shown a correlation between the wealth of a residential area and its total number of trees and amount of green space. This image is a particularly striking example of that trend.

28.614656°, 77.057758°

ABOVE AND OPPOSITE

**Delhi Expansion**
1989 / 2018

———

Delhi, which contains India's capital of New Delhi, has undergone one of the fastest urban expansions on Earth. These images show croplands and grasslands transforming into gray city blocks (as seen on the previous page) in a matter of three decades. From 1991 to 2011, the population of Delhi nearly doubled, and its geographic size followed suit. The metropolitan area is currently home to 26.5 million residents, and the city is expected to become the most populous in the world by 2030, with nearly 39 million people.

8.646677°, 76.813073°

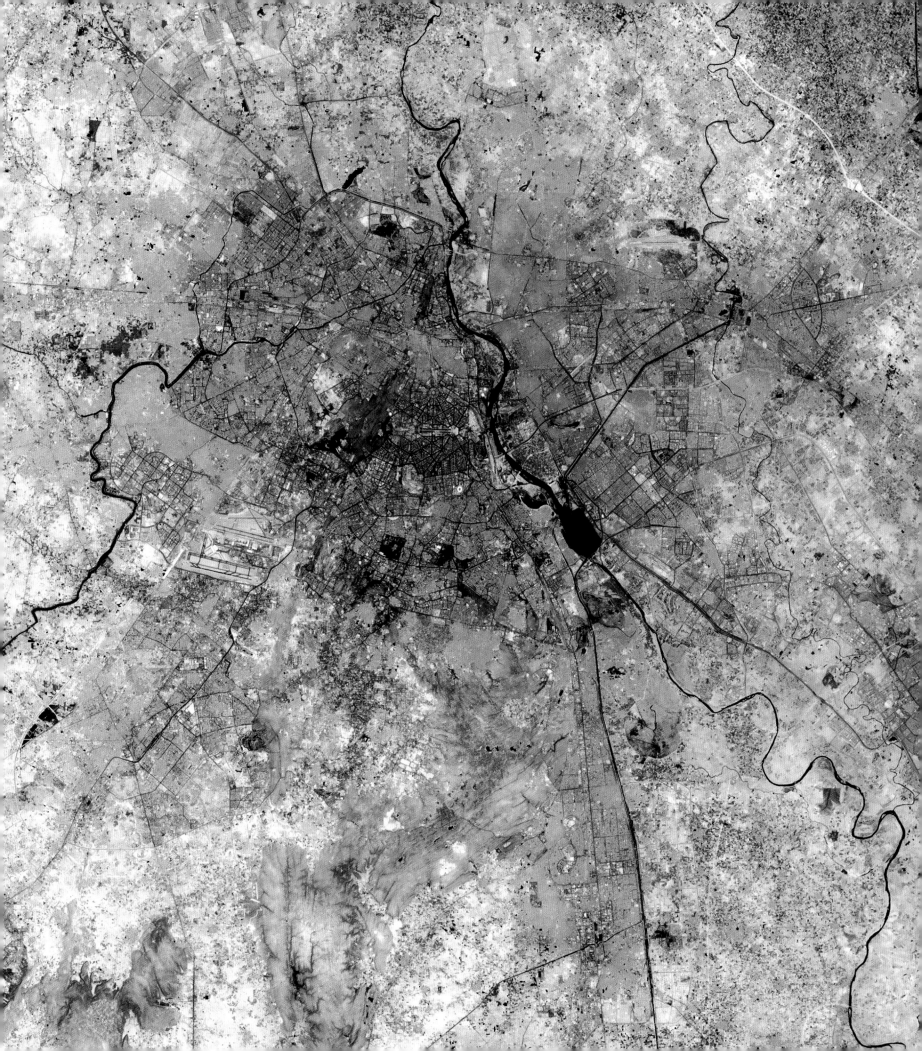

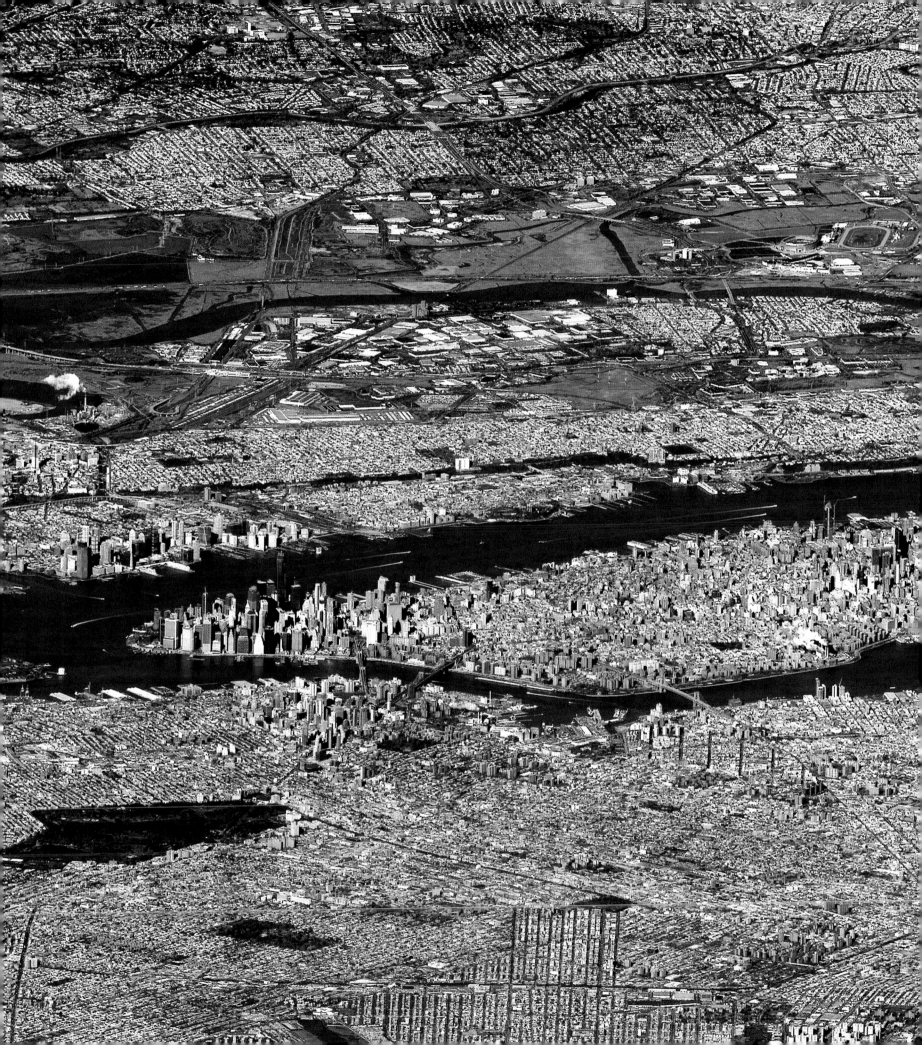

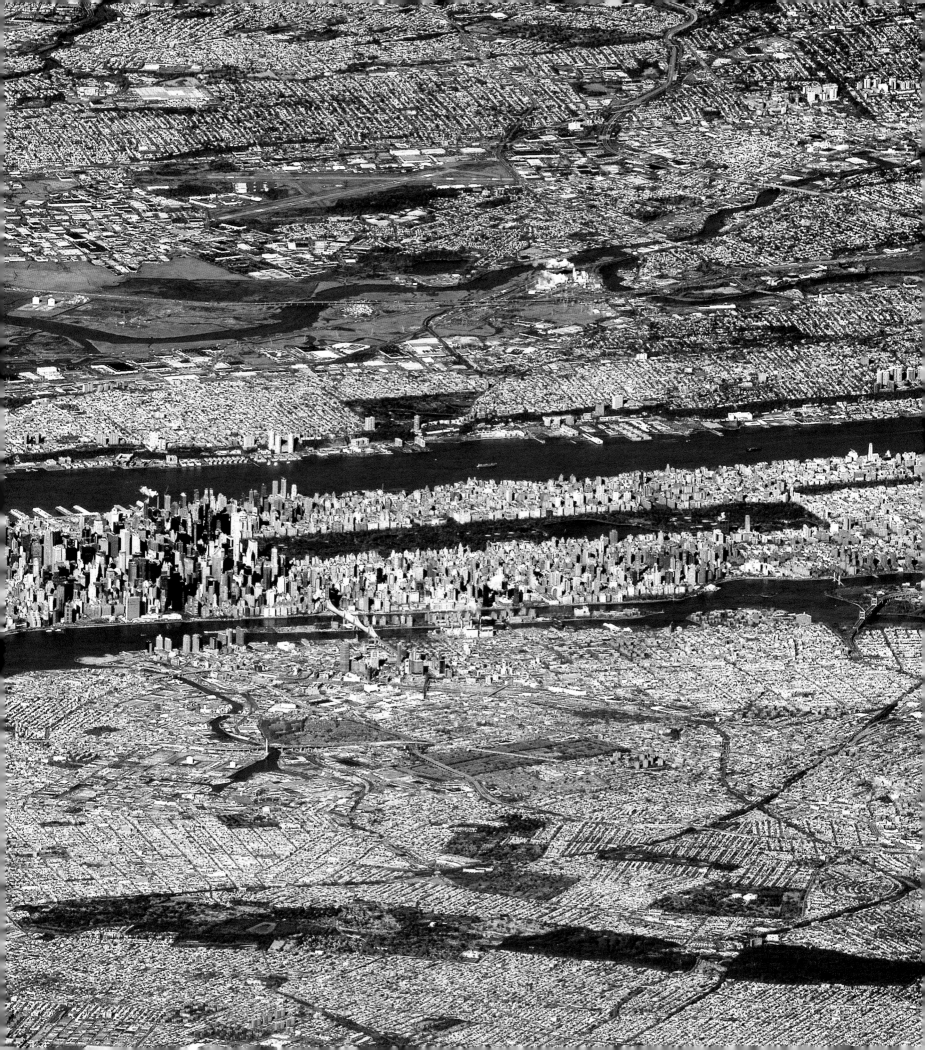

**New York City**
2016

New York City, captured on the previous page by satellite at a low angle, is the most populous and most densely populated major city in the United States, with nearly 8.4 million people on a land area of 302 square miles (782 square kilometers). To accommodate its high population density, the city is one of the most vertically built in the world, most notably seen in the skyscrapers of Manhattan. As of 2020, the city had more than 7,000 high-rise buildings that are at least 115 feet (35 meters) tall and 284 completed skyscrapers that rise at least 492 feet (150 meters) in height. There are 29 more buildings under construction that will be taller than 492 feet (150 meters).

40.761432°, -73.979815°

RIGHT

**Central Park**
Fall / Winter

Central Park in New York City spans 843 acres (341 hectares), which is 6 percent of the island of Manhattan. Seen here, across multiple seasons, the park contains numerous tennis courts and baseball fields, an ice-skating rink, and a swimming pool. Central Park has more than 38 million visitors annually, making it the most visited urban park in the United States. One of the main influential innovations in the park's design was its "separate circulation systems" for pedestrians, cyclists, horse riders, and cars.

40.782997°, -73.966741°

OPPOSITE

**Sheep Meadow**
Spring

The crowds at Sheep Meadow in Central Park are a reflection of New York City's density and the park's popularity. The field draws massive crowds in the spring, after city residents have spent more time indoors during the cold winter months. Covering 15 acres (6 hectares) on the park's west side, the grass attracts up to 30,000 visitors a day during the warmer months of the year.

40.770784°, -73.977618°

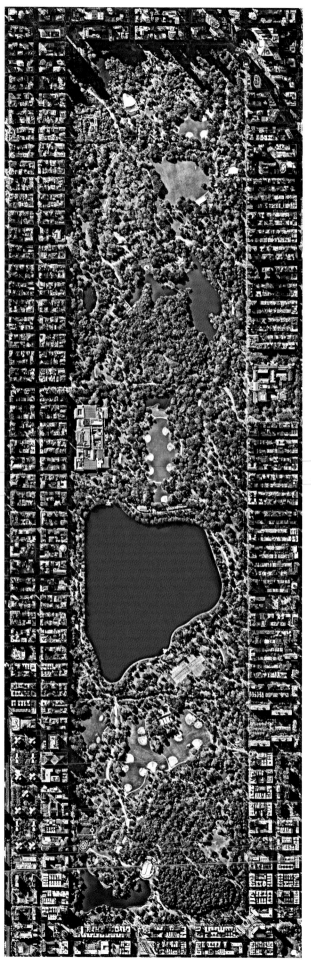

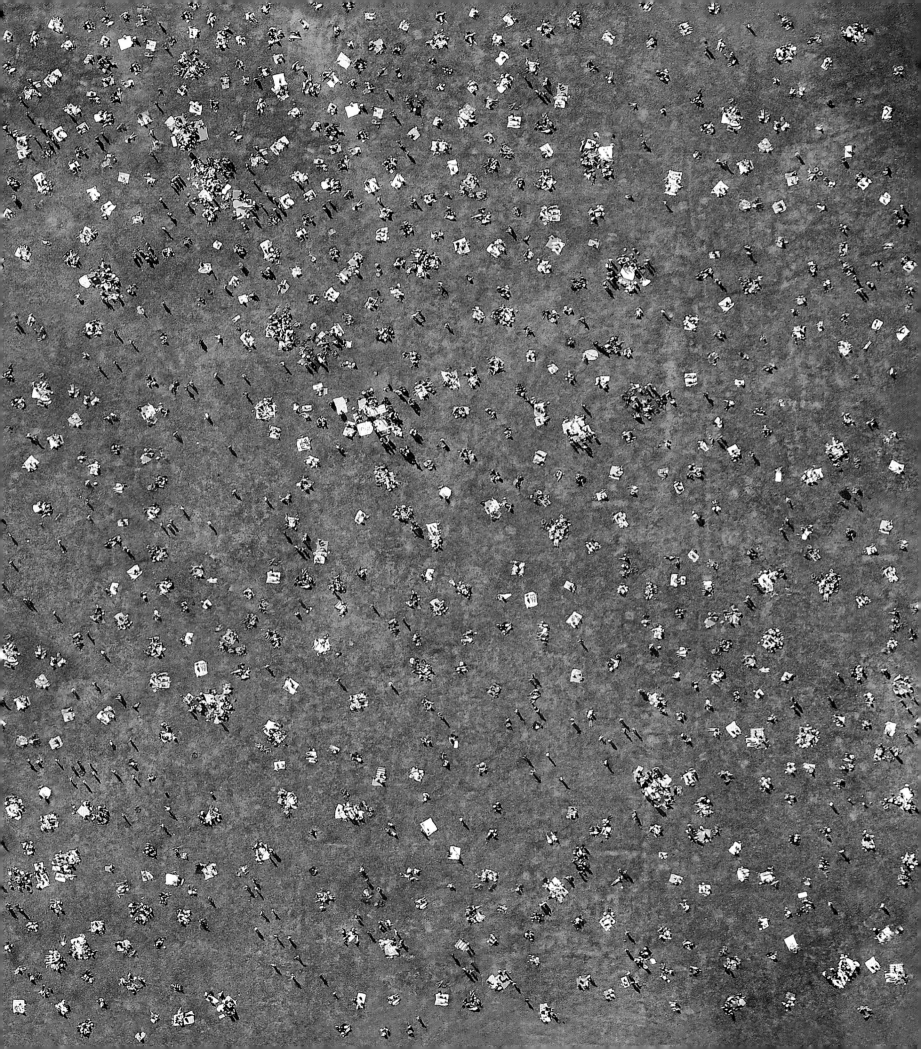

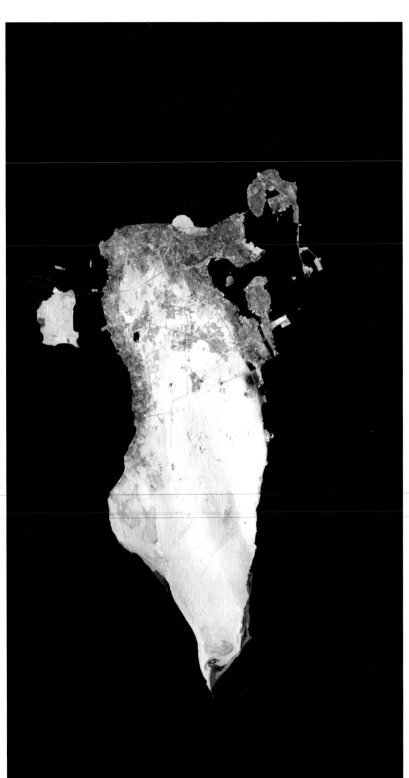

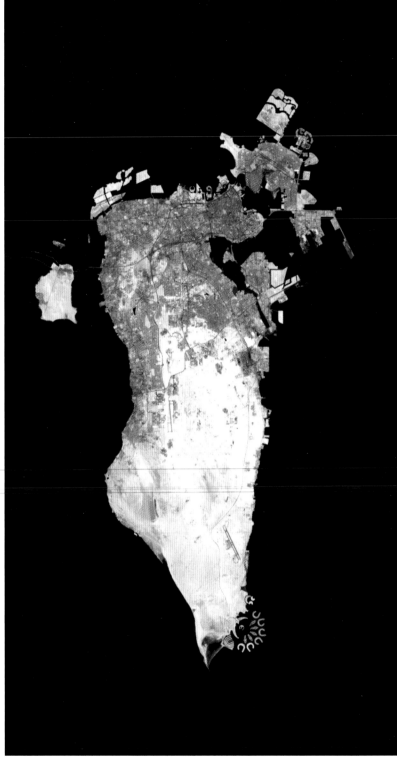

**Bahrain Land Reclamation**
1987 / 2018

In recent decades, Bahrain has significantly increased its national territory through systematic land reclamation. This process involves dredging up earth from the seafloor, depositing it onshore, and using the new land for development. Land reclamation in Bahrain dates back to the mid-1960s, but it has escalated in recent decades, increasing the nation's total land area from about 239 square miles (619 square kilometers) to 300 square miles (777 square kilometers).

26.100883°, 50.514655°

**Bahrain Land and Waterway Development**
2019

A land reclamation project on the southern tip of Bahrain, by the Durrat Al Bahrain islands, has created waterways on which residential and industrial development can be built. The center of this area will presumably house a new marina for residents' vessels.

25.827300°, 50.586704°

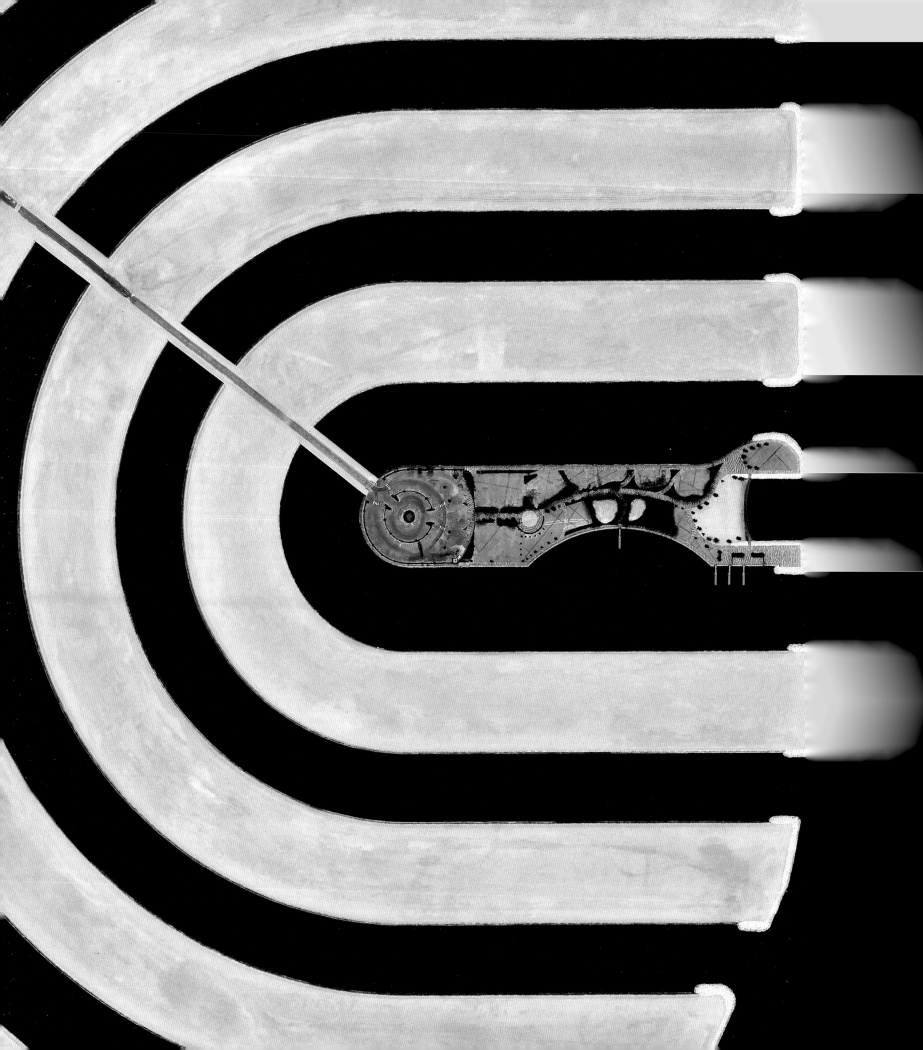

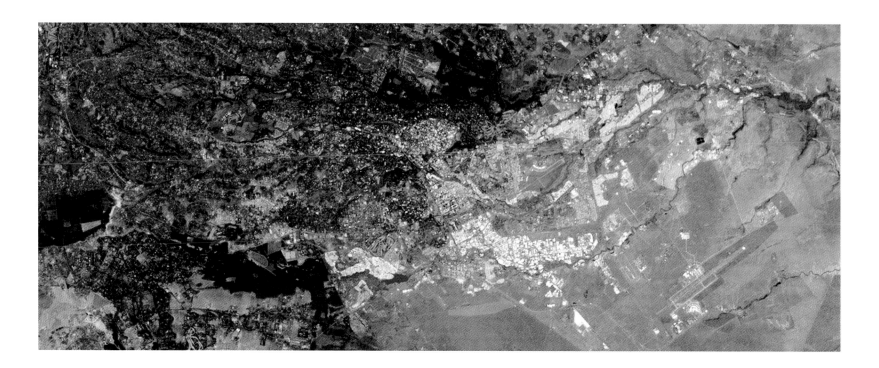

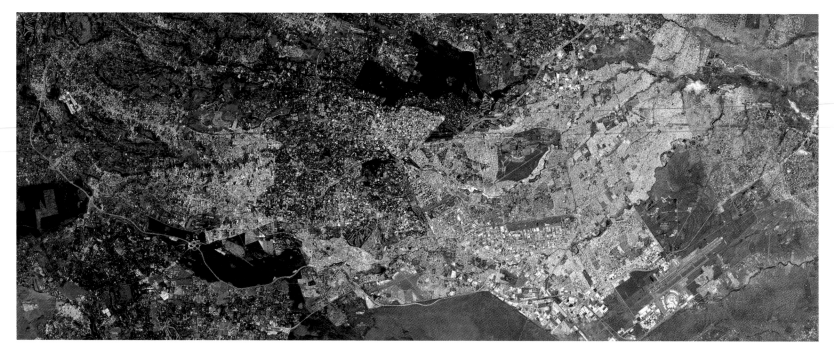

ABOVE

**Nairobi Expansion**
1986 / 2016

Nairobi, the capital of Kenya, has grown rapidly since Kenya gained independence from Great Britain in 1963, with its urban population jumping from roughly half a million to more than 4.3 million in the last 50 years, an eightfold increase. Thirty years of development are visible over the course of these two Overviews. Nairobi's boom, as in many cities in Africa, has been fed mostly by younger generations moving from rural areas to the city in search of work.

-1.302861°, 36.706965°

OPPOSITE

**Kibera**
2017

This Overview shows a portion of Kibera, Nairobi's largest slum and the largest urban slum in Africa. Most of Kibera's population, which is estimated to be at least 1 million, lives in extreme poverty, earning less than a dollar per day. While exact population figures are difficult to determine, estimates put the density of Kibera at roughly 777,000 inhabitants per square mile (300,000 per square kilometer).

-1.315174°, 36.794770°

# Venice
## 2018

———

Venice, Italy, is situated upon 118 small islands that are separated by canals and linked by bridges. The Grand Canal—the city's 2.4 mile long (3.9 kilometers) central waterway lined by 170 buildings—is visible in this Overview. With water so central to the city, Venice is already starting to feel the impacts of rising tides and sea levels. Living by water is the norm for most urban dwellers, with 90 percent of major urban areas situated on the coast of a major body of water. To see Venice's potential solution to the problem, turn to page 251.

45.435621°, 12.328626°

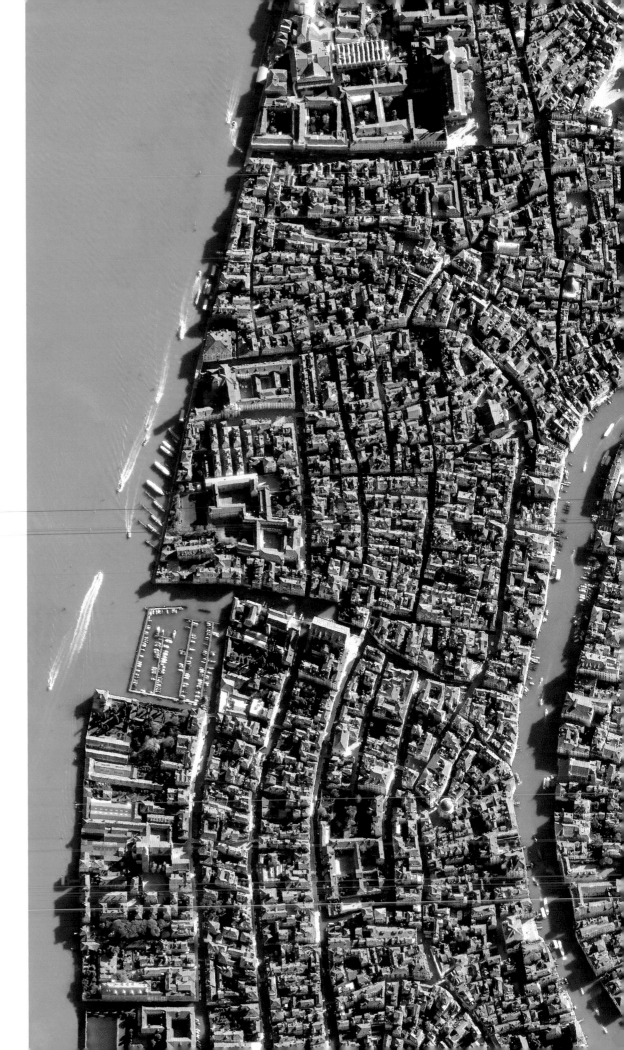

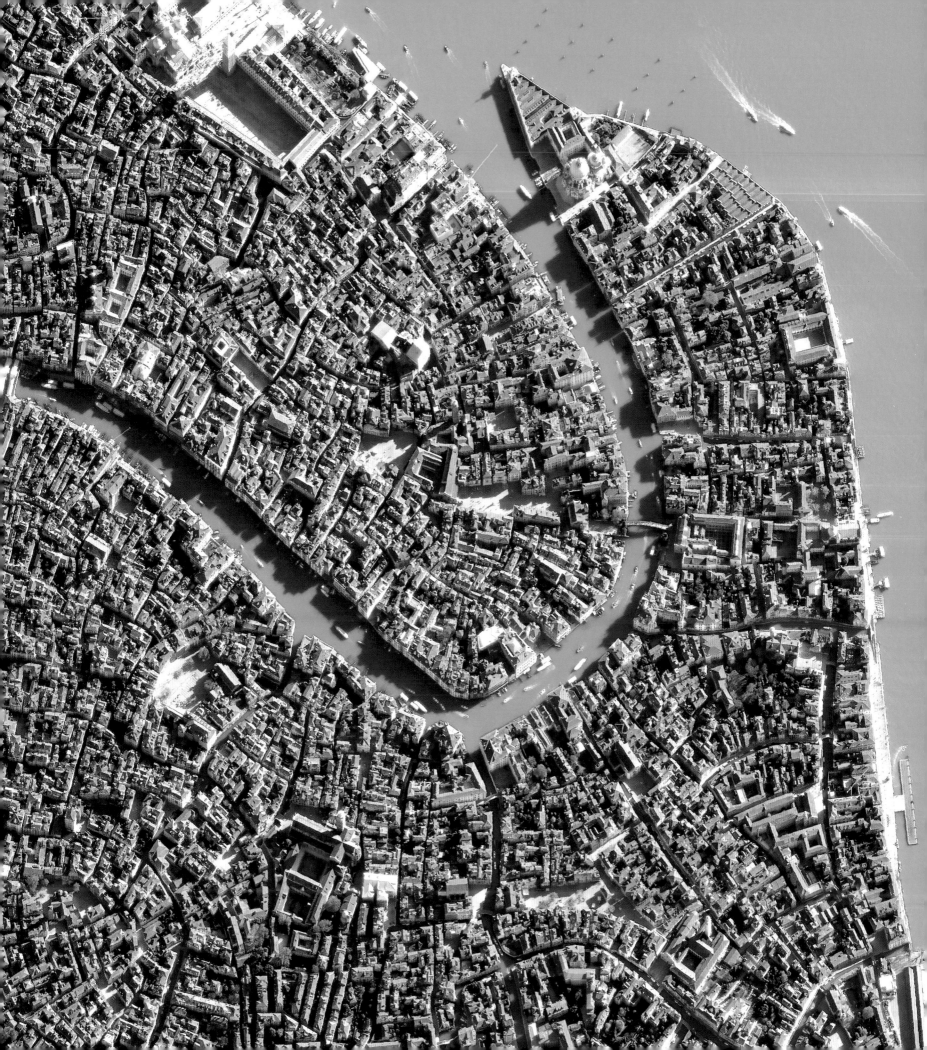

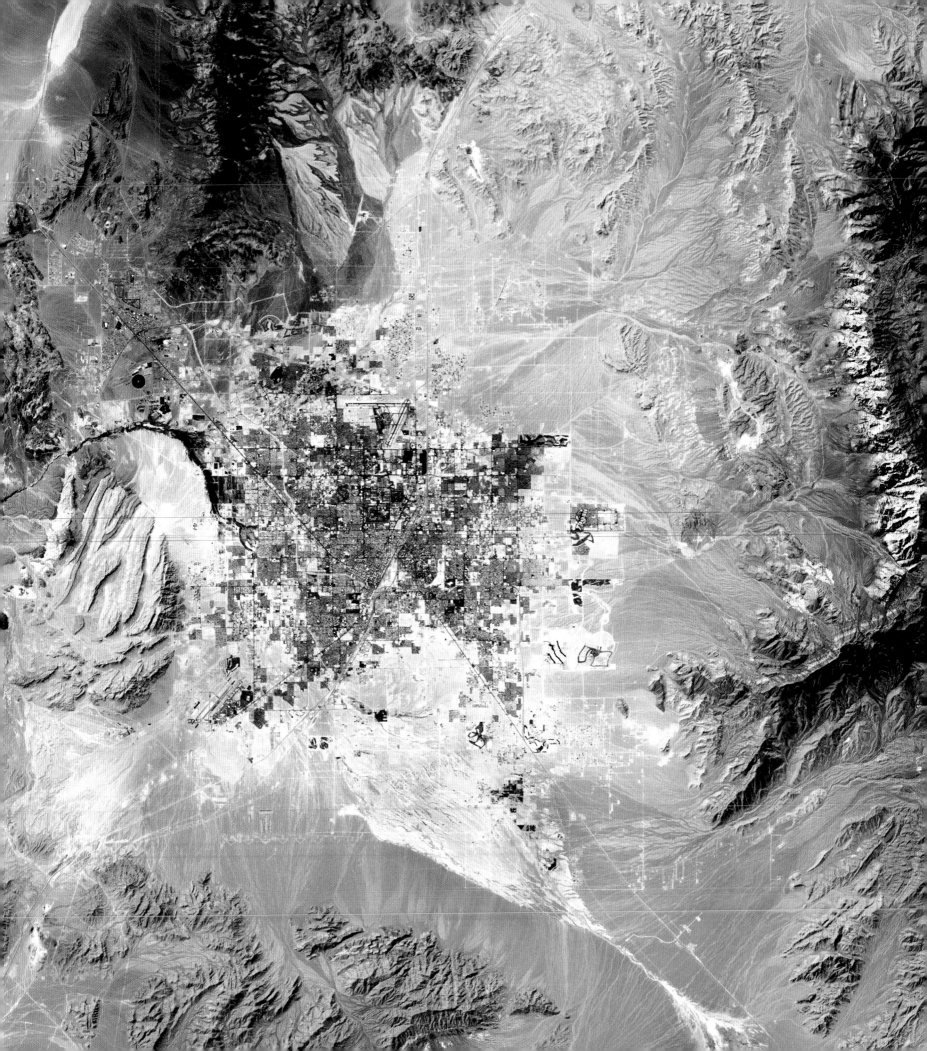

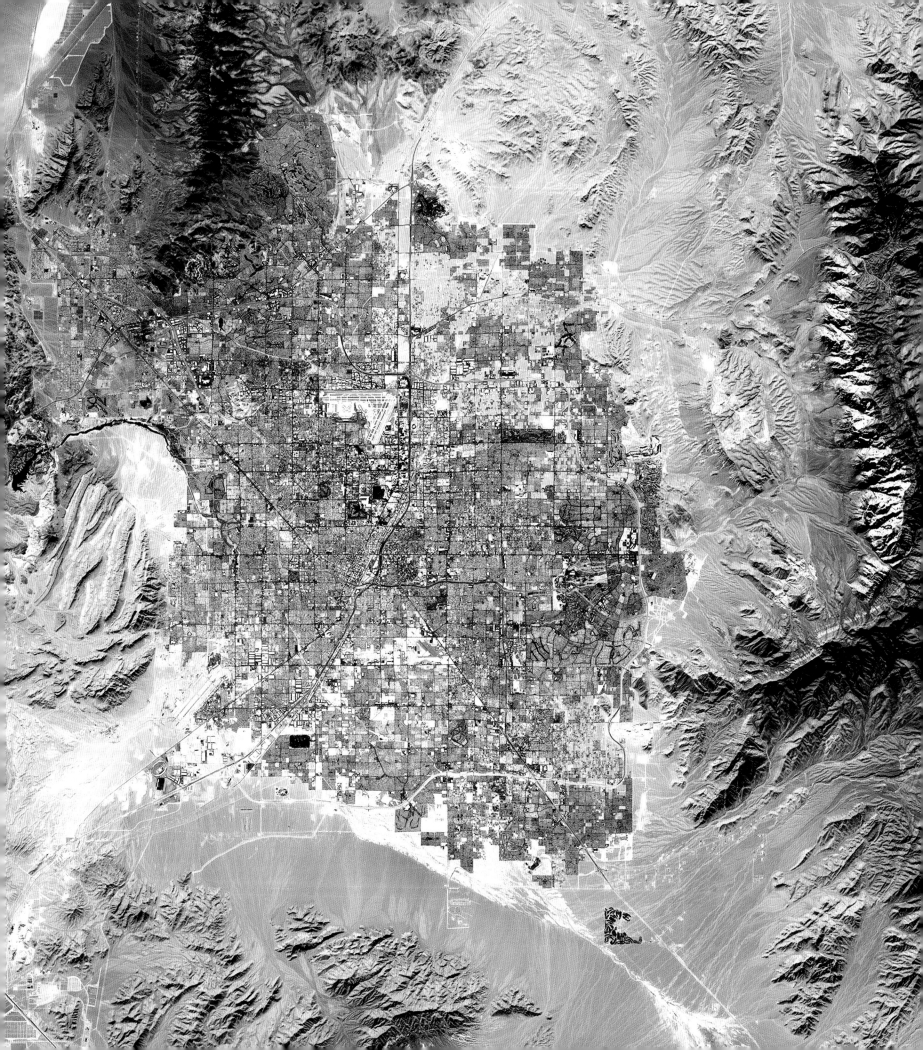

2014

2015

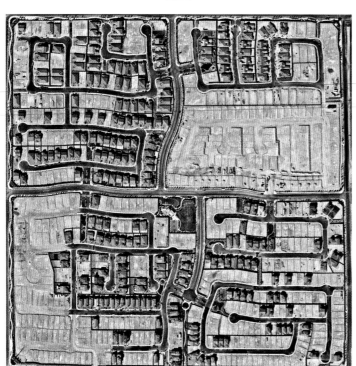

2017

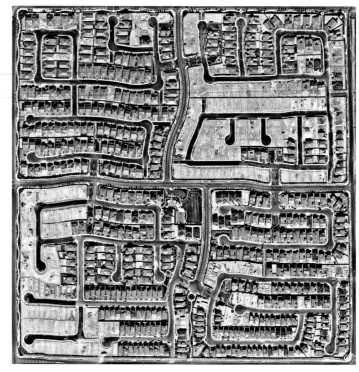

2018

PREVIOUS PAGE

**Las Vegas Expansion**
1989 / 2019

———

Over the course of thirty years, the metropolitan area of Las Vegas experienced a more than fourfold population increase—from 710,000 to more than 3 million people. This drastic growth has contributed to Nevada becoming one of the fastest-growing states in America over the last several decades. The city's expansion can be observed by its streets, homes, and buildings sprawling into the surrounding desert.

36.124673°, -115.455186°

ABOVE AND OPPOSITE

**Las Vegas Residential Development**
2014–2019

———

Teton Cliffs is a planned housing development on the ever-expanding northwest edge of Las Vegas, Nevada. The construction of this community is illustrative of the sprawl that has occurred in the city, as seen on the previous pages. The conversion of desert into the residential community is visible over a five-year period. When fully complete, this neighborhood will contain 155 homes.

36.308952°, -115.310174°

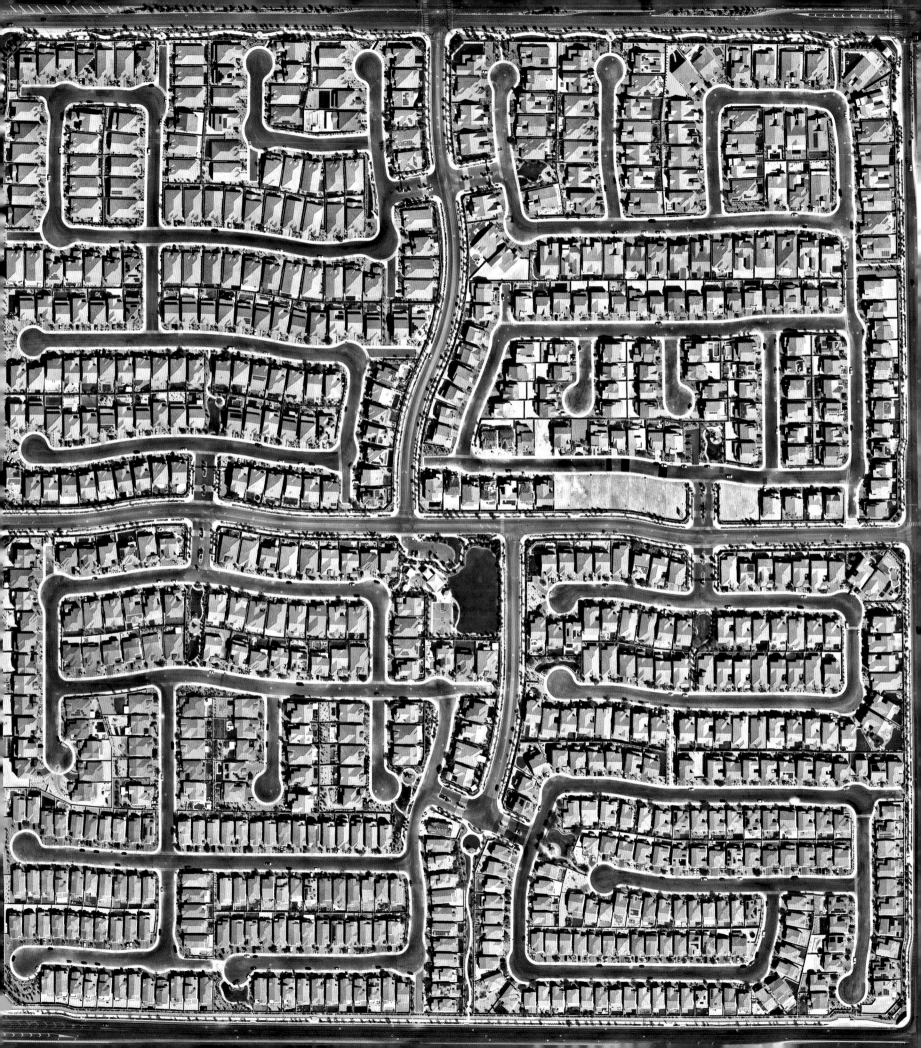

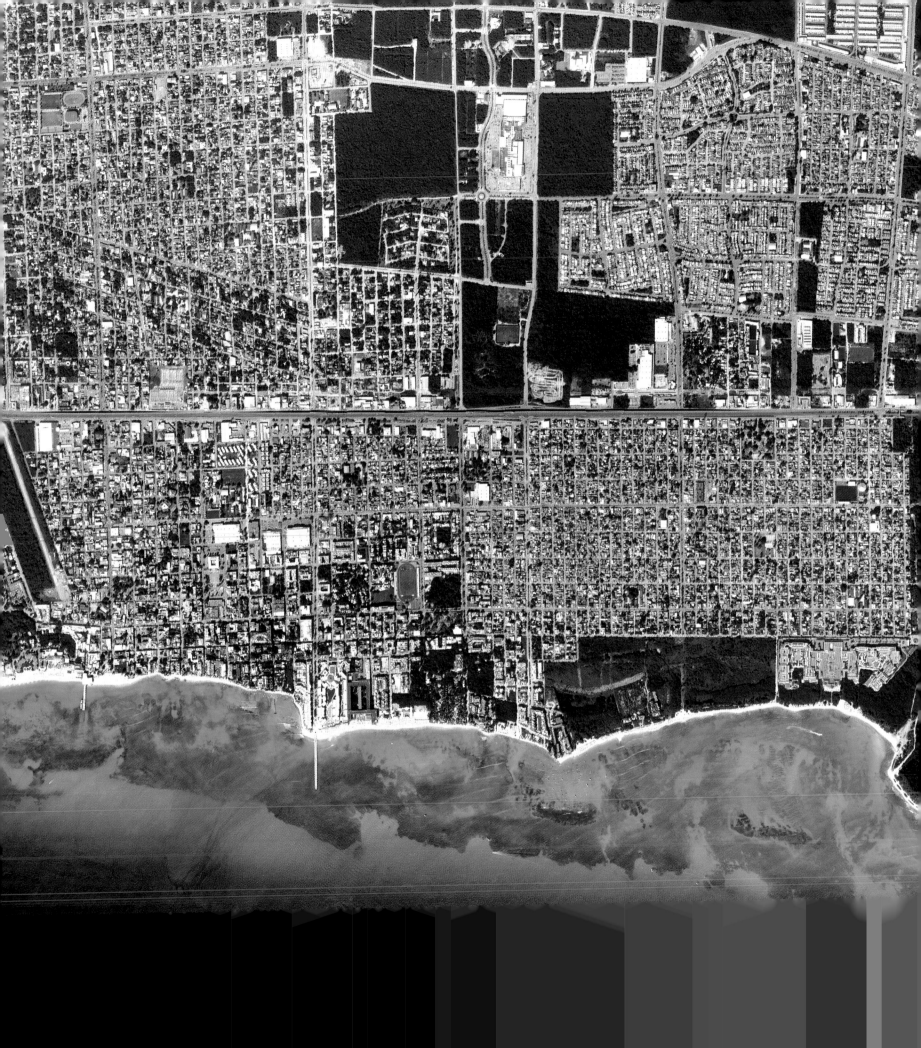

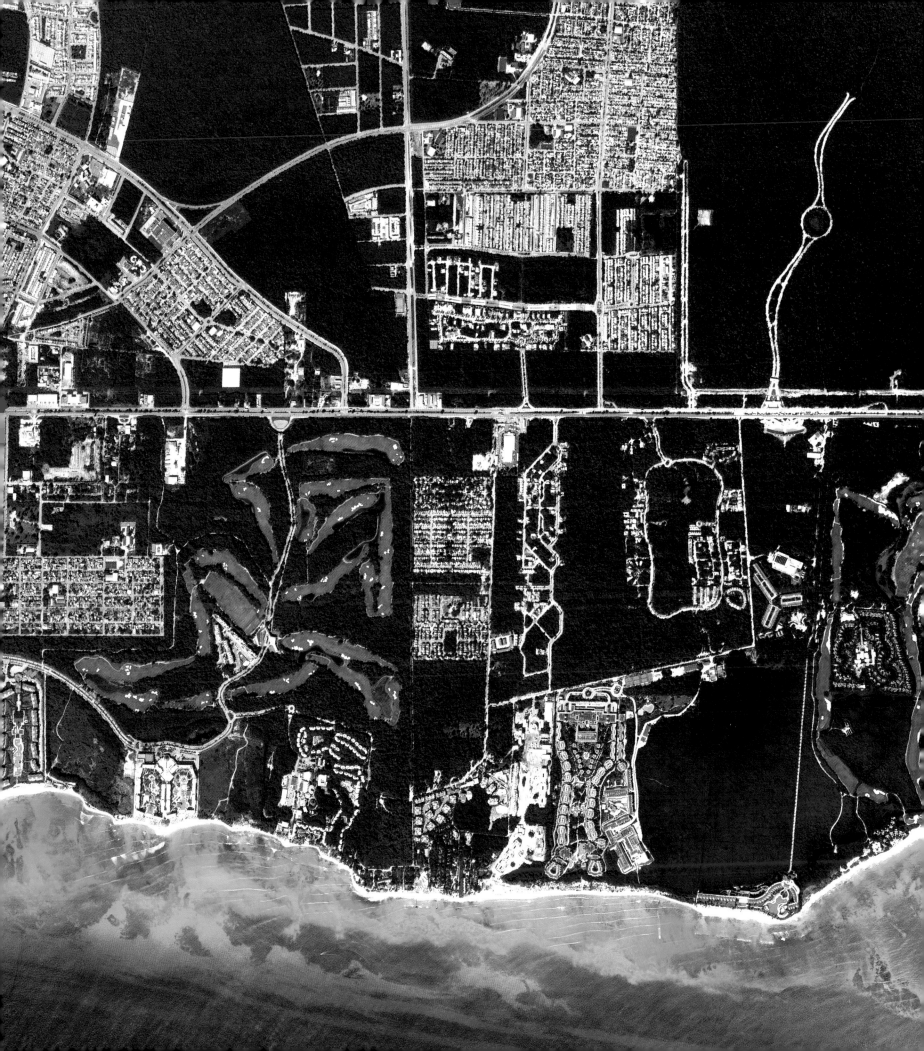

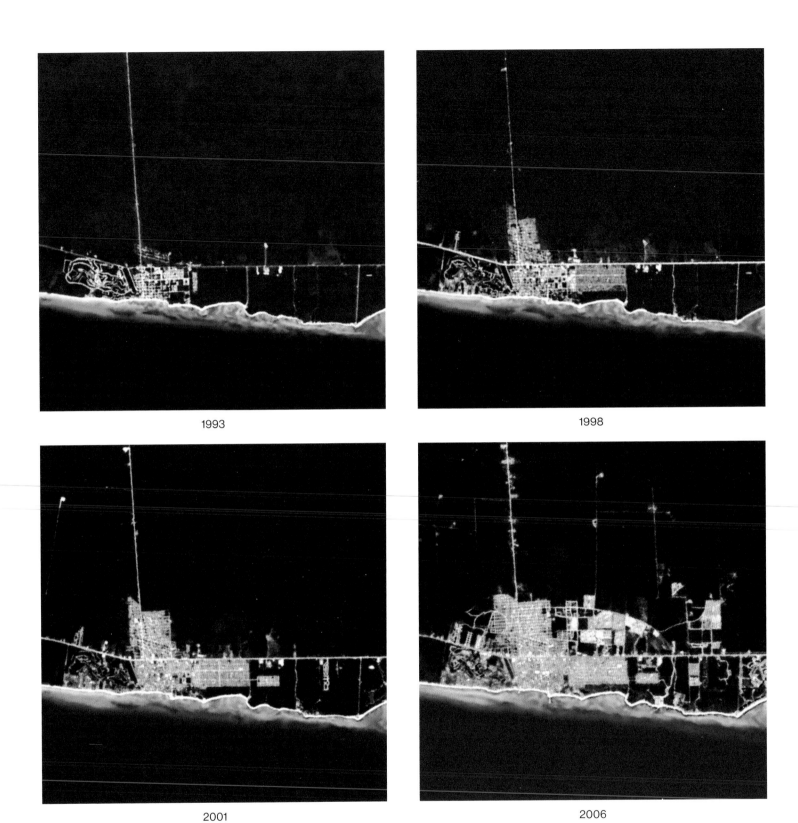

1993

1998

2001

2006

PREVIOUS PAGE

**Playa del Carmen Seafront**
2017
—

The Overview on the previous page shows extensive development of Playa del Carmen, located at the tip of Mexico's Yucatán Peninsula along the Caribbean Sea. The influence of tourism on this area is immediately visible, with golf courses, resorts, condominiums, and other large developments situated on the coast.

20.653868°, -87.106801°

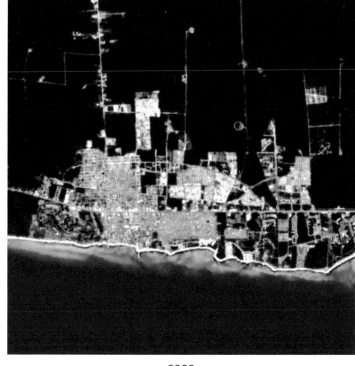

2009

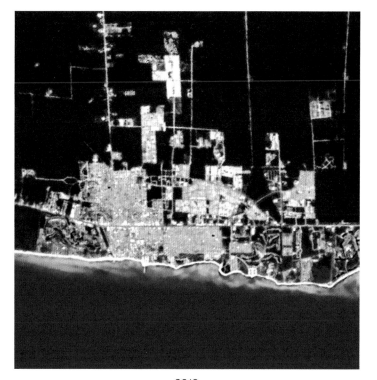

2012

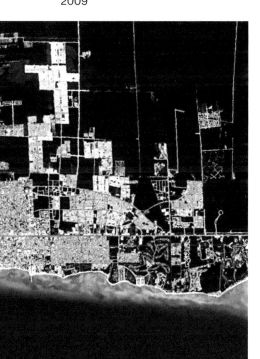

2015

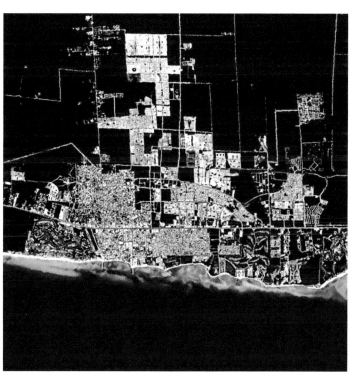

2018

**Playa del Carmen Expansion**
1993–2018

———

Originally a small fishing town, Playa del Carmen has recently undergone rapid development to accommodate an influx of tourism. As a common stop for cruise ships making their way along the Riviera Maya, the city has boomed with the construction of luxury residential condos, restaurants, boutiques, and entertainment venues. According to local estimates, Playa del Carmen's population is the fastest growing in Mexico and is expected to increase by 22 percent by 2023.

`20.653868°, -87.106801°`

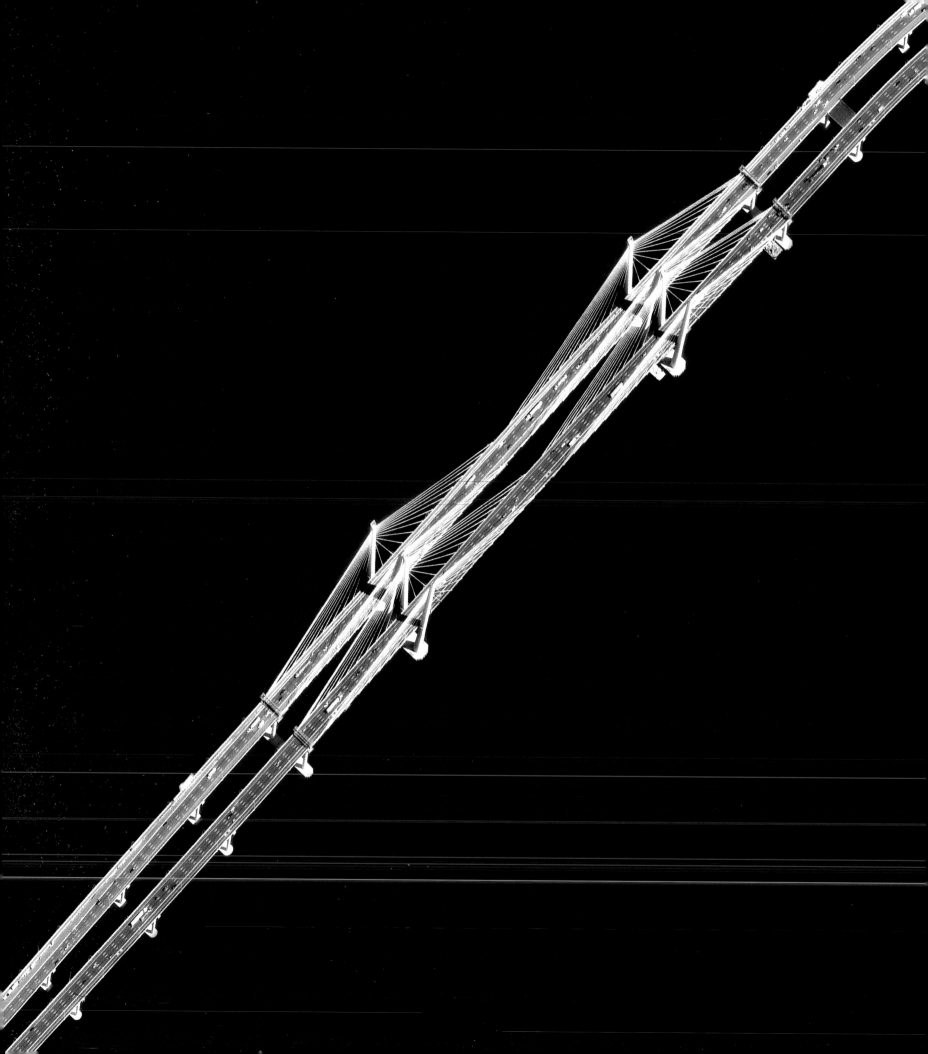

"A journey of a thousand miles
  begins with a single step."

— Lao Tzu

# Transportation

Our growing population has rapidly accelerated the demand for global transportation, moving passengers and freight alike. It has never been easier to travel to distant locales to see family, friends, colleagues, or new places and cultures. That ever-increasing need or desire to move has led to more than a doubling of greenhouse gas emissions from transportation since 1970, with nearly 80 percent of this increase coming from road vehicles alone. Our travel demands show no signs of slowing down—for example, over 4 billion passengers took a flight in 2019 and that number is expected to double in the next twenty years as flying becomes more affordable and more people have more access to long-distance travel. Currently, 10 percent of the population is responsible for 80 percent of passenger travel, an indication of how much more those in developed economies travel than those in less developed areas. As individuals in emerging economies begin to travel more—often via car or plane—the impact from transportation will be amplified.

Our transportation hubs support much of the connectivity that enables the various forms of human movement, from wanderlust, to commerce, to work commutes. To meet this growing need, these systems must be built, improved, expanded, and repaired to keep up. Observing entire airports, train stations, or seaports is a powerful visual reminder of just how many of us frequently participate in travel. In this chapter, several stories show one transit hub captured in numerous, dispersed moments to emphasize this perpetual motion of machines and people. In another story, we follow the shipment of an automobile over a vast distance, examining how water transportation networks enable even more movement on land. These same networks make it possible for goods to move across oceans, over land, and through the air, facilitating the consumption that we will consider in the next chapter.

As our transportation systems propel us forward, they will continue to take a toll on the planet. The transportation sector is deeply reliant on fossil fuels—half of worldwide oil consumption provides the power for 95 percent of all transportation. That reliance is the main reason transportation accounts for 25 percent of worldwide carbon emissions, and as demand increases with the same systems in place, this number could jump to 50 percent by 2035. By avoiding unnecessary journeys and increasing use of public transportation, walking, and biking, we have the potential to curtail our impact. Technology must also be a part of the solution—widespread utilization of electric vehicles, alternative mobility solutions, and improvements in engine efficiency can also contribute to a future in which our movement is sustainable. Transportation is essential for civilization's growth and progress, but we must reckon with the effect it has and dramatically evolve its systems to minimize their impact on the planet.

OPPOSITE

**Tappan Zee Bridge**
2019

———

The Tappan Zee Bridge is a twin cable-stayed bridge crossing the Hudson River north of New York City. Construction on the larger-capacity, replacement bridge seen here began in 2013 to handle increased traffic to and from the major metropolitan area. Once the larger replacement project was finished in 2017, the old, inactive bridge was demolished. The new bridge has a shared-use path for bicycles and pedestrians and was built with the capacity for a future commuter rail line at a later date. Approximately 140,000 automobiles cross the bridge every day.

41.071389°, -73.891111°

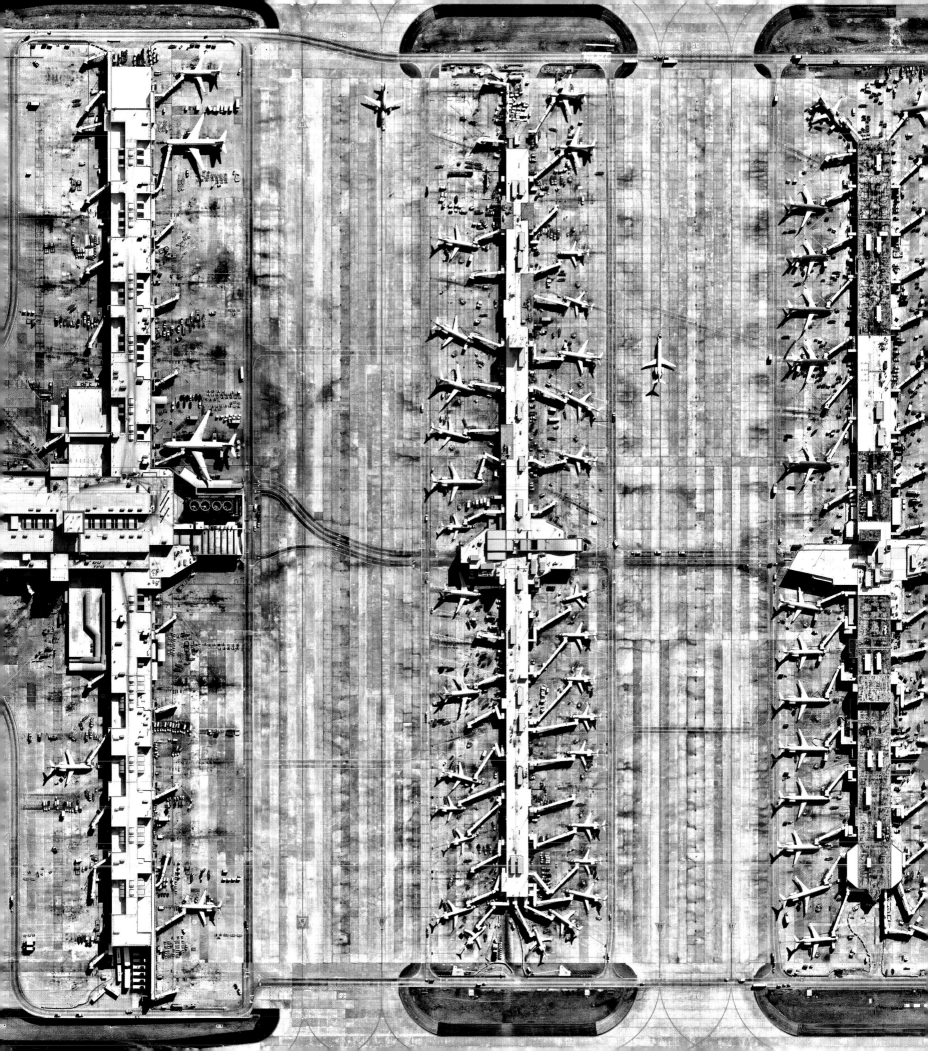

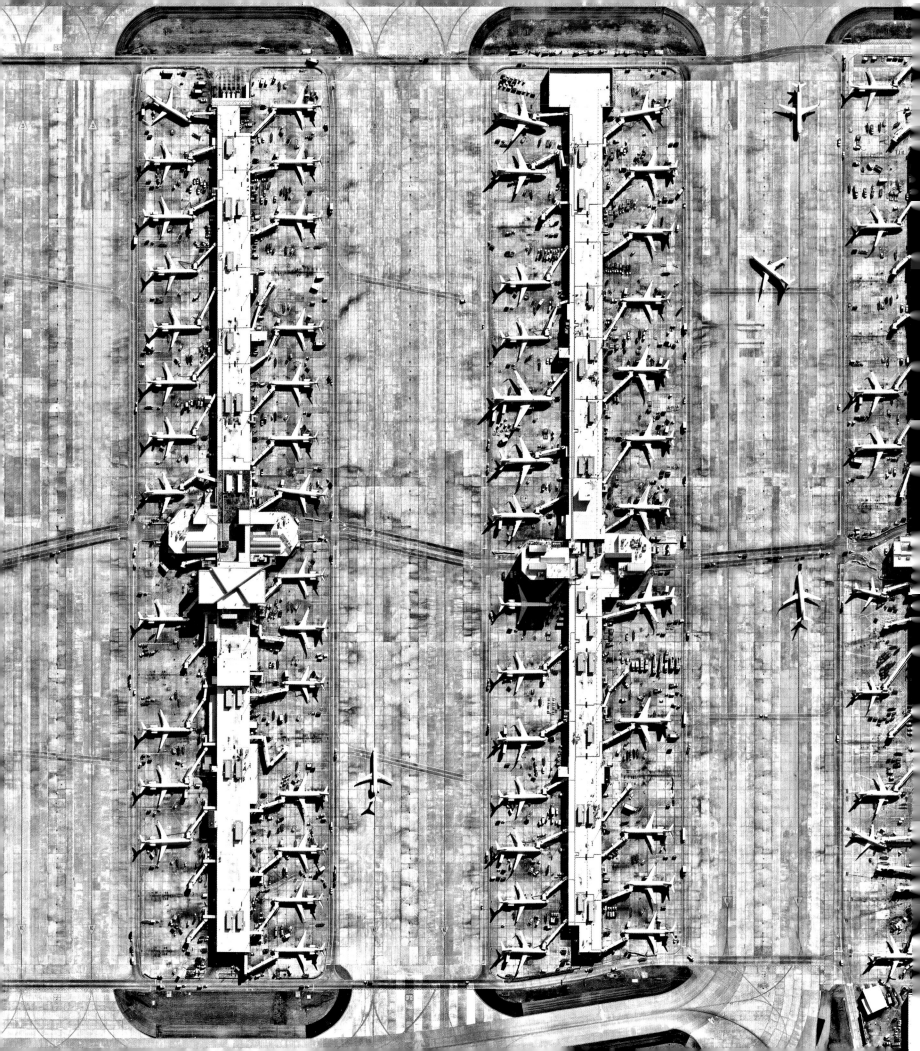

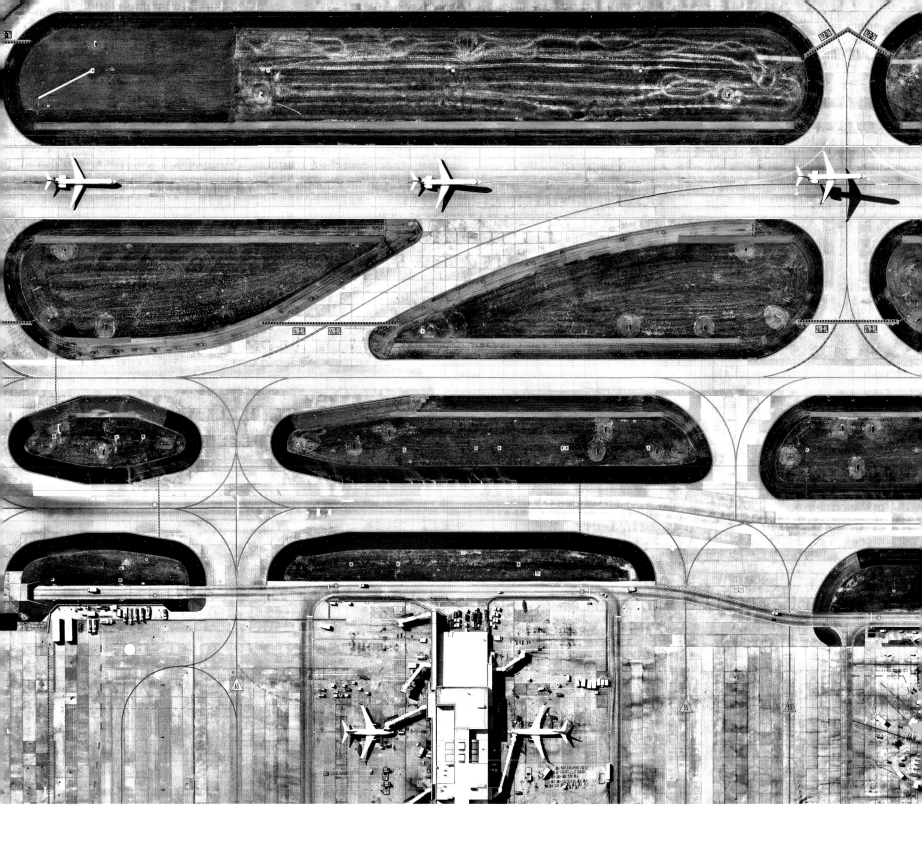

PREVIOUS PAGE

**Hartsfield-Jackson Atlanta International Airport (ATL)**

2017

———

Hartsfield-Jackson Atlanta International Airport (ATL) has been the world's busiest airport since 1998. Accommodating 107 million passengers a year, or more than 12,000 passengers hourly, the facility is located within a two-hour flight of 80 percent of the US population and is a popular hub for transportation to Europe. With 192 gates and seven different terminals, transportation through the airport takes place via an underground "Plane Train"—a three-mile-long automated people mover that carries 200,000 people daily.

33.640333°, -84.435139°

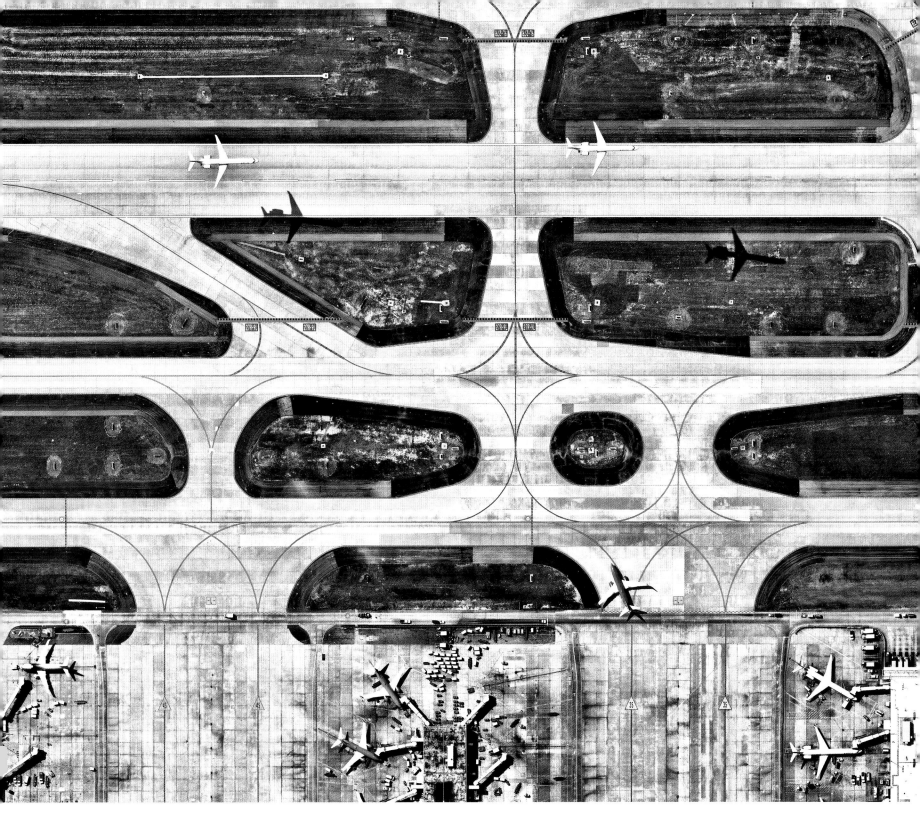

**Hartsfield-Jackson Takeoff**
2016

Captured with multiple exposures, an airplane takes off from one of ATL's five runways. Approximately 2,700 flights depart from and arrive at the facility each day. The most fuel intensive portion of flying occurs during takeoff due to the high level of engine thrust required to get the plane airborne and up to cruising altitude. Therefore, short-haul flights are the least efficient, since the same initial energy consumption is necessary, regardless of how much time the plane spends at its more-efficient cruising altitude.

33.635206°, -84.431762°

2012

2015

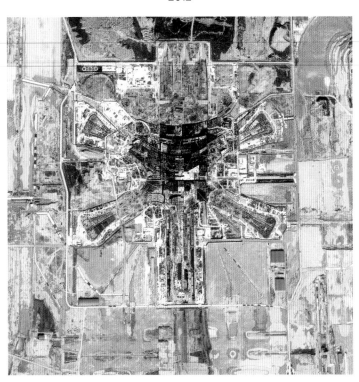

2016

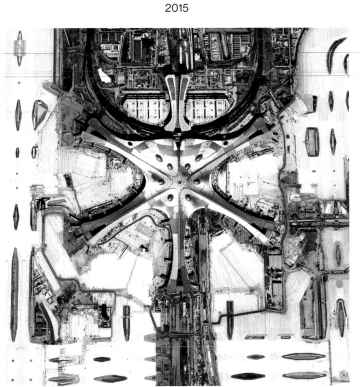

2018

**Beijing Daxing International Airport (PKX)**
2012–2020

———

Farmland and small towns in the Daxing district of Beijing were converted over the course of seven years to build the Beijing Daxing International Airport (PKX). Completed in 2019, the facility contains the largest single-structure airport terminal in the world, with an area of more than 11 million square feet (1 million square meters). Designed with a central hub surrounded by six curved spokes, the facility has the capacity to support approximately 70 million travelers and 620,000 flights every year.

39.509167°, 116.410556°

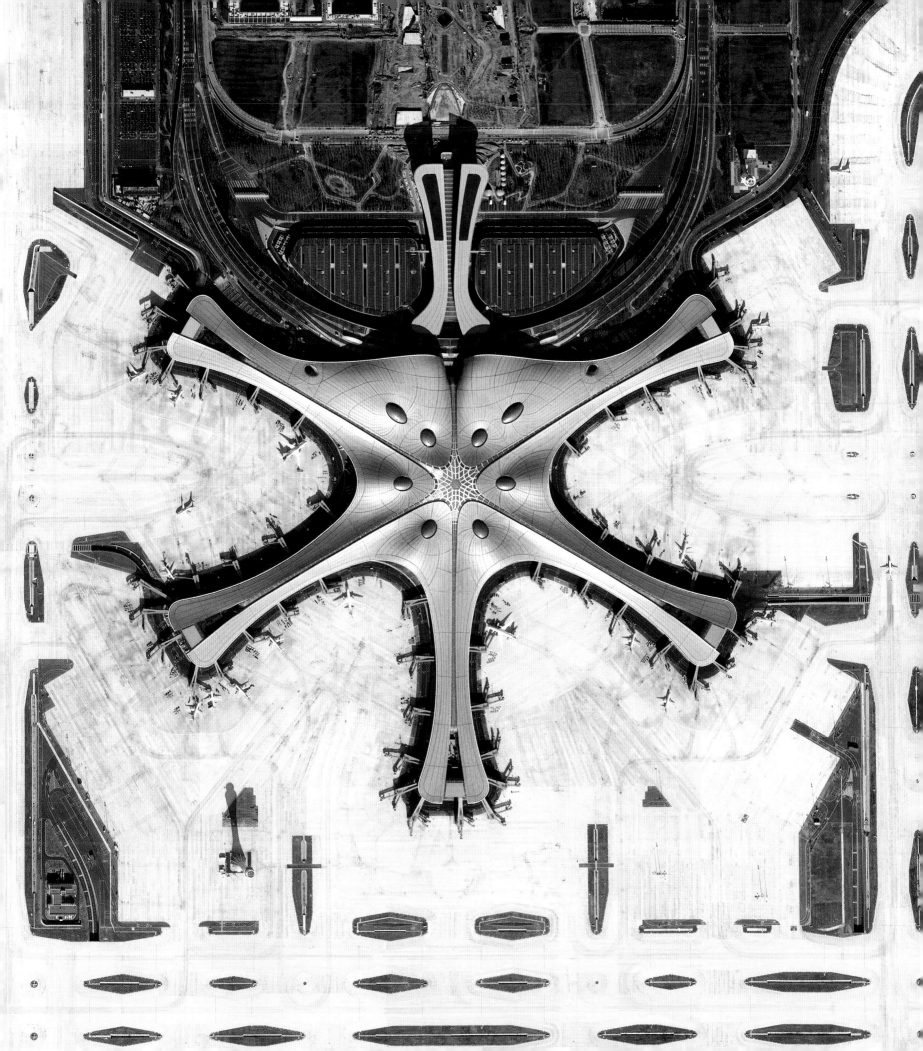

ABOVE AND OPPOSITE

**Grounded 737 MAX Airplanes**

2019

———

Forty 737 MAX jetliners are parked at Boeing's factory in Seattle, Washington. This airplane model was grounded in March 2019 following two fatal crashes due to software errors in less than six months. The development of the MAX, an updated version of Boeing's popular 737 jet, began under pressure in 2011 as the company sought to fend off competition from its rival Airbus. Boeing overlooked safety risks and played down the need for pilot training in its effort to design, produce, and certify the plane as quickly as possible. With more than 400 planes already produced at the time of the accidents, the company had to keep these planes grounded until they were deemed safe to fly again.

47.539025°, -122.314226°

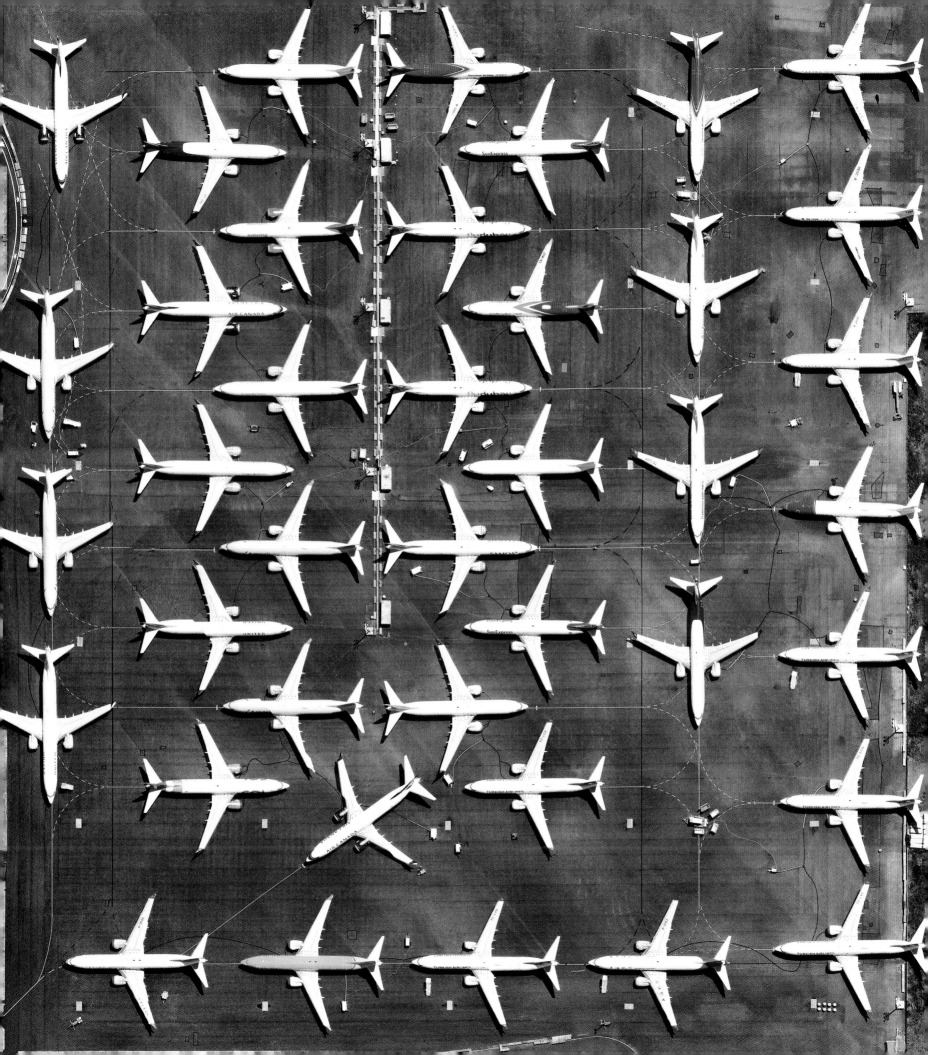

## German Cars en Route to Singapore

BELOW

**Wolfsburg Volkswagen Factory**
Day 1

Volkswagen's Wolfsburg plant is the world's largest car manufacturing plant, producing approximately 800,000 cars a year—a substantial portion of the 10 million cars sold annually by the company. Each day nearly 180 double-decker rail cars and about 185 trucks leave the plant with a cargo of some 3,200 vehicles. Meanwhile raw materials from suppliers arrive at the plant on some 100 rail cars and 2,000 trucks each day. The facility also serves as the worldwide headquarters for the company.

52.433800°, 10.779600°

OPPOSITE

**Port of Bremerhaven**
Day 6

The Port of Bremerhaven in northern Germany imports and exports more cars than any other port in Europe. More than 2 million cars move through the facility every year and the surrounding area has a storage area for 120,000 cars, with space for 45,000 in covered garages. Most cars enter the port through the rail system, which transports shipments from manufacturers elsewhere in Germany. When the cars are ready to be shipped, they are loaded onto car carriers, such as the red one pictured at right. Car carriers are roughly 630 feet (192 meters) long and can carry anywhere between 6,000 and 9,000 cars.

53.550000°, 8.583333°

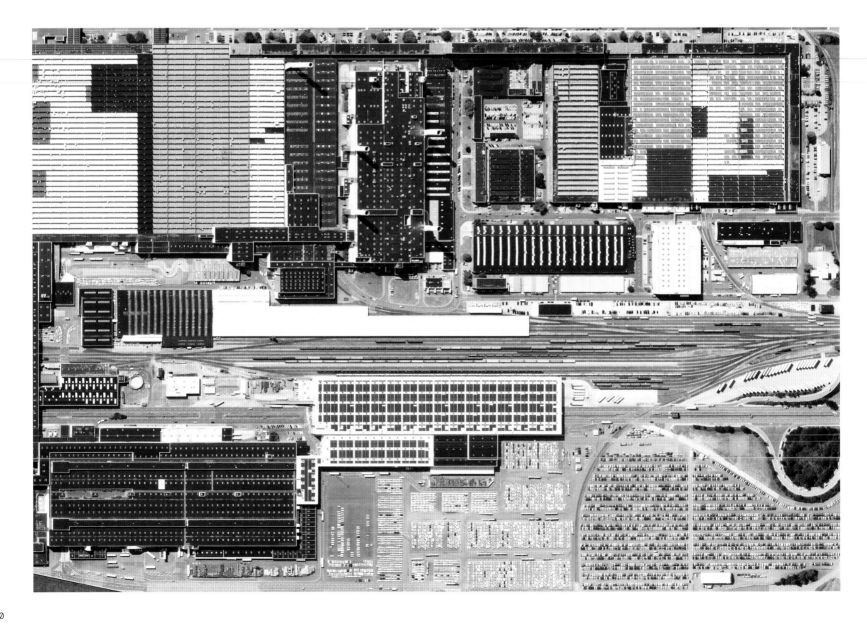

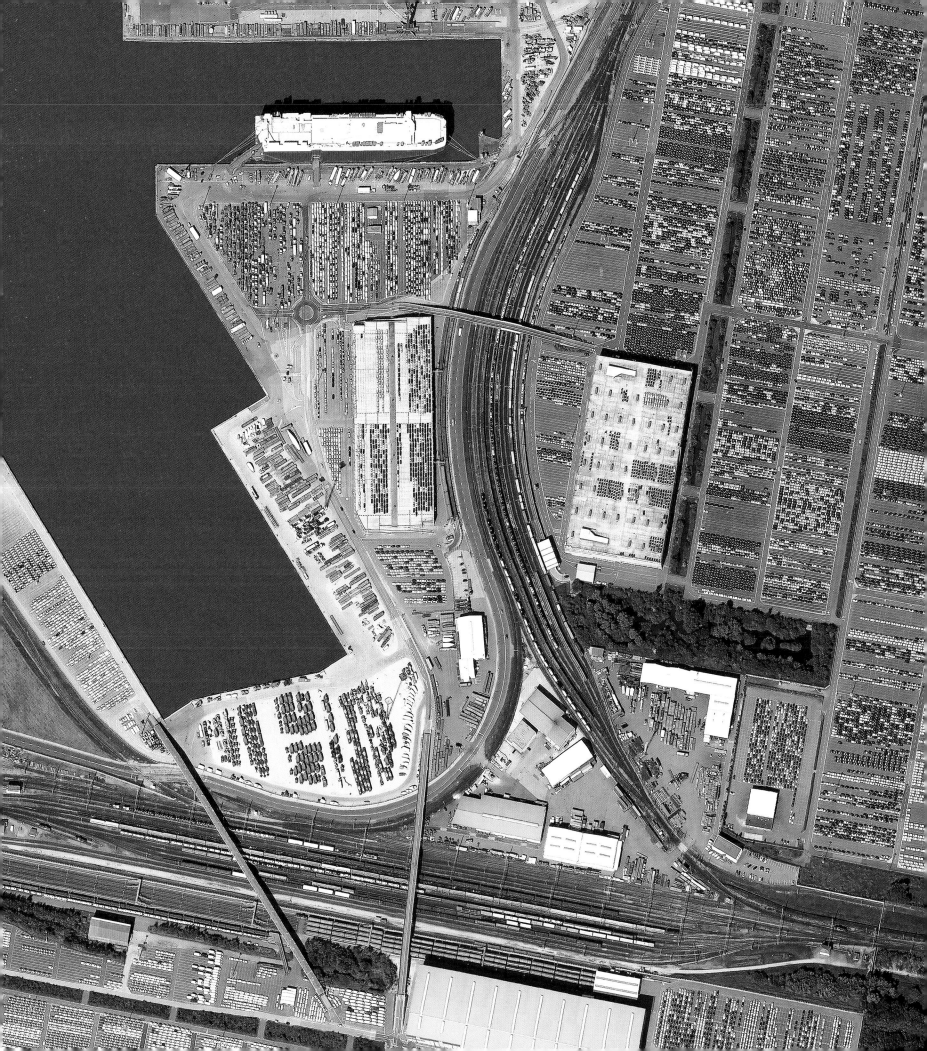

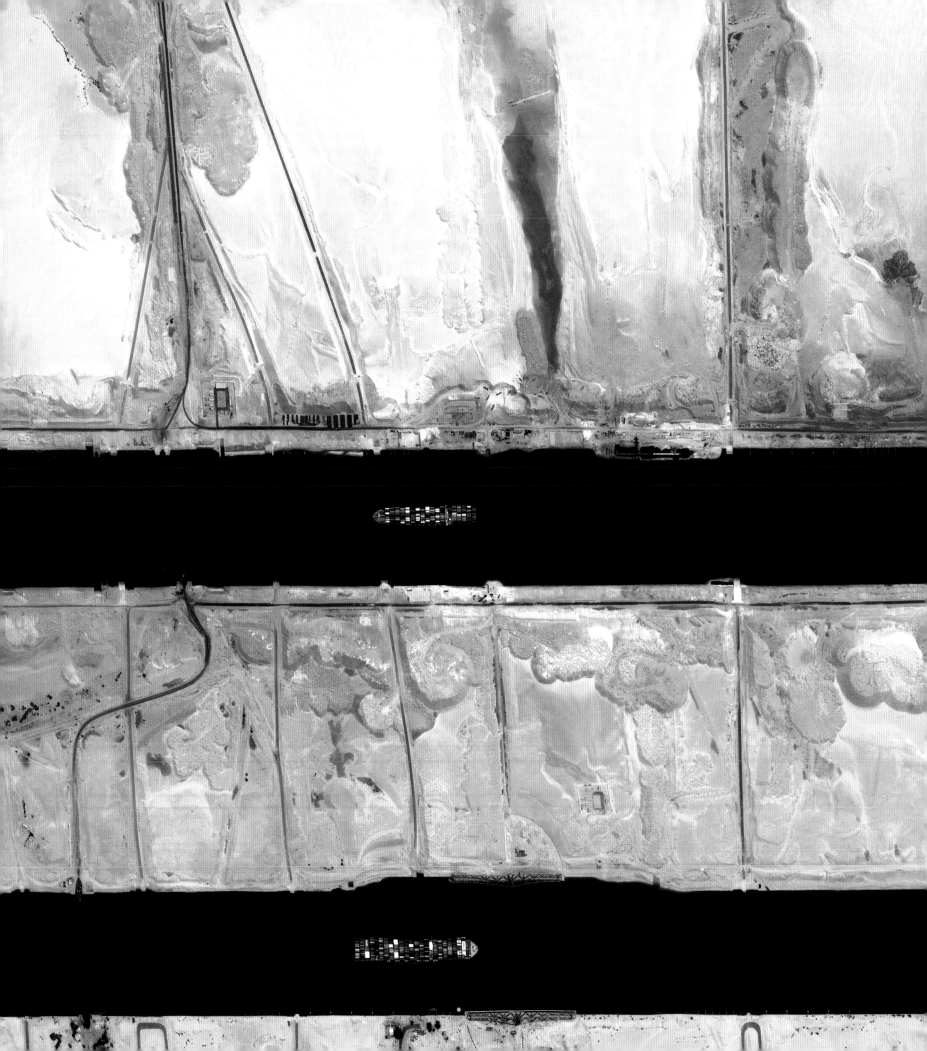

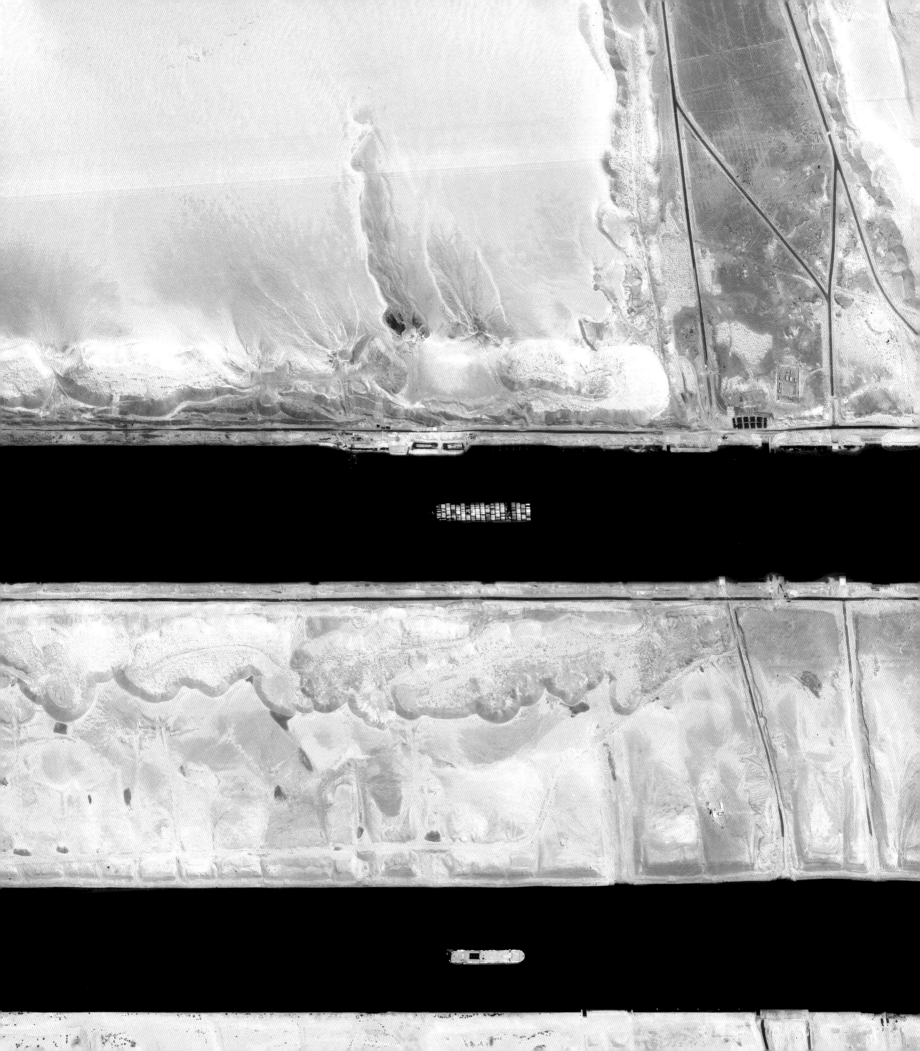

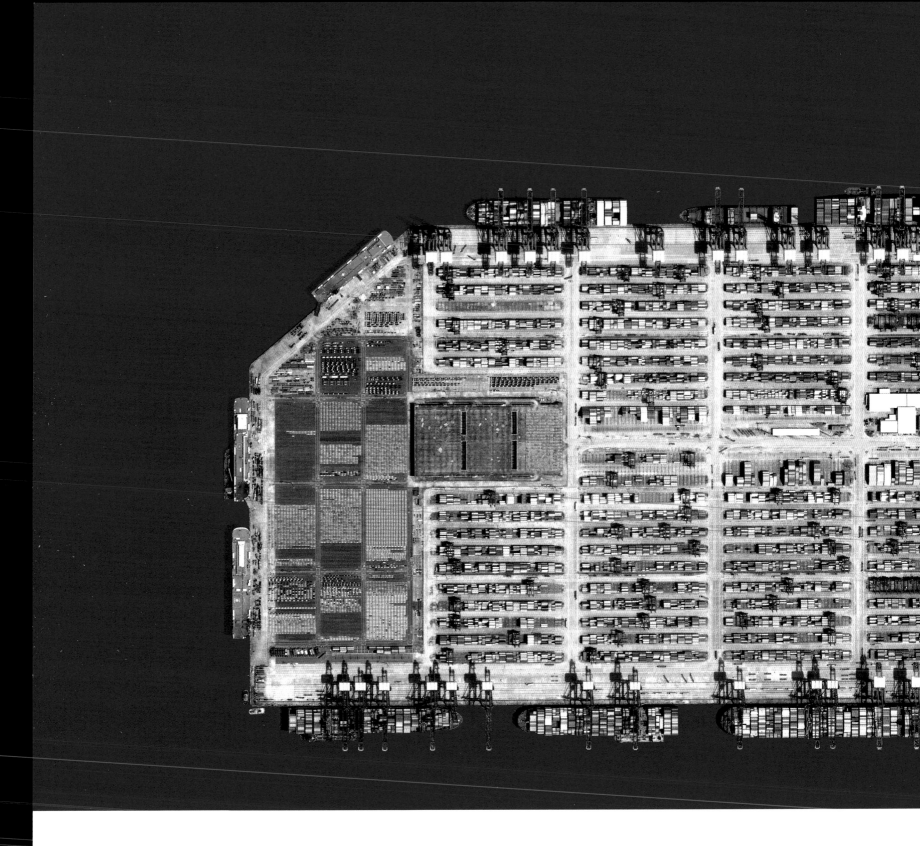

PREVIOUS PAGE

**Suez Canal**
Day 21

Car carriers, such as the light blue one seen at bottom right in this Overview, sailing to Asia from the port of Bremerhaven move through the Suez Canal in Egypt. Officially opened in 1869 as a way to connect the Mediterranean Sea and the Red Sea, the 120-mile long (193 kilometers) channel has more than 18,000 ships pass through its waterways each year. In total, construction took about ten years, with more than 1.5 million people employed during the excavation. In 2014, the Egyptian government began a construction project to expand and widen the Ballah Bypass, in order to shorten the transit time through the canal. The expansion nearly doubled the capacity of the canal, from 49 to 97 ships per day.

30.565472°, 31.886110°

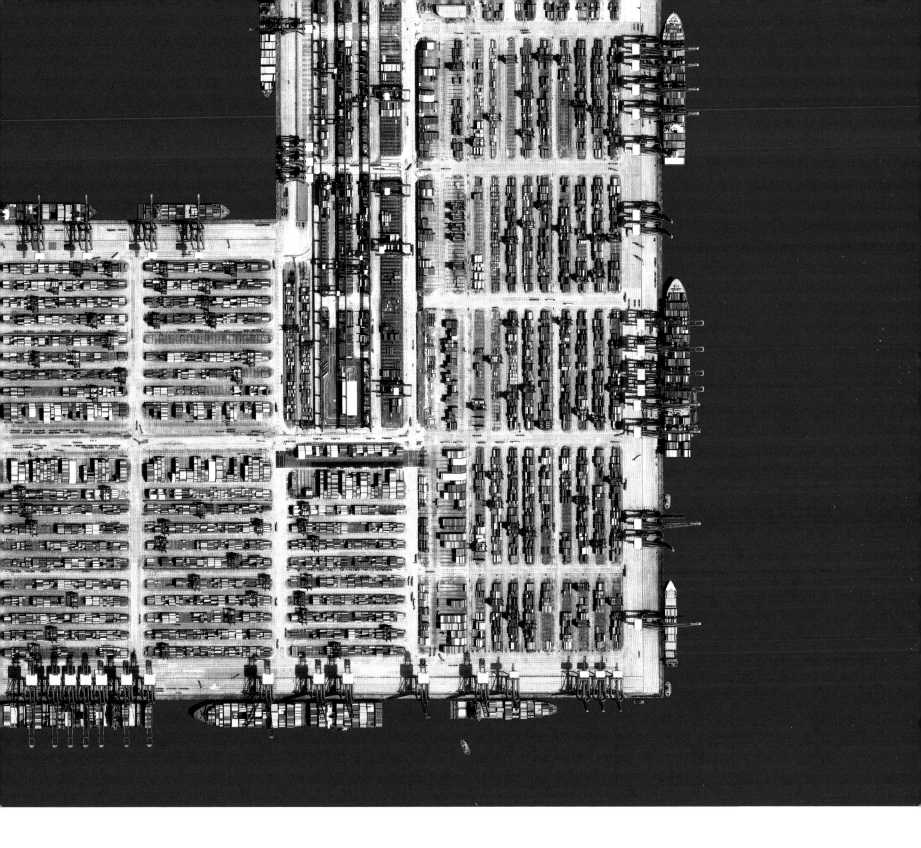

**Port of Singapore**
Day 42

Upon arrival at the Port of Singapore, cars are driven off the car carriers (seen at the upper left of this Overview). The facility operates a dedicated car terminal and serves as a vehicle transportation hub for the region, handling about 1 million vehicles annually. In total, the country of Singapore has about 600,000 private automobiles on its roads, but in 2018, the government instituted a temporary ban on the purchase of new vehicles to decrease congestion and encourage greater use of public transportation.

1.264000°, 103.840000°

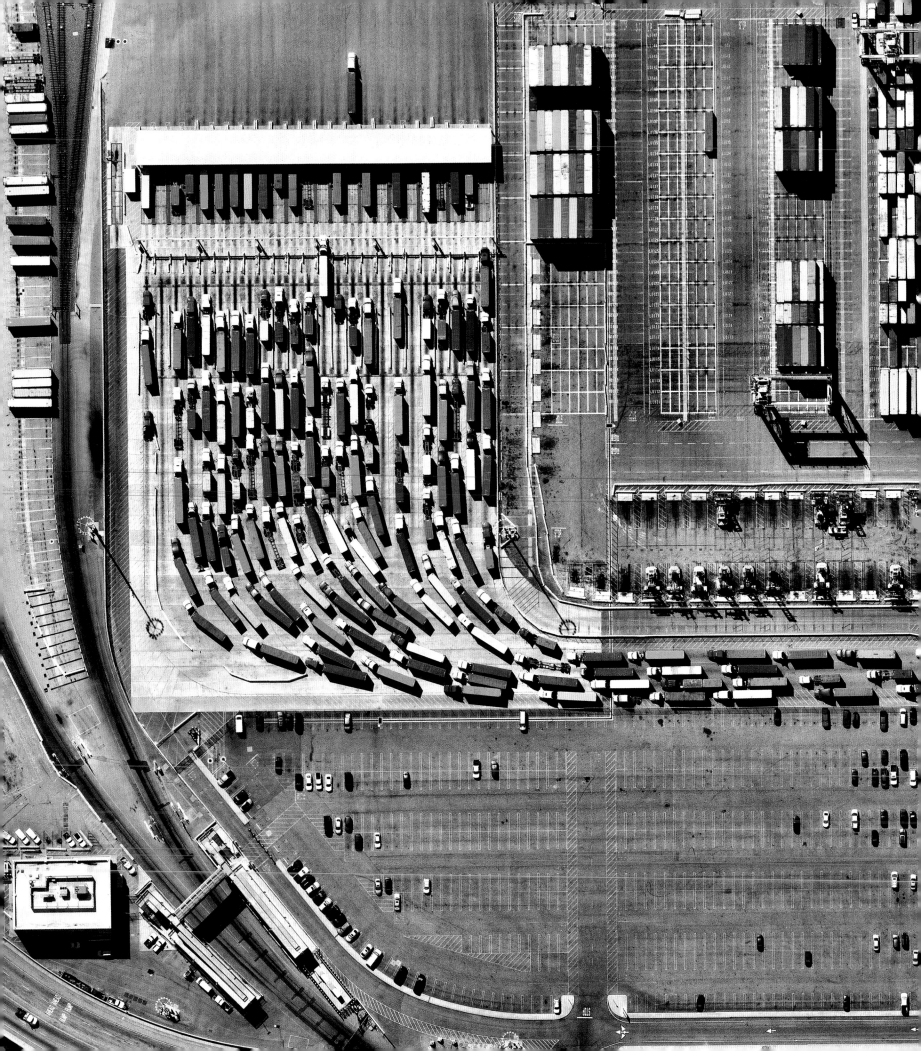

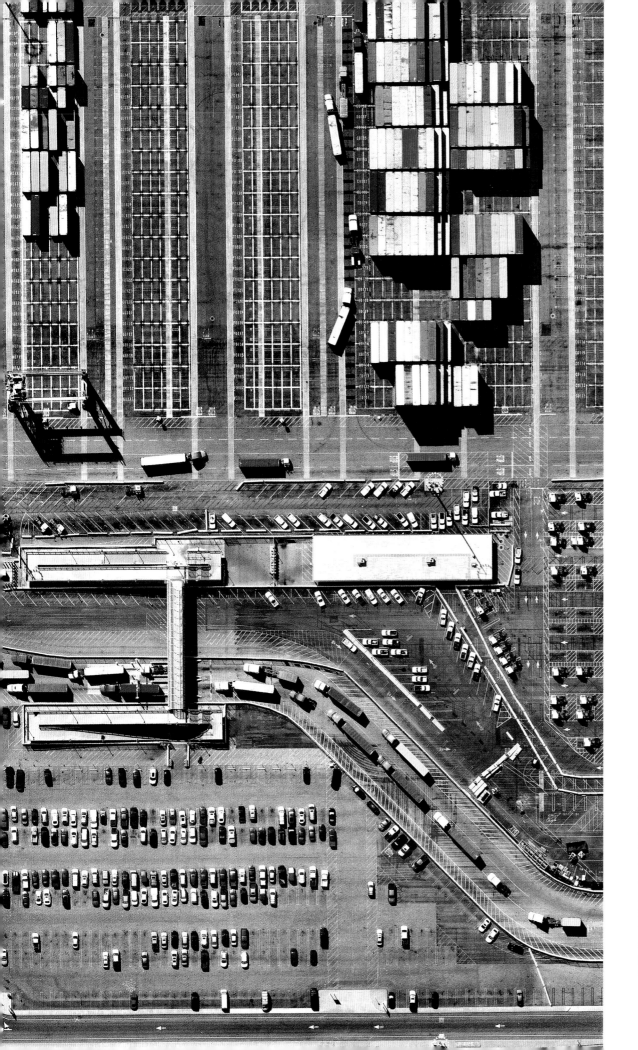

**Trucks at the Port of Los Angeles**
2019

Long-haul trucks wait in line to enter a container terminal at the Port of Los Angeles in California. Trucks carry nearly 70 percent of freight tonnage in the United States and while they account for only 4 percent of vehicles in the country, they consume 25 percent of fuel. It is estimated that there are 3.5 million American truck drivers that cover nearly 140 billion miles on American highways each year. As displayed in this Overview, regardless of how far goods travel by rail or ship, they typically begin and end their journey on trucks.

33.730003°, -118.240100°

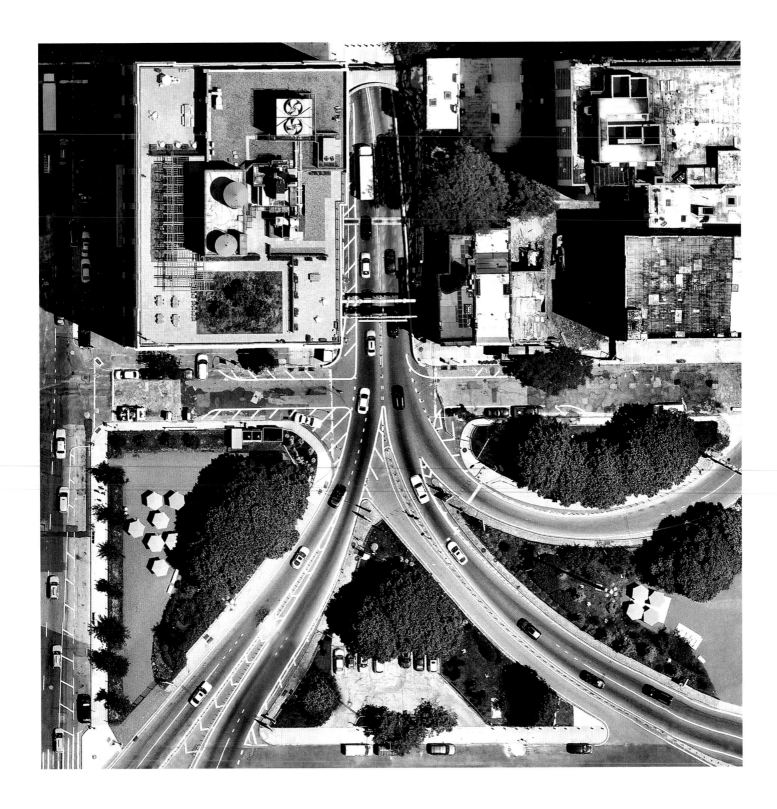

**Holland Tunnel Traffic**
Midday / Rush Hour

---

The Holland Tunnel is one of two tunnels into Manhattan, New York City. Originally opened in 1927, the tunnel connects the city to the state of New Jersey and now serves some 15 million commuters each year. At the time of its creation, the tunnel was the first of its kind constructed for vehicular traffic in the world and the first to use a mechanical tunnel ventilation system to prevent carbon monoxide buildup. The system's fans can replace all of the air inside the tunnel every 90 seconds.

40.724805°, -74.007230°

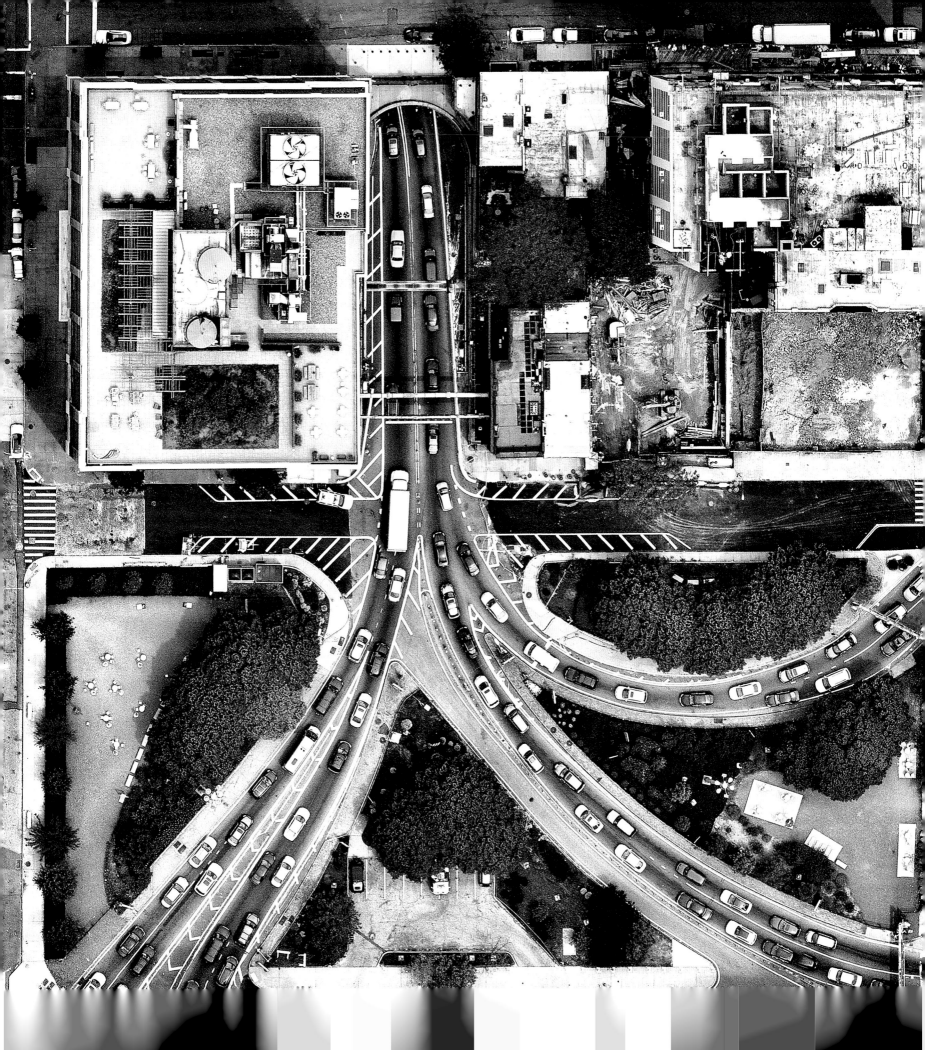

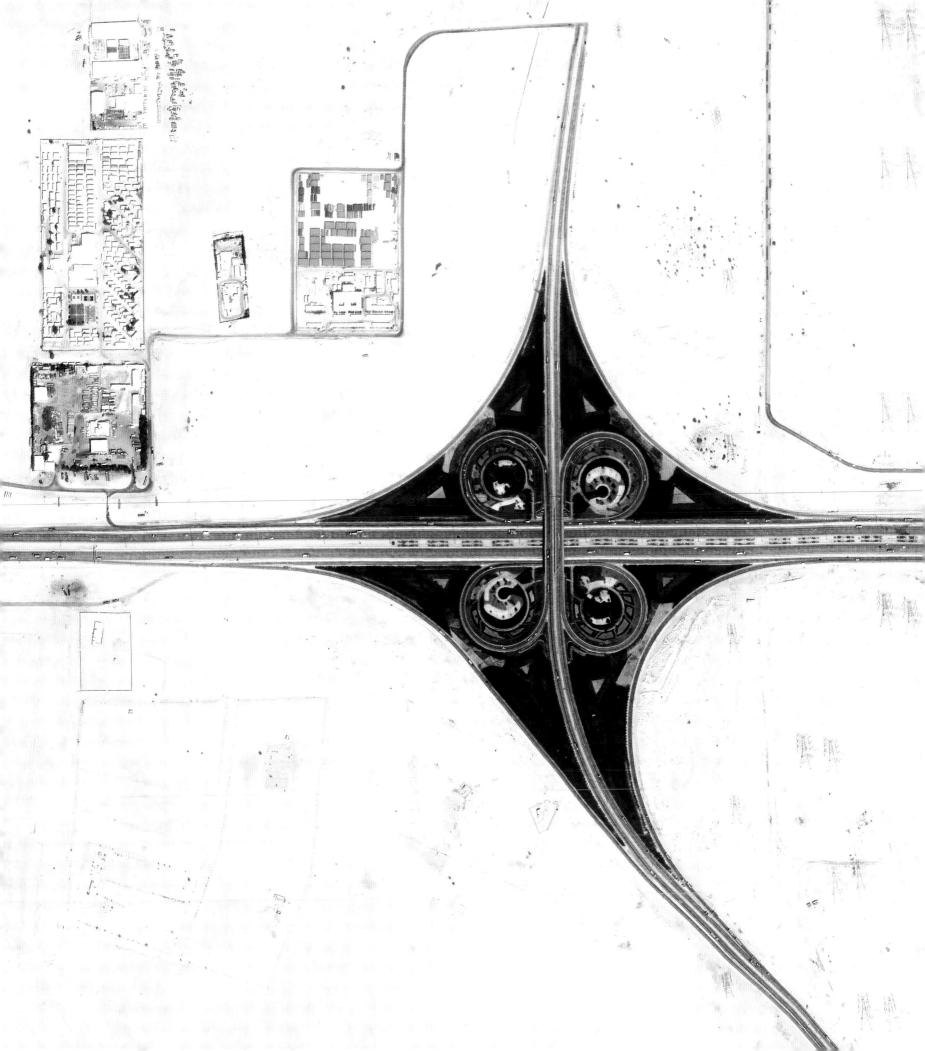

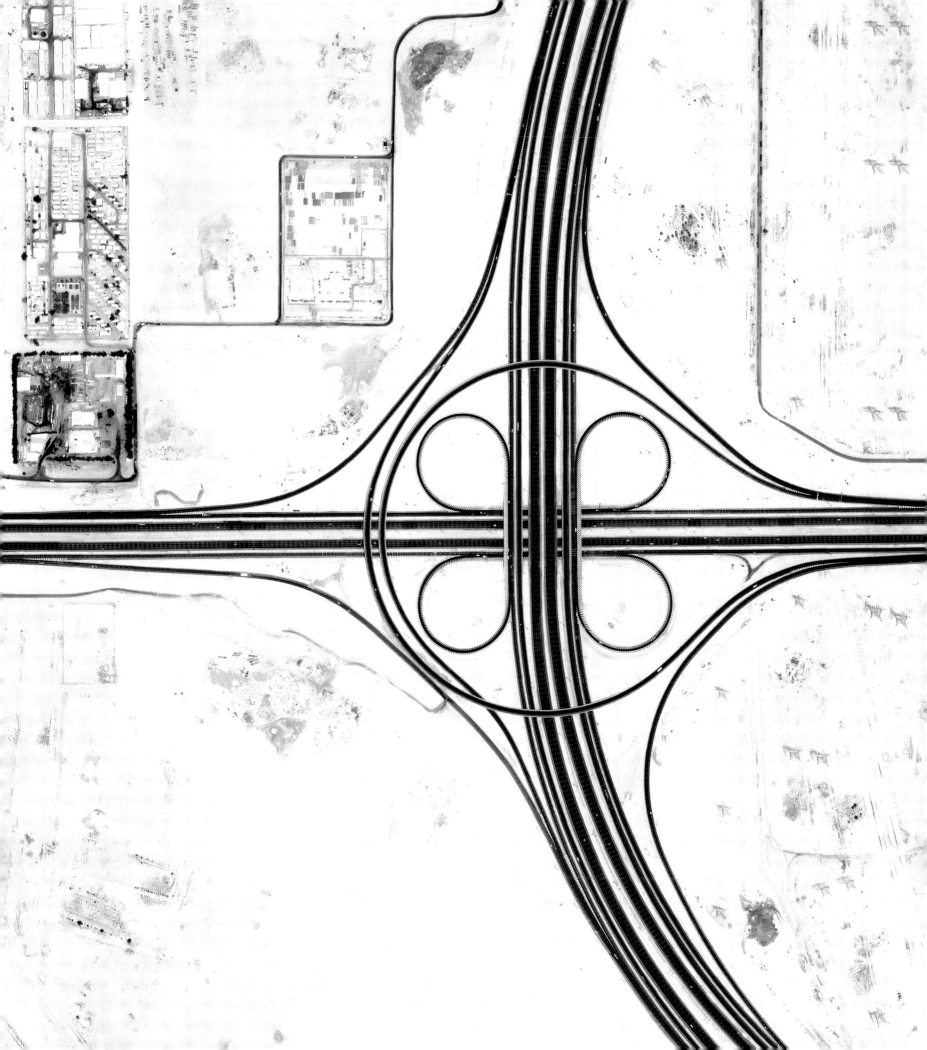

PREVIOUS PAGE

PREVIOUS PAGE

**Qatar Interchange Redesign**

2014 / 2019

This cloverleaf interchange outside of Doha, Qatar, was redesigned over five years. Doha has undergone massive growth in the last 20 years, requiring expansion of its transportation system to alleviate congestion on its roads. The redesign of this interchange will increase lane capacity from three lanes to five, allowing the intersection to handle 20,000 vehicles per hour.

25.174689°, 51.326337°

ABOVE AND OPPOSITE

**Diesel Volkswagen Parking Lot**

2016 / 2017

Thousands of diesel-powered Volkswagens are parked at Southern California Logistics Airport in Victorville, California. While this facility is usually used as a graveyard for retired airplanes, Volkswagen leased enough land here to park 21,000 vehicles. Following an emissions scandal in 2015, the company gave customers the option to sell their cars back to the company. The cars involved in the scandal were designed to only turn on emissions controls during testing, not during normal operation. They emitted up to 40 times more nitrous oxide (one of the most potent greenhouse gases) into the air than regulations allowed. Of the 500,000 cars involved, more than 350,000 customers elected to return their vehicles. They will continue to sit in locations like this one until they have been repaired or approved for export.

34.597500°, -117.383056°

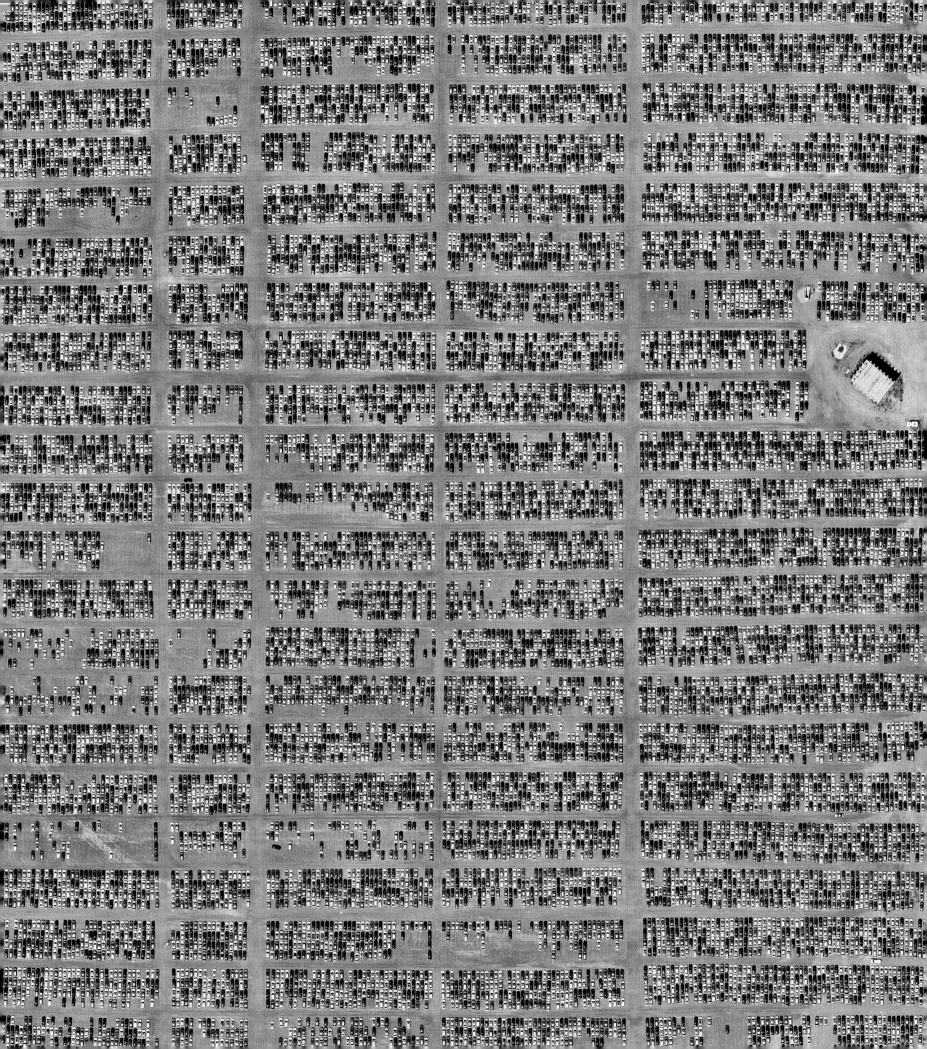

08:17

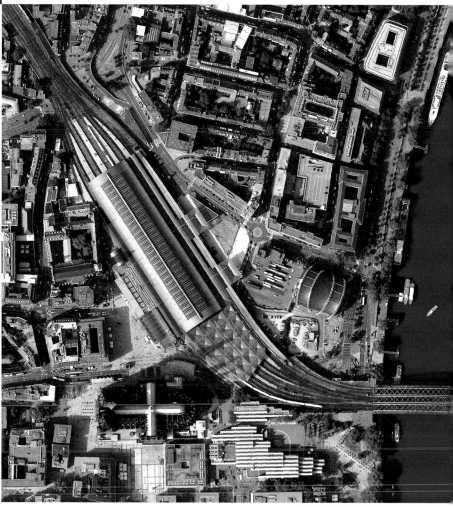

08:42

## Train Stations along Thalys 9424
08:17 – Düsseldorf / 08:42 – Cologne / 09:46 – Liège-Guillemins / 12:08 – Gare du Nord

Thalys operates high-speed rail service across France, Germany, Belgium, and the Netherlands. Trains traveling from Düsseldorf to the Gare du Nord station in Paris move partly on dedicated high-speed tracks using electric power, and partly on conventional tracks shared with normal-speed trains. Construction of lines such as this one has resulted in the decreased usage of short-haul flights and automotive traffic between the connected cities.

Railway transport is capable of high levels of passenger and cargo capacity, and has relative energy efficiency, especially when using electric-powered trains. Even though electric trains have no direct carbon emissions, the means by which the electricity is generated for the trains still creates carbon emissions. Many trains are still powered by diesel engines; however, over the past 25 years, fuel efficiency in diesel locomotives has increased by 85 percent. Rail transport produces 60 to 75 percent less greenhouse gas emissions per passenger mile than single-occupancy vehicles, making train transport a more efficient means of moving large numbers of people with minimal compromise on convenience.

```
51.219827°,  6.794479°
50.943924°,  6.959049°
50.624433°,  5.566708°
48.880948°,  2.353119°
```

09:46

12:08

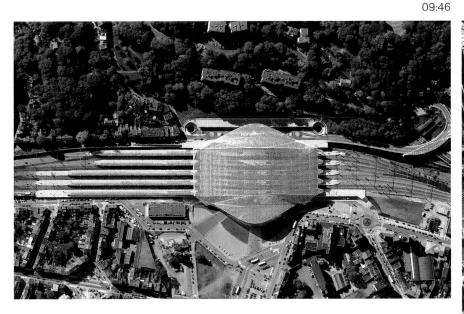

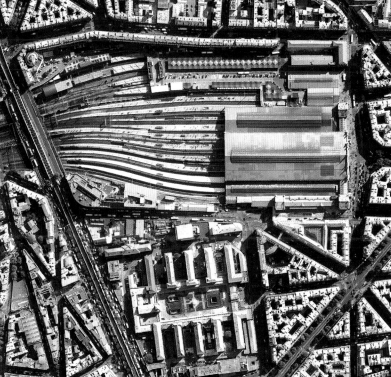

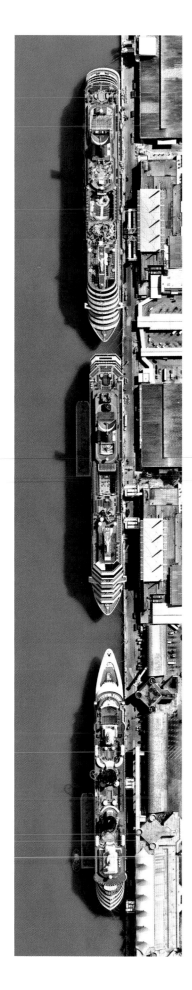
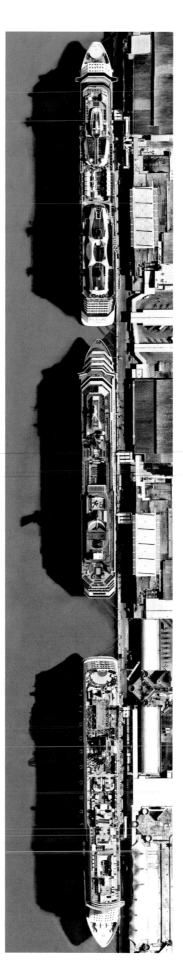
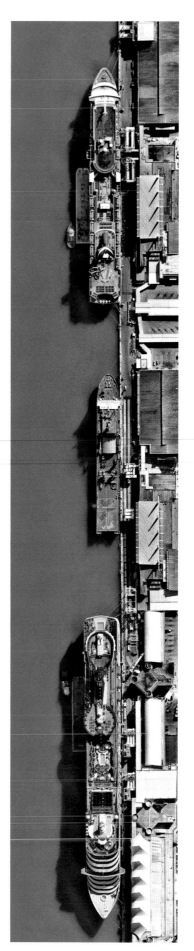

LEFT

## PortMiami
Saturday / Sunday / Thursday

PortMiami, known as the "cruise capital of the world," is a major seaport located near Miami, Florida. With more than 5.5 million cruise passengers passing through each year, it is the largest passenger port in the world. Worldwide, the cruise industry accommodates more than 25 million passengers every year.

`25.778053°, -80.175367°`

OPPOSITE

## Navigator of the Seas
May 2019

The Navigator of the Seas was the largest cruise ship in the world upon its commissioning voyage in 2002, and it remained so until 2005. It is now only the thirtieth largest ship as the industry continues to build larger-capacity models to keep up with growing customer demands. With accommodations for 4,000 passengers and 1,200 crew members, the ship contains a surfing simulator, a basketball court, multiple pools, and an outdoor movie screen. Over a single day, cruise ships like the Navigator emit as much particulate as a million idling cars, while dumping hundreds of gallons of sewage into the ocean.

`25.778951°, -80.170621°`

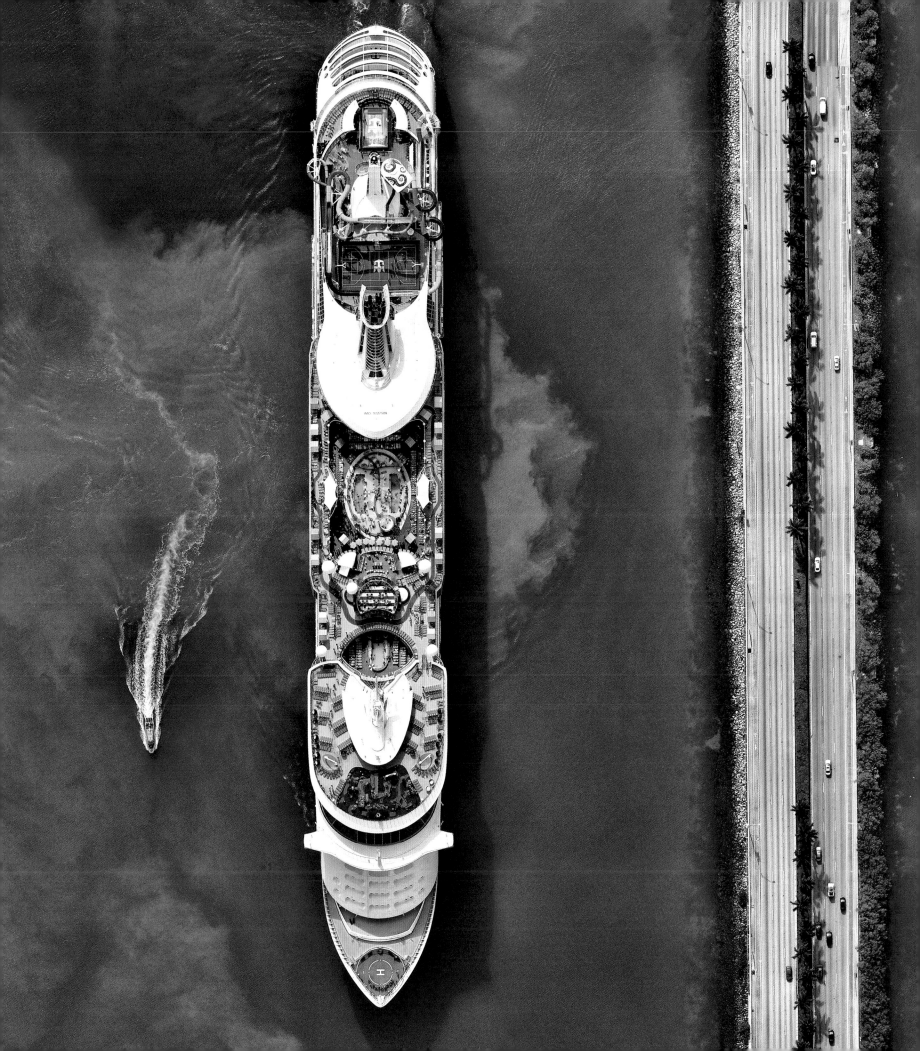

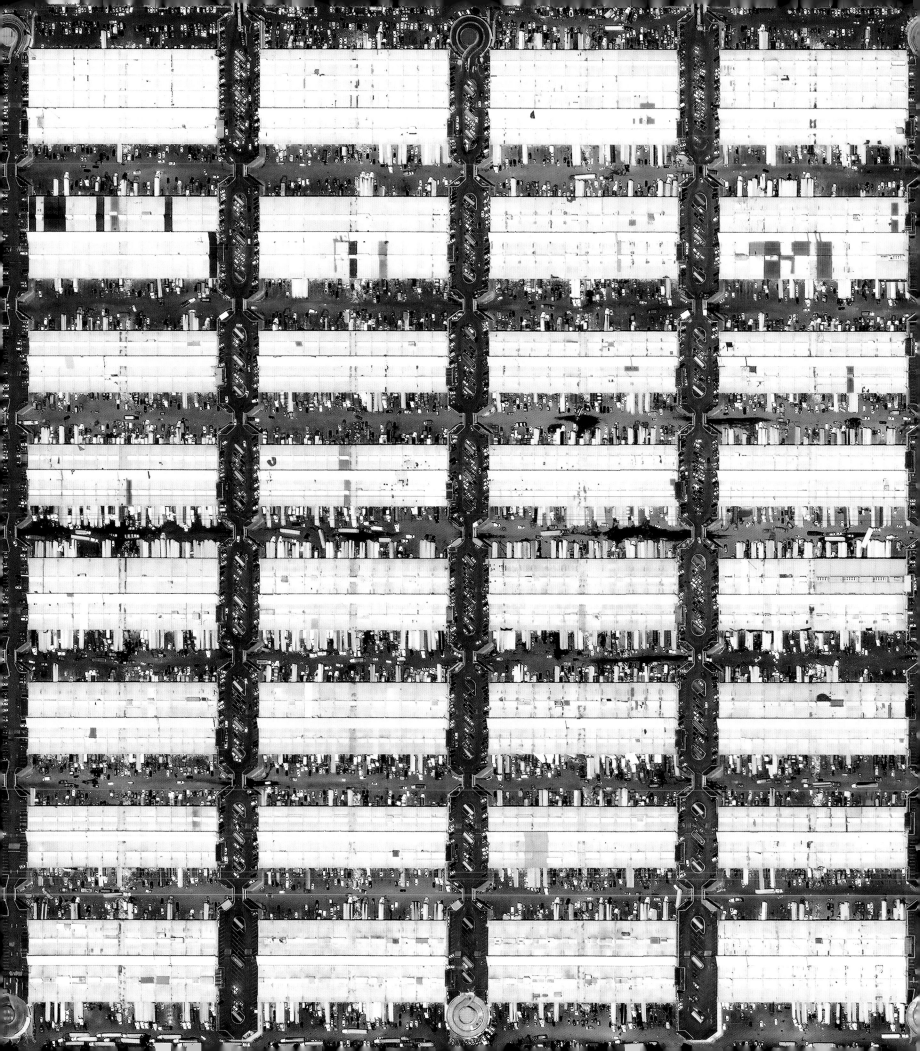

# Consumption

"One of history's few iron laws is that luxuries tend to become necessities and to spawn new obligations."

—Yuval Noah Harari

Participating in modern civilization often means searching for the food, activities, and products that make life enjoyable. While our eating habits, daily routines, and lifestyles vary greatly, we all must consume to survive. Electricity, which we all use, makes many of our activities possible. It is a cornerstone of modern life, and our access to it is regularly taken for granted (so much so that it becomes newsworthy when it briefly goes away). The scope of our consumerism is ever evolving and takes many different forms, from where we obtain our sustenance, to the experiences we seek out, to the byproducts of that behavior. Each of these actions presents distinct challenges if we hope to live in greater balance with the planet.

Utilizing our networks of transportation, we are now able to travel comfortably over great distances for events, vacations, or spaces designed for enjoyment within or outside our cities. These same transportation networks bring many of the things we consume directly to us. That ease of access to products, combined with the technology of the internet, has fueled a significant rise in the amount of goods the average person acquires. It also means we are usually physically removed from the development of the goods and foods we buy. Even with the recent increase in eco-conscious behaviors, it is clear that our consumption of the newest technologies and products from around the world (and receiving them as quickly as we can) has taken precedence over our regard for the sustainability of our actions. For example, the relatively recent development and widespread exploitation of single-use plastics has created a worldwide glut of these permanent materials. While we only started using plastics in the 1950s, as of 2020, humans have already produced 7.8 billion tons of the material—roughly one ton for every person living on the planet today.

Like plastics, many of the things we consume do not break down or simply disappear, so the best visual evidence of our consumption is the waste we generate. These discarded materials represent a fraction of things we once had that we no longer want. We then send these materials back into the world—to be recycled, buried, burned, or taken elsewhere. Successful recycling is rare—only 10 percent of goods deemed recyclable have ever been reused. We continue to measure our growth and the success of our civilization with GDP (gross domestic product), which essentially totals the consumption of new things. Perhaps we should also be guided by how effective we are in our ability to reuse the things we already have. To change our behavior, we must broaden the focus of our consumption to consider the effect of what we have already consumed, before we move on to what we will have next. On a planet with finite resources, we cannot continue to ignore the reality of how our consumption, including our use of energy, often takes away without giving back to the earth.

OPPOSITE

**Central de Abasto**

2017

———

Thousands of trucks and cars surround the Central de Abasto, Mexico City's largest wholesale market for produce and other foodstuffs. The market serves more than 300,000 people every day and handles over 30,000 tons (27,215 metric tons) of merchandise, which accounts for 80 percent of the daily food consumption in the Mexico City metropolitan area.

19.373908°, -99.088439°

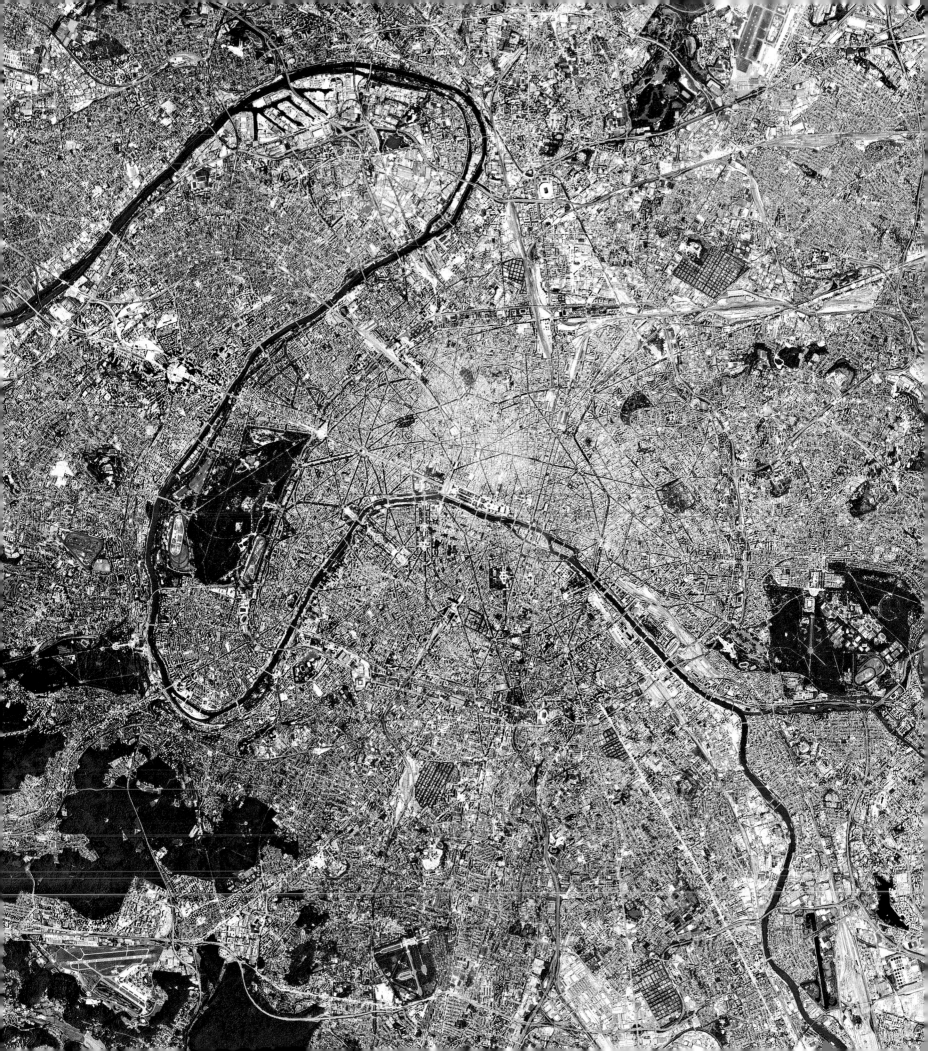

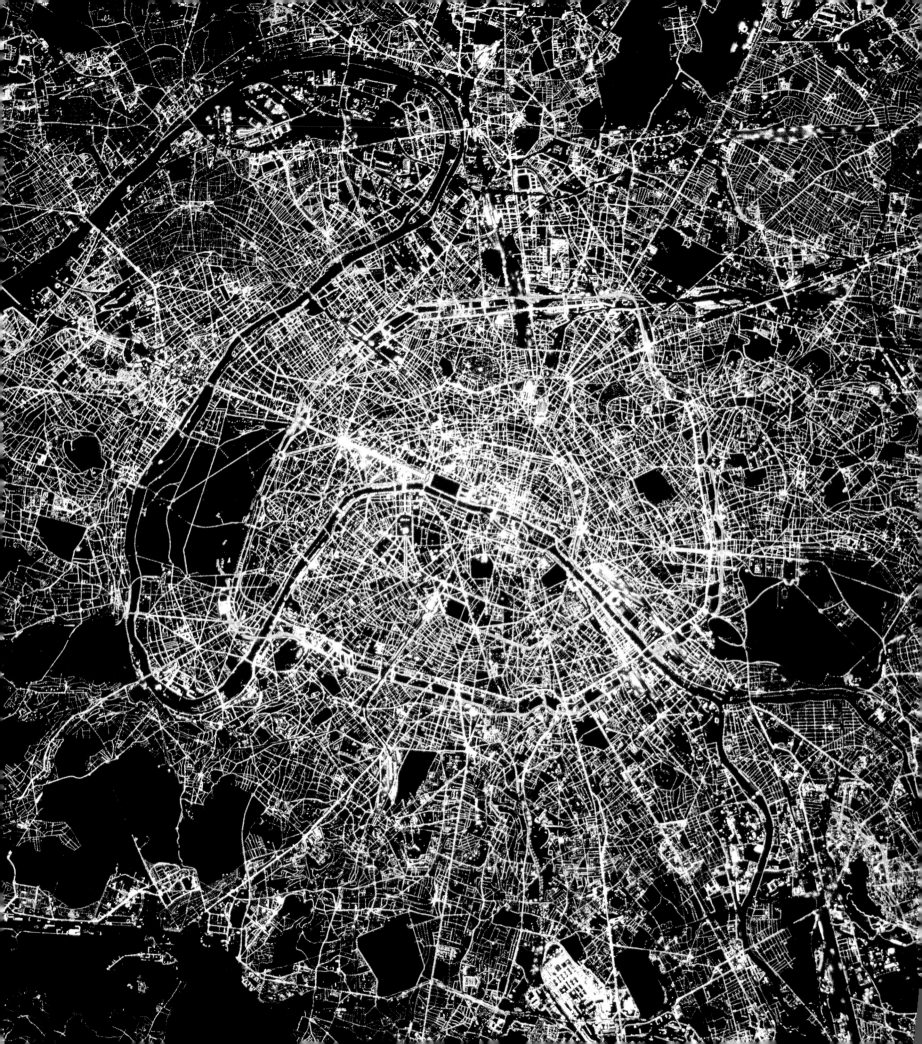

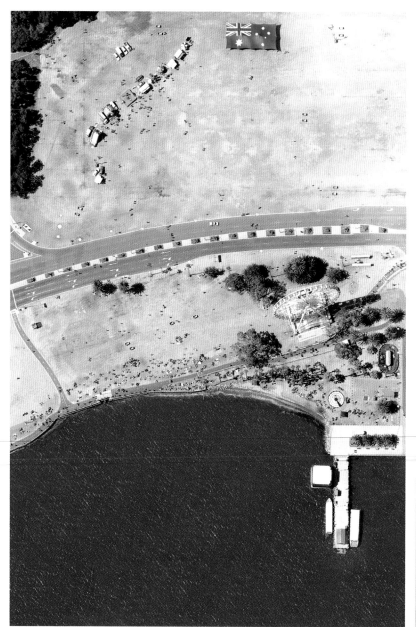

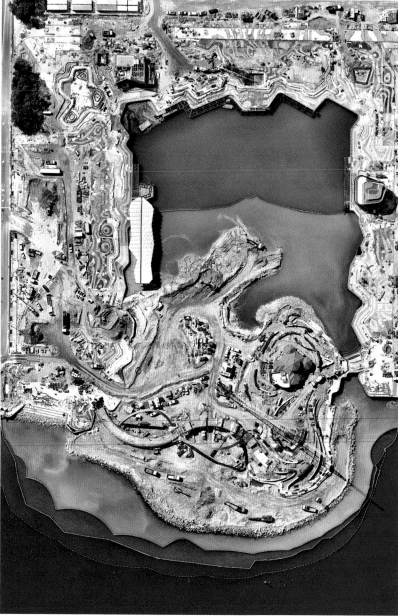

PREVIOUS PAGE
**The Lights of Paris**
Day / Night

Paris is often called the "City of Light," a name that originates from its implementation and illumination of 56,000 gas lamps in the 1860s. Today, the city receives half of its energy (and its light) from nearby energy plants that simultaneously generate electricity and heat (called "cogeneration"). Thirty-five percent of the city's power is generated by the Nogent Nuclear Power Plant. Nationally, France gets 75 percent of its power from nuclear plants. The remainder of Paris's energy comes primarily from trash incineration (9 percent) and methane gas (5 percent). Solar and wind power combined contribute 0.1 percent of the energy that provides powers to the city's 2.1 million residents.

48.858521°, 2.067562°

ABOVE AND OPPOSITE
**Esplanade Reserve / Elizabeth Quay Conversion**
2009 / 2015 / 2018

Elizabeth Quay is a mixed-use public space in Perth, Western Australia, that was developed with a new artificial inlet in an area previously known as Esplanade Reserve (pictured on Australia Day in 2009, above left). Total costs for the project were estimated at $440 million and also included the construction of the Queen Elizabeth Quay Bridge (seen opposite, at bottom). In the first years when the inlet became operational, there were numerous problems with water circulation and buildup of fecal bacteria, which led to the ten-month closure of the quay's water park and the cancellation of the swimming leg of the city's triathlon race.

-31.957638°, 115.856551°

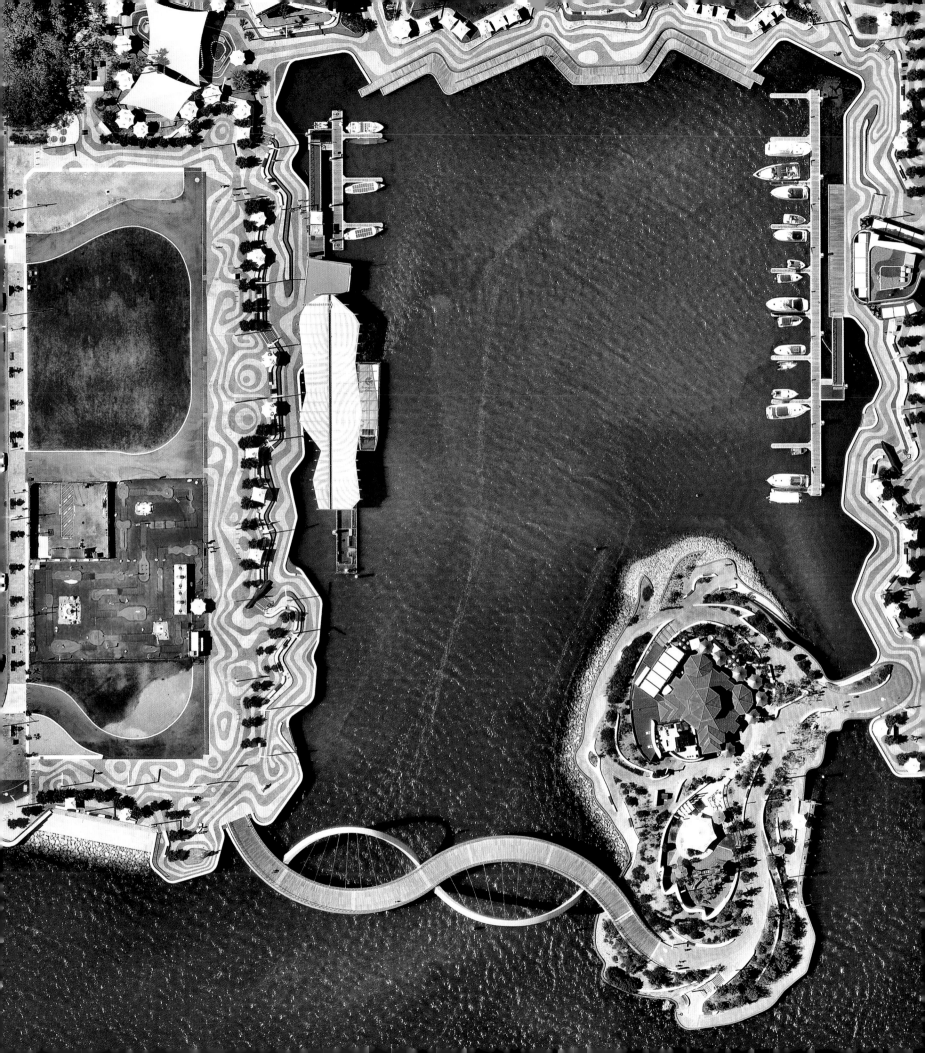

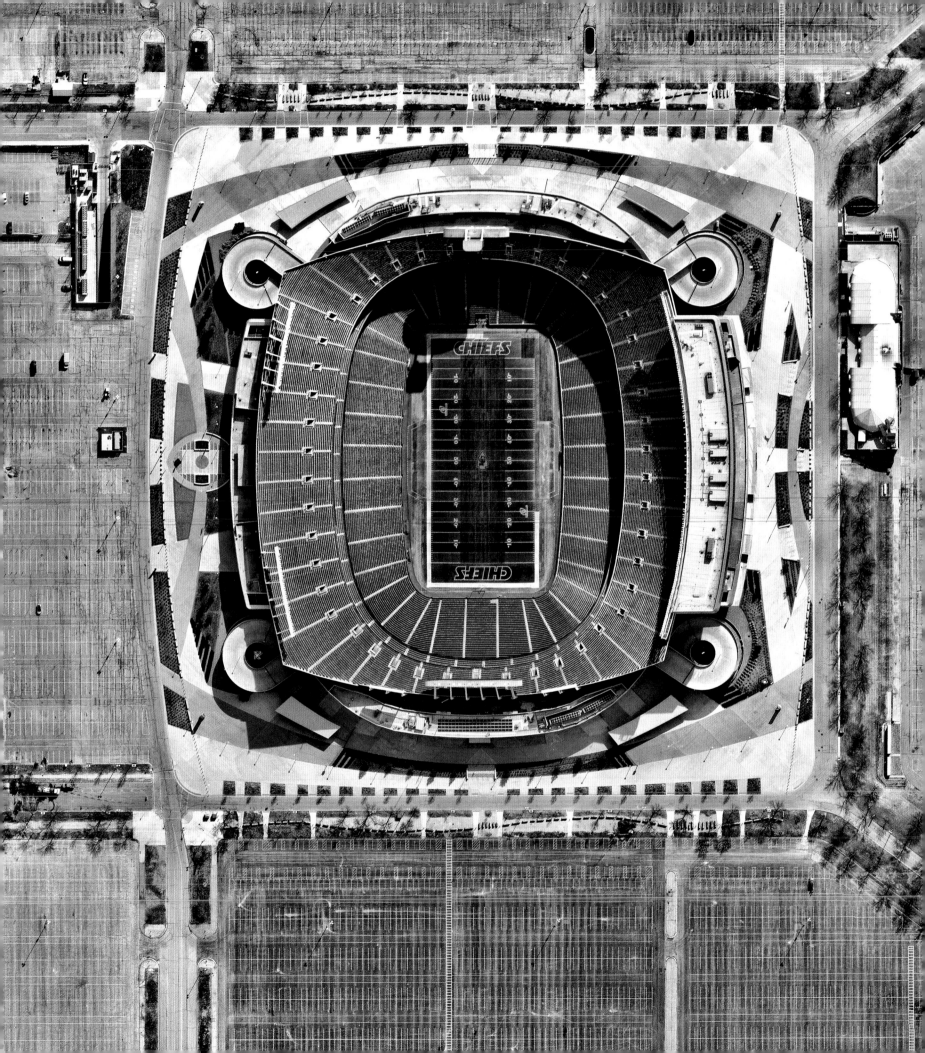

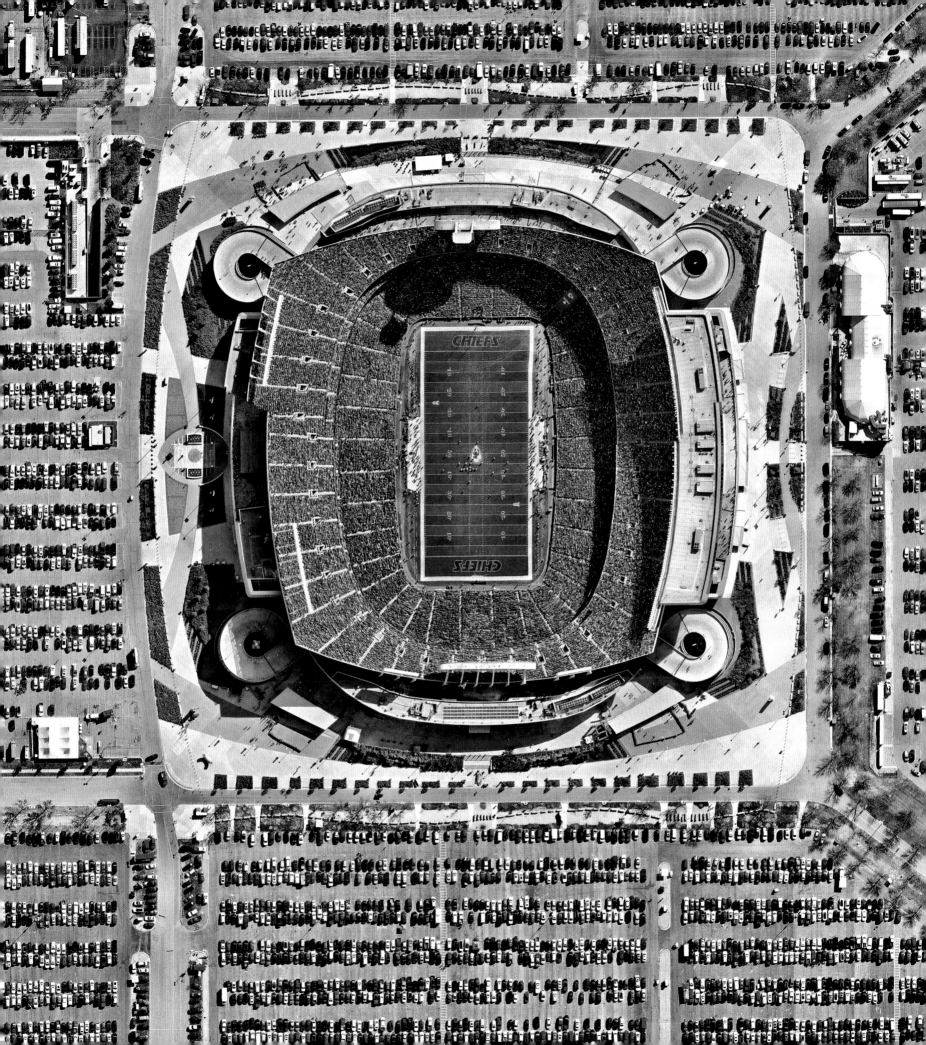

**Arrowhead Stadium**

Wednesday / Sunday

The majority of American professional football games are played on Sundays. Arrowhead Stadium, home of the 2020 Superbowl champion Kansas City Chiefs, sees minimal activity during most days of the week and is then filled to capacity with more than 76,000 fans during home games. In total, the National Football League (NFL) generates roughly $15 billion per season while, globally, all professional sports generate roughly $213 billion every year.

39.048943°, -94.486100°

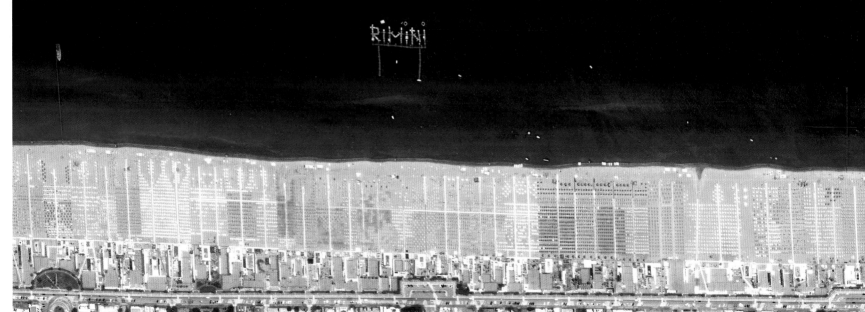

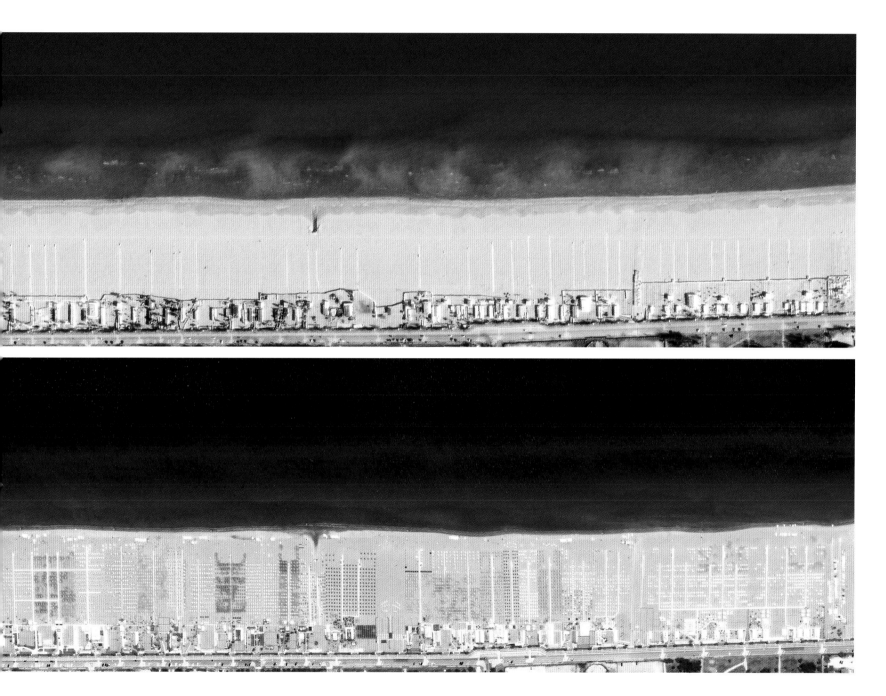

**Rimini Beach Umbrellas**
January / April

Beach chairs and umbrellas are added to the shoreline of Rimini Beach in northern Italy during the warmer months each year. Located on the Adriatic Sea, Rimini is a city of roughly 150,000 people and attracts more than 4.5 million visitors each year (primarily traveling from Germany). Its 9-mile-long (14.5 kilometers), umbrella-dotted beach is surrounded by more than a thousand hotels and thousands of bars, clubs, and restaurants.

44.064972°, 12.586833°

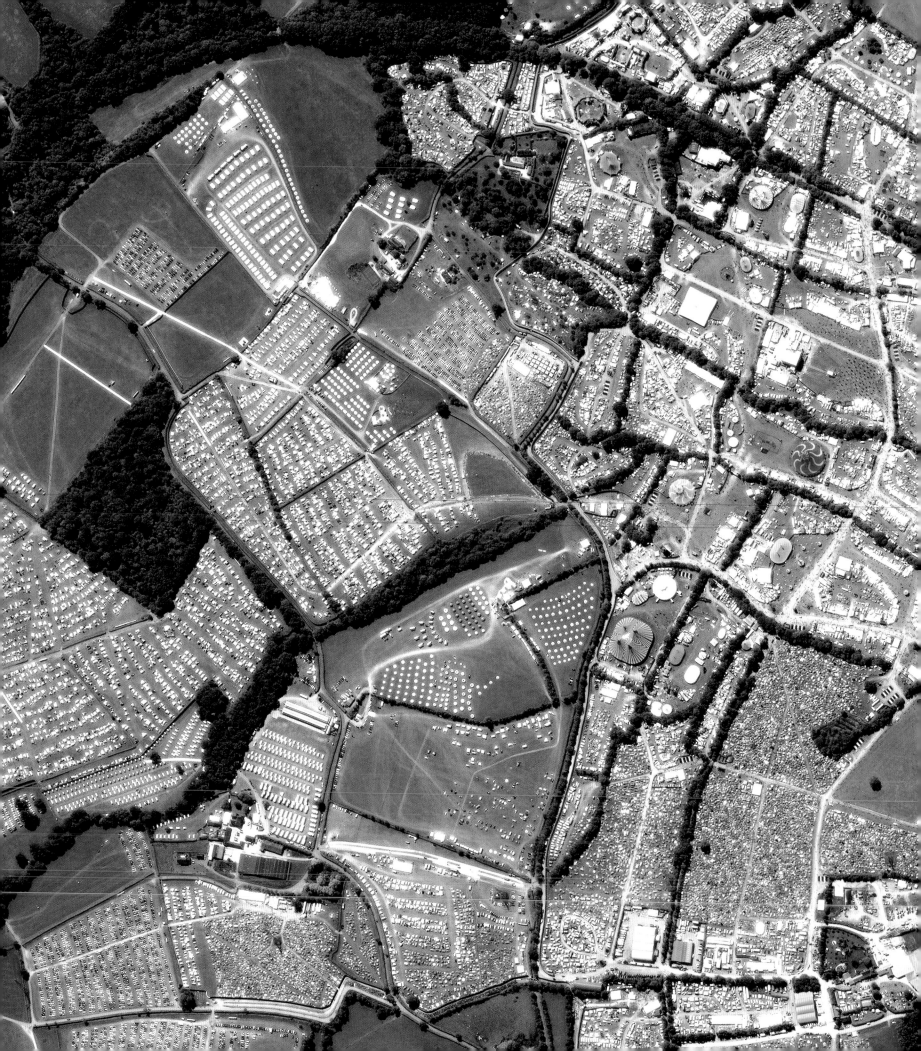

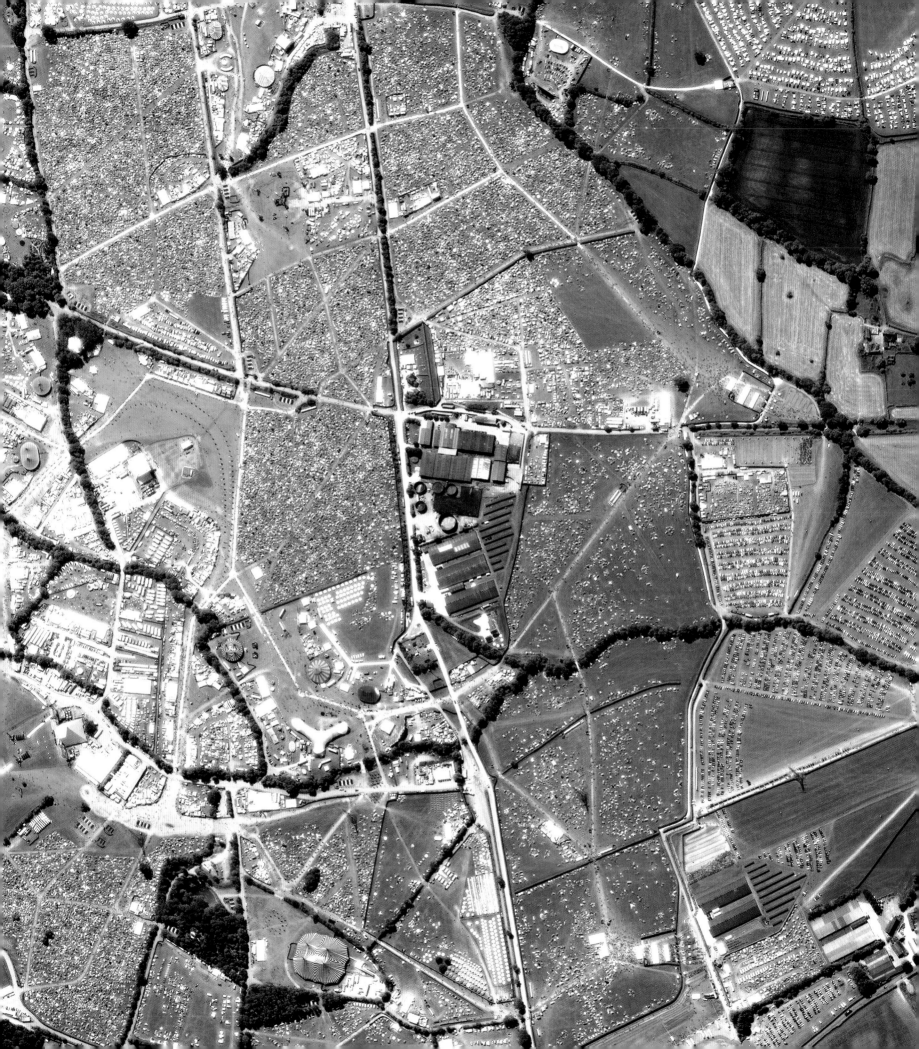

PAGES 68–71

**Glastonbury Festival**
Before / During

The Glastonbury Festival takes place every year in Pilton, England. The annual, five-day music event is attended by roughly 200,000 people. Concertgoers are provided a campsite at the venue and bring their own tents, which colorfully dot much of the landscape in the Overview on the previous two pages. The population of Pilton on the other 360 days of the year is 998.

51.148500°, -2.714000°

RIGHT AND OPPOSITE

**Burning Man**
August 18–September 7, 2019

The construction and cleanup of Black Rock City, Nevada, is seen here over the course of three weeks between August and September, 2019. During this time, Burning Man—an annual event characterized by community, art, and radical self-reliance—takes place here. At peak population, the city contains roughly 80,000 people. As seen in this progression, one of Burning Man's key principles is "Leave No Trace"—meaning significant efforts are taken by organizers and participants to make sure the desert is returned to its original state once the event ends.

40.786981°, -119.204379°

August 27

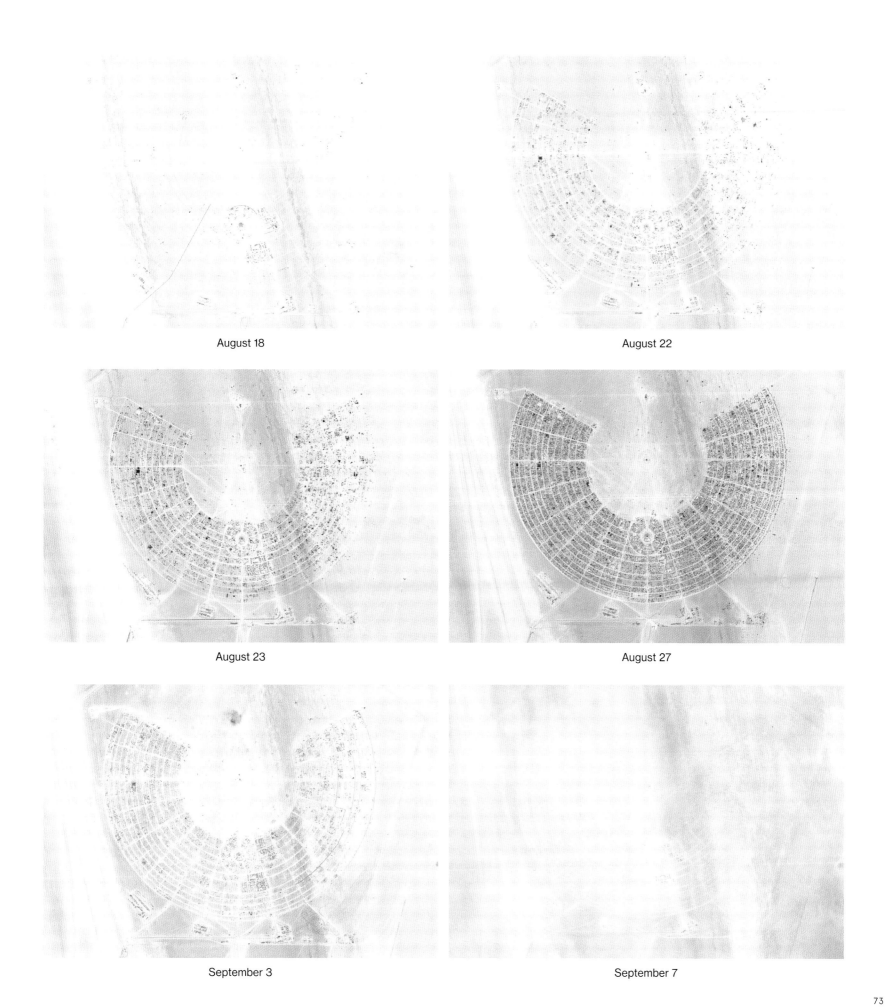

August 18

August 22

August 23

August 27

September 3

September 7

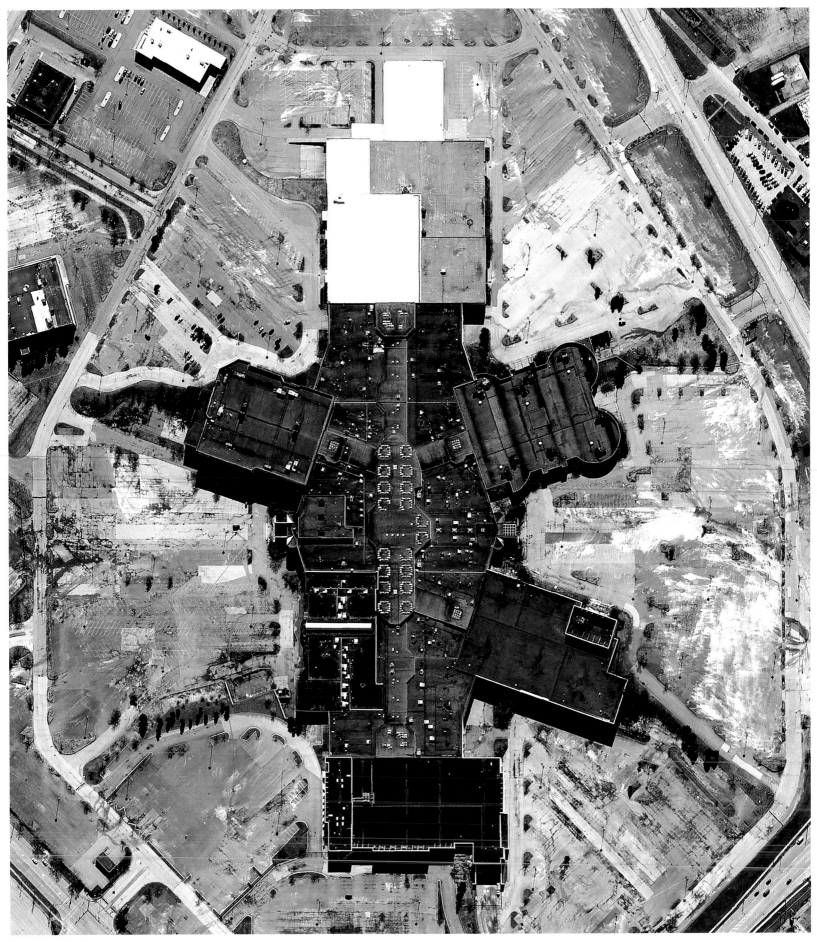

2012

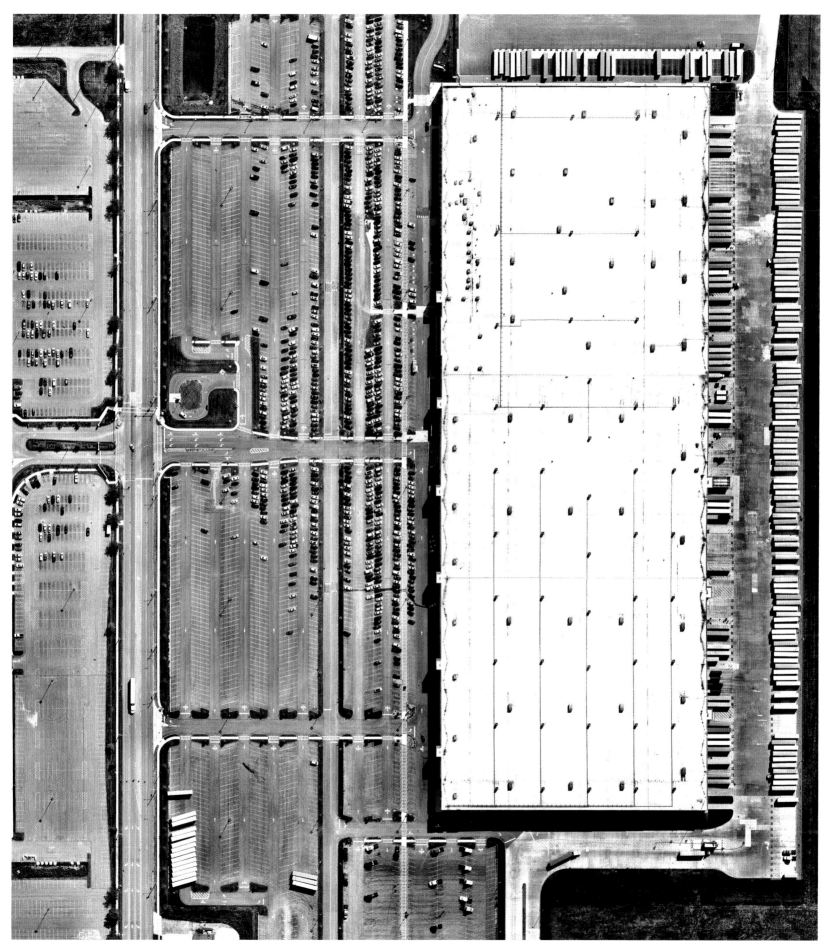

2019

PREVIOUS PAGE

**Shopping Mall Conversion
into Fulfillment Center**
2012 / 2019

Randall Park Mall was a shopping mall located outside of Cleveland, Ohio, that closed in March 2009. Abandoned for a number of years, the facility was eventually purchased, demolished, and converted into an 855,000-square-foot (79,432-square-meter) fulfillment center operated by Amazon. Perhaps there is no better story to show the transformation in our global consumption habits with decreased use of physical stores and increased use of online purchasing. In 2019, for the first time in US history, sales by online retailers surpassed those of physical stores. In New York City alone, it is estimated that 1.5 million Amazon packages are delivered every day. While convenient, online shopping typically has higher rates of return, and the shipping that follows does not come without a cost to the environment.

41.433045°, -81.532374°

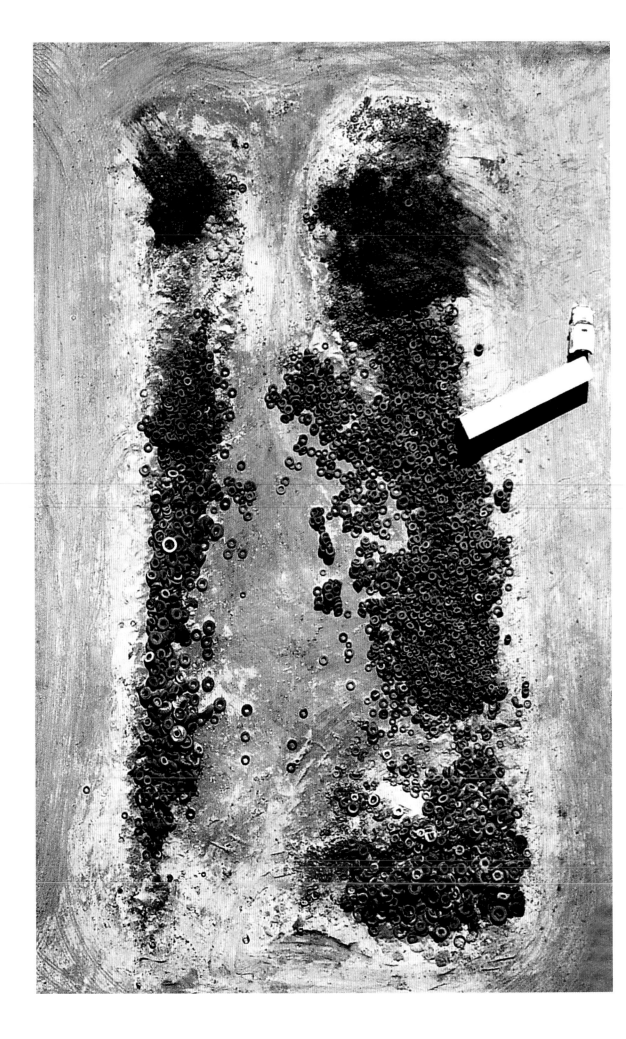

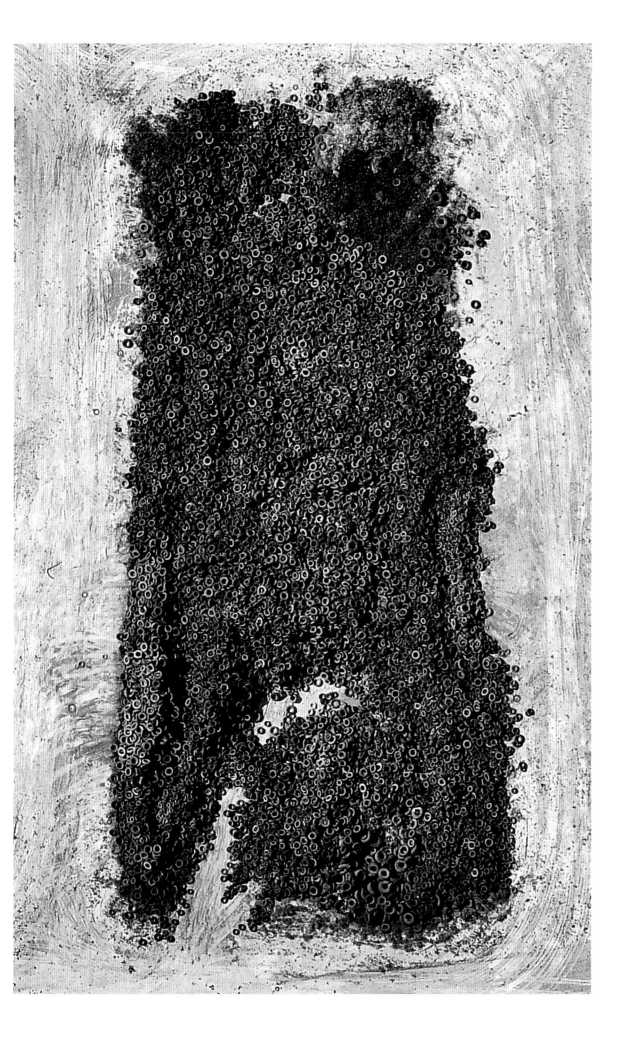

OPPOSITE, LEFT, AND FOLLOWING PAGE

**Tire Graveyard**
March 2018 / August 2018

———

Tires are added to massive piles at the world's largest tire dump in Hudson, Colorado. The facility contains dozens of roughly 150-foot-wide (45 meters) sections filled with approximately 60 million scrap tires. Worldwide, an estimated 1.5 billion tires are discarded each year. Of that amount, more than half are burned for their fuel. For a sense of scale, compare the 80-foot-long (24 meter) tractor trailer seen in the first image here and in the zoomed-out view of the dump on the following page.

40.176890°, -104.682676°

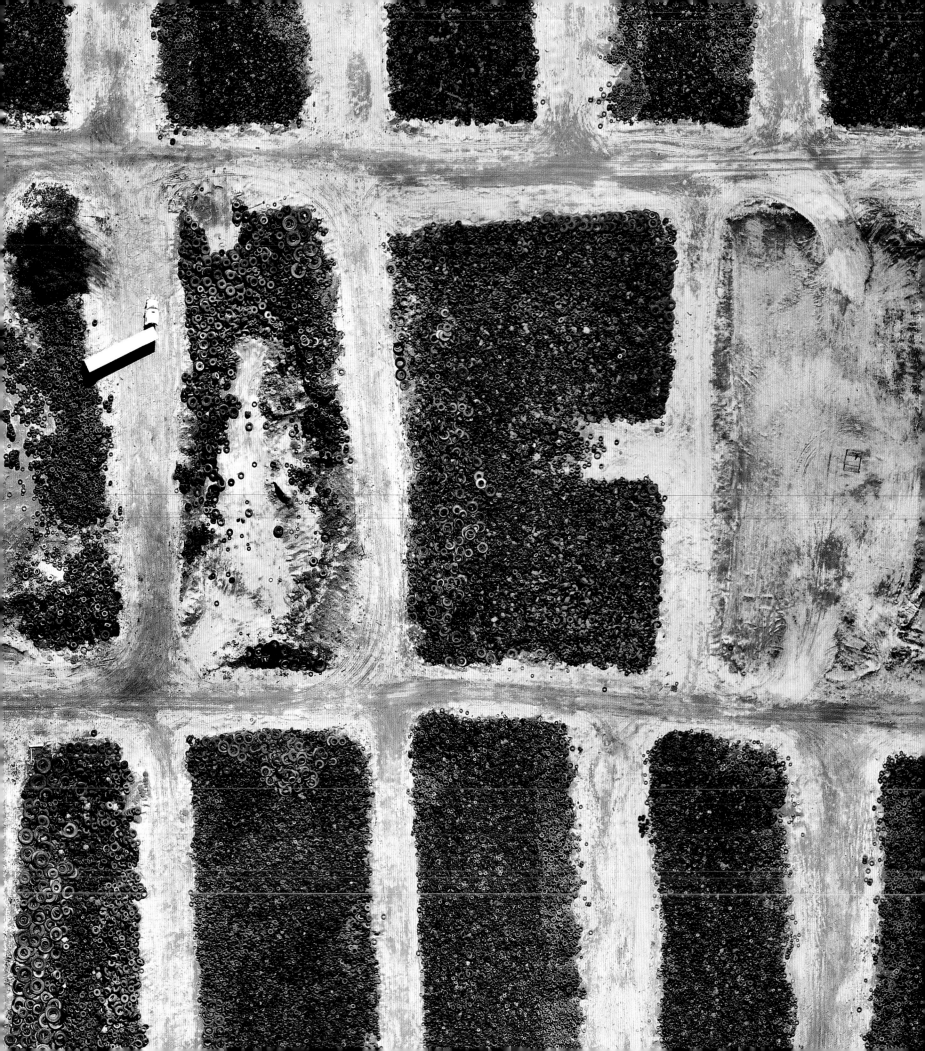

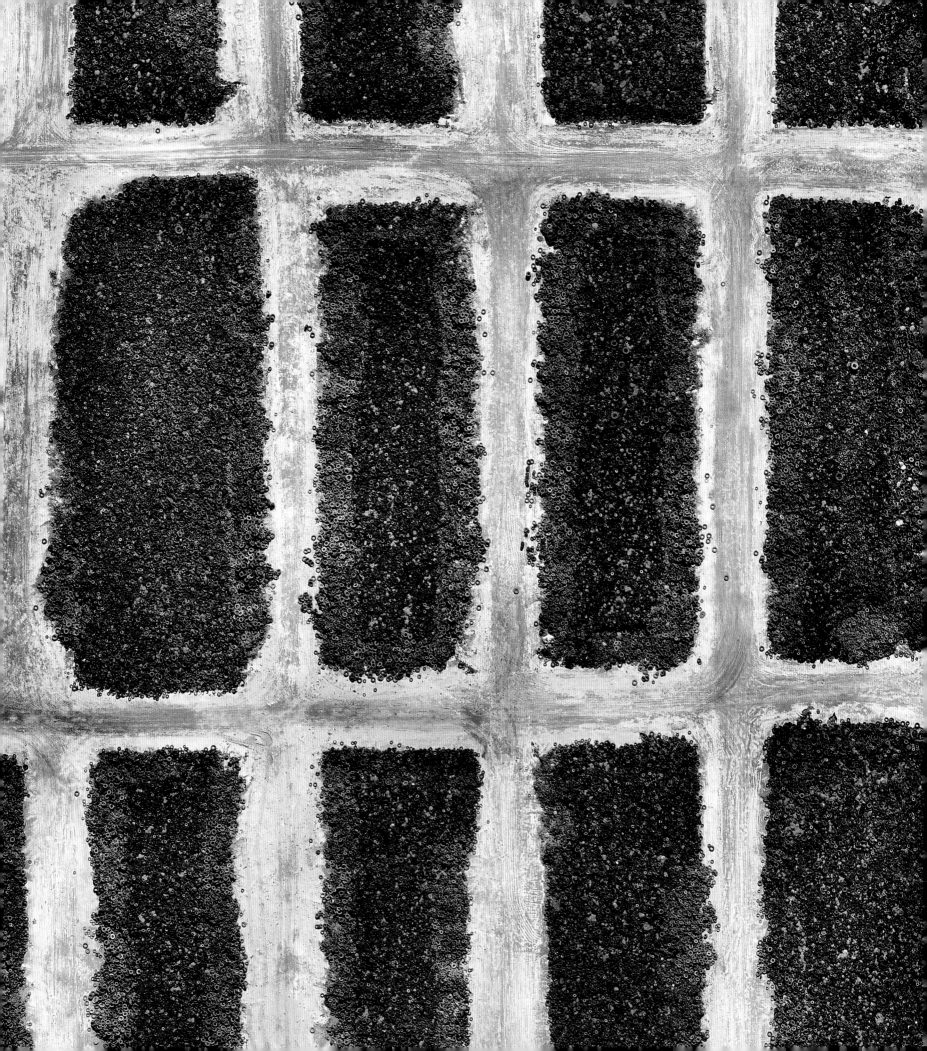

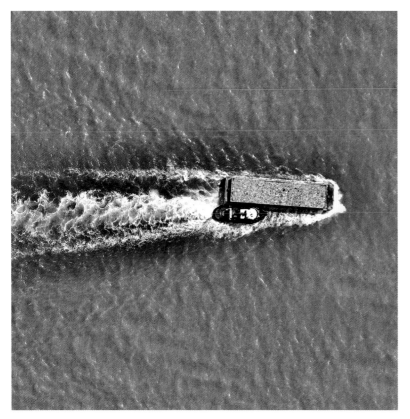

### Step 1

Barges load up potentially recyclable materials at various locations throughout New York's boroughs and then travel through the city's waterways toward the plant in Brooklyn.

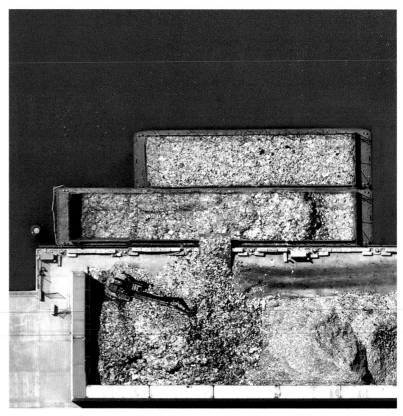

### Step 2

Trash is unloaded from the barges by massive cranes and construction equipment at the plant's dock on Gowanus Bay. These piles are then moved inside the facility for processing.

ABOVE AND OPPOSITE

**NYC Recycling Process**
2018

The Sims Recycling plant in Brooklyn, New York, is responsible for the processing and sorting of all of New York City's glass, metal, and plastic. As the largest facility of its kind in the United States, Sims handles about 800 tons (726 metric tons) of material every day, and plant officials estimate that water bottles account for 8 percent (128,000 pounds/58,060 kilograms) of that total weight. They also estimate that roughly half of the city's recyclable material does not end up here and instead goes into a landfill. The facility's process for recycling follows the steps above.

40.661940°, -74.009168°

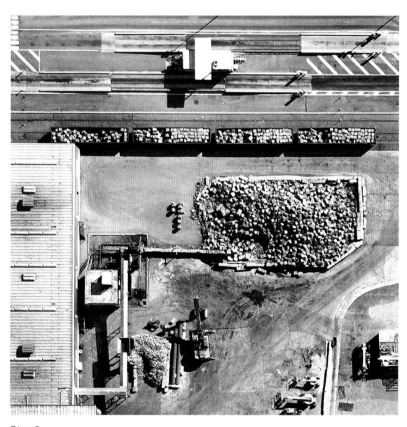

**Step 3**

Once inside, all materials are shredded to make them a more manageable size. Then cameras that can identify certain materials and various machines (including large magnets) separate paper, glass, metal, and plastic. Glass and paper are sent to another facility for processing. The remaining materials deemed recyclable are then compressed into massive blocks. A large pile of those blocks is seen here outside the processing center.

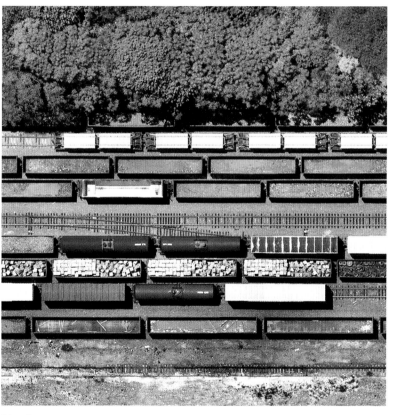

**Step 4**

The plant sells these massive blocks to customers from various industries. They are loaded into train cars (as seen here) to be shipped away. The majority of these blocks end up at power plants, where they are burned for energy recovery. The steel and cement industries purchase and burn the material to power their operations. To learn more about the production of plastics, see page 172.

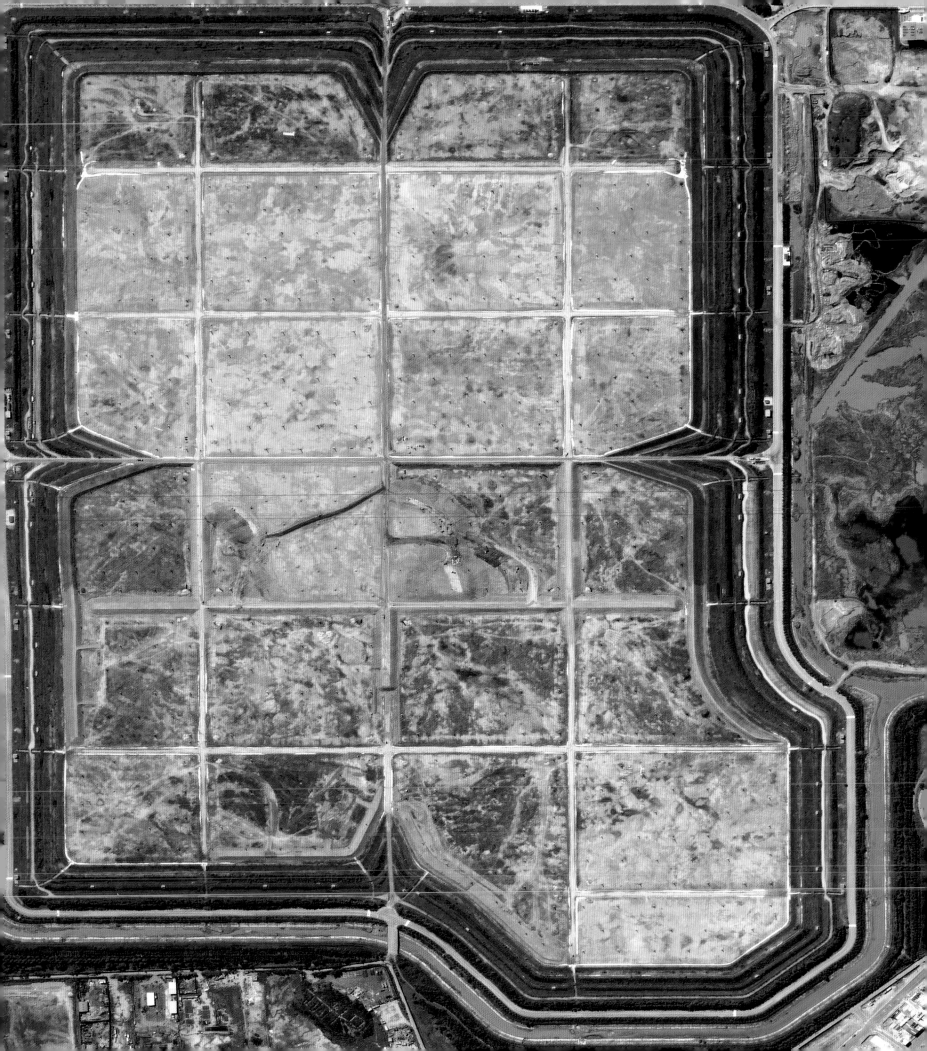

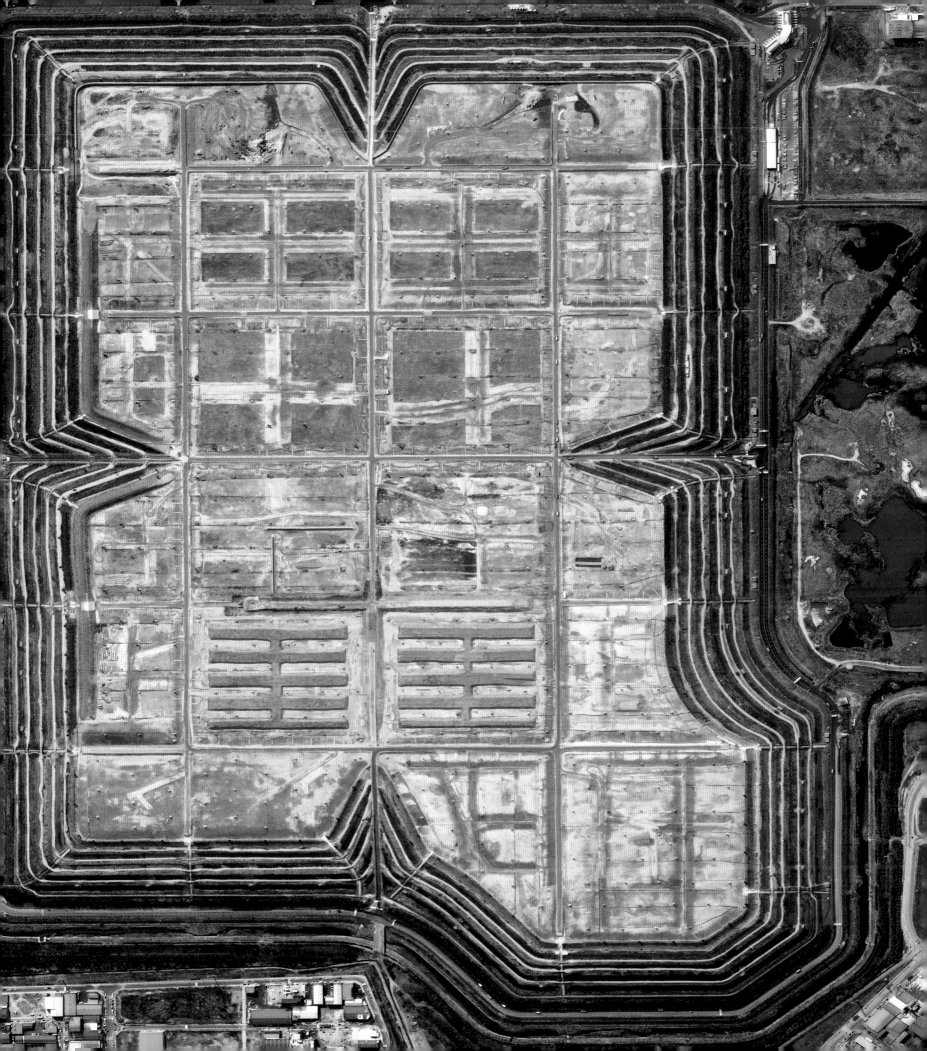

## Sudokwon Landfill Buildup
2008 / 2015

The Sudokwon Landfill is the destination of nearly all of the waste generated by the 22 million people and happenings in the metropolitan area of Seoul, South Korea. The nearly eight-square-mile (20.7 square kilometers) site processed about 18,000 tons (16,329 metric tons) of trash every day between 2008 and 2015, one of the site's active landfill sections built up numerous layers, progressively growing in height. For many years, there have been efforts to close down the facility because it poses significant environmental risks and creates foul odors that seep into the surrounding residential areas. However, the 2016 date when officials intended to close the facility was canceled, and a nearby area was added to take on more trash.

37.575981°, 126.611526°

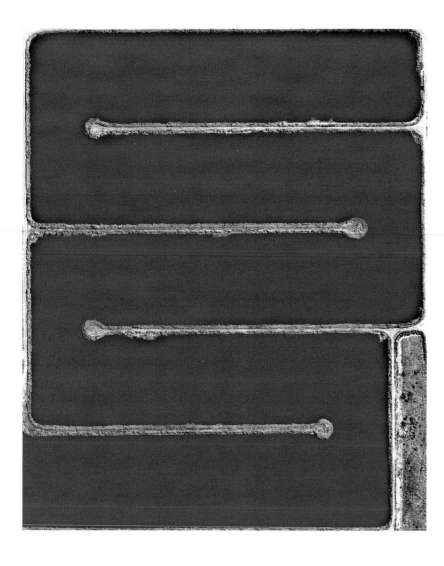 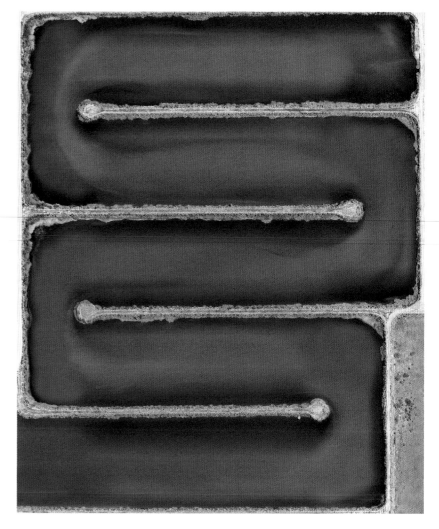

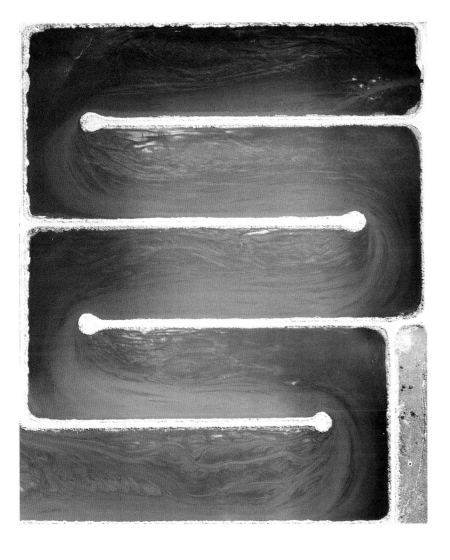
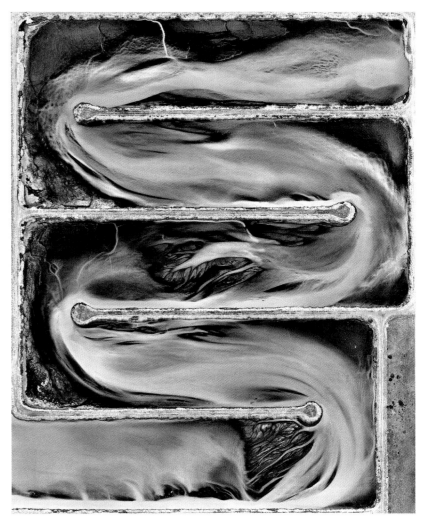

**Melbourne Wastewater Treatment**
2013–2018

———

Shown over four separate years with varying levels of dilution, wastewater moves through a basin at the Western Treatment Plant in Cocoroc, Australia. This facility treats half the human sewage produced in the nearby city of Melbourne and is nearly 26,000 acres (10,522 hectares) in size—roughly equal to the total area of Disney World. Biosolids, which are the organic materials left over from the sewage treatment process, are recycled here to be reused in energy production, farming, or other soil products.

-37.985131°, 144.610272°

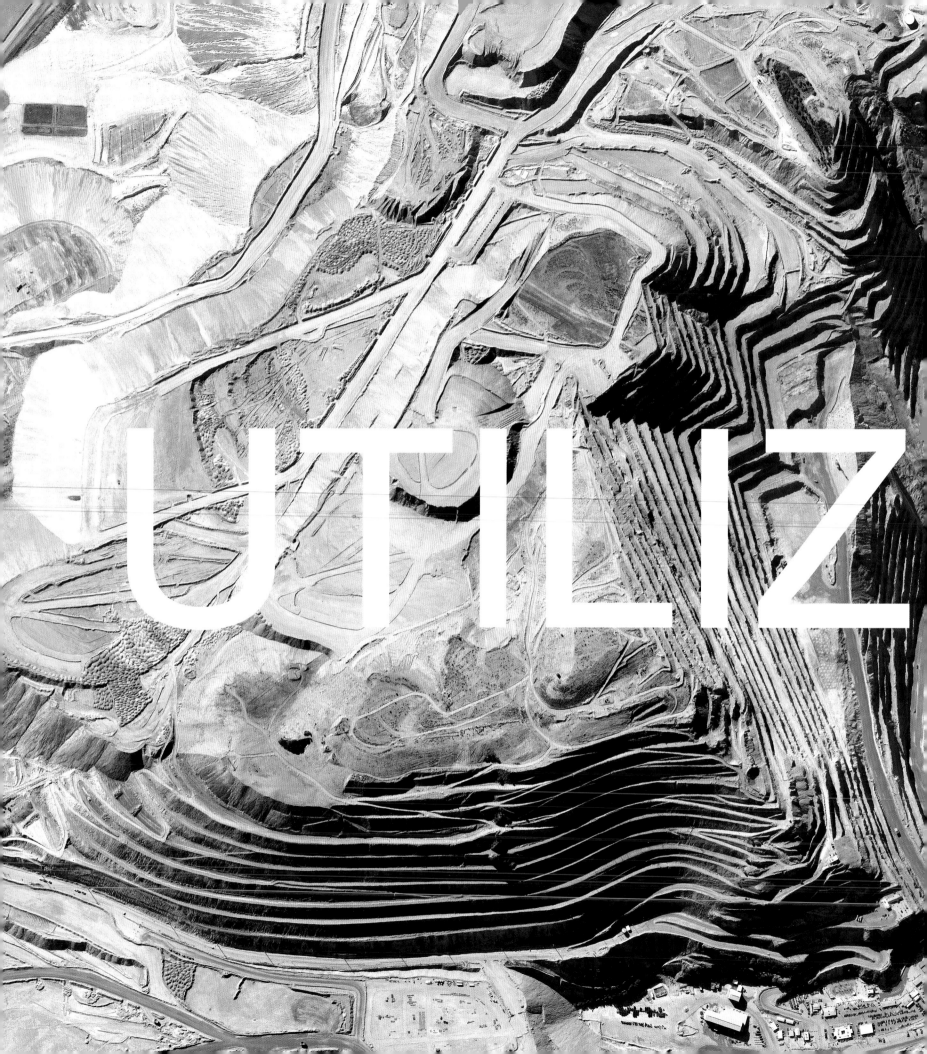

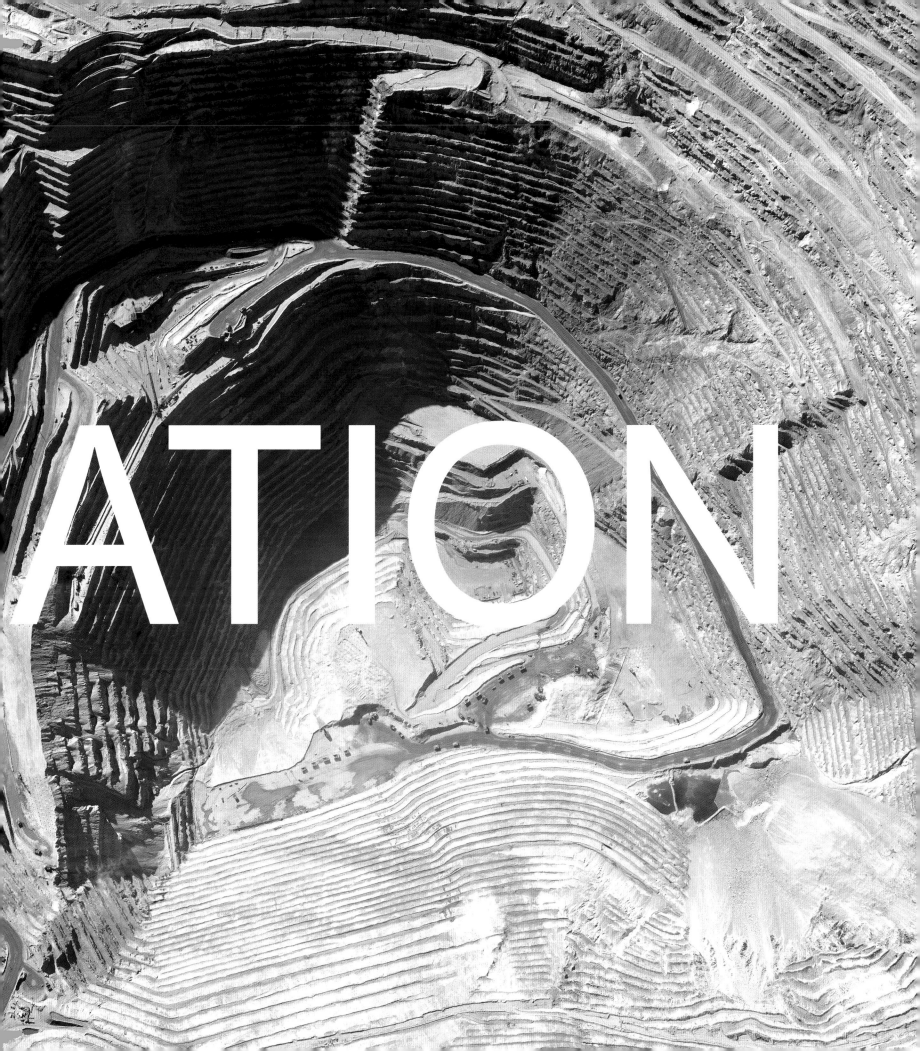

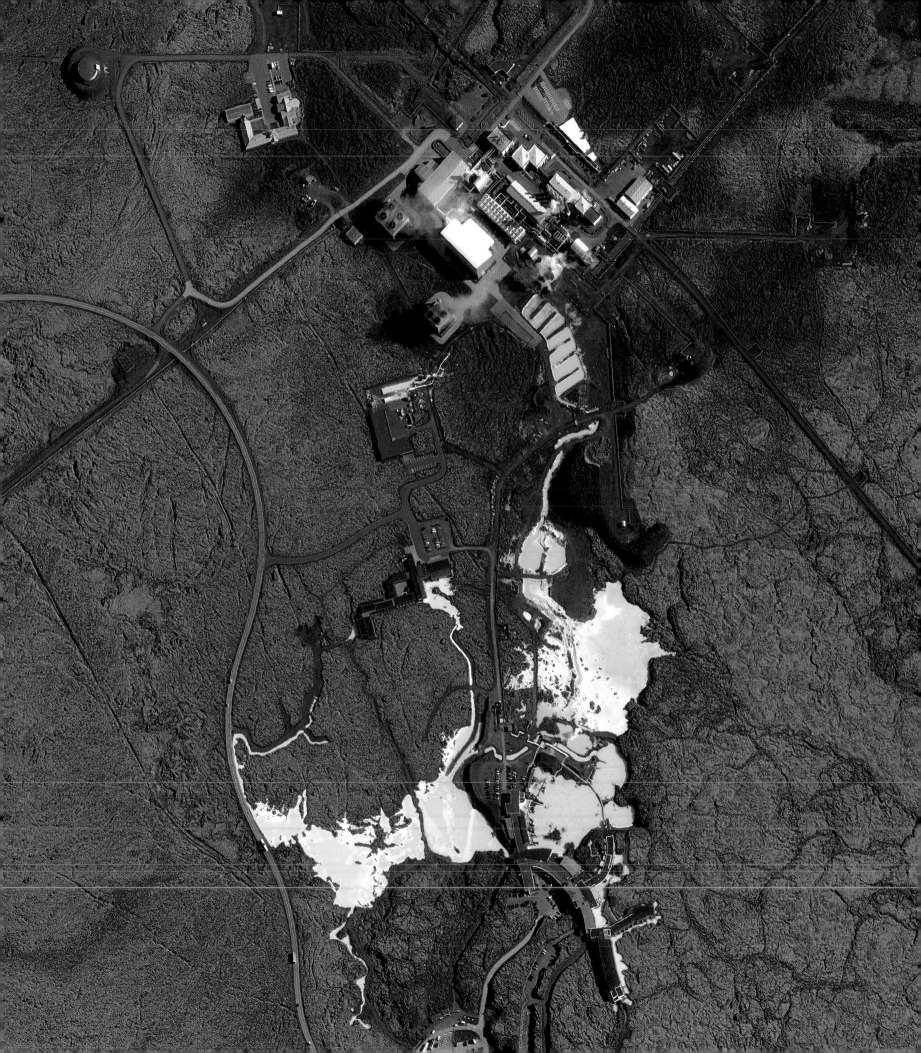

# Water

Water is the most important substance on Earth and its consumption is vital to all forms of life. Its movement has formed the planet into much of what we see today. Water makes up 60 percent of the human body, and we cannot survive for more than five days without proper hydration. It is no coincidence that our cities have flourished on coastlines and beside navigable waterways. We depend on fresh water for an endless list of necessities such as drinking water, sustenance for our agriculture, sanitation to maintain our health, and even some of the energy that we produce. This chapter observes a selection of places where water has been utilized by humanity, always at a grand scale, sometimes with unintended consequences.

From the beginning, water has shaped civilization. The use of fresh water to irrigate crops enabled a major shift for our species. No longer following our food supply as hunter-gatherers, we could now permanently settle and expand from established areas. In our modern world, we go to great lengths—sometimes by drilling deep underground or with massive diversion projects—to get the water we need. Our ventures into the oceans for exploration, transportation, and fishing have granted us access to new worlds and goods. By damming rivers, we simultaneously generate electricity and make previously uninhabitable land ripe for development. Furthermore, much of our electricity generation happens through the spinning of turbines that are powered by pressurized steam. With its far-reaching and versatile implementation, water is an indispensable resource to civilization as we know it.

Though we often treat it as such, water is not an endless resource. In total, water covers 70 percent of the planet, but only 2.5 percent of that volume is fresh water. Conservation and reuse of water will only become more vital as demand rises and we create more processes that utilize $H_2O$ as a key ingredient. It is possible that new technologies such as desalination (the removal of salt from saltwater) will increase supplies in regions with shortages, but those processes are expensive, energy-intensive, and produce less palatable water. Ultimately, water may be viewed as a protagonist in how change happens on Earth—making all life and development as we know it possible. But if we are not able to adapt our behavior, our overutilization of Earth's natural resources will also make water the antagonist of our climate story, flooding us with far too much or leaving us vulnerable with far too little.

PREVIOUS SPREAD

**Bingham Canyon Mine**
2012

The Bingham Canyon Mine is an open-pit mine in Salt Lake City, Utah. At 2.5 miles (4 kilometers) wide and 0.6 miles (1 kilometer) deep, it is the largest man-made hole in the world and is considered to have produced more copper than any other mine in history—more than 20 million tons (18.1 million metric tons). The major applications of copper are in electrical wires (approximately 60 percent of total use), roofing and plumbing (approximately 20 percent), and industrial machinery (approximately 15 percent). Copper is also combined with other elements to make alloys (approximately 5 percent) such as brass and bronze.

40.522166°, -112.166895°

OPPOSITE

**The Blue Lagoon**
2018

The Blue Lagoon is a man-made geothermal spa in southwestern Iceland. Located 12 miles (19 kilometers) from Keflavík International Airport, it is one of the most visited attractions in the country. The water comes from the nearby Svartsengi Power Station (seen at the top of this Overview) and gets its milky-blue shade from a high silica content. When it opened in 1976, the power station was the world's first geothermal power plant for electric power and hot-water production, and it still provides hot water to more than 21,000 households.

63.881121°, -22.450751°

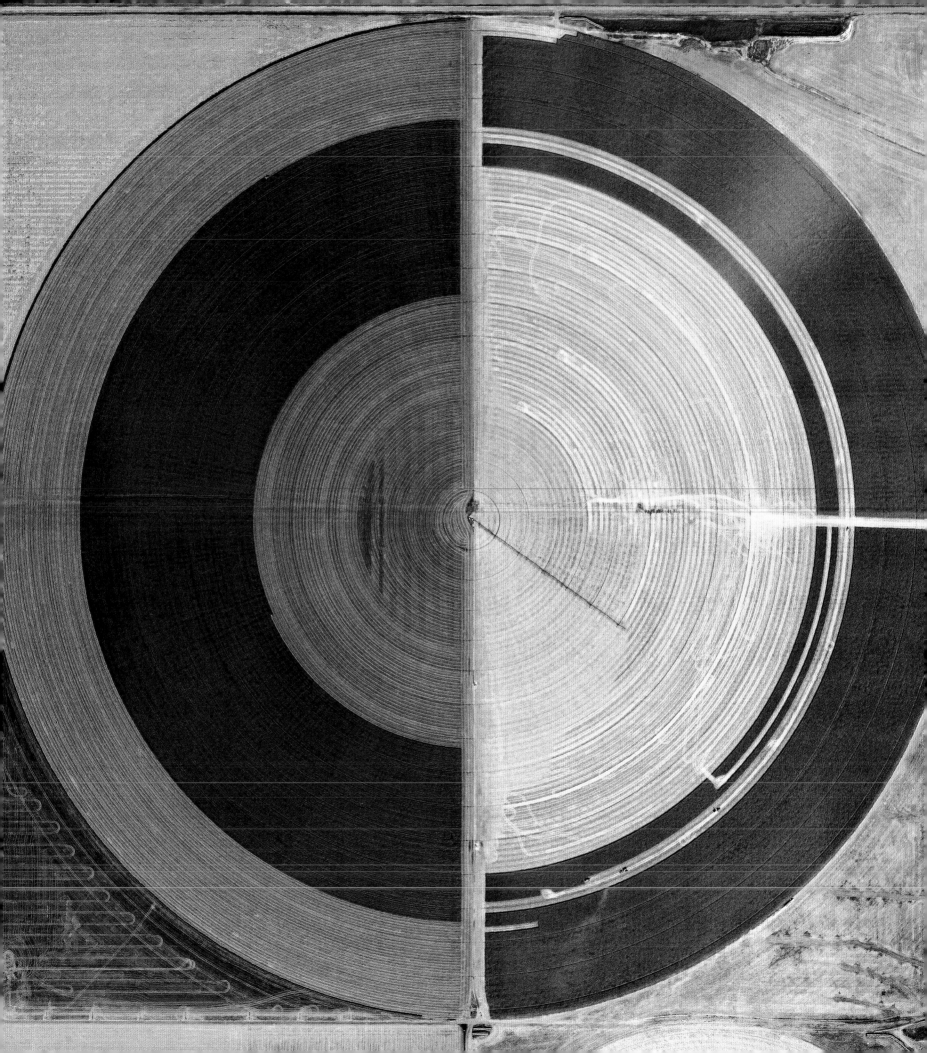

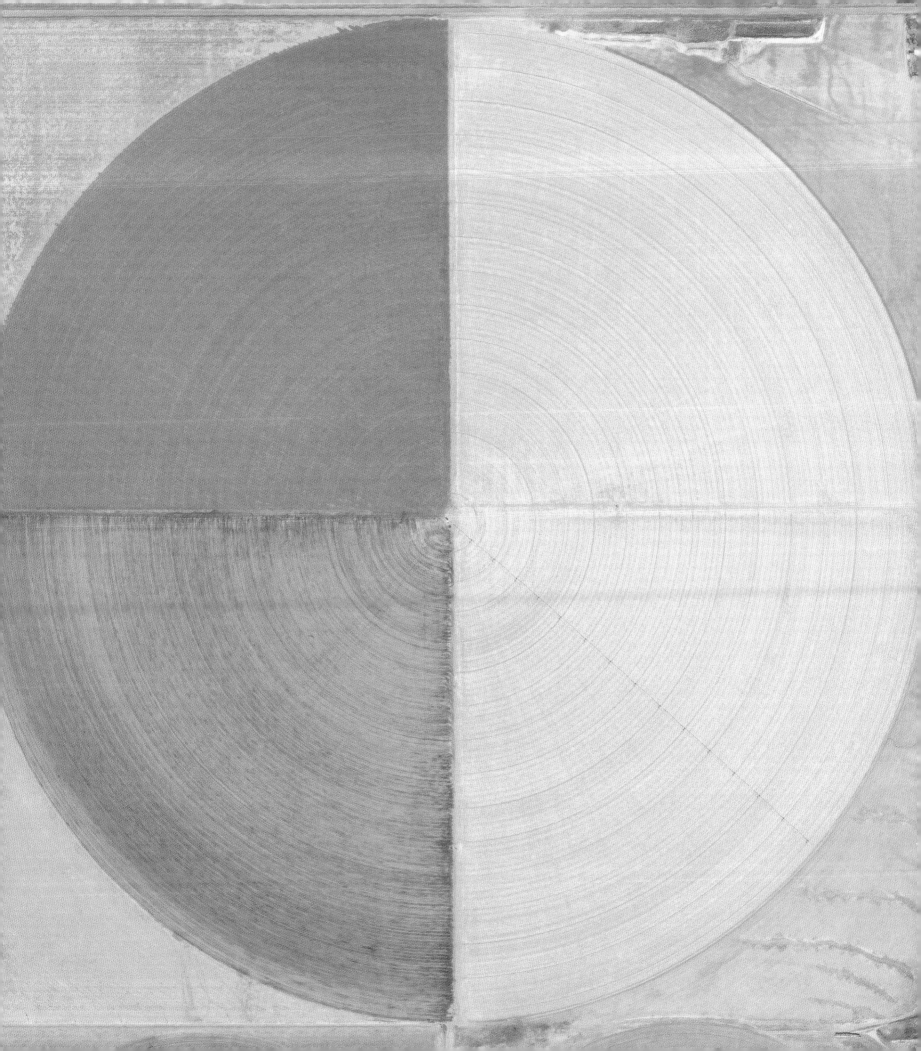

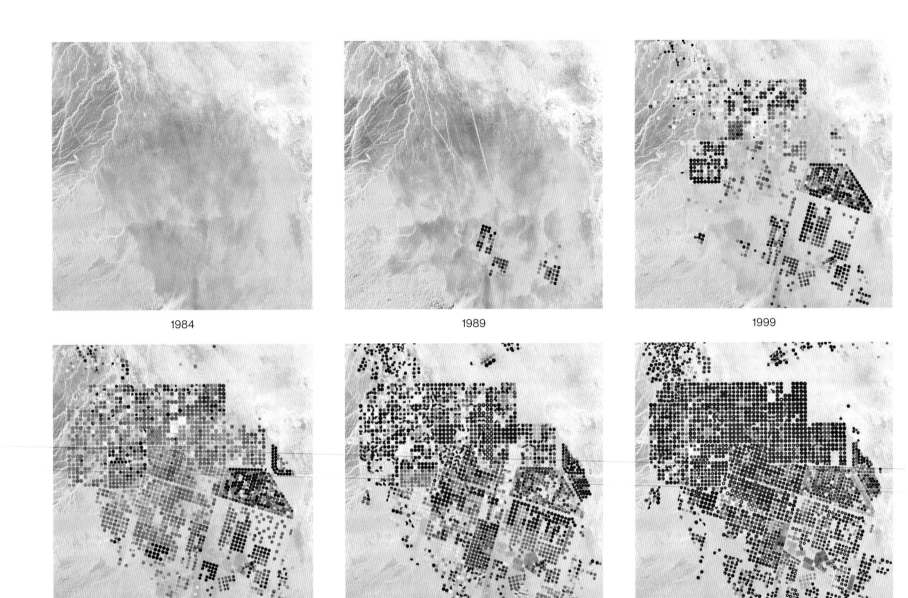

1984

1989

1999

2002

2009

2015

PREVIOUS PAGE

**Pivot Irrigation Field**
October / January

A pivot irrigation field is seen in Hereford, Texas, during a harvest and a winter month. The circles occur where a line of sprinklers rotates and irrigates crops around a central, electric motor. For a center pivot to be used, the terrain needs to be reasonably flat. As seen here, these systems do not function during the colder months when water is not present and crops are not grown.

34.991850°, -102.571400°

ABOVE AND OPPOSITE

**Saudi Arabia Pivot Irrigation Expansion**
1984–2019

In recent decades, pivot irrigation use has increased drastically throughout the Wadi As-Sirhan Basin of Saudi Arabia. Water is pumped to the surface from depths as great as 0.6 miles (1 kilometer) and evenly distributed by sprinklers that rotate 360 degrees around central motors. Cultivated land in Saudi Arabia grew from 400,00 acres (161,874 hectares) in 1976 to more than 8 million acres (3.2 million hectares) by 1993, spurred by a government effort to strengthen its agricultural sector. This specific project is expected to face serious challenges in the future as underwater supplies will not refresh rapidly enough to meet the ongoing demand of water needed to continuously irrigate crops in an extremely hot, dry region. The average high temperatures in this area reach upward of 110°F (43.3°C), requiring the sprinklers to be on in the middle of the night to avoid substantial water losses due to evaporation.

30.169968°, 38.338924°

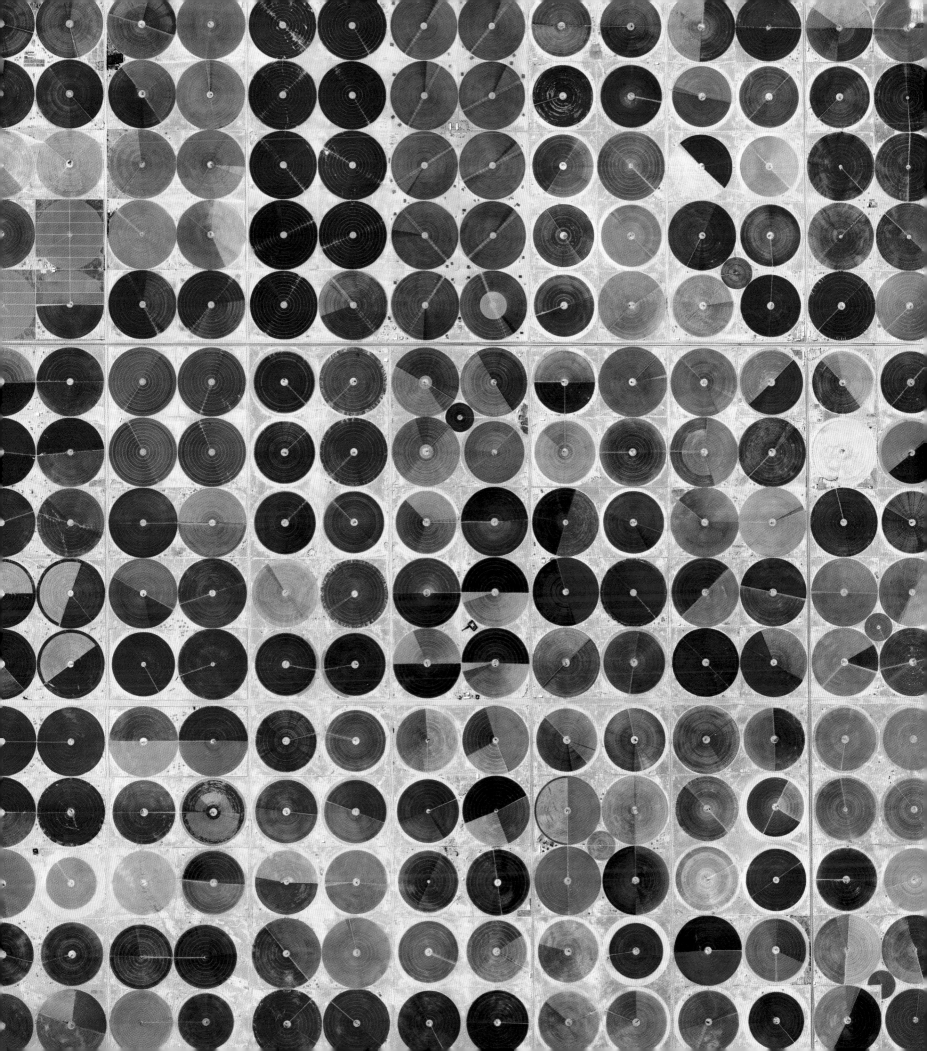

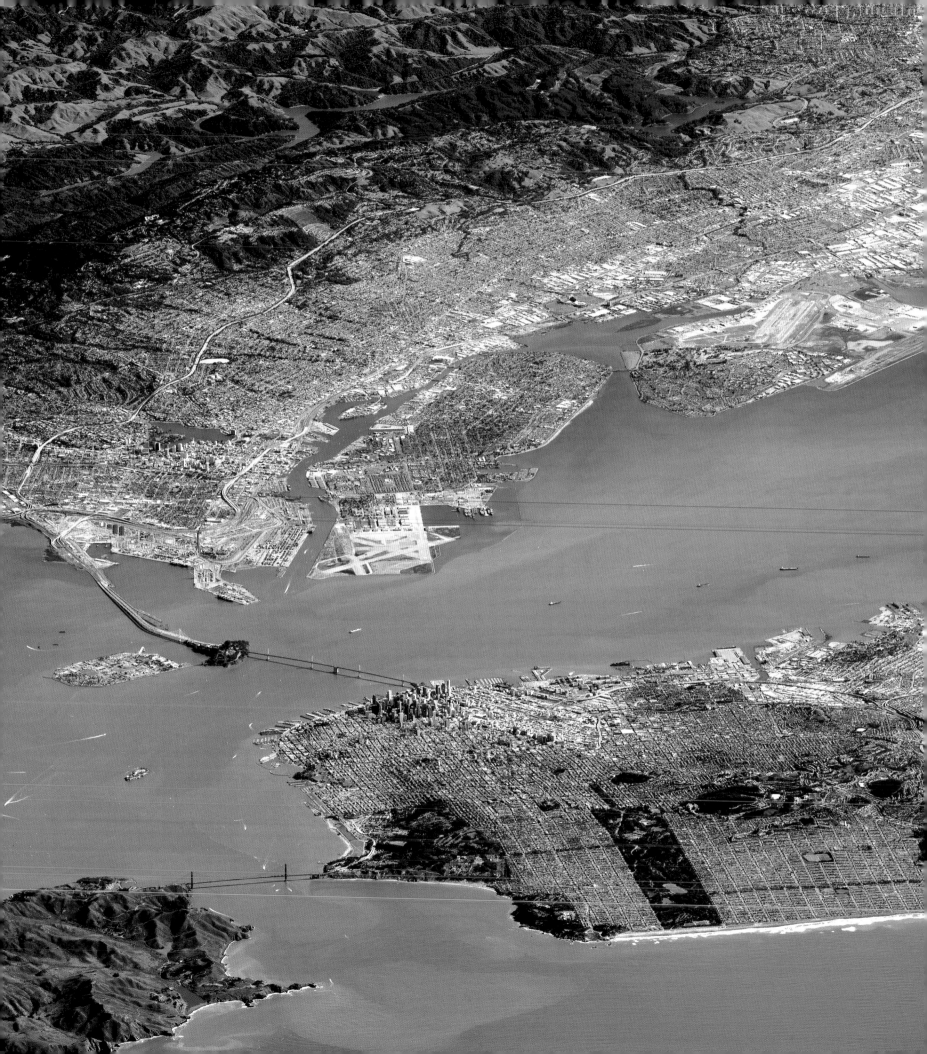

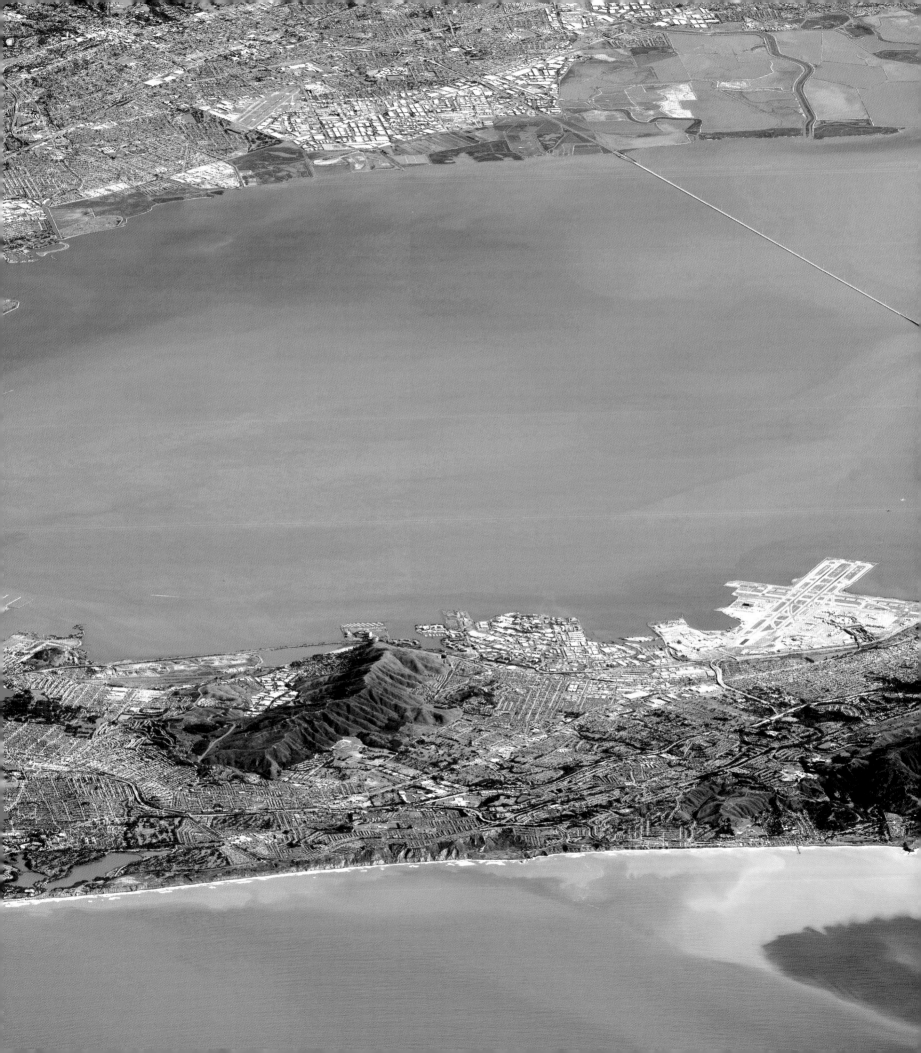

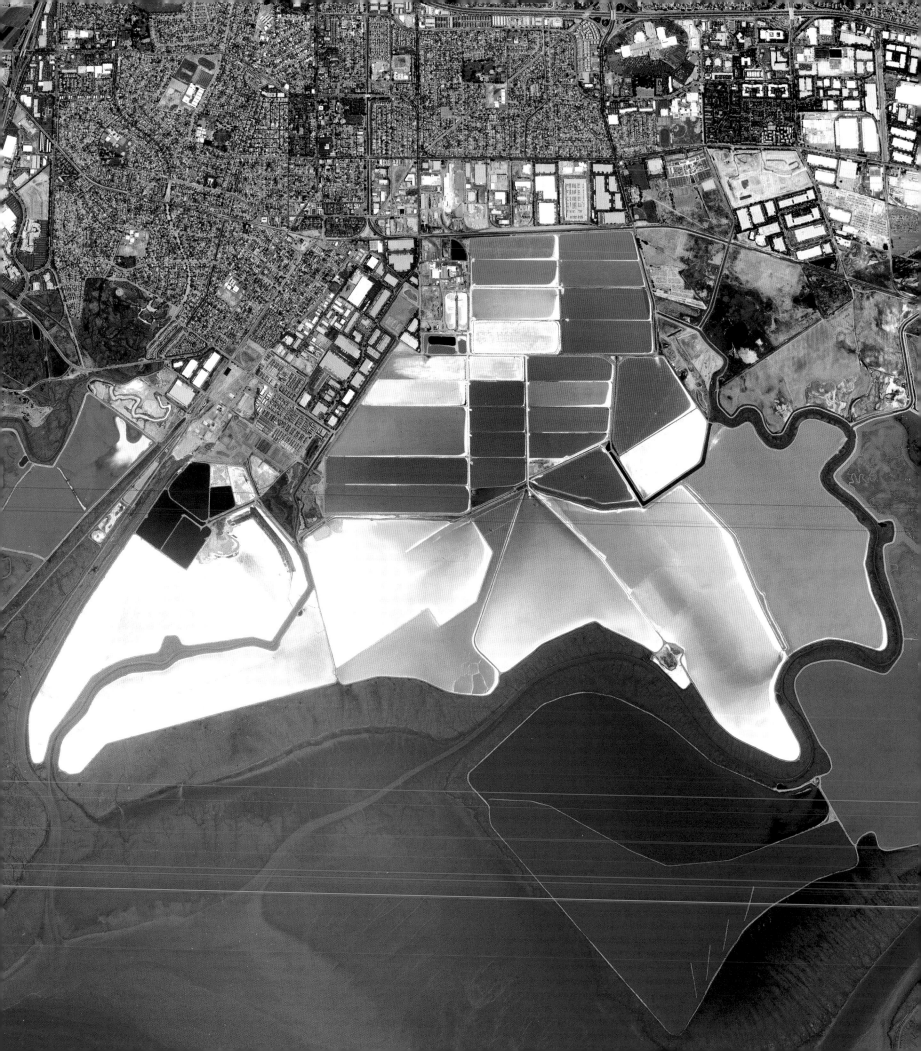

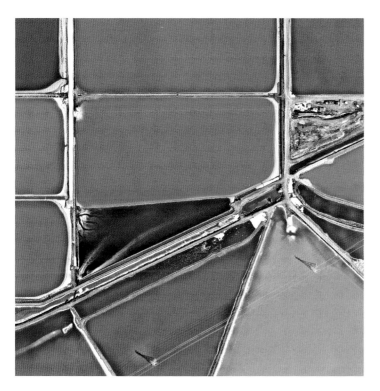
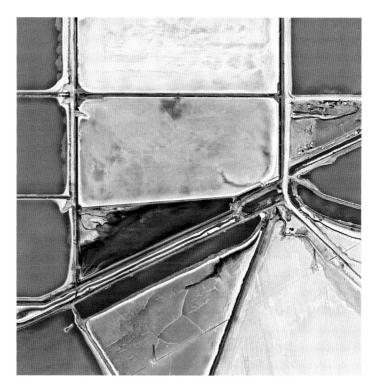

PREVIOUS SPREAD
**San Francisco Bay Area**
2016
———

San Francisco, California, and the surrounding Bay Area, home to some 8 million people, is captured here by satellite at a low angle from 800 miles away over the Pacific Ocean. When freshwater from inland California mixes with salty water coming from the ocean, it creates brackish wetlands that provide a vibrant habitat for wildlife, including many species of birds. Over the last century, nearly 80 percent of the Bay's wetland habitats have been diked and filled for building, farming, and salt extraction. A large section of the ponds where salt extraction occurs is visible in the upper right corner of this Overview.

37.794358°, -122.560478°

OPPOSITE AND ABOVE
**San Francisco Bay Salt Ponds**
2015–2019
———

The salt ponds located on San Francisco Bay are seen here with varying coloration at different times. Water from the bay is channeled into large ponds and exits through natural evaporation. Once the water evaporates, the salt that remains can be collected and is used primarily for industrial purposes. The massive ponds get their vibrant and varying colors from the algae that thrive in the extremely salty water. Areas that have a bright red hue are caused by the algae Dunaliella, a species that thrives in water with high salt content.

37.495364°, -122.160180°

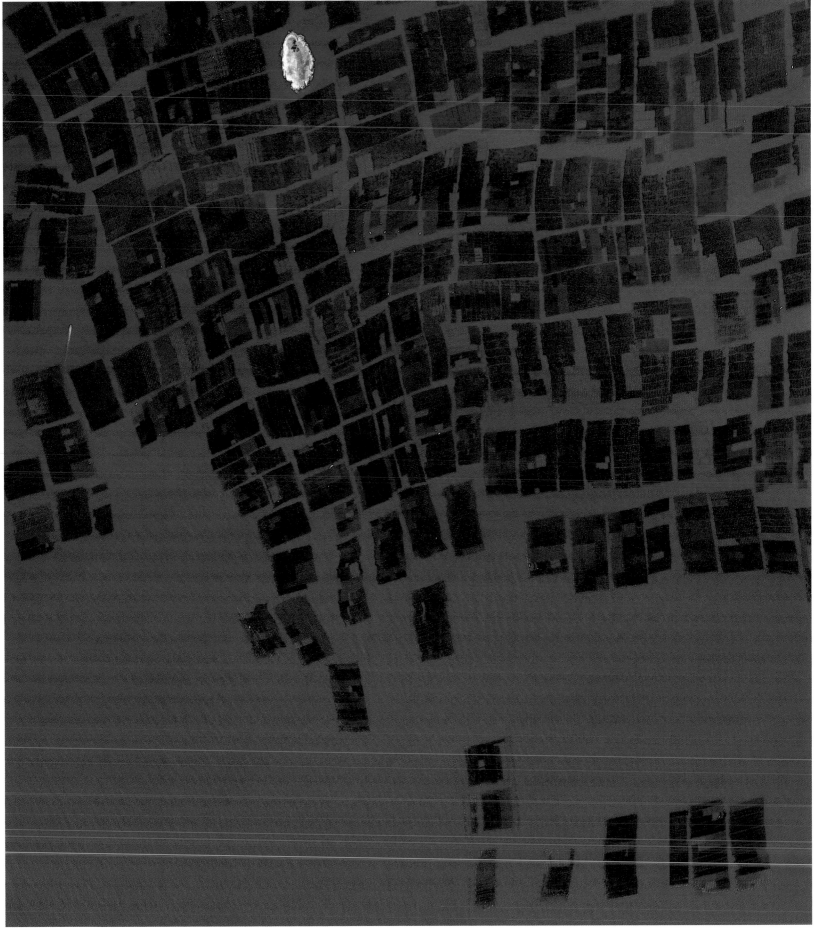

2009

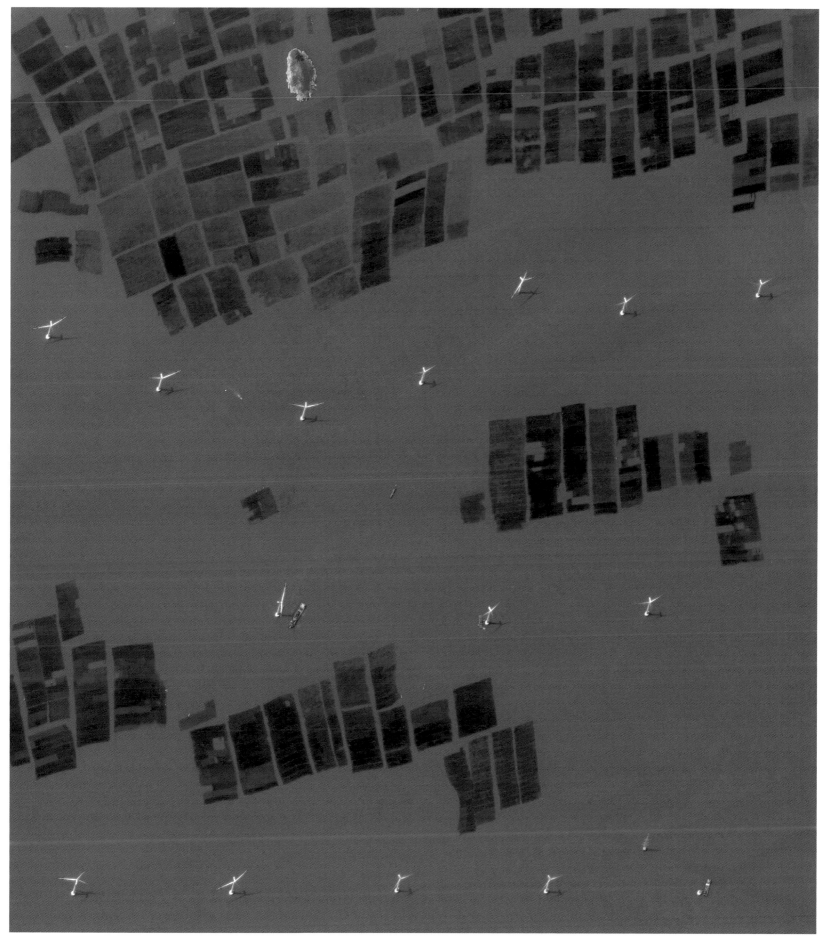

2018

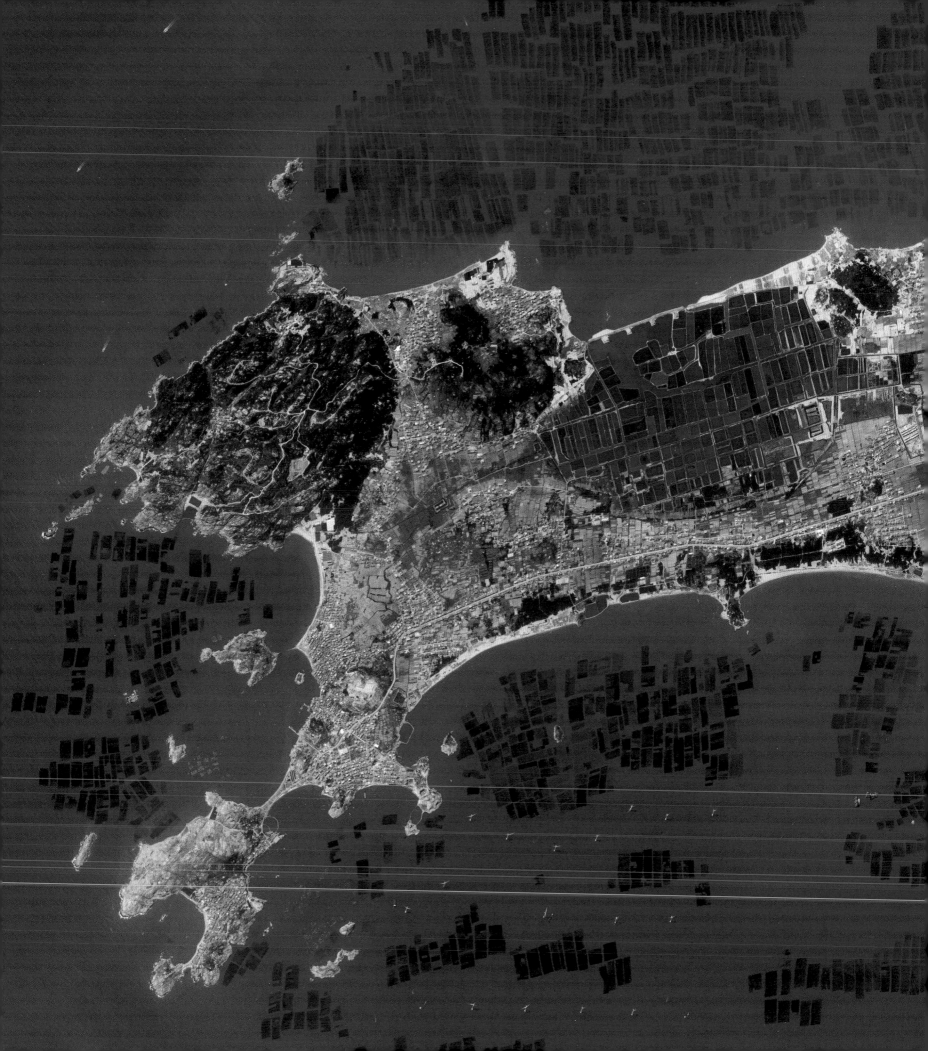

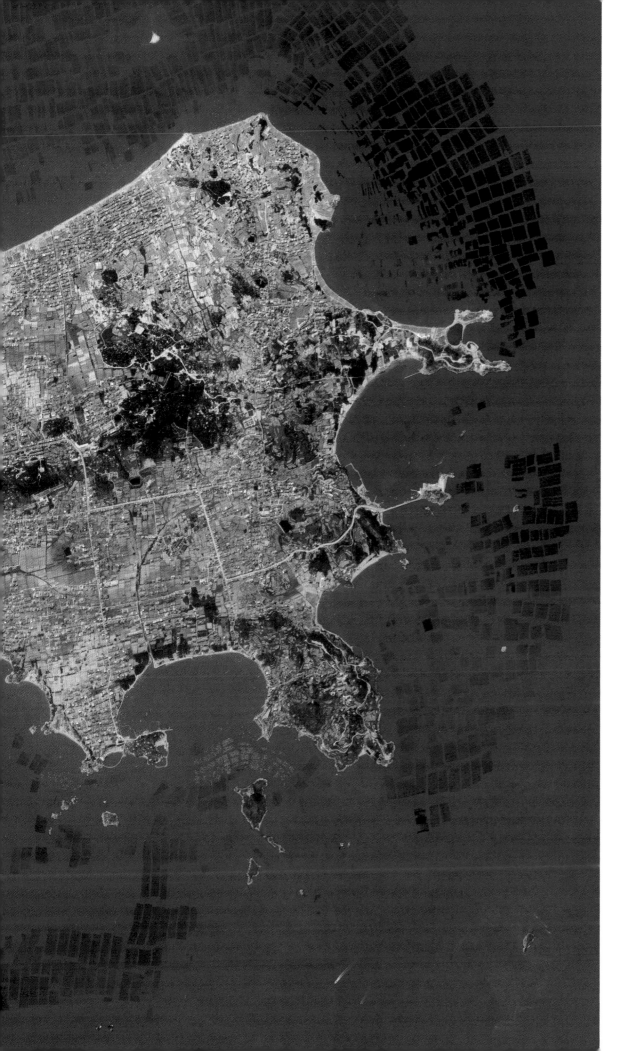

PREVIOUS SPREAD AND LEFT

**Nanri Island Aquaculture /
Offshore Wind Farm**
2009 / 2018 / 2018

For decades, the waters of Nanri Island, located off the coast of China, have been cultivated for the growth of kelp, seaweed, and the raising of abalone (large sea snails). Since 2015, the water surrounding the island has also been utilized for the production of offshore wind energy in the midst of the nets. For more information on how these turbines generate electricity, see page 127. To date, more than 130 wind-power generators have been installed, with minimal effect on the total production of aquaculture. In 2018, the area produced 179,000 tons (162,386 metric tons) of seafood products and increased its total output over the previous year by 6.2 percent.

25.178506°, 119.460871°

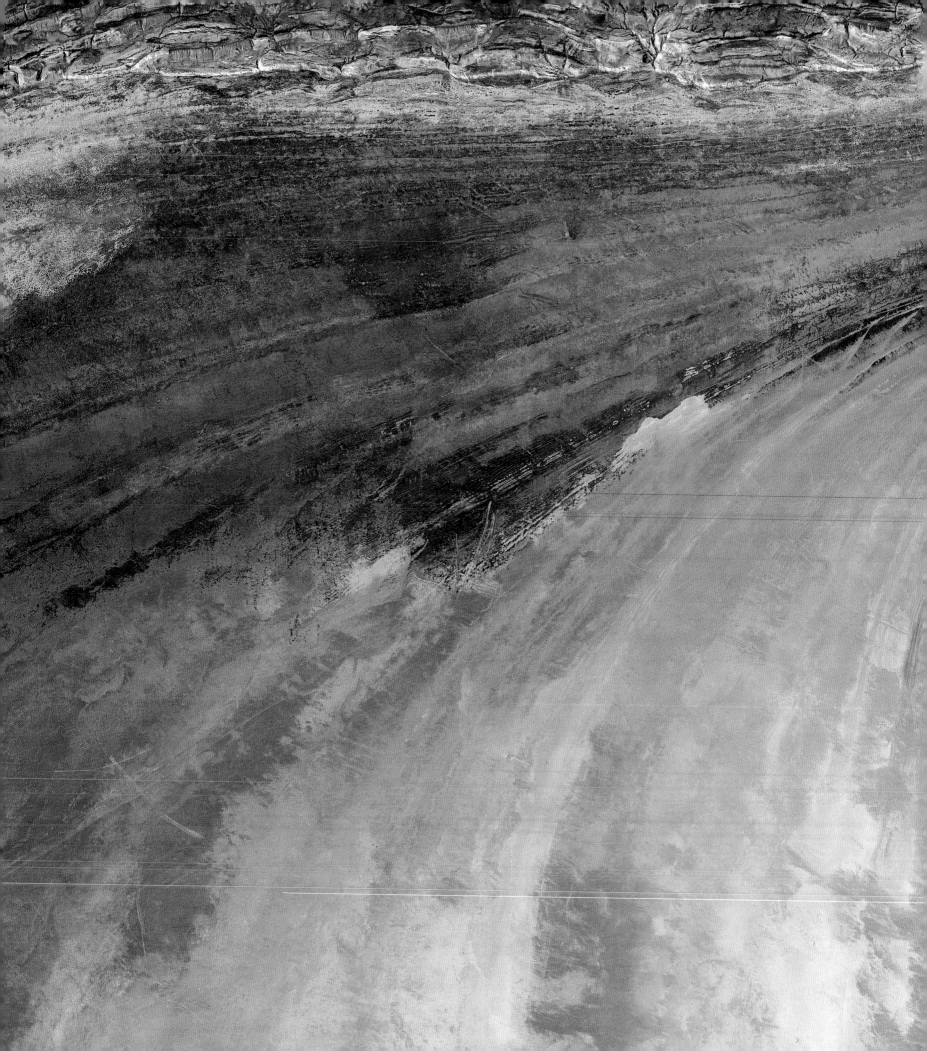

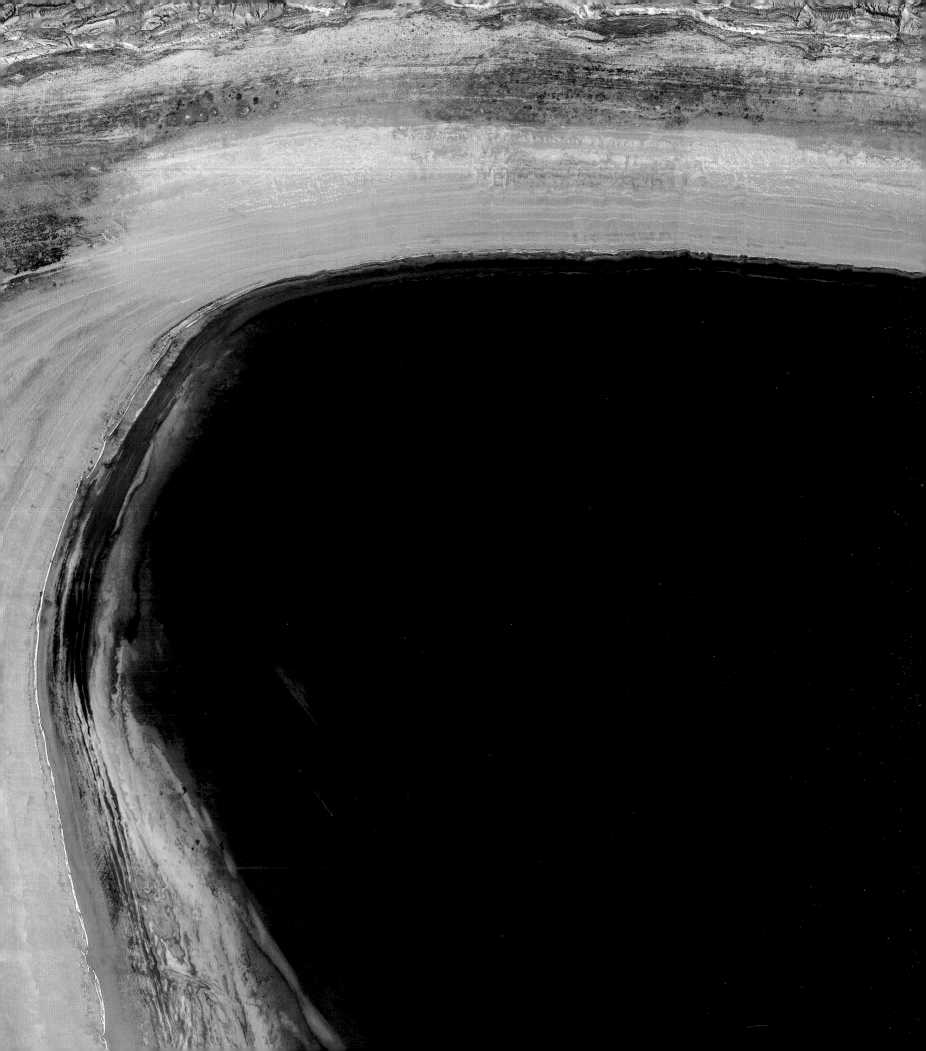

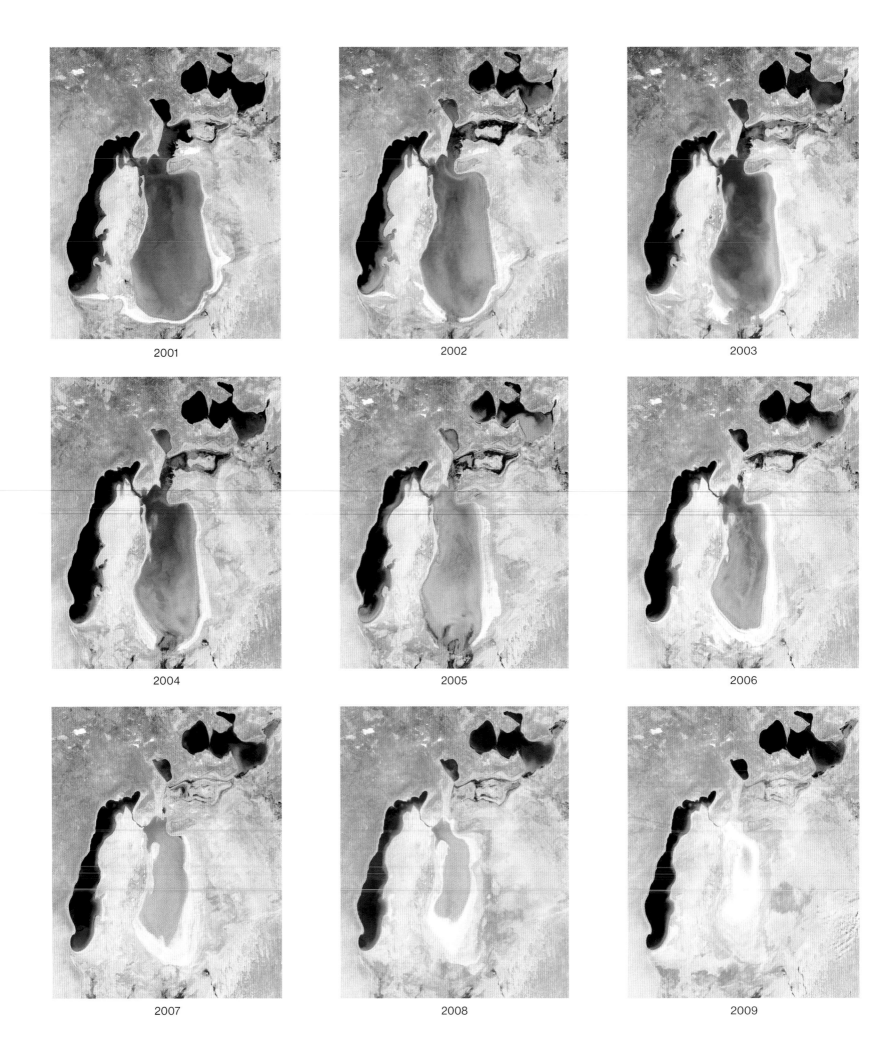

2001

2002

2003

2004

2005

2006

2007

2008

2009

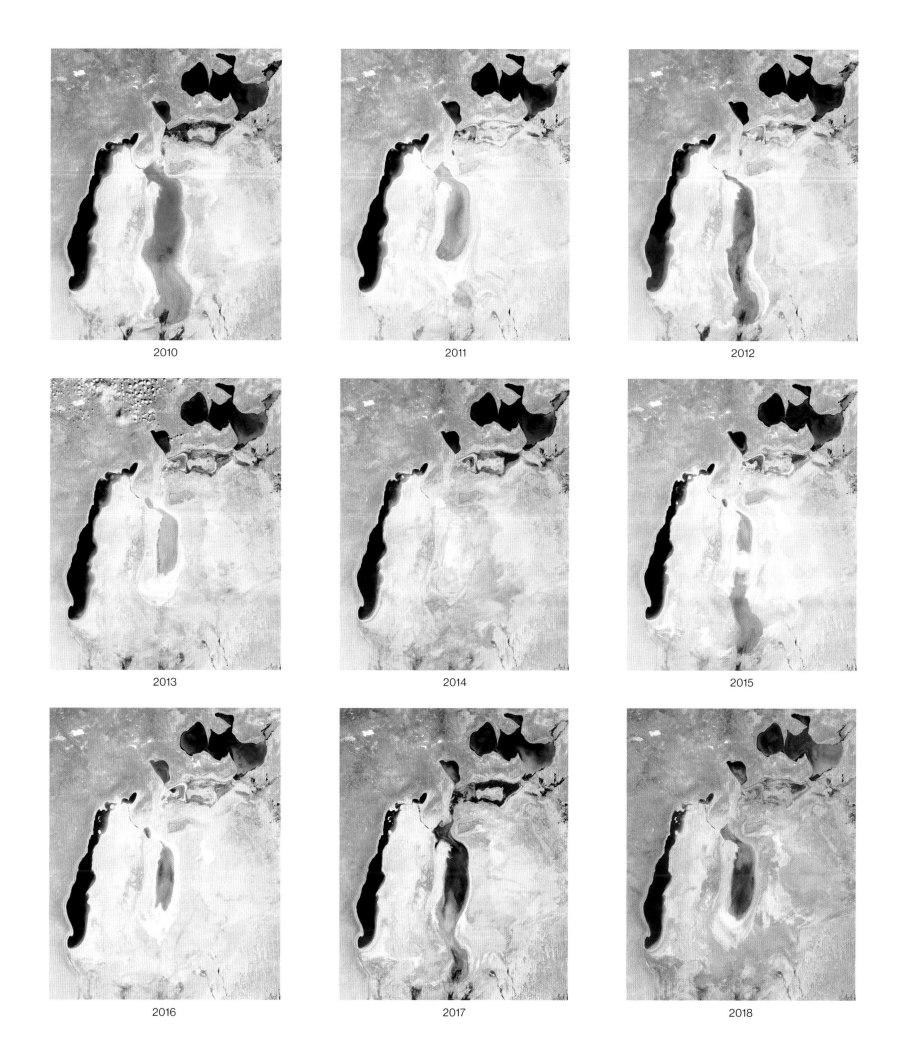

2010

2011

2012

2013

2014

2015

2016

2017

2018

## The Shrinking Aral Sea

PAGES 102–103
### Aral Sea East Basin
2019

—

Vast stretches of exposed seabed are visible in the area that was once the Aral Sea, effectively expanding the neighboring Aralkum desert. Due to water diversion projects described below, over 75 million tons of dust and poisonous salts now rise from the Aral Sea region into the atmosphere each year. These dust storms can grow as large as 250 miles (400 kilometers) long and 25 miles (40 kilometers) wide. Furthermore, the increased frequency of these events, combined with the chemicals that are released into the air from the exposed lakebed have raised concerns for the respiratory health of residents in the surrounding areas.

44.399981°, 58.334293°

PREVIOUS SPREAD
### Aral Sea Diversion
2001–2018

—

The Aral Sea, located on the border of Kazakhstan and Uzbekistan, was once the fourth largest lake in the world. Shown on the following spreads, annually from 2001 to 2018, water levels have been gradually decreasing over time as a result of irrigation projects that began in the 1960s to support agricultural development, primarily for cotton, in the adjacent Kyzylkum Desert (see below caption). By diverting the Syr Darya and the Amu Darya rivers, the Aral Sea has continued to evaporate without its primary sources of water replenishment. Due to the massive reduction of water levels, the region has experienced colder winters, hotter summers, and the complete devastation of its fishing industry.

44.906967°, 59.569799°

LEFT
### Kazakhstan Cotton Farming
2018

—

The Syr Darya, or Syr River, flows alongside and irrigates cotton fields roughly 500 miles (805 kilometers) away from the Aral Sea (see previous four pages). However, as the Aral Sea continues to disappear, the long-term prospects of cotton growth in the region have already begun to falter as the water source that made it possible in the first place dries up. By the late 1980s, the river diversion had proven to be effective as Uzbekistan became one of the world's largest exporters of cotton (they currently rank eleventh).

41.896400°, 67.947869°

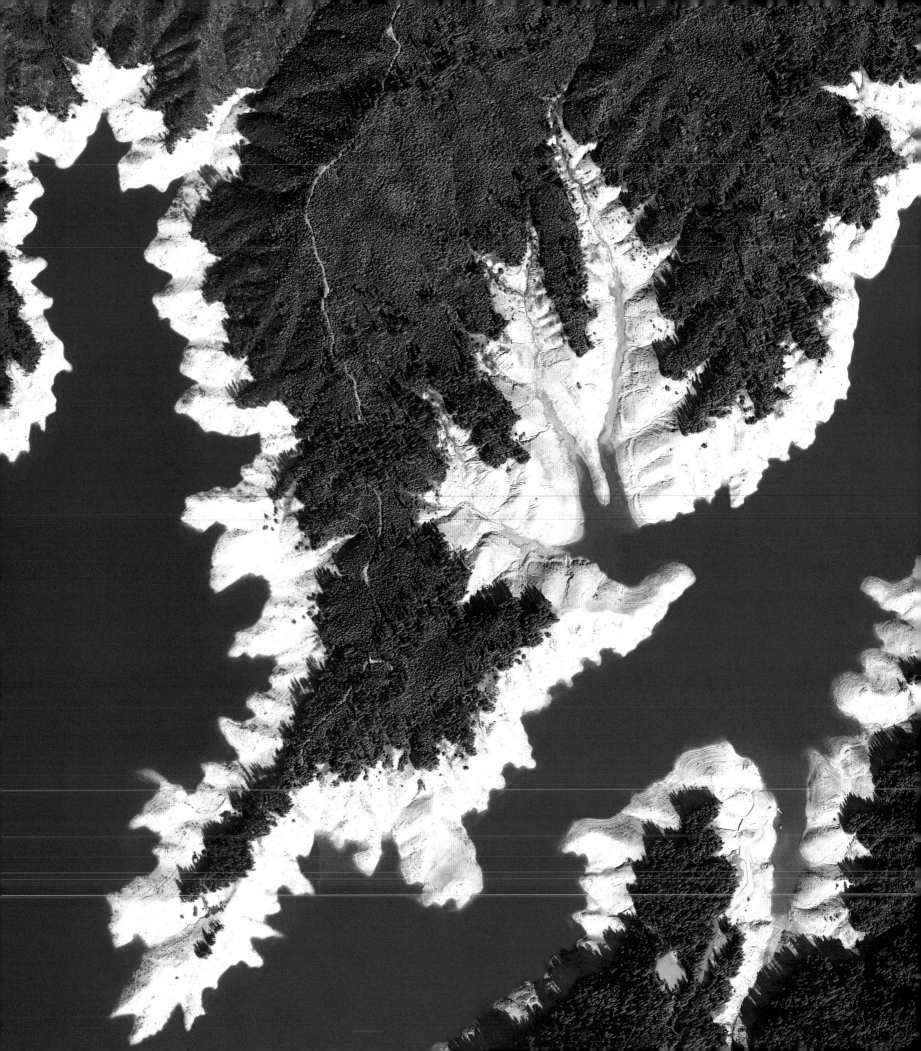

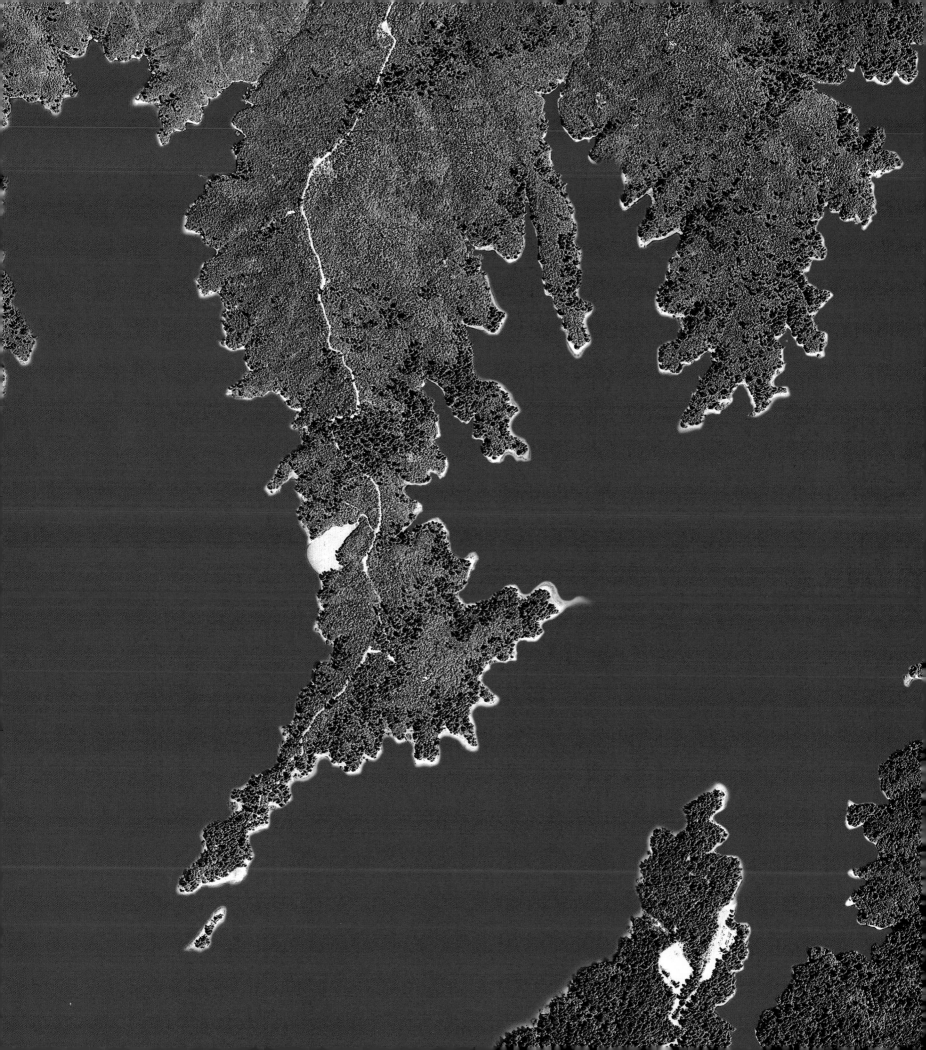

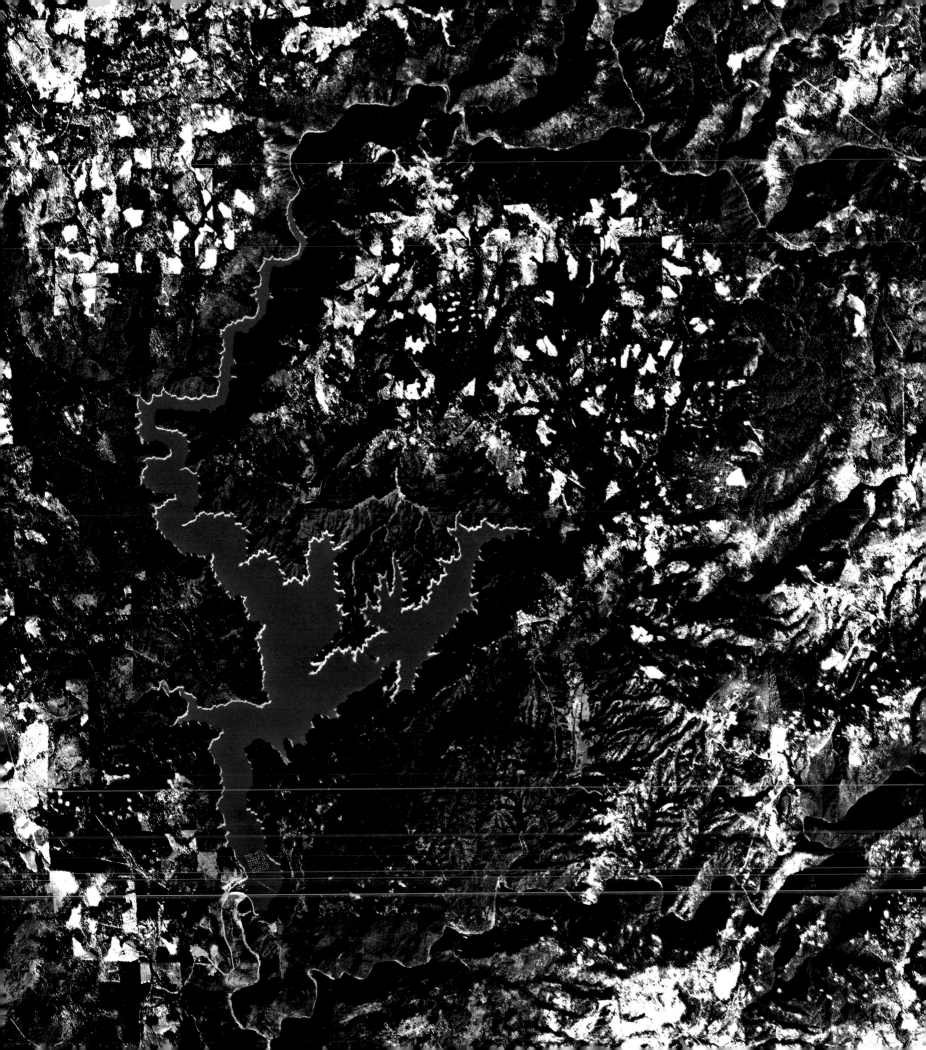

PREVIOUS SPREAD

**New Bullards Bar Reservoir
Drought Recovery**
April 2015 / May 2017

———

The New Bullards Bar Reservoir is located in Yuba County, California. Filled by rivers and snowmelt flowing from the Sierra Nevada mountain range, the reservoir has the capacity to hold a volume of water that is roughly half that of Mount Everest. In 2015, California experienced its lowest snowpack in at least 500 years, and the visible signs of that drought and the recovery that followed in 2017 can be seen in these before-and-after Overviews. The drought is reflected most obviously in this section of the reservoir's exposed (2015) and then submerged (2017) shoreline. To see how precipitation that aided in drought recovery caused other problems, see the Oroville Dam Spillway on page 205.

39.458387°, -121.191854°

LEFT

**Sierra Nevada Snowpack**
February 2019

———

A dense snowpack covers the Sierra Nevada mountain range in California after a year of intense snowfall. Through the month of February 2019, resorts in the mountains recorded as many as 543 inches (45.3 feet / 13.8 meters) of snow. The New Bullards Bar Reservoir (shown zoomed out at left and on the previous spread) is fed directly by snowmelt and streams running from these mountains. Globally, 1.9 billion people rely on the melting and downhill flow of water, sometimes called "natural water towers."

Water experts predict that with current and future pressures—including greater demand for drinking water and water for irrigation and industrial processes—these elevated regions will face potential supply issues. Additionally, future geopolitical tensions could affect water sources, especially when the bodies of water themselves intersect national boundaries. Above all, the most pressing threat to water supplies is climate change; a warmer planet will disrupt precipitation patterns, limit the storage capacity of glaciers, and create less volume in reservoirs.

39.460419°, -120.989563°

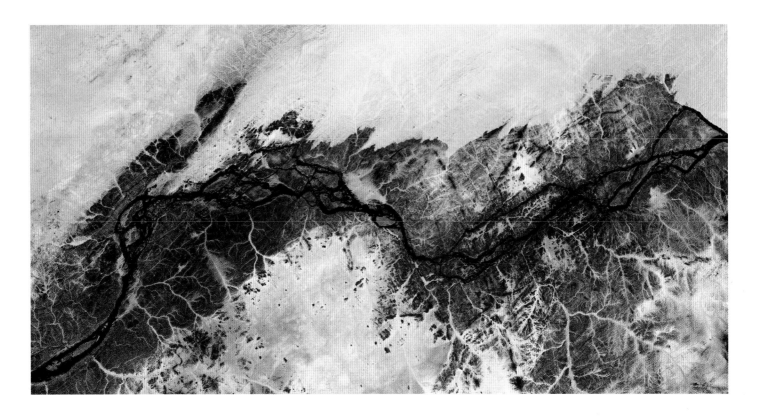

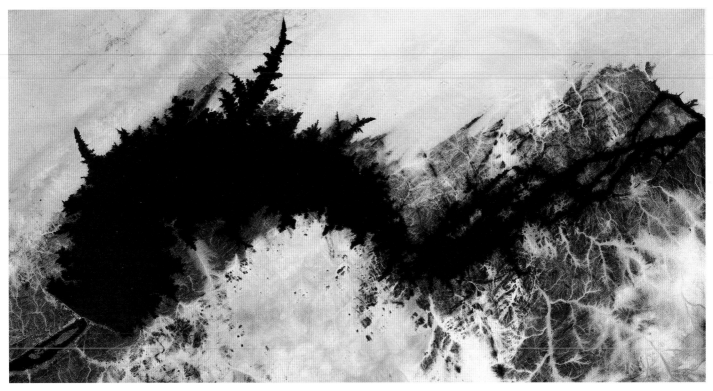

ABOVE AND OPPOSITE

**Merowe Dam Project**
2002 / 2019 / 2019

Built along the Nile River in Sudan, the Merowe Dam is the largest hydroelectric project in Africa. River diversion began in 2004, with construction finishing in 2009. Upon completion, the dam doubled Sudan's electricity supply. Because the dam backed up and expanded the flow of the river into a reservoir, the surface area of the Nile increased roughly 270 square miles (699 square kilometers) and displaced 70,000 indigenous people who relied on the land for farming. Due to the warm climate in the region combined with this increase in surface area, the reservoir is now experiencing evaporation losses of 396.3 billion gallons (1.5 billion cubic meters) of water every year, roughly 8 percent of the water allocated to Sudan from the 1959 Nile Waters Treaty.

18.668933°, 32.050127°

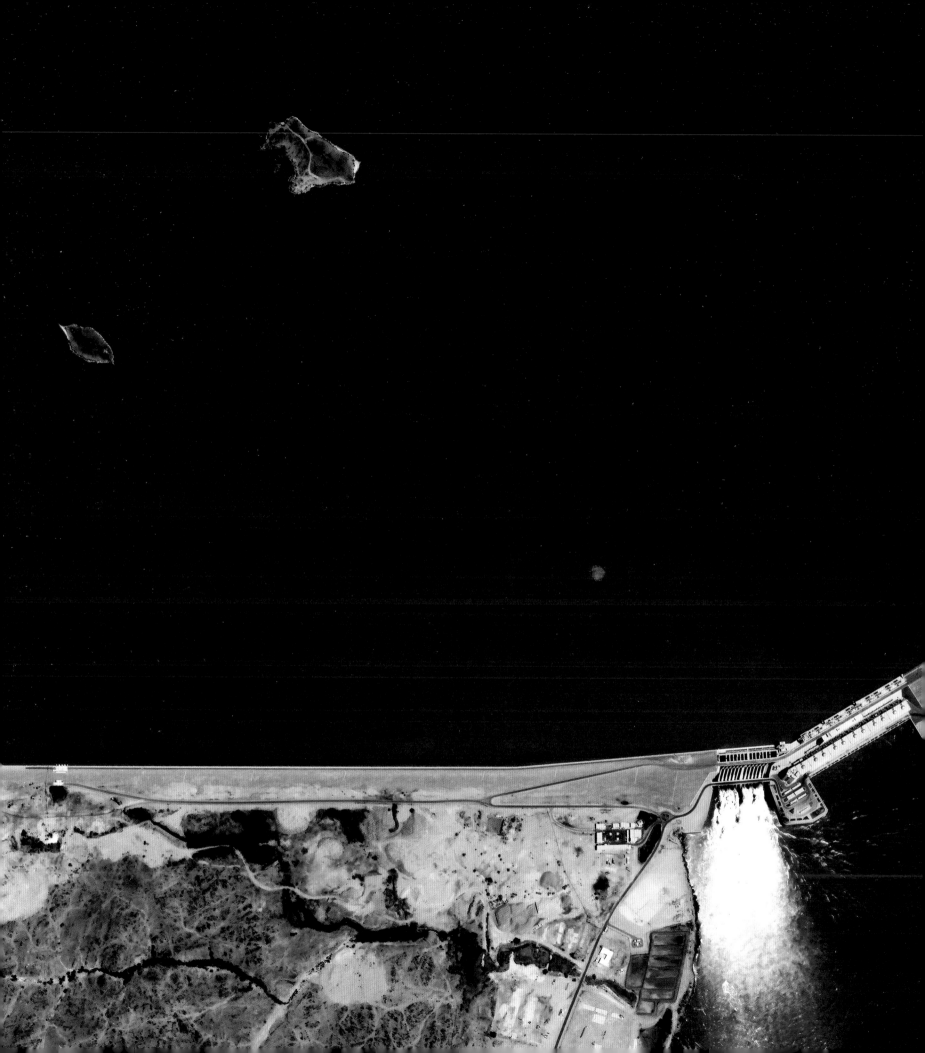

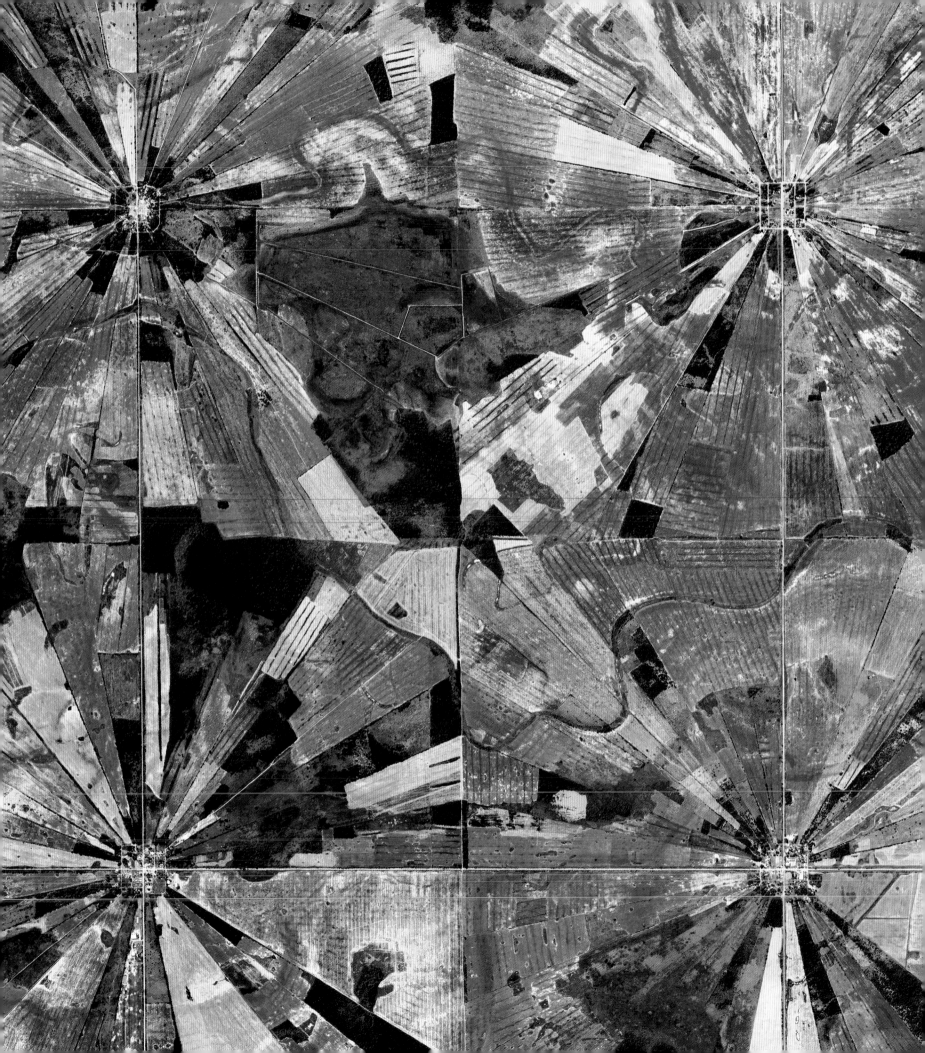

"Nature has introduced great variety into the landscape, but man has displayed a passion for simplifying it. Thus he undoes the built-in checks and balances by which nature holds the species within bounds."

— Rachel Carson

# Land

We spend most of our time, and build almost all of our settlements, on land. The cultivation of land for agriculture enabled our urbanization, and today, one-third of the world's population still makes its living from farming. While we will never be free from a dependence on food, we are increasingly removed from the processes of its production. Forty percent of Earth's deemed "usable" land is devoted to raising plants and animals to feed our growing population. Agriculture is responsible for 25 percent of all greenhouse gas emissions, an enormous share. Accordingly, the natural spaces that have been transformed to enable it are a major focus of this chapter.

Statistics about land use and emissions often fail to consider that, for much of the past few centuries, Earth's forests and trees—the best means of capturing and storing excess carbon from the atmosphere—have been cut down to increase the area where crops can be grown or animals can be raised. Deforestation continues, often at an alarming rate, in many of the world's still-forested regions. Further complicating this trend is the fact that not every area on Earth is subject to the same technology or policies when it comes to clearing and using land. The differences between these processes matter, as does what is (or is not) replanted when forests are destroyed. Burning is particularly concerning as trees, many of which have been absorbing the carbon emissions from our activities since the beginning of the industrial revolution, release their captured carbon, adding to the total amount in the atmosphere. In this chapter, you can visually compare multiple instances of deforestation to better understand varying methodologies and what might be the most sustainable way of moving forward.

With the global population expected to hit nearly 10 billion people by 2050, we must adopt new, long-term approaches to land use. A warming climate—and how it affects our food supplies—could present serious challenges as we try to feed our population. Additionally, we must consider that the environmental cost of producing certain foods is not equal. For example, the harmful environmental effects of raising cattle need to be more widely understood as the global demand for beef continues to grow. While food production will always be fundamental to our use of land, it also now offers an exciting opportunity to experiment with newer technologies like solar and wind energy that can transform otherwise unused areas, and even ones that are already functioning, into spaces that produce cleaner energy and food. As we move into the future, how and what we consume will continue to shape Earth's land.

OPPOSITE

**Deforestation in Bolivia**
2017

—

This Overview shows a deforested area of Santa Cruz, Bolivia. Since the mid-1980s, the resettlement of people from the high plains of the Andes Mountains and a corresponding agricultural development effort known as the Tierras Bajas project has led to utter deforestation in this region. The pinwheel-patterned fields are the result of a design called the San Javier resettlement scheme, with each pinwheel containing a central community that includes a church, bar/café, school, and soccer field. The light-colored areas of the formations are primarily fields of soybeans, and the dark lines running through the fields are structures known as windbreaks that prevent the erosion of the area's unusually fine soil.

-16.685360°, -62.859360°

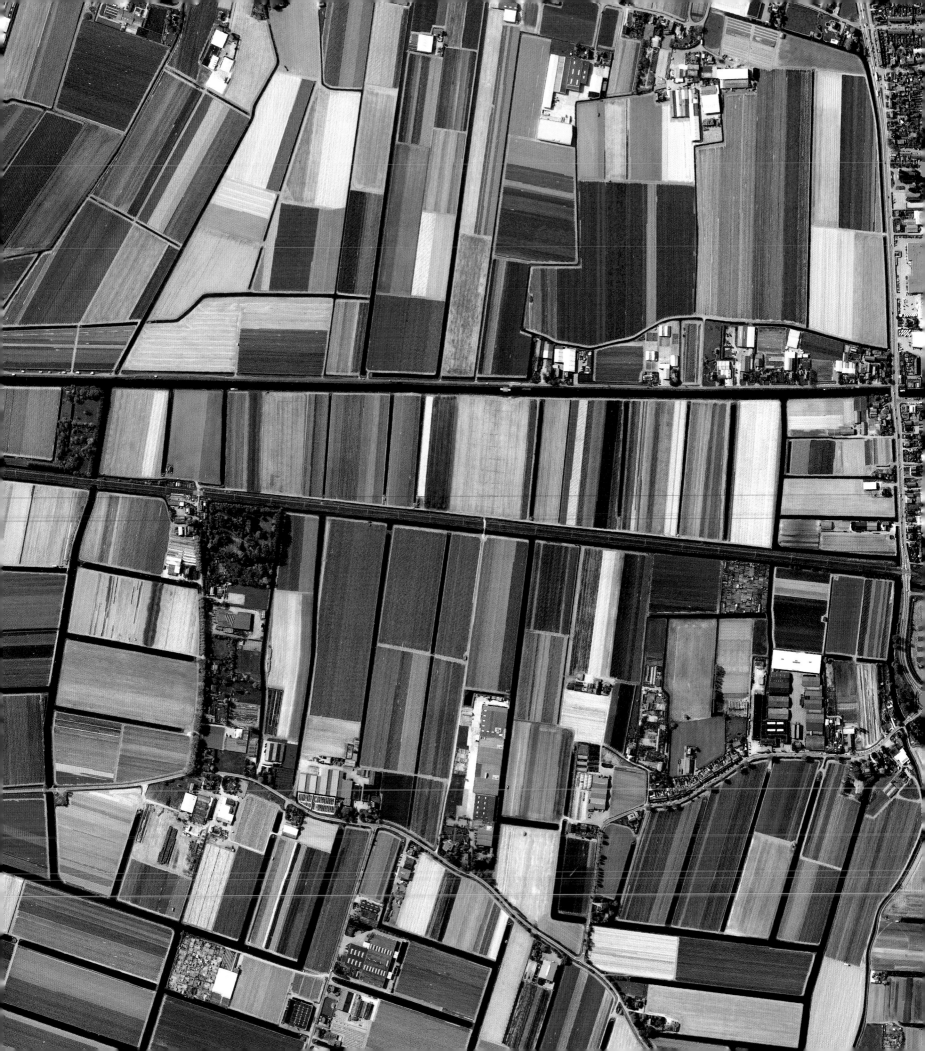

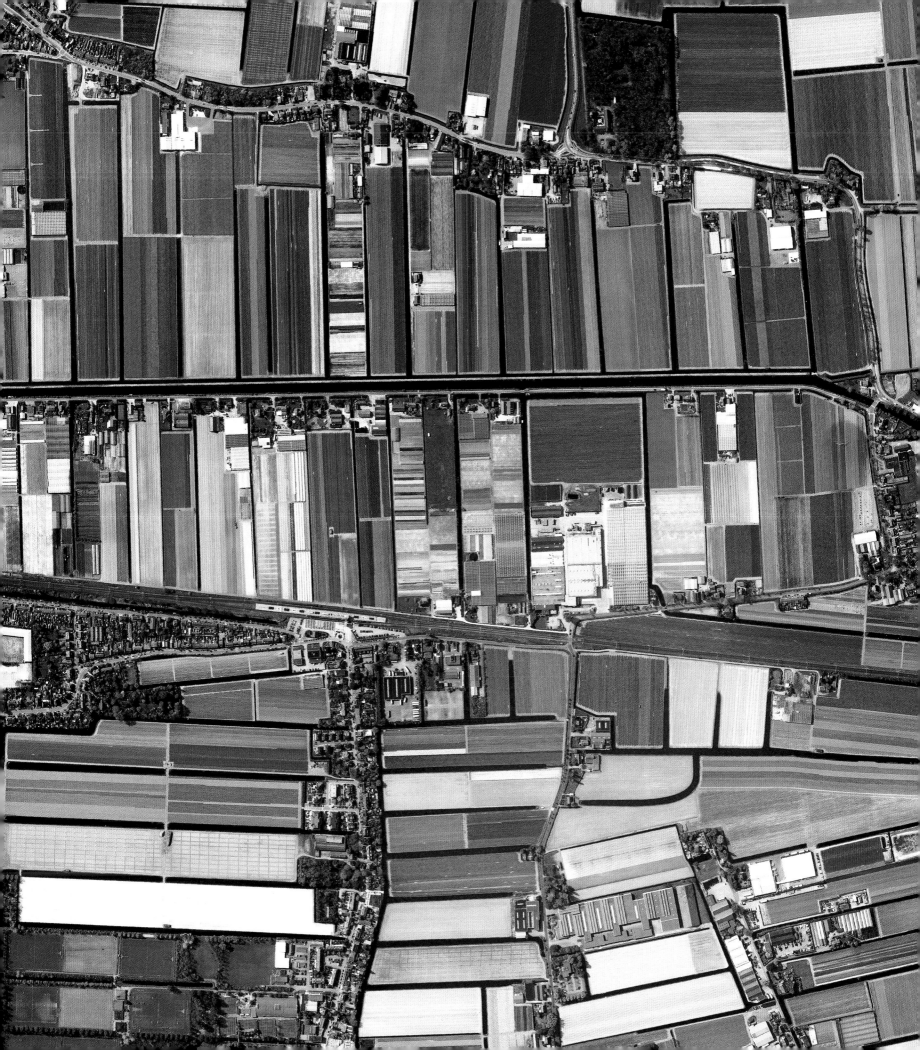

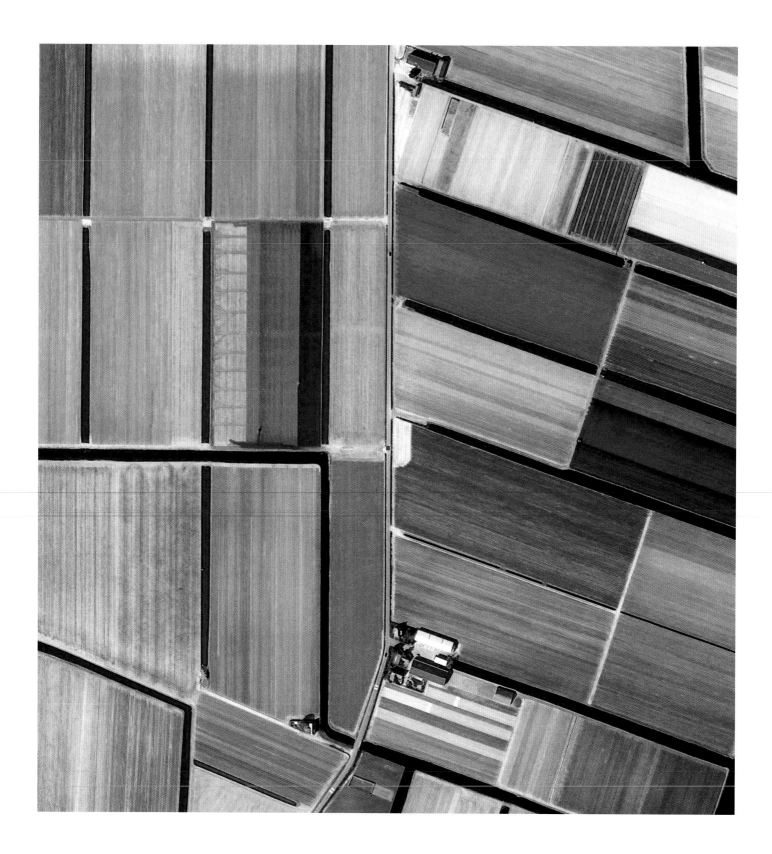

**Blooming Dutch Tulips**
March / April

————

The tulip fields in Lisse, Netherlands, bloom in the spring each year. The colorful transformation of the fields between the months of March and April is visible here. A larger section of tulip fields and agricultural development is seen on the previous page. Approximately two-thirds of all the world's flower bulbs and nine out of every ten tulips are exported from the Netherlands. The Dutch are also top exporters of tomatoes, peppers, cucumbers, and pineapples, none of which they consume in great quantities domestically.

52.276355°, 4.557080°

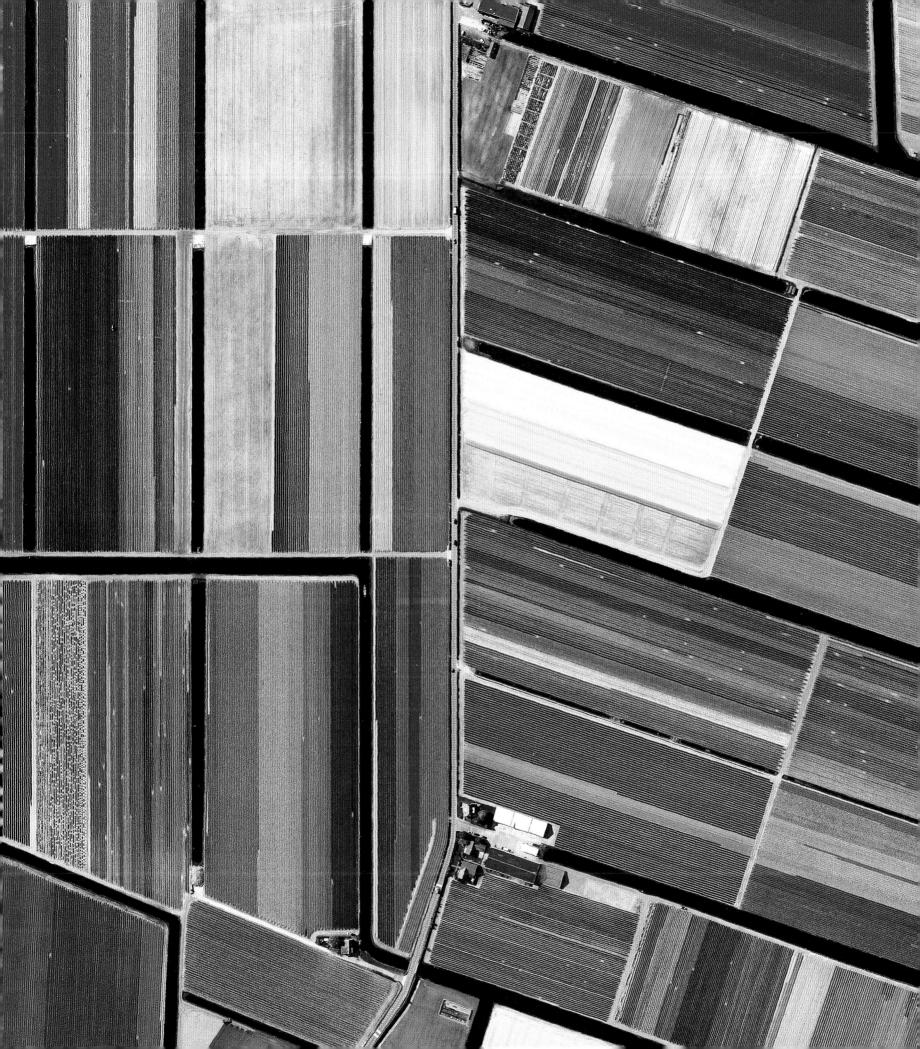

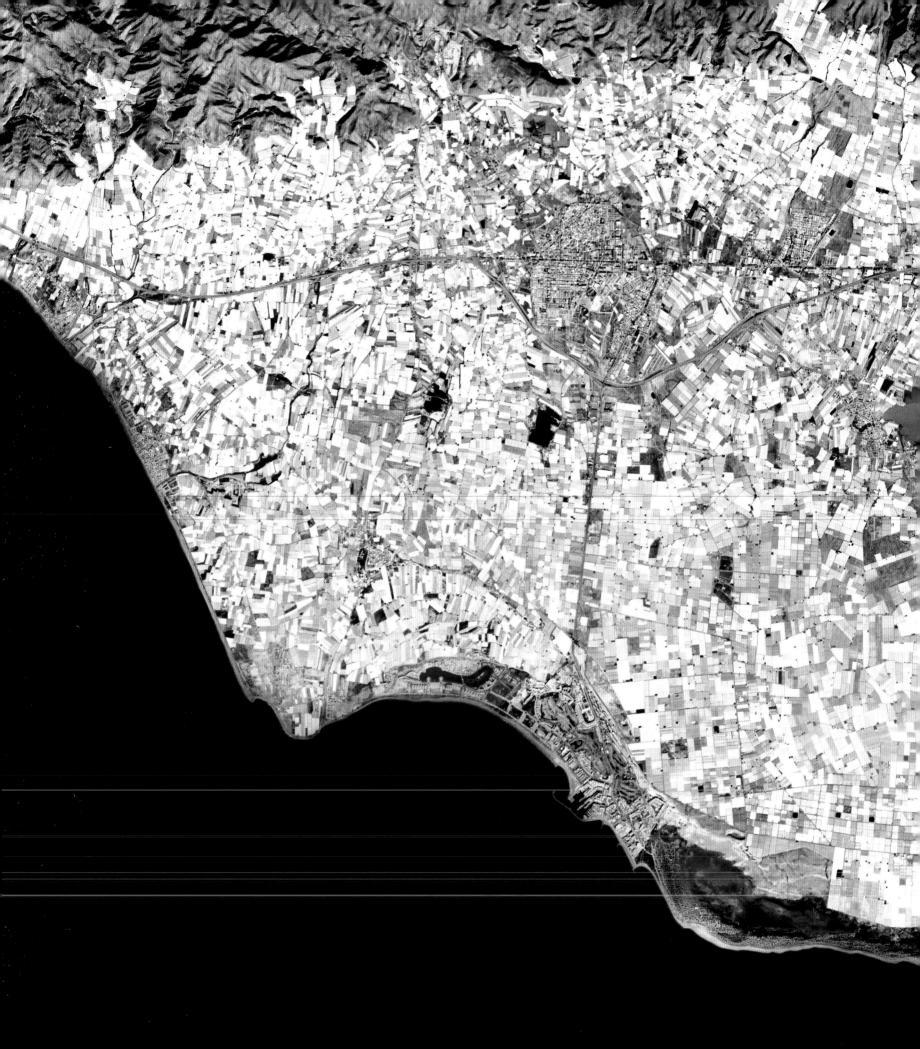

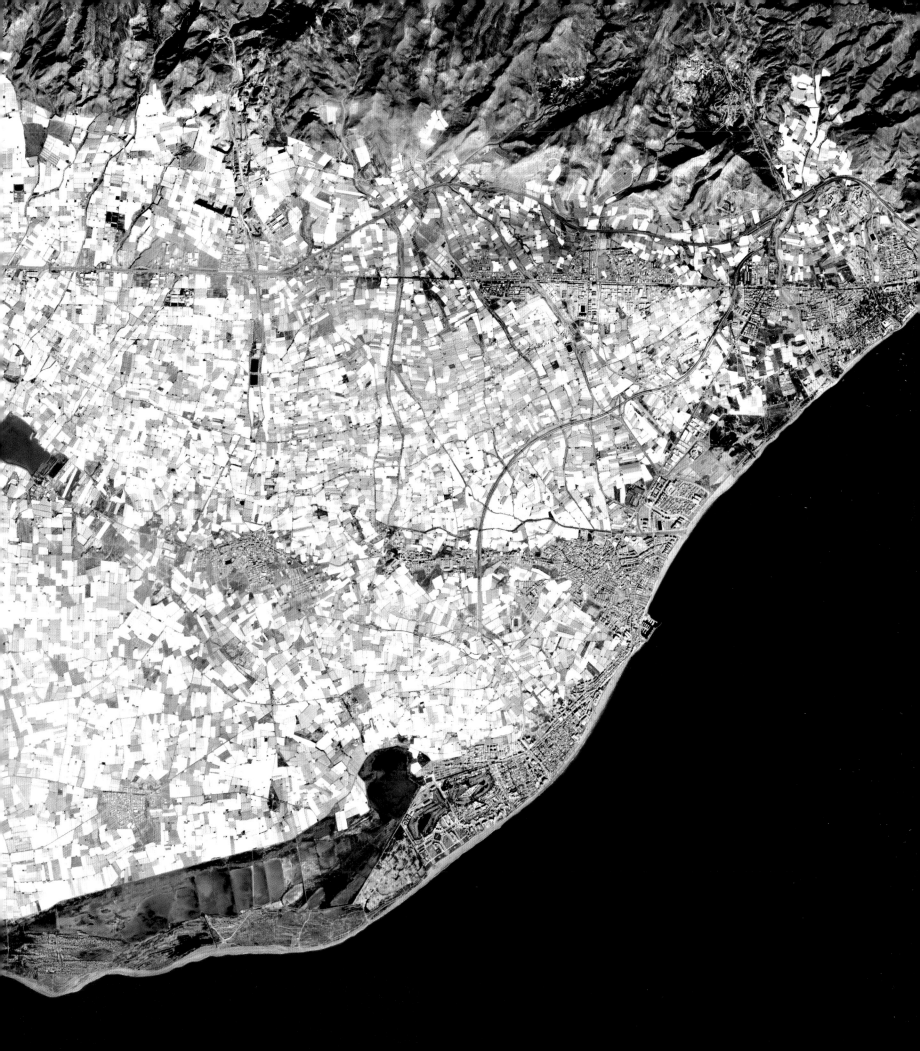

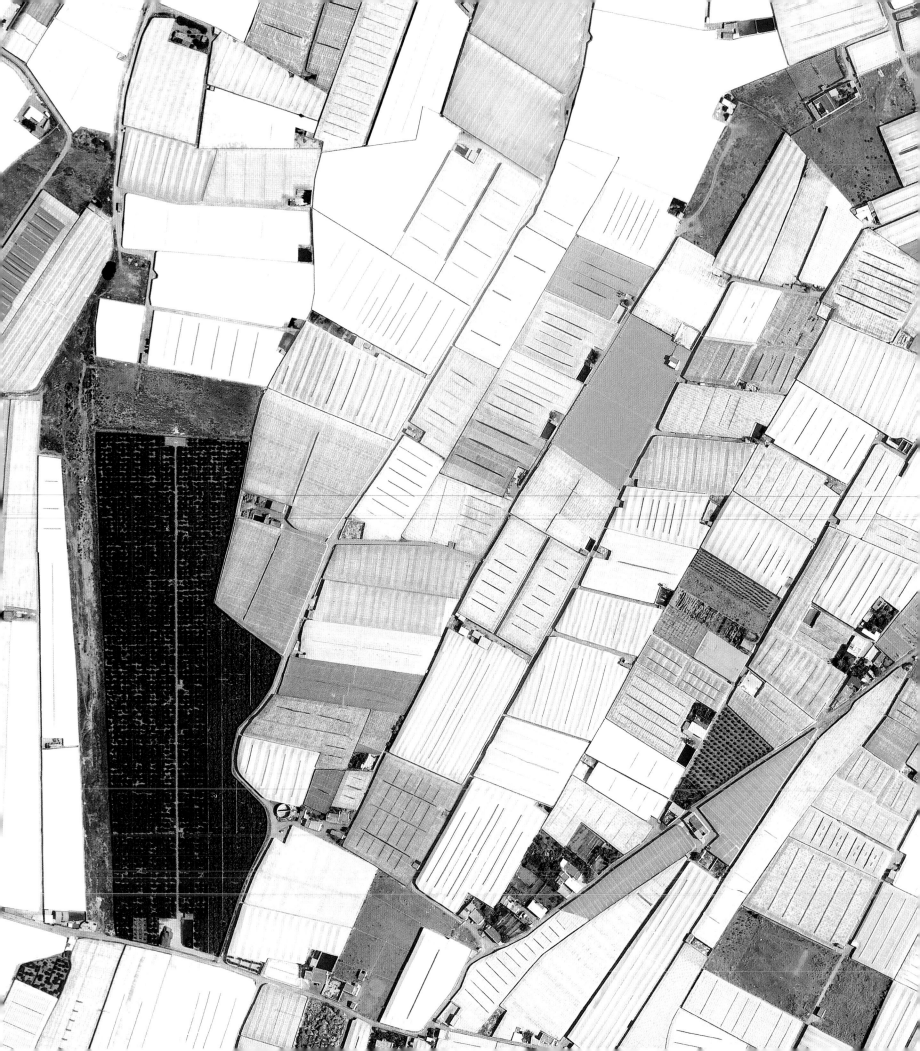

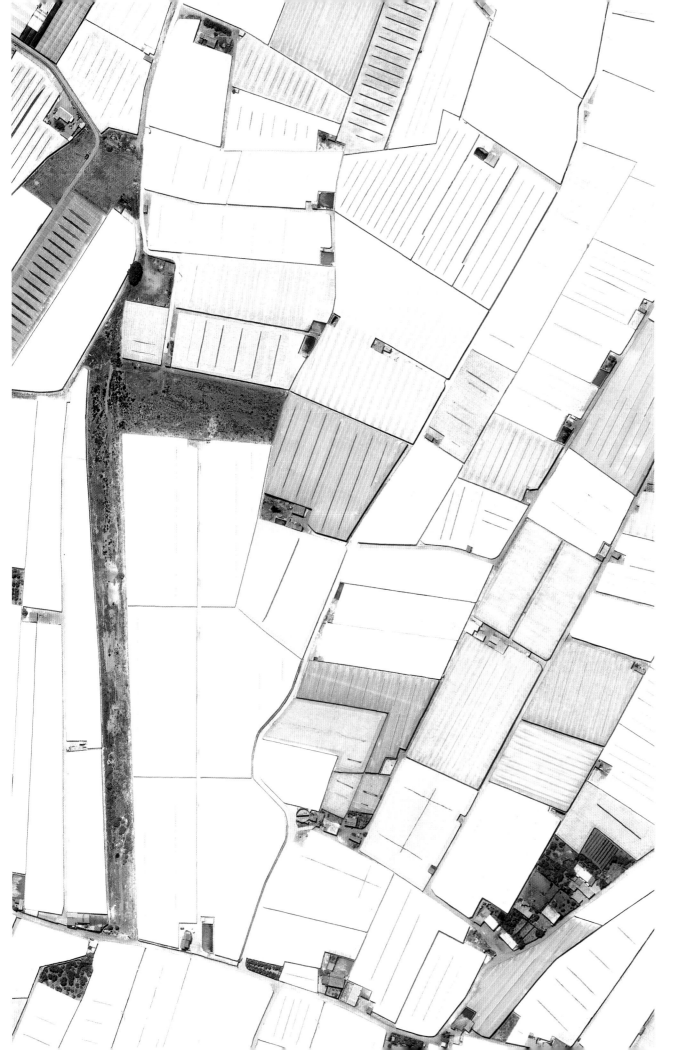

PREVIOUS SPREAD, OPPOSITE, AND LEFT

**Greenhouse Construction**
2011 / 2019

A field of crops in Almeria, Spain, is covered by a greenhouse in the time between 2011 and 2019. The first Overview provides an understanding of what exists beneath all of the surrounding roofs. In total, greenhouses in this area cover approximately 75 square miles (194 square kilometers) of land. More than half of Europe's fresh fruits and vegetables are produced here. The use of plastic coverings (known as "plasti-culture") is designed to increase produce yield and size, and shorten growth time.

36.753993°, -2.874187°

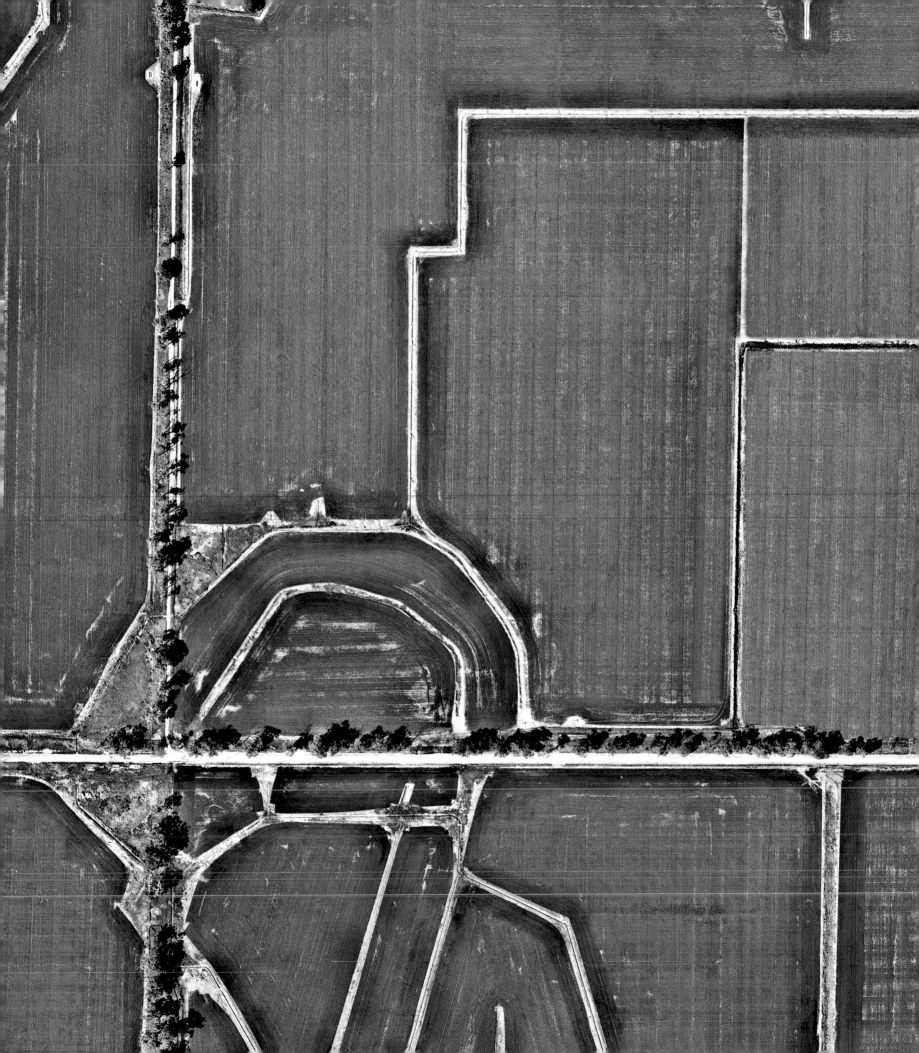

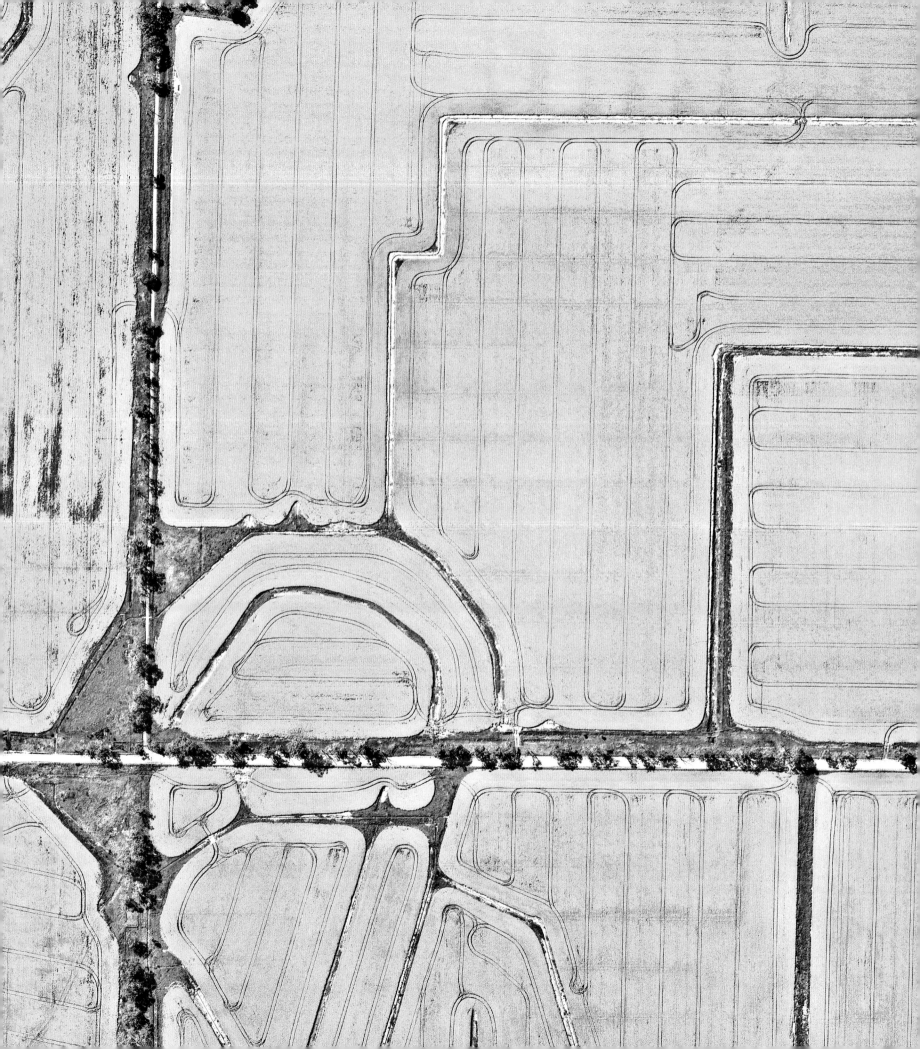

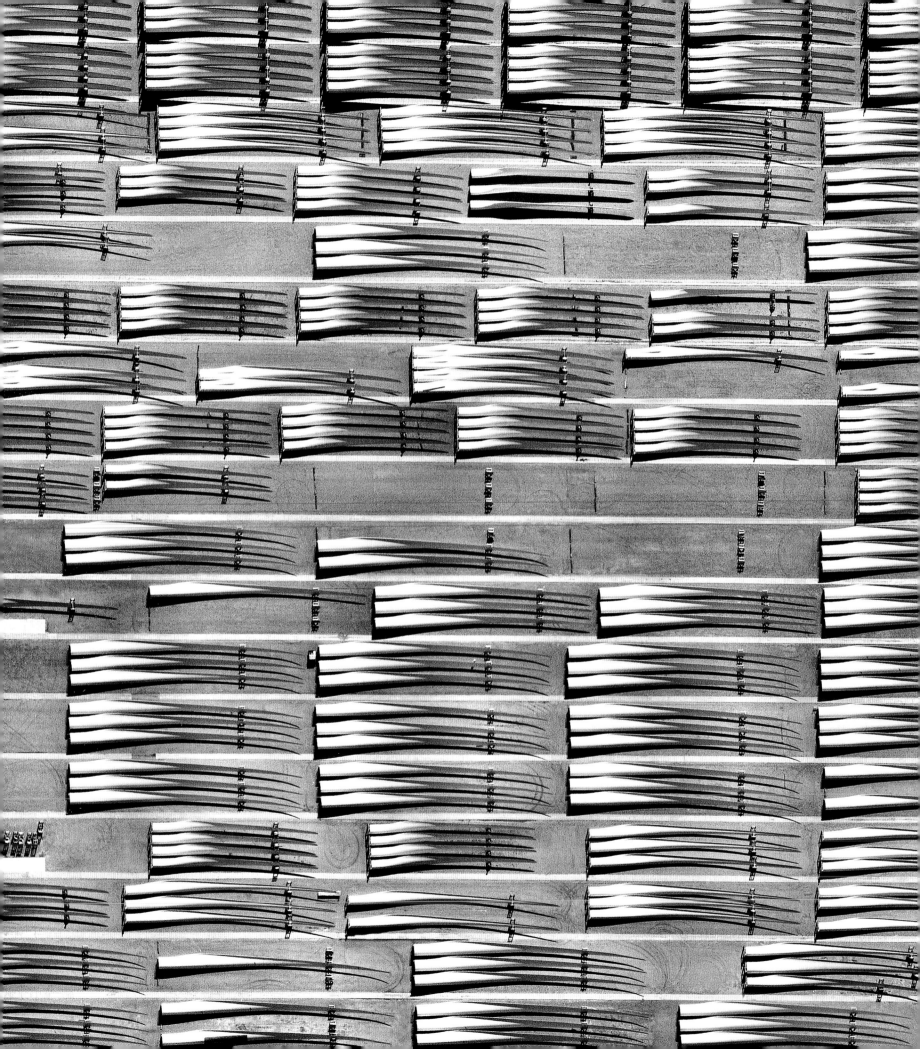

PREVIOUS SPREAD

**Blooming Canola Flowers**
August / September

Canola flower fields cover the landscape and bloom in Cocoroc, Australia. The crop is grown for the production of its oil, which is extracted by slightly heating and then crushing the flower seeds. Primarily used as a source of biodiesel and a key ingredient in many foods, canola is Australia's third biggest crop. Canola is also used by wheat farmers as a break crop, meaning it is grown to interrupt the repeated planting of other crops and to improve soil quality.

-37.943141°, 144.649480°

OPPOSITE

**Wind Farm Turbine Factory**
2016

———

Blades for wind turbines are seen here, grouped together at a manufacturing facility in Little Rock, Arkansas. Individual blades are transported from this facility to wind farms on top of trucks and then assembled on-site. Turbines like these, manufactured by General Electric, are delivered to wind farms like the one seen at right. For a sense of scale, the longest blades here are 350 feet (107 meters) long, or 1.3 times the length of a New York City block.

44.590278°, 28.565278°

RIGHT

**Fântânele-Cogealac Wind Farm**
2018

———

The Fântânele-Cogealac Wind Farm in Romania is the largest onshore wind farm in Europe. The facility is constructed in the midst of canola fields (see previous spread). In total, it has 240 operational turbines constructed with blades like the ones seen at left that generate approximately 10 percent of the country's renewable energy production. When wind blows against the blades of a wind turbine, they slowly rotate. The blades are connected to a drive shaft on the top of the turbine that turns a generator, thereby producing electricity that is carried through underground cables to each site's substation. The turbines operate independently of one another, and each has an internal computer that constantly calculates wind speed and direction. The top of the turbine and its blades can rotate a full 360 degrees; the computer can also change the pitch of the blades to always face into the wind and position them for optimal energy creation.

34.712103°, -92.185479°

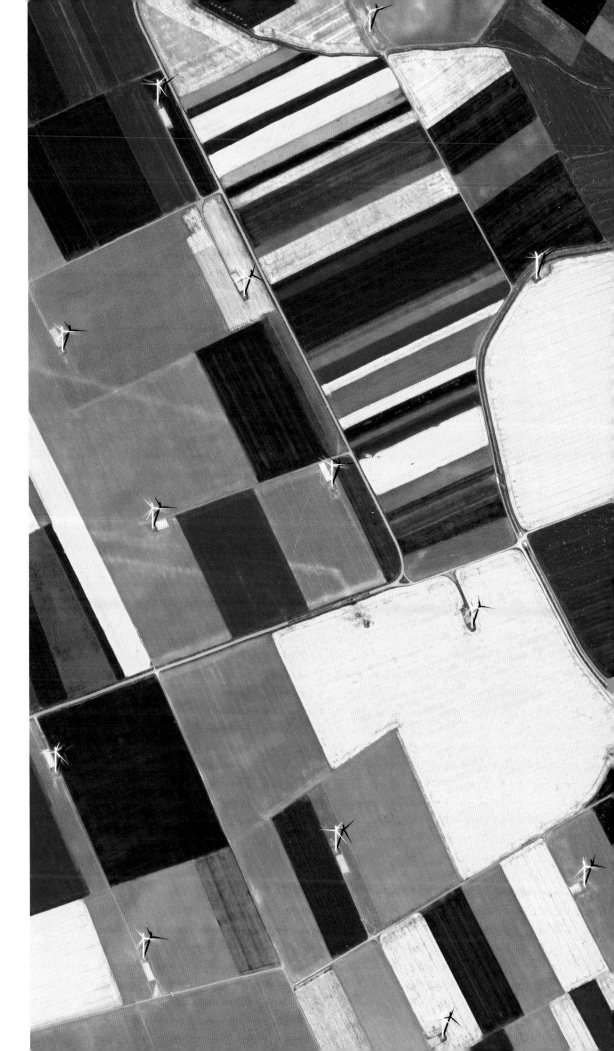

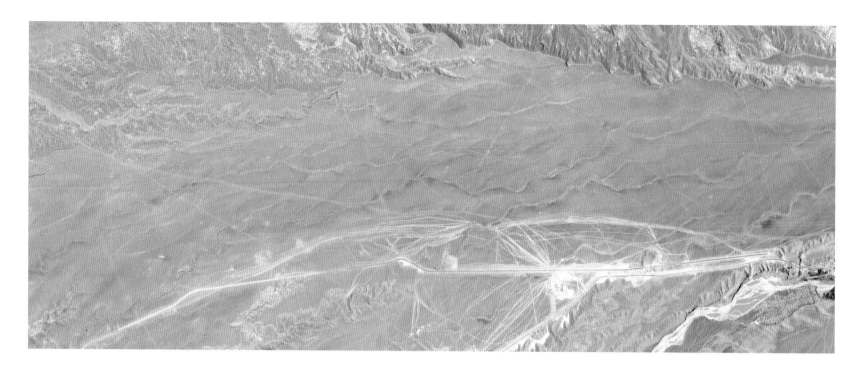

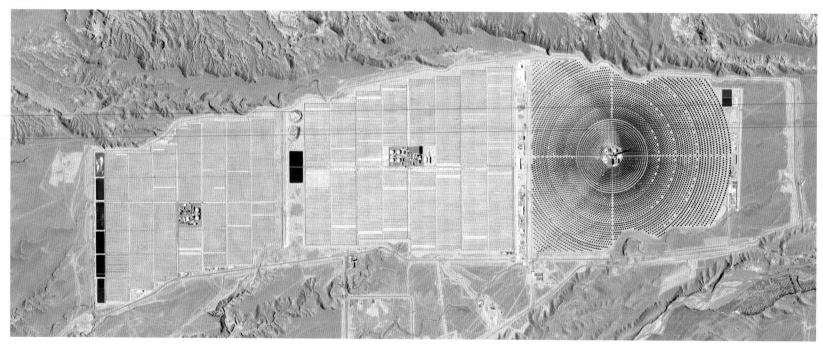

ABOVE

## Ouarzazate Solar Power Station Construction
2009 / 2018

The Ouarzazate Solar Power Station is a multiphase solar power complex located in Ouarzazate, Morocco. As of 2020, it is the world's largest concentrated solar power plant, with an energy capacity of 510 megawatts. Starting in May 2013, the project was constructed in three distinct phases (Noor I, II, and III) that have continued to increase its production and storage over time. Noor I and II are built with parabolic troughs (the rectangular sections seen at left above) that function by concentrating solar energy to heat up oil to a temperature around 752°F (400°C). Once the oil is heated, it transfers thermal energy to water, ultimately producing pressurized steam. This steam then drives a turbine which converts mechanical energy into electricity through a generator.

30.994401°, -6.863301°

OPPOSITE

## Noor III Solar Concentrator
2018

Noor III is the newest stage of the Ouarzazate power station that utilizes a concentrated solar power (CSP) tower design. This design uses 7,400 heliostat mirrors to focus the sun's thermal energy toward the top of a 820-foot-high (250 meters) tower at its center. At the top of the tower, there is molten salt, which is used in this process due to its ability to get very hot (500–1022°F / 260–550°C). The molten salt then circulates from the tower to a storage tank, where it is used to produce steam and generate electricity. The Noor III CSP tower can produce and then store enough energy to provide continuous power with no sunlight for ten days.

30.994401°, -6.863301°

2018

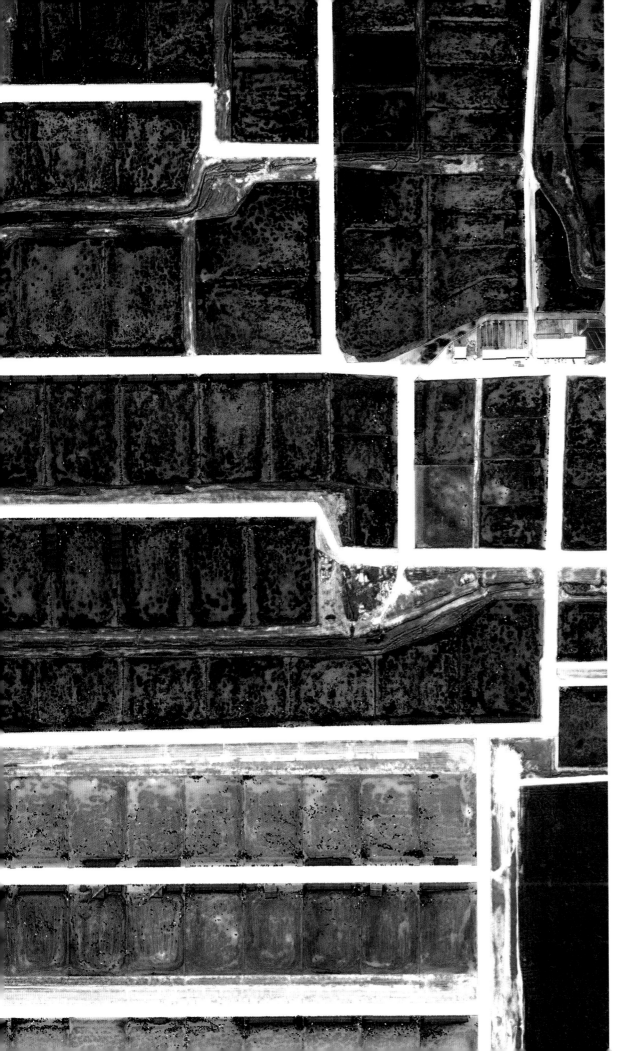

PREVIOUS SPREAD AND LEFT

**Cattle Feedlot Expansion**
2011 / 2018

⸻

Over the course of the 2010s, the Fort Kearney Consolidated cattle feedlot in Minden, Nebraska, underwent a significant expansion to increase the capacity of the facility. Most visibly, a large basin was built to hold the waste and manure generated by its cows. The full extent of the expanded facility is seen here in 2018. Feedlots are destinations for cattle once they reach a weight of 650 pounds (295 kilograms). At that point, they are moved to these facilities and placed on a strict diet of specialized animal feed. Over the next three to four months, the cows gain up to 400 pounds (181 kilograms) before they are shipped off to slaughter.

In total, roughly one-quarter of Earth's land is used for livestock grazing and one-third of the planet's arable land is occupied by crops cultivated to feed the animals. The cultivation of beef is particularly harmful as it accounts for more greenhouse gas emissions than any type of food. In particular, the deforestation required to create space for pastures, the amount of water needed to produce beef (1800 gallons per pound), and the greenhouse effects of methane emitted by the animals while grazing, make beef one of the least sustainable means of feeding people.

40.604295°, -98.930377°

## Deforestation

Deforestation is often a necessary part of land usage; agriculture, urbanization, and logging, among other activities, require clearing away trees to make use of the land. Yet the methods for doing so vary significantly across the world. Each method presents its own challenges and consequences. As we aspire to move towards more sustainable land use, we can look at various methods from around the world to understand how each approach affects the health of the planet.

ABOVE AND OPPOSITE

**Amazon Rainforest Slash and Burn**
2014 / 2016

The effects of "slash and burn" agriculture can be seen in the rainforest of Mato Grosso, Brazil. In this method of deforestation, the trees are cut down and left to dry before the ground is burned, resulting in a rich layer of ash that creates fertile soil for farming. The Amazon rainforest acts as one of the world's largest "carbon dioxide sinks," absorbing excess carbon from the atmosphere. However, when the trees are burned, they release the carbon they have absorbed to date, thereby accelerating atmospheric levels of $CO_2$. With drier climates and warmer temperatures, burns often become uncontrollable and lead to longer-lasting fires that result in dangerously poor air quality for those living in the surrounding areas.

-14.012800°, -54.932000°

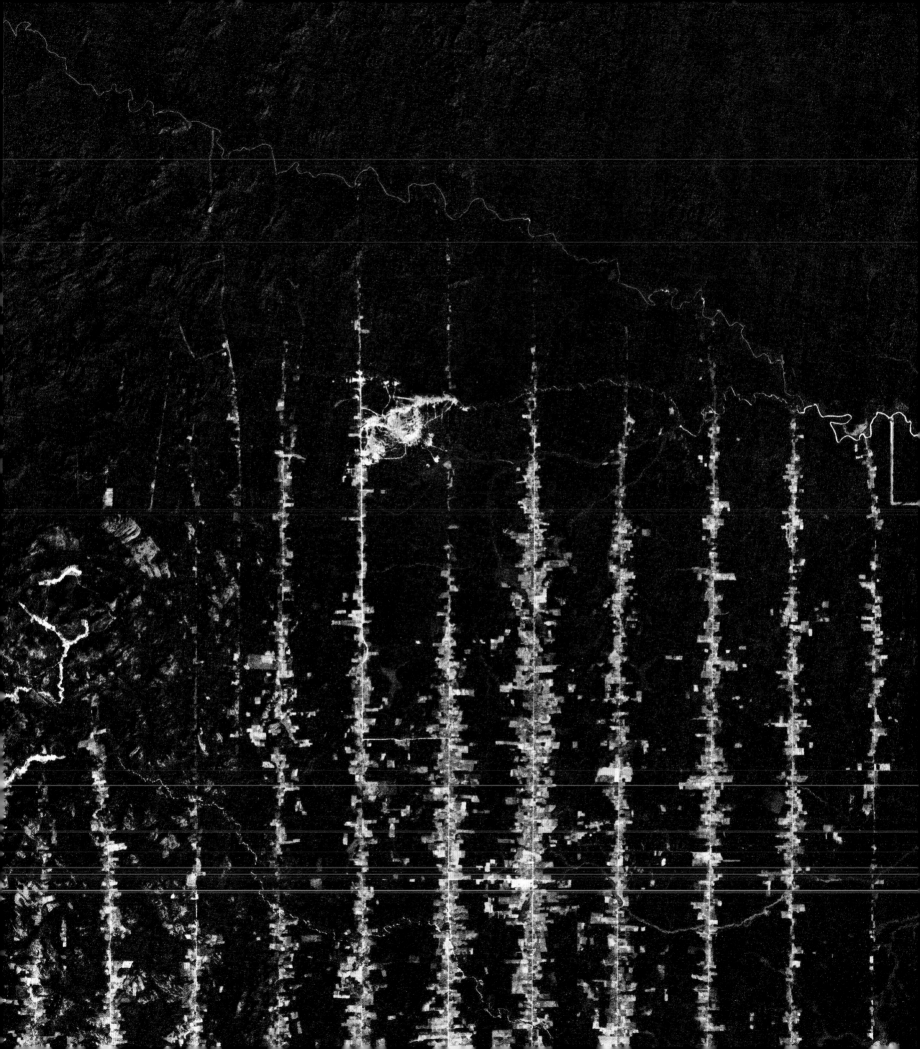

PREVIOUS PAGE

**Amazon Rainforest Deforestation**
1989 / 2019

———

The state of Rondônia in western Brazil has become one of the most deforested parts of the Amazon rainforest. Once home to 80,000 square miles (207,199 square kilometers) of forest, the past three decades have seen rapid clearing and degradation. By 2003, an estimated 26,000 square miles (67,340 square kilometers) of rainforest—an area larger than the state of West Virginia—had been cleared. That devastation continued in the following decades and was greatly exacerbated by the Amazon fires of 2019. At one point during the year, 76,000 fires were burning simultaneously, with many ignited for purposeful deforestation, destroying roughly 7,200 square miles (18,648 square kilometers) of forest.

-9.937550°, -63.425200°

RIGHT

**Rondônia Deforestation Pattern**
2018

———

The clearing pattern in this Overview took one of the most common deforestation trajectories in the Amazon region. First, legal and illegal roads penetrate a remote part of the forest, and farmers soon migrate to the area. Farmers claim land along the road and begin to clear trees for crops. Within a few years, heavy rains and erosion deplete the soil, and crop yields begin to fall. The farmers then convert the degraded land into pasture for cattle (a cattle feedlot is seen at the right) and clear more forest for crop growth. Eventually the small landholders, having cleared much of the land they claimed, sell it or abandon it to cattle holders, who consolidate the plots into large areas of pasture. Mining operations, which extract raw materials like gold, tin, and bauxite, are also visible at right.

-9.753523°, -62.793919°

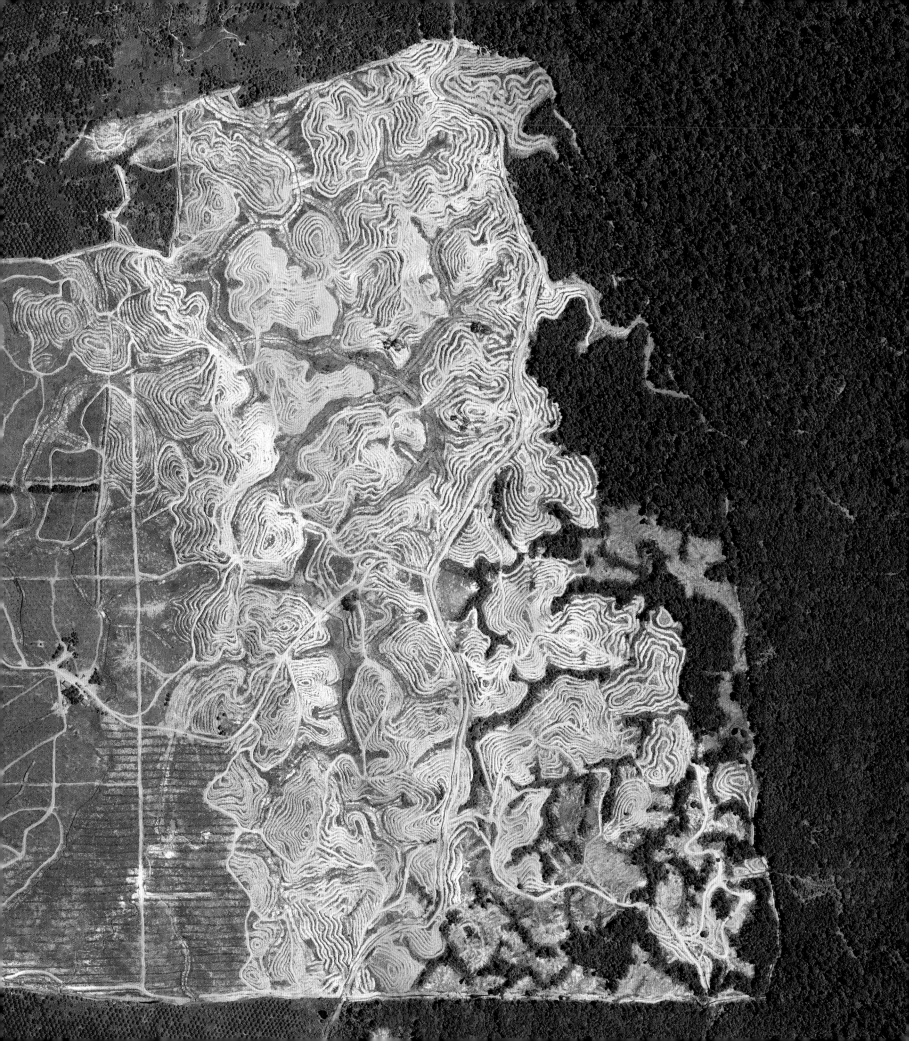

PREVIOUS PAGE

## Sumatra Deforestation

2016 / 2018

———

Deforestation for palm oil production can be seen in the forest of Sumatra, Indonesia. The images show 4.25 square miles (11 square kilometers) of natural peatlands and dense forests within the Leuser Ecosystem being cleared for the recent planting of palms. The trees are cultivated in terraces cut into the contours of hills to avoid erosion caused by streaming water. This region is one of the last known places where Sumatran orangutans, elephants, tigers, and rhinos coexist in the wild, and it is home to more than 200 mammal and 500 bird species. When the thick, native forests are cleared for the planting of relatively spread-out palm trees, ecosystems collapse, and net carbon emissions rise significantly.

3.985230°, 98.032040°

RIGHT

## Sumatra Palm Oil Plantation

2019

———

A massive palm oil plantation—13 square miles (34 square kilometers) is visible here—covers the landscape in Sumatra. A common layout is employed, with houses for plantation workers centrally located within the palms. In recent decades, Indonesia has become one of the world's largest exporters of palm oil (which is used primarily as a cooking ingredient), shipping nearly 35 million tons (31.8 million metric tons) of it per year. Land use change, driven by the palm industry, in Indonesia and Malaysia emits roughly 500 million tons (453.6 million metric tons) of carbon dioxide annually, accounting for 1.4 percent of global $CO_2$ emissions. This amount is higher than the greenhouse gas emissions from the entire state of California.

-2.213380°, 100.905640°

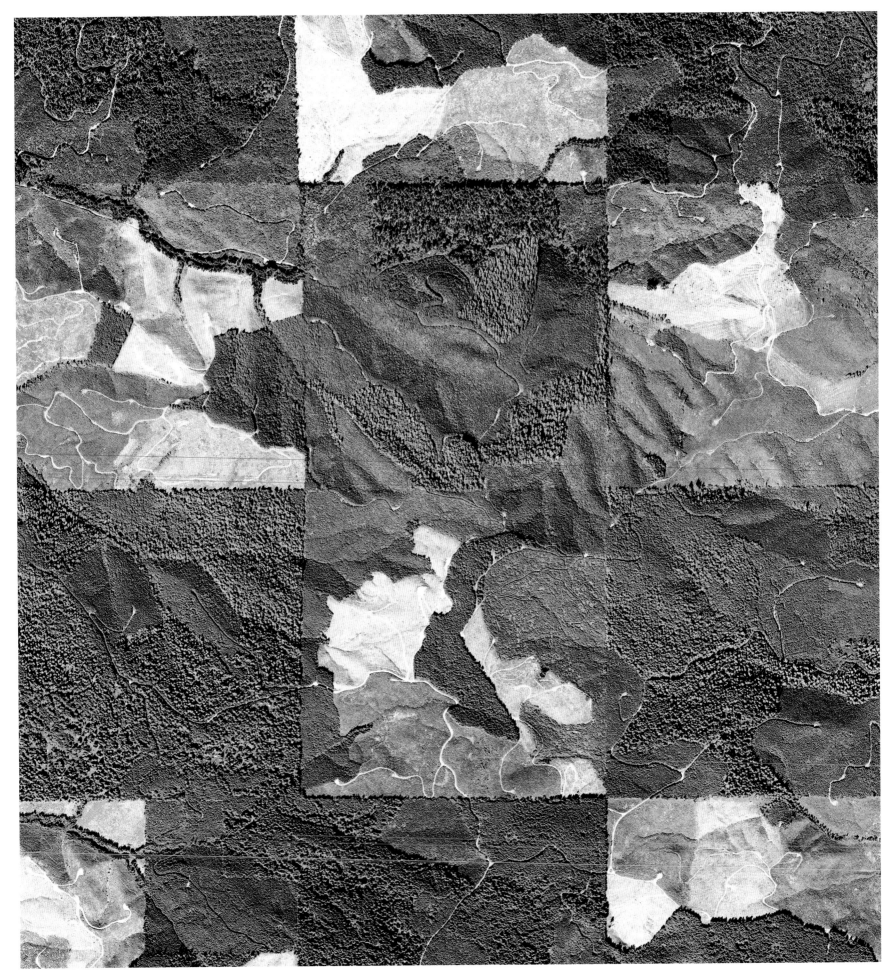

2010

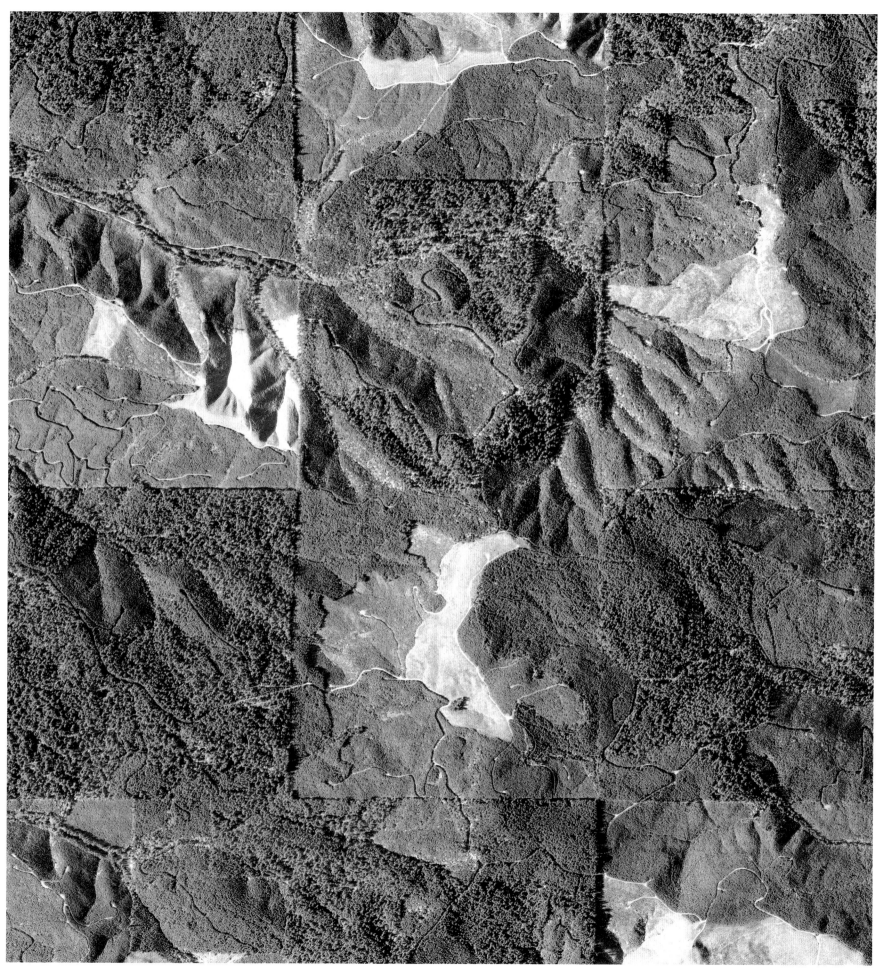

2018

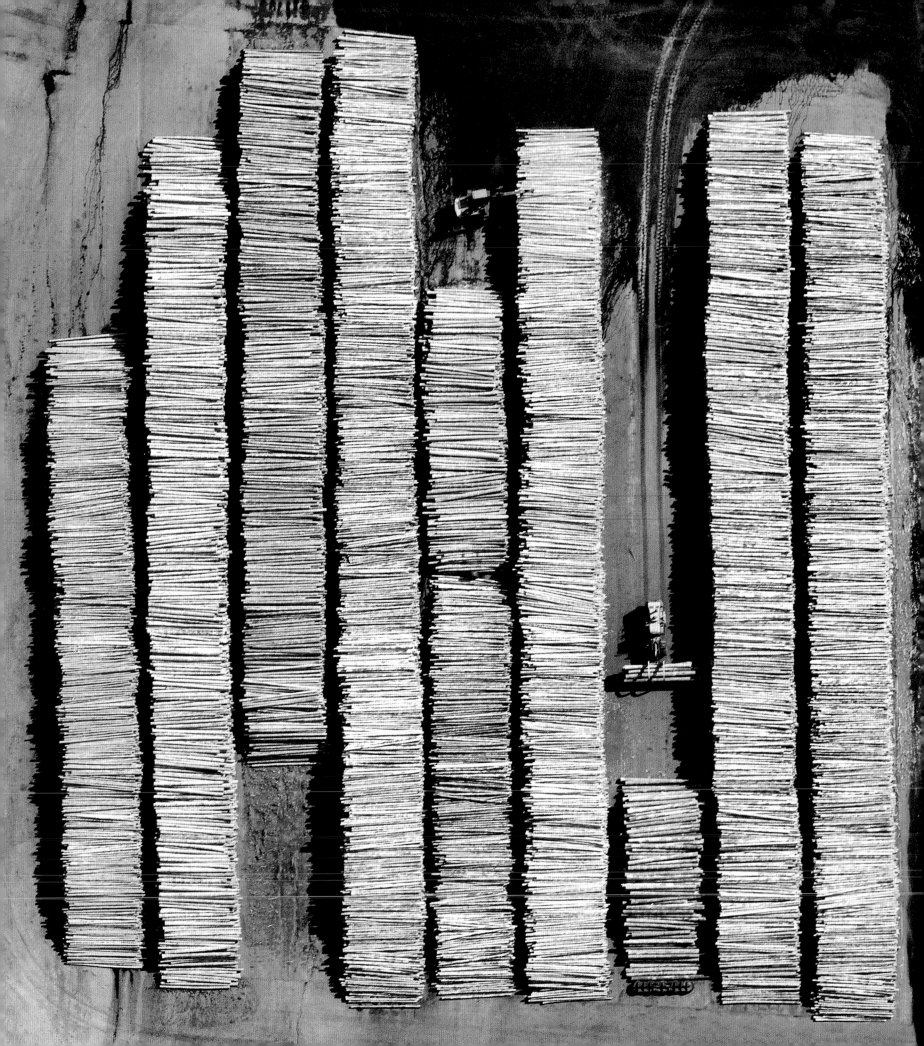

# Materials

For more than 10,000 years, we have utilized materials that naturally occur on Earth. In a reinforcing feedback loop, these resources have enabled us to develop more ways of efficiently extracting and transforming other materials into more things of use. We construct complex processes and infrastructure that ensure our extraction can grow and keep up with demand. For example, our current dependence on burning fossil has evolved over a century and has become ingrained in much of how our civilization functions. These efforts can be alarming to see at scale, yet they are also a testament to our ingenuity.

Our use of materials also provides evidence of just how far we will go to get what we need from the earth. In this time of unprecedented global industrialization and urbanization, the demand for certain raw materials has skyrocketed. As the products we consume have evolved, material extraction processes have followed suit. Lithium, for example, has become vital to support the vast technological ecosystem of lithium-ion-battery-powered products like smartphones and laptops. Furthermore, massive amounts of energy and water must be used to get these materials out of the earth. As material production and usage often involves numerous steps across different places, the majority of stories in this chapter show various locations in sequence to help connect the dots of how these processes take place. Stories often begin with extraction and end with an example of how that material has been utilized in civilization.

Two of the resources that we have spent much of our efforts digging out of the ground are oil and coal. Historically and through the present day, these substances have provided a cost-effective means of generating heat and electricity. However, when these types of fuels are burned, they break down and release a significant amount of carbon dioxide, the most prominent greenhouse gas. Worldwide mining and burning of carbon-rich fossil fuels is the primary reason our atmosphere now contains its highest concentration of carbon dioxide in more than 800,000 years. With an eye on the future, we have developed alternative means of generating power—primarily solar and wind—that produce significantly less carbon and are dependent on resources that exist in seemingly infinite quantities. While these technologies are not yet fully able to meet our energy demands, a shift toward greater adoption of these solutions is an essential step if we will one day generate energy in a manner that does not further contribute to an atmosphere already dangerously rich in carbon.

OPPOSITE

**Qinhuangdao Coal Terminal**
2019

The coal terminal at the Port of Qinhuangdao in China is the largest coal shipping facility in the country. From here, approximately 231.5 tons (210 million metric tons) of coal are transported via ship and rail to coal-burning power plants throughout southern China every year. China is the largest producer and consumer of coal in the world. Estimates suggest that from 1988 to 2015, the Chinese coal industry accounted for more than 14 percent of total global emissions. Current estimates put China's investment in the material, including domestic projects and its support of projects in other countries, at more than half of all global coal power capacity under development. To read more about coal generation, turn to page 159.

39.933622°, 119.683840°

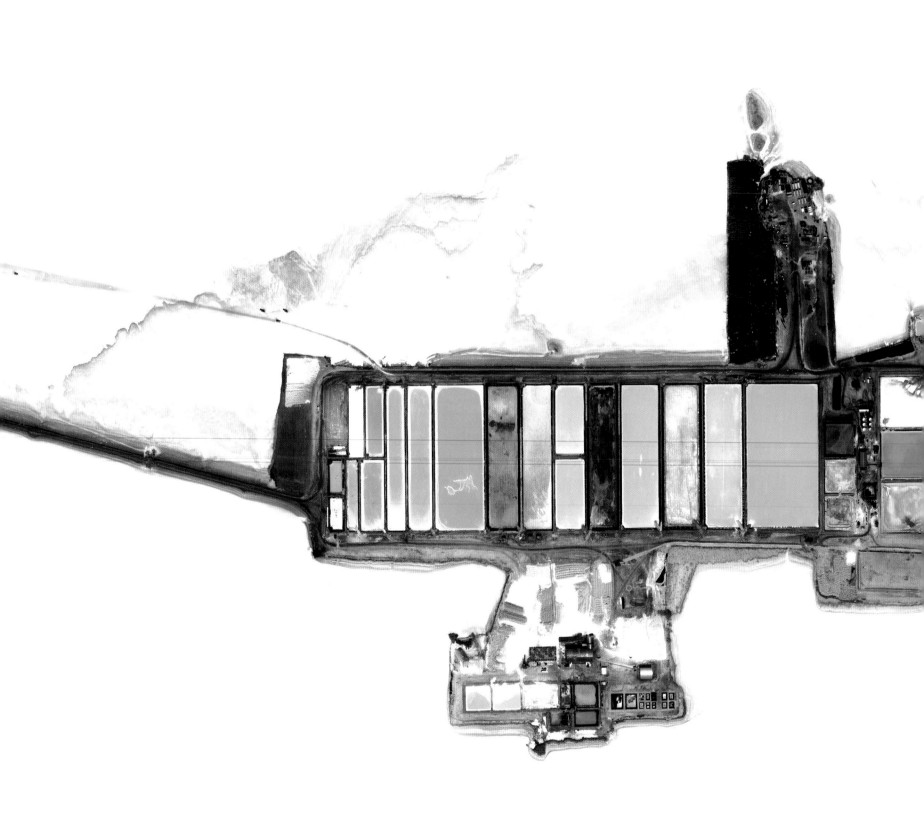

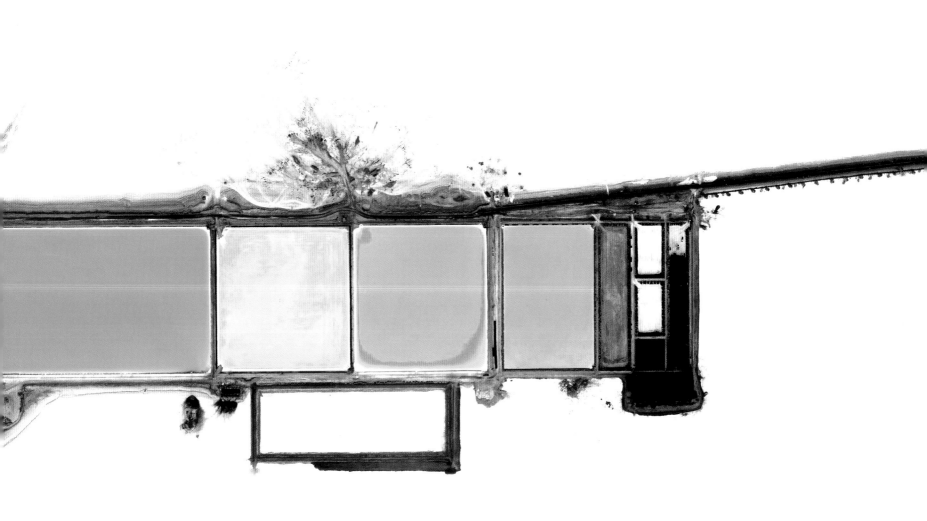

## Lithium Mining and Production

PREVIOUS PAGE AND ABOVE

**Salar de Uyuni Lithium Mines**
2013 / 2019

The expansion of lithium mining operations is seen here at Salar de Uyuni—the world's largest salt flat, located in Bolivia. Lithium is a reactive alkali metal primarily used in lithium-ion batteries, which power everything from smartphones to electric vehicles. The mining process begins by drilling and pumping water into holes in the salt flats to bring salty, mineral-rich brines to the surface. The brine is left in pools to evaporate for months, creating a mixture of minerals that are continuously filtered until enough lithium carbonate can be extracted.

-20.208642°, -68.152484°

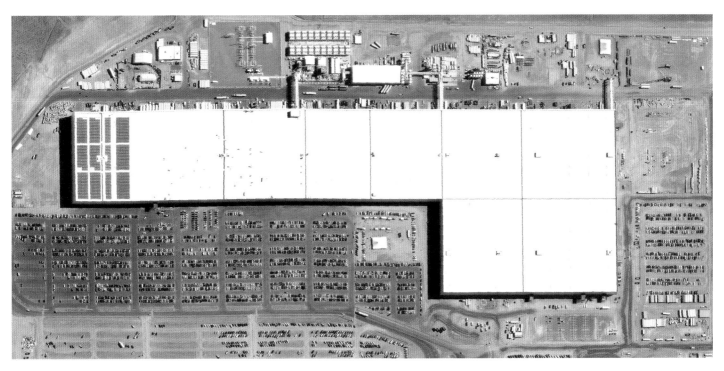

**Gigafactory 1**
2011 / 2019

——

Opened in 2016, Tesla's Gigafactory 1 is a lithium-ion battery and electric vehicle sub-assembly facility near Reno, Nevada. There are plans to further expand the complex; the building is projected to have the largest footprint in the world, sprawling across 15 million square feet (1.4 million square meters), and will also become energy self-reliant through a combination of on-site solar, wind, and geothermal sources. When the facility operates at peak capacity, it produces more lithium-ion batteries in a year than the total amount produced in the entire world in 2013.

39.538016°, -119.441228°

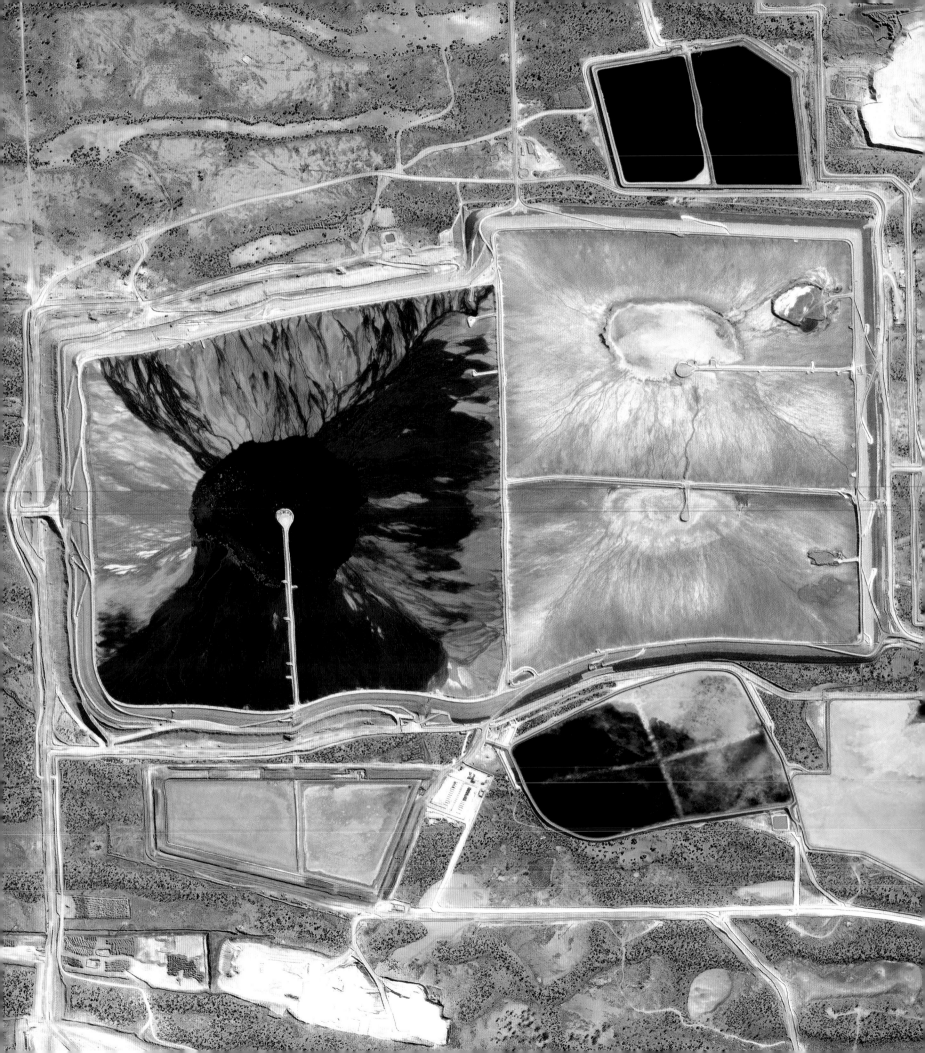

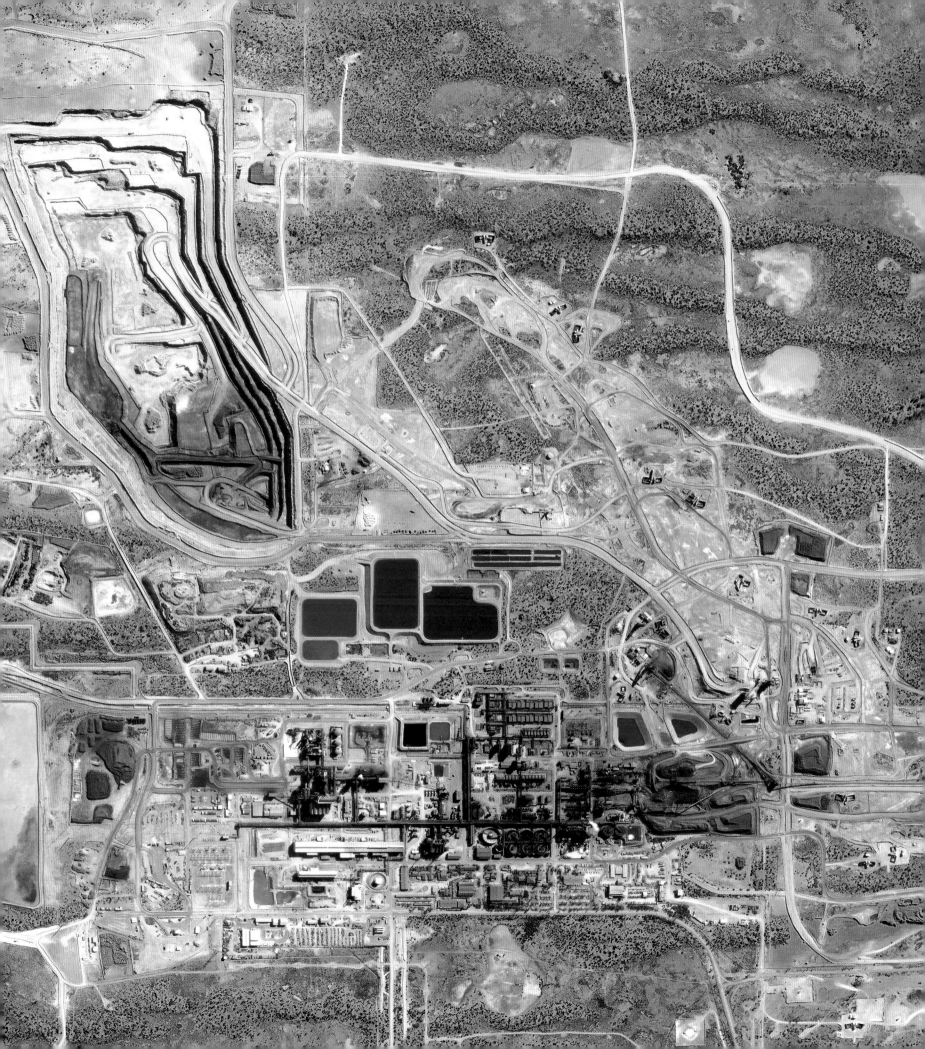

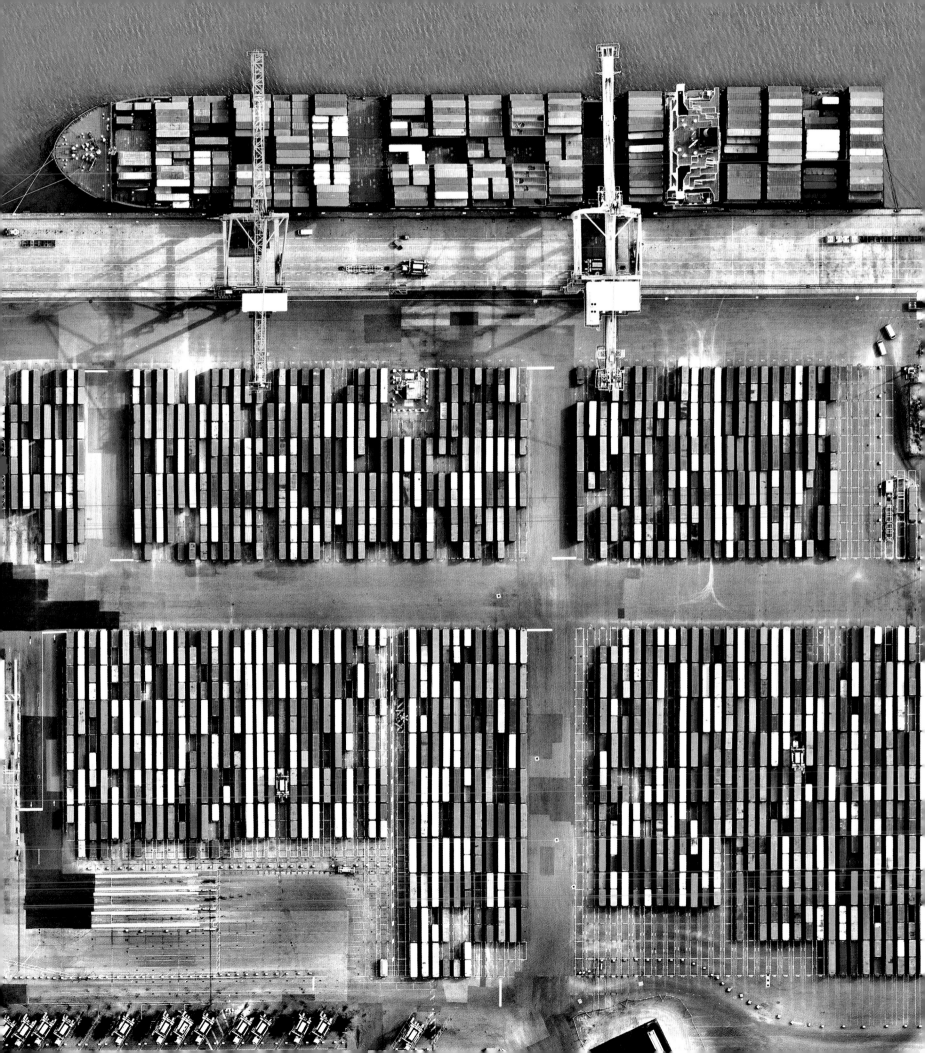

# Nuclear Power Generation

PREVIOUS SPREAD
## Olympic Dam Mine
Step 1

The Olympic Dam mine in South Australia contains the largest known deposit of uranium in the world and is the country's largest producer of uranium oxide, or "yellowcake." Mining the material is the first step in processing uranium for energy. Before it can be fabricated into a fuel, the uranium must be enriched through the process of isotope separation.

-30.444444°, 136.866667°

OPPOSITE
## Port Adelaide
Step 2

Australia is home to 33 percent of the world's uranium deposits and is the world's third-largest producer of uranium. However, the country does not have any nuclear power plants or nuclear weapons, meaning all of the uranium mined there is shipped overseas to other countries that use the material. Uranium that is mined at Olympic Dam is shipped via Port Adelaide, located 350 miles (563 kilometers) away. The yellowcake is packaged in 200-liter drums and sent inside shipping containers on container ships like the one seen here at the port.

-34.769640°, 138.490393°

RIGHT
## Palo Verde Nuclear Generating Station
Step 3

More than half of the uranium exported from Australia is purchased by the United States, a country that generates around 30 percent of the world's nuclear power. The American nuclear facility with the largest capacity is Palo Verde Nuclear Generating Station near Tonopah, Arizona, which produces an average of 3.3 gigawatts, or enough power to serve roughly 4 million people. In contrast to coal-fired plants, nuclear plants do not burn anything to generate electricity (and therefore do not emit greenhouse gases in this stage of the process). Nonetheless, the mining and refining of uranium ore and the creation of reactor fuel are both energy-intensive processes. Instead of burning to create heat, these facilities split uranium atoms in a process called fission. Fission releases energy that heats water to roughly 520°F (271°C), converting it to steam, which then spins turbines. Since the plant is not located near a large body of water, water from the sewage treatment facilities of several nearby cities provides cooling for the steam that it produces.

33.389158°, -112.865096°

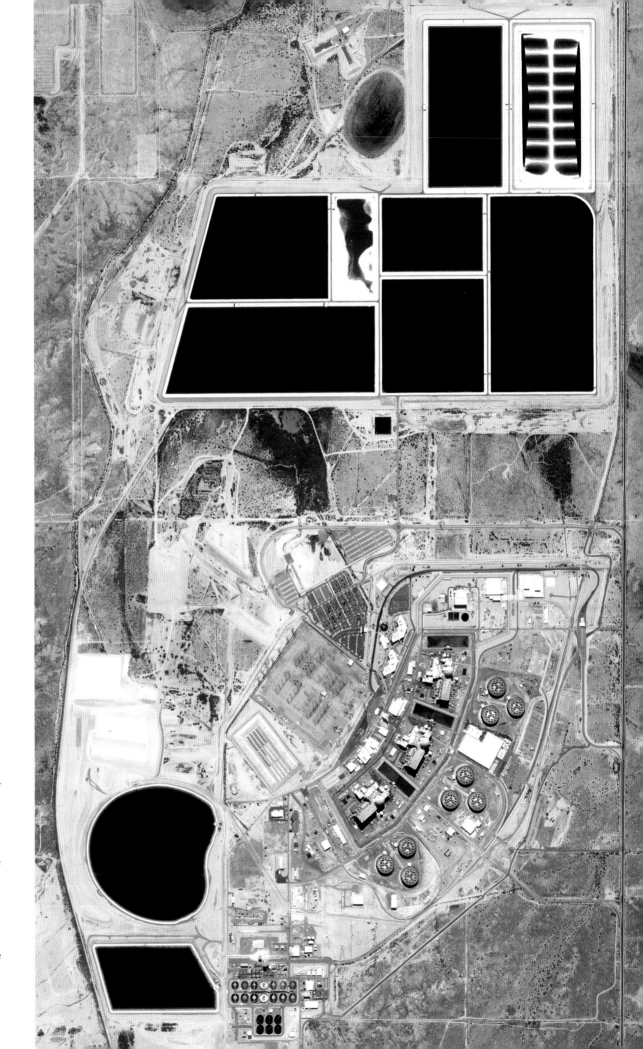

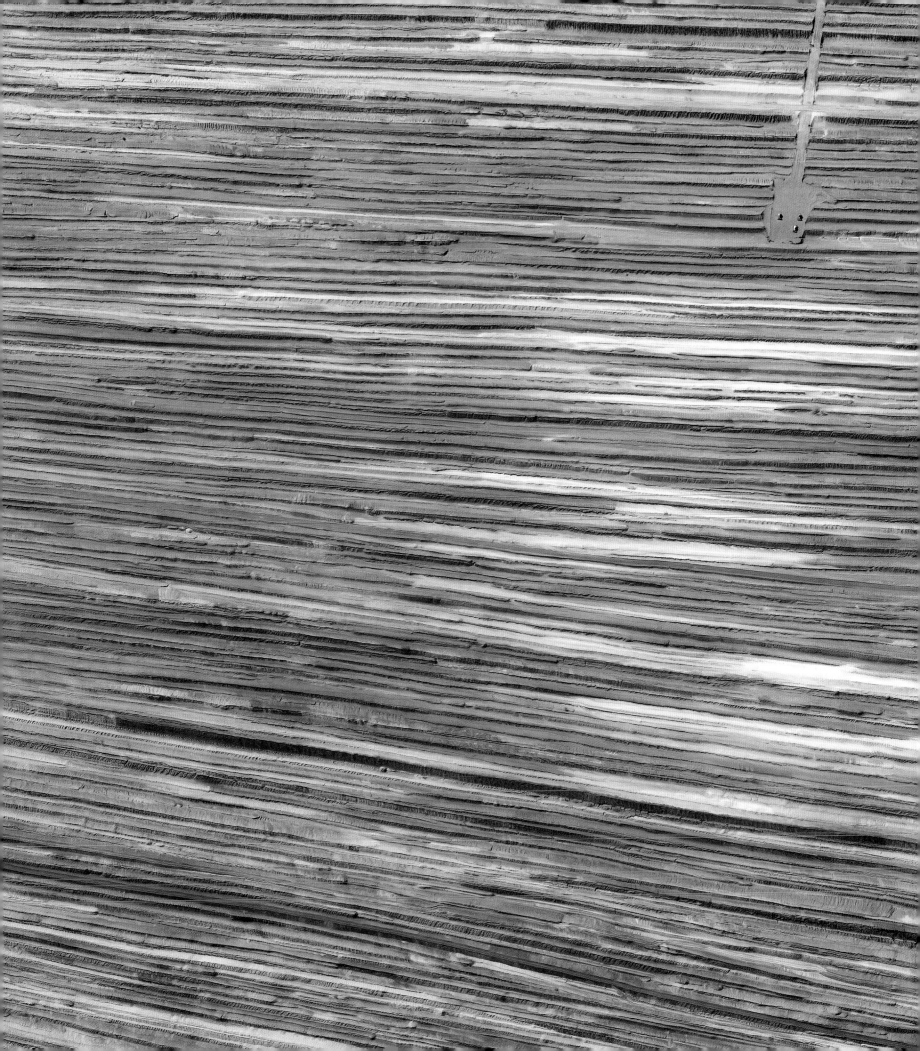

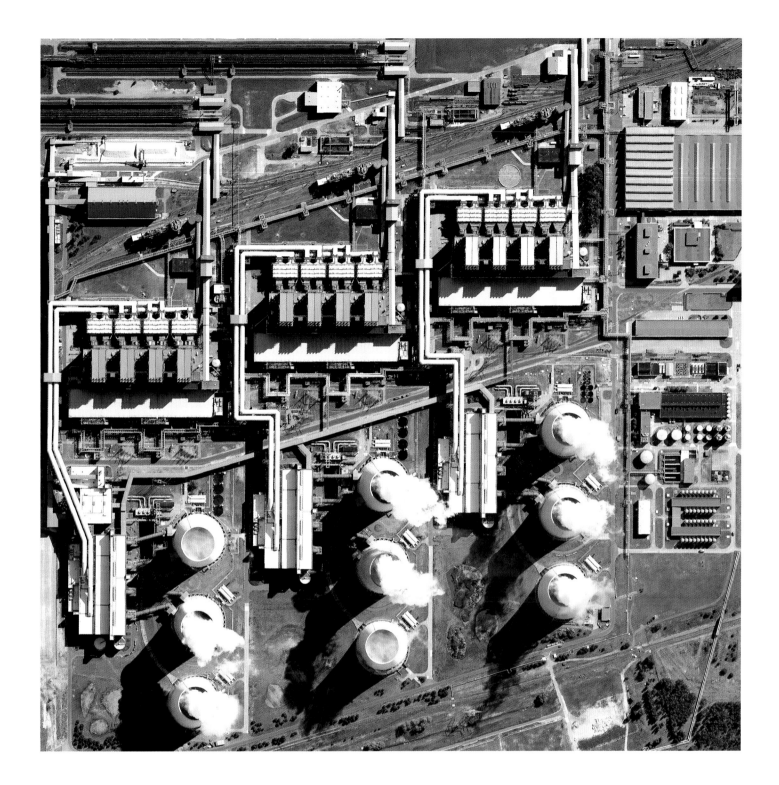

## Coal Mining and Power Generation

OPPOSITE

### Jänschwalde Surface Mine
Step 1

Coal surface mines are situated in close proximity to the Jänschwalde Power Station in Jänschwalde, Germany. Lignite, or "brown coal," is a combustible sedimentary rock formed from the natural compression of peat. The coal is scraped off the surface and brought via trains to the power station, where it is burned as the fuel for steam-electric power generation. Using brown coal to generate power requires large volumes of the material due to its fairly low energy density, so it is regularly transported via train from mines to nearby power plants to avoid greater transit costs.

51.834380°, 14.539700°

ABOVE

### Jänschwalde Power Station
Step 2

Coal train unloading platforms are visible in the upper left of this Overview. The Jänschwalde Power Station burns approximately 80,000 tons (72,575 metric tons) of brown coal a day at its six power plant units. Due to the high amounts of carbon dioxide released when coal is burned—globally representing 30 percent of $CO_2$ emissions related to energy—Germany has created a coal exit commission that has set a pathway for the country to phase out the fossil fuel as a power source by 2038.

51.835861°, 14.456122°

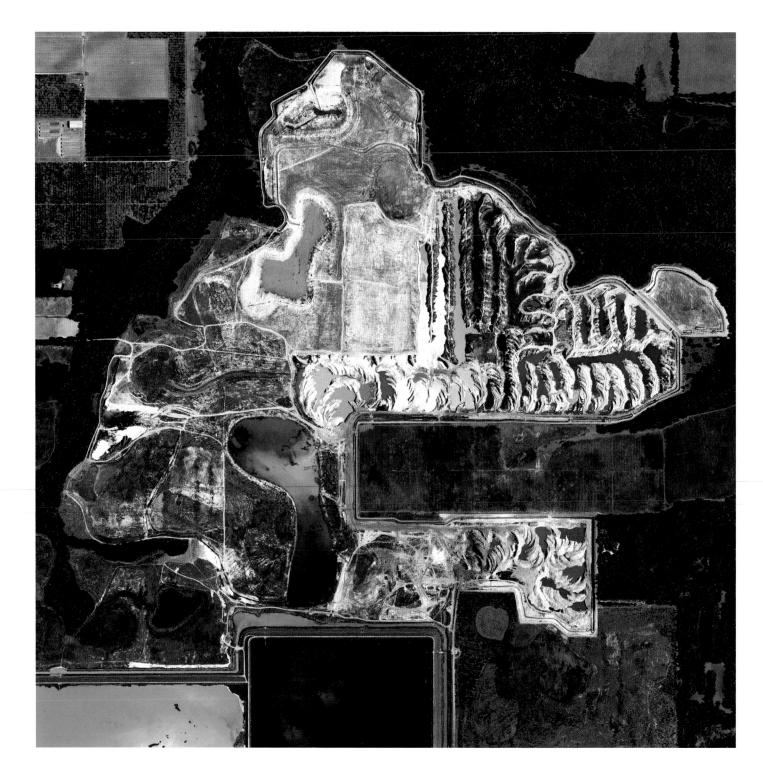

## Fertilizer Production and Use

ABOVE

### Florida Phosphate Mine
Step 1

An active phosphate mine is visible outside of Keysville, Florida. Roughly 30 million tons (27 million metric tons) of phosphate rock are mined every year in the United States, making it the world's third-largest producer, after China and Morocco. Phosphate is an essential ingredient in the production of fertilizer used in soils to help plants grow.

27.908000°, -82.088400°

OPPOSITE

### Kansas Wheat Production
Step 2

Ninety percent of mined phosphate rock is used for agricultural fertilizers. Phosphorus, nitrogen, and potassium are the three key nutrients needed by plants. Maintaining proper levels of these nutrients helps a plant acquire, store, and transfer energy. However when these materials drain from agricultural developments into nearby water systems, algae blooms can occur (see the Miami red tides on page 185). In the US agriculture industry, the majority of phosphorus is used to aid in the production of wheat—a staple crop that is cultivated heavily in the state of Kansas. Seen opposite, pivot irrigation fields, primarily growing wheat, cover the landscape north of the town of Copeland.

37.631919°, -100.706841°

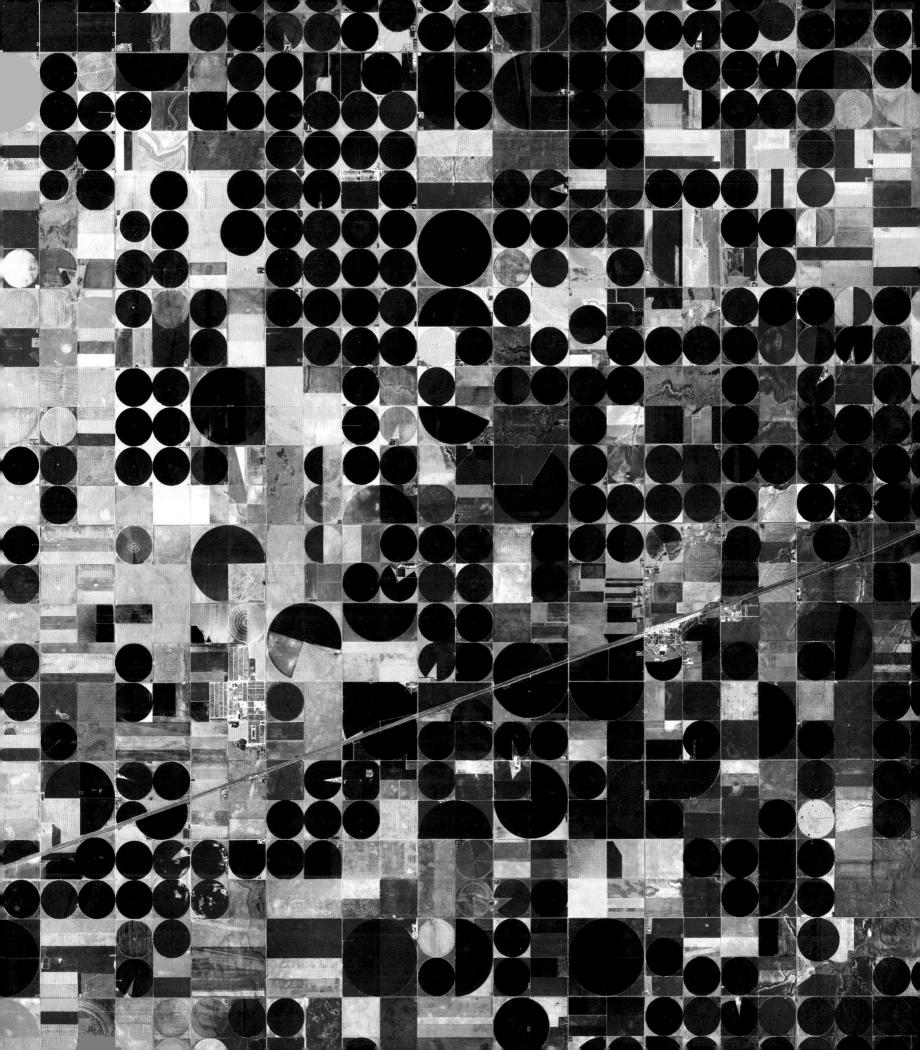

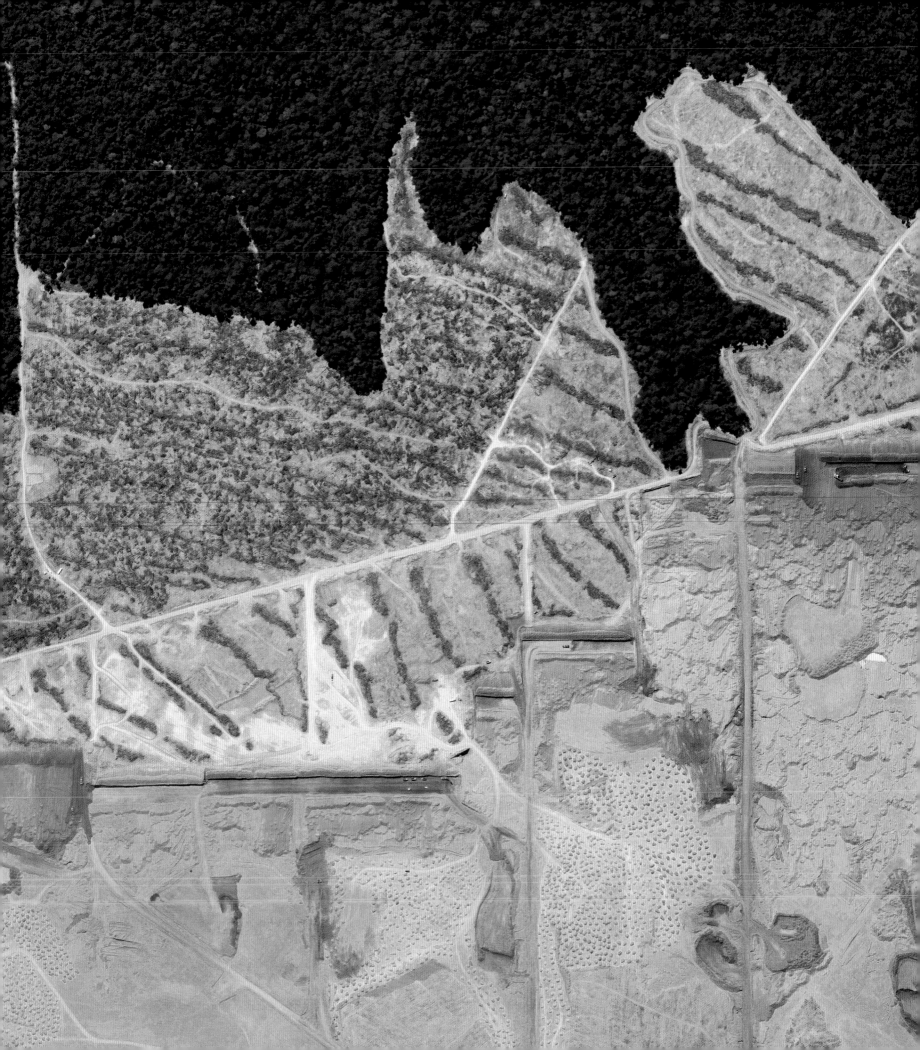

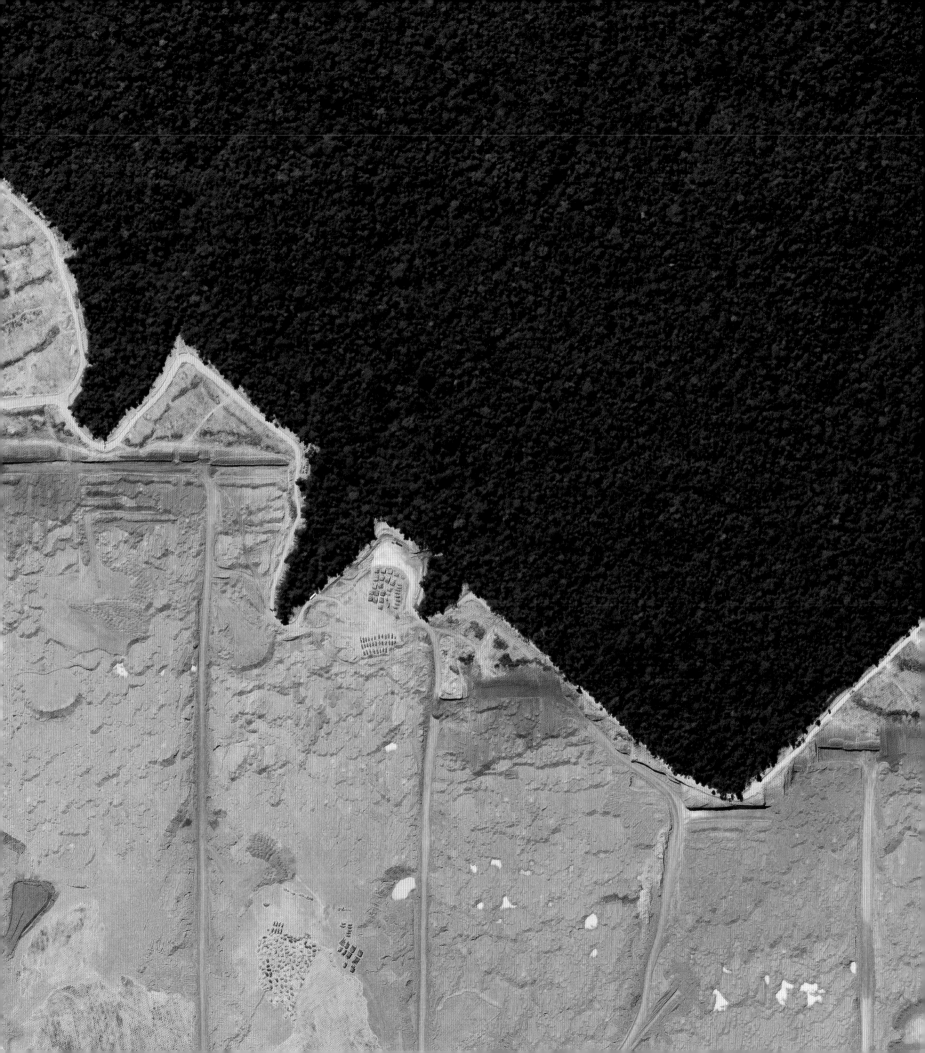

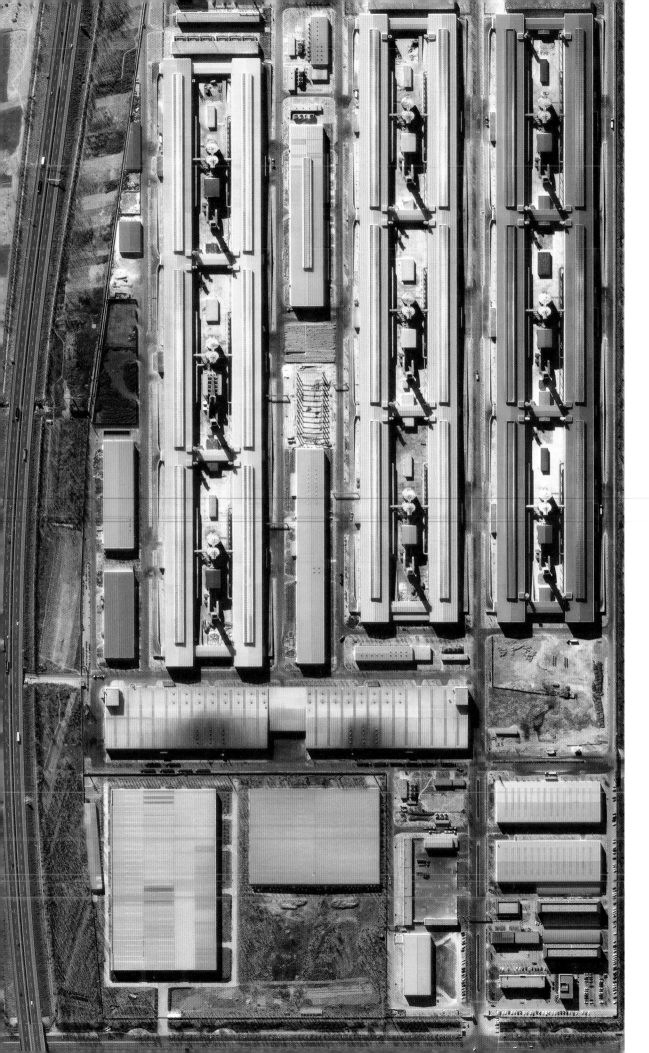

## Aluminum Production and Use

PREVIOUS PAGE

### Paragominas Bauxite Mine
Step 1

Aluminum is the third most abundant element in the earth's crust, but it does not naturally occur as a metal. The first step in producing aluminum is mining its ore—bauxite. The Paragominas bauxite mine in Brazil produces more than 5 million tons (4.5 million metric tons) of bauxite every year, and it represents one of the largest reserves of the material in the country.

-3.241538°, -47.695262°

LEFT

### Binzhou Aluminum Factory
Step 2

Next, aluminum manufacturing takes place in two phases: the Bayer process refines the bauxite ore into aluminum oxide, and then the Hall-Héroult process is used to smelt the aluminum oxide in order to produce pure aluminum. These processes take place at a facility like the Binzhou aluminum factory in Binzhou, China. The facility is the largest of its kind in the world, with an annual capacity of 3.6 million tons (3.3 million metric tons) of aluminum.

37.372399°, 117.897315°

OPPOSITE

### Aluminum Roofing in Ansan
Step 3

Aluminum is a widely used material because it is lightweight and malleable. The metal is used in a huge variety of products such as cans, foils, and airplane parts. The striking blue color seen here in Jeongwang-dong, an industrial sector of Ansan, South Korea, results from the use of aluminum roofing, which is popular for its low cost and durability.

37.336147°, 126.718587°

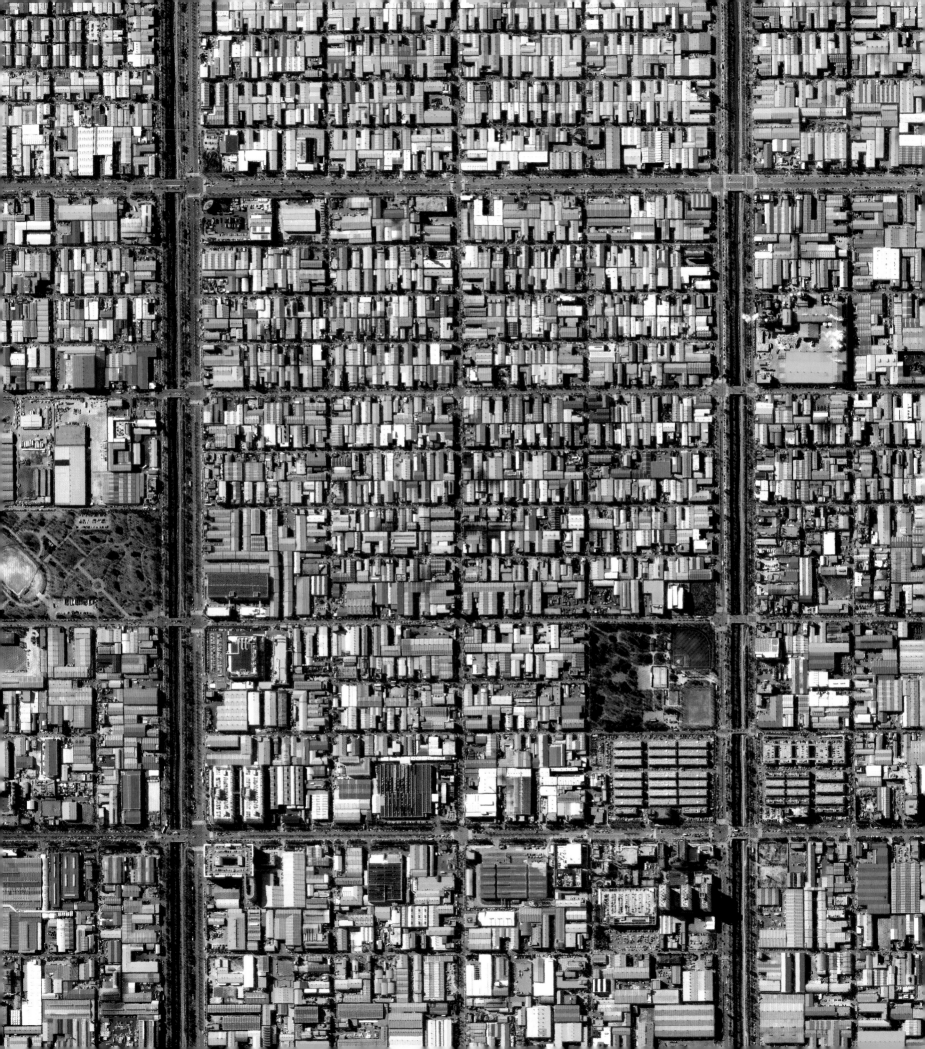

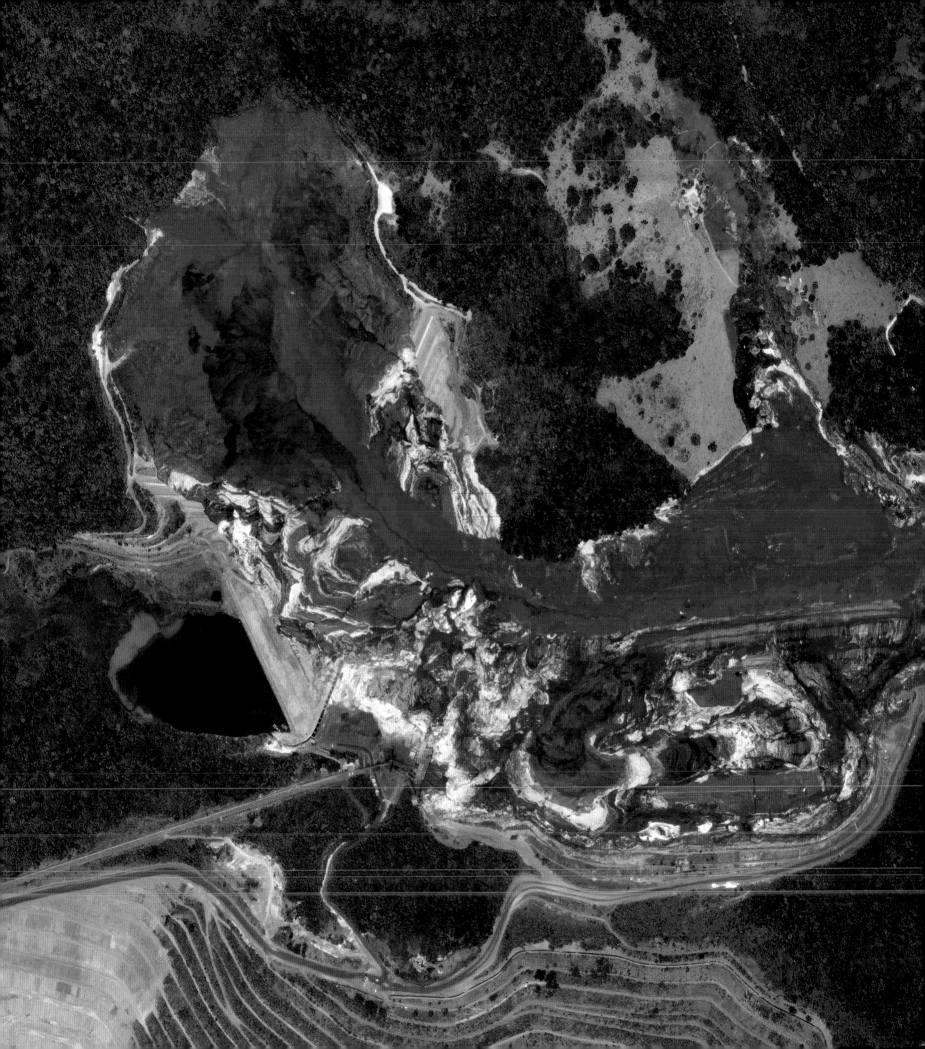

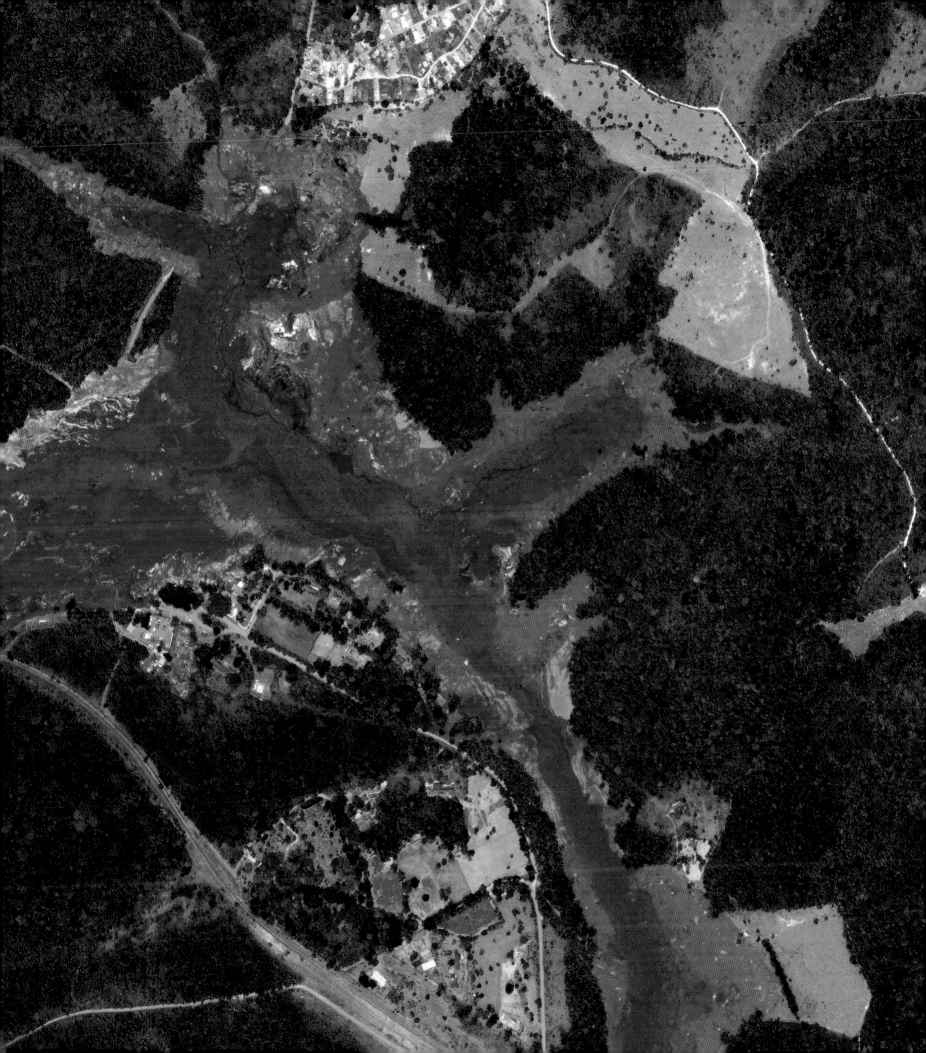

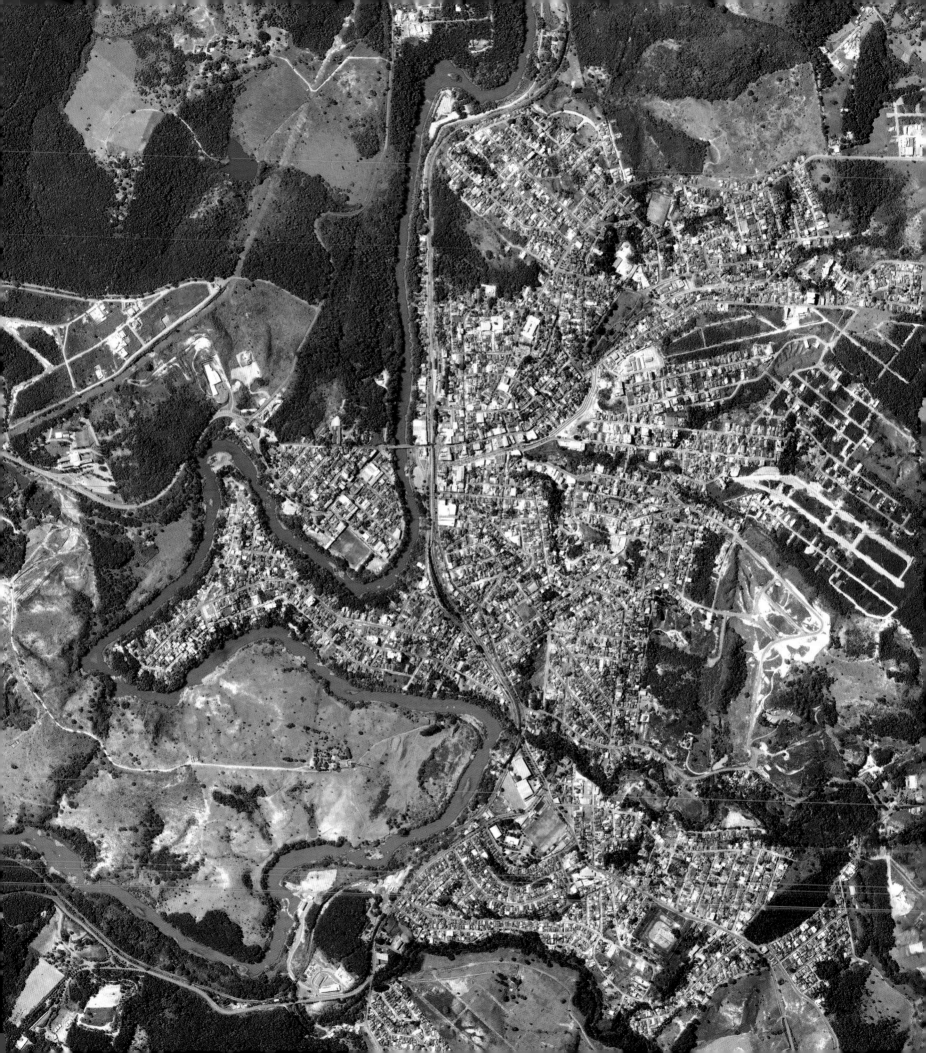

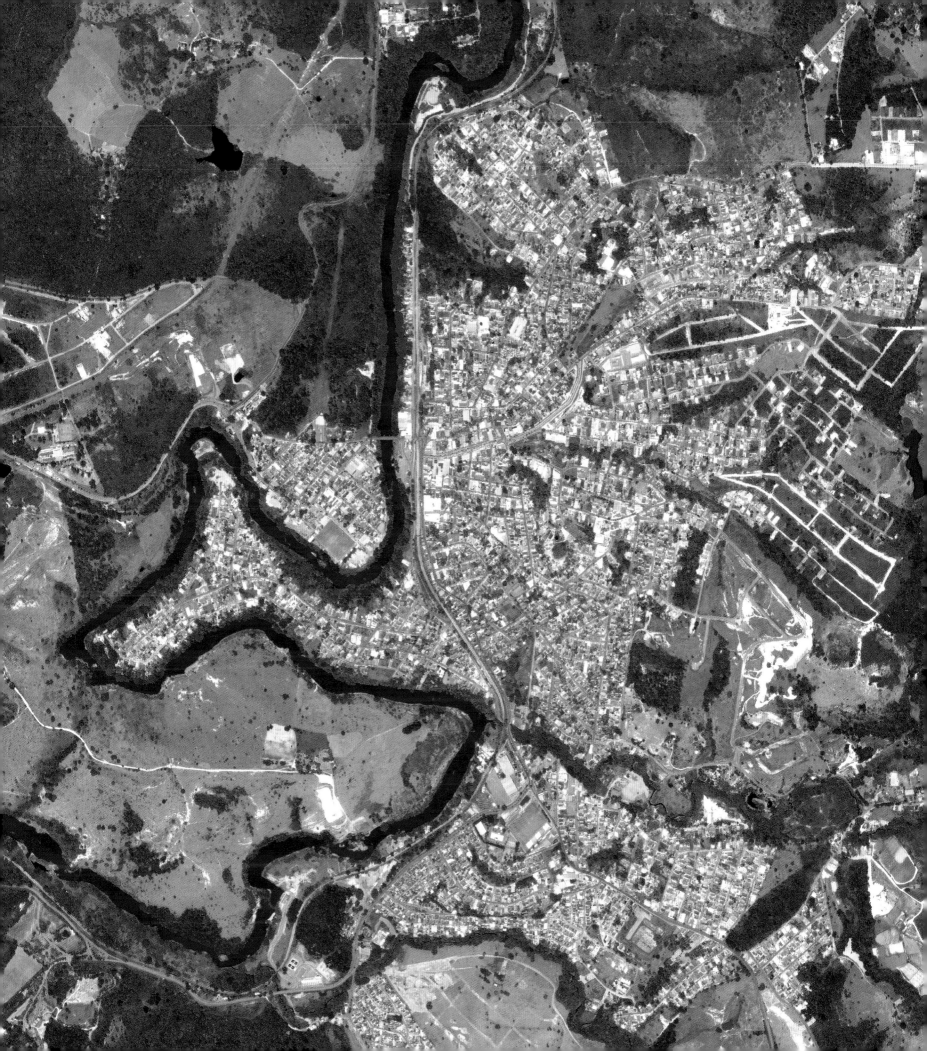

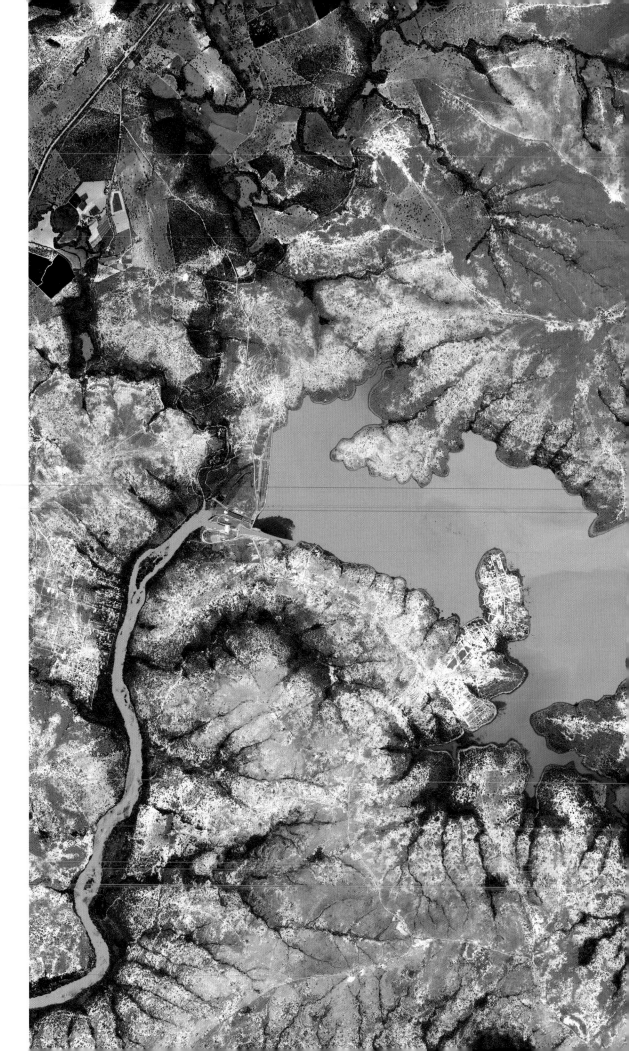

## Iron Ore Tailings Dam Collapse

PAGES 166–167

### Brumadinho Dam Collapse
January 2019

Ninety-eight percent of mined iron ore is used to make steel, and is thus a major component in the construction of buildings, automobiles, and appliances such as refrigerators. During the extraction and refinement process, iron ore waste is placed into massive ponds that are often dammed to contain the toxic materials. On January 25, 2019, one of these dams collapsed at an iron ore mine in Brumadinho, Brazil, and spilled more than 3 billion gallons (11.4 billion liters) of red mud, debris, and toxic sludge into the surrounding area and the Paraopeba River. The powerful mudflow claimed the lives of 272 people, many of whom were employees working on-site at the dam that day. This Overview was captured four days after the dam collapsed.

-20.125235°, -44.127103°

PREVIOUS PAGE

### Paraopeba River Contamination
Before / After

The town of Brumadinho is seen on the previous page with the contaminated Paraopeba River flowing through its center. In total, the Paraopeba River supplies water to roughly 1.5 million people who live in the Greater Belo Horizonte region. The Brazilian National Water Agency estimated that the wastewater would pollute over 185 miles (300 kilometers) of waterways as arsenic, mercury, and acid drainage was absorbed into the soils of the riverbeds.

-20.146683°, -44.156695°

RIGHT

### Distant Contamination
March 2019

To get a sense of how much waste flooded into the Paraopeba River and how far that impact was felt, this Overview shows orange, polluted waters in this reservoir, which is located roughly 150 miles (241 kilometers) downstream from where the dam collapsed in Brumadinho. This image was captured 43 days after the dam broke.

-18.939529°, -44.803545°

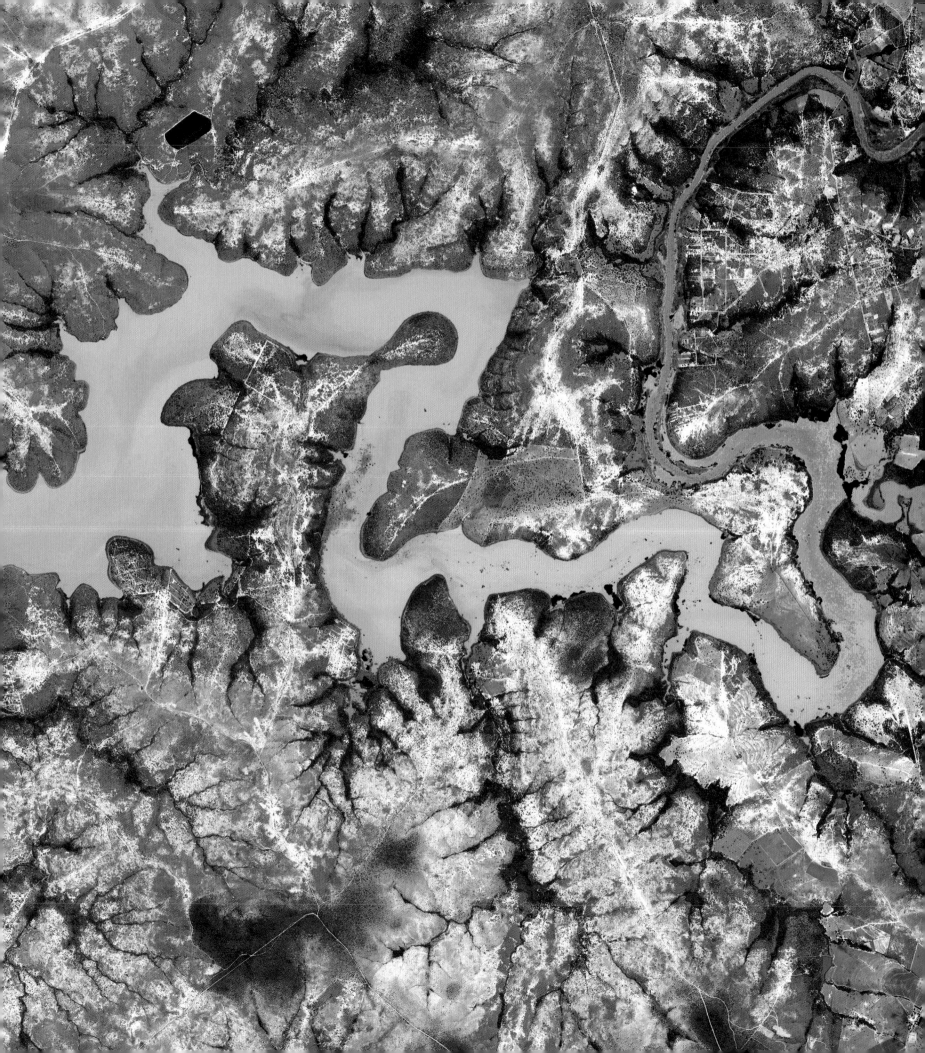

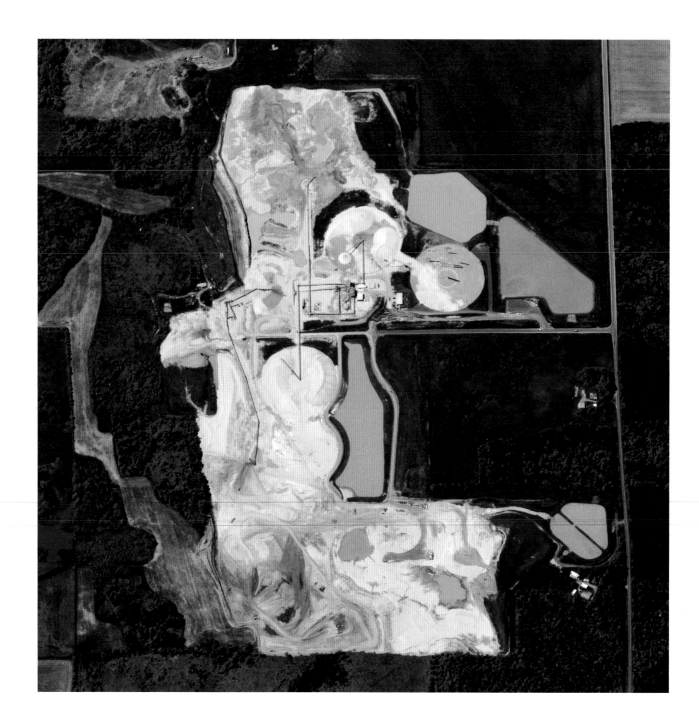

## Hydraulic Fracking and Plastics Production

ABOVE

ABOVE

**Wisconsin Sand Mine**
Step 1

A sand mine in Chetek, Wisconsin, is seen in this
Overview. The industry in this area has experienced
a massive increase in mining operations due to the
valuable role that sand plays in the natural gas extraction
process known as fracking. Nearly half of the frac sand
produced in recent years in the United States has come
from Wisconsin, since what is extracted here—unusually
round, hard, and silica-rich grains—are the preferred
composition for fracking.

45.257137°, -91.641976°

OPPOSITE

**Oklahoma Fracking Wells**
Step 2

Fracking consists of drilling operators pumping extracted sand, mixed with water and chemicals, underground at high
pressure. The pressure of the fluid produces a fracturing of the earth that allows crude oil and natural gas contained in the
dense rocks below to flow into a bored well and be brought up to the surface. Natural gases are an essential component
in petrochemical facilities, which you can see on page 174 . From 2000 to 2015, the number of fracking wells in the United
States soared from 23,000 to 300,000. One area that has seen a massive increase in this activity is Oklahoma, where
fracking wells, like the ones seen here outside the town of Leedey, have begun to appear all over the state. In recent years,
Oklahoma has experienced an unprecedented number and frequency of earthquakes. Whereas the average was roughly
two earthquakes per year before widespread fracking, that number soared into the hundreds for every year of the 2010s,
with 903 earthquakes occurring in 2015.

35.738824°, -99.565435°

**Petrochemical Factory and Plastics Production**
Step 3 (2011 / 2018)

———

These before-and-after Overviews show the ongoing construction of a petrochemical factory in Westlake, Louisiana. Once it is complete, the facility will use extreme heat to "crack" the molecular bonds in natural gas (ethane), which in turn will create the by-product ethylene, an essential component in the production of plastic goods such as bags and packaging. While plastics are now commonplace in our civilization, large-scale production of plastics only began in the 1950s. From then until 2020, an estimated 7.8 billion tons (7.1 billion metric tons) of plastic have been produced worldwide, of which about 9 percent has been recycled, 11 percent incinerated, and the remaining 80 percent dumped in landfills or waterways.

30.242732°, -93.276493°

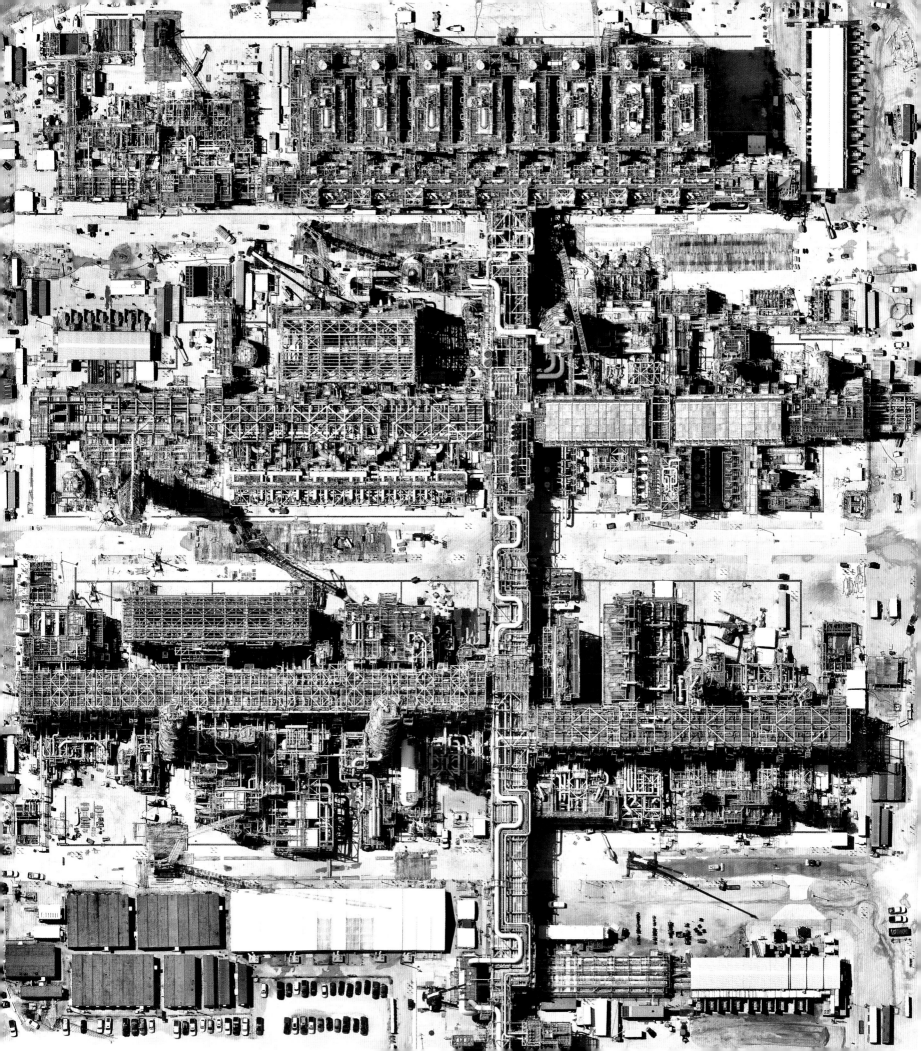

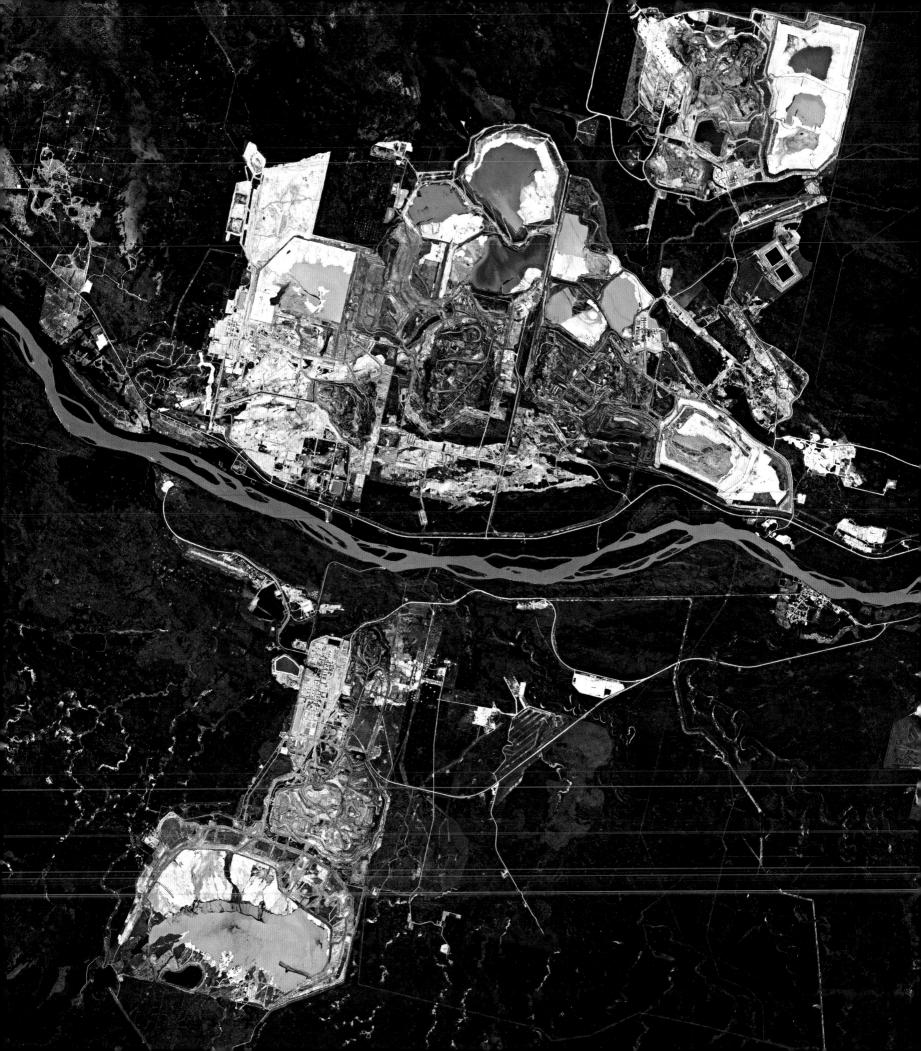

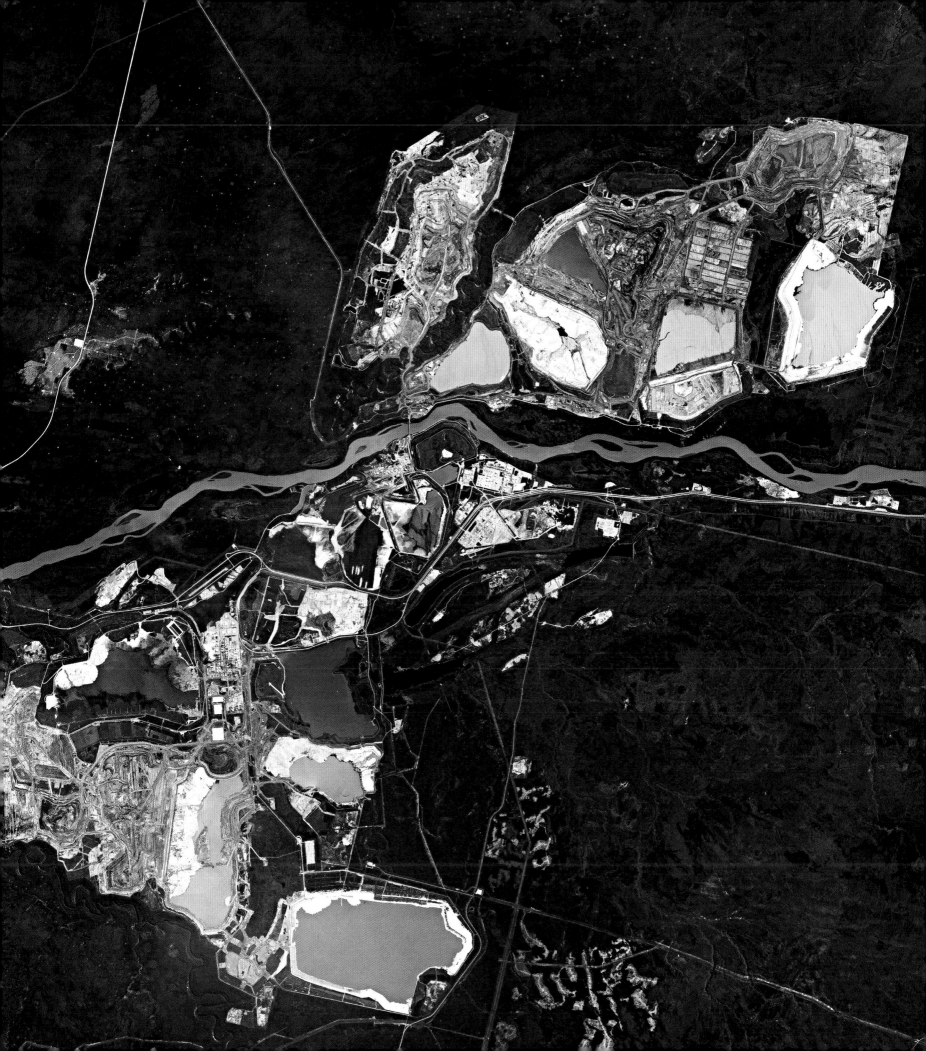

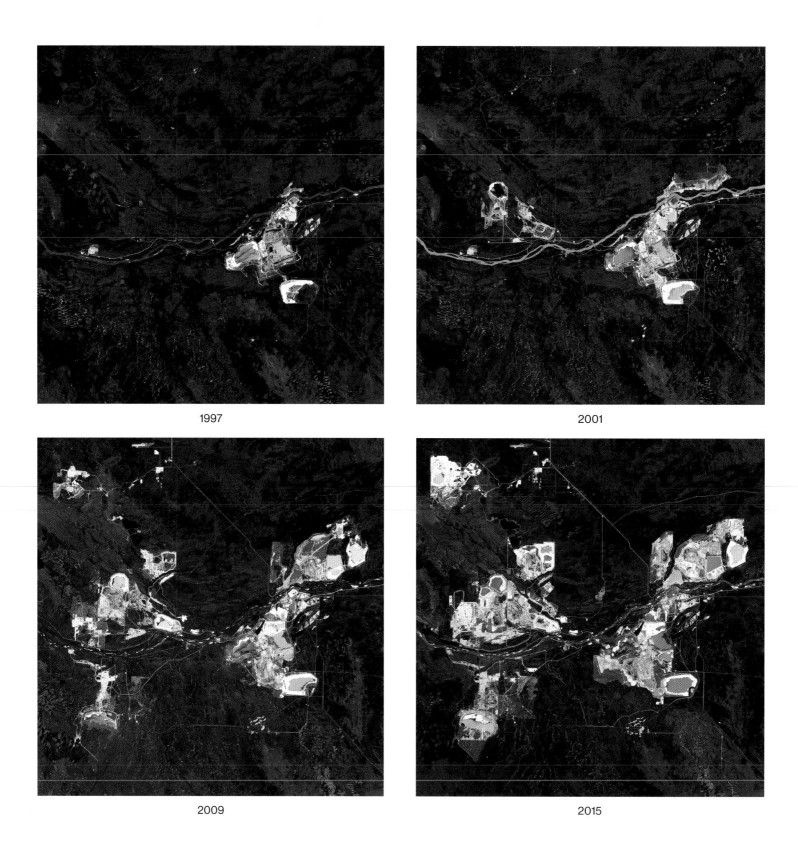

1997

2001

2009

2015

PREVIOUS PAGE, ABOVE, AND OPPOSITE

**Athabasca Oil Sands Expansion**
2019 / 1997–2015 / 2019

The Athabasca Oil Sands contain the largest known deposits of bitumen on Earth. Bitumen is a semi-solid form of crude oil that occurs as a mixture of sand, clay, and water. The additional energy required to mine and then remove the sand from the bitumen releases more emissions than in any other form of oil production. The mining and refining operations that take place here make use of large tailings ponds that store waste byproducts, such as the one seen at right that covers roughly four square miles (10 square kilometers). While the facility has significantly expanded in size since the 1990s and covers roughly 100 square miles (258 square kilometers), the entire Athabasca area still contains enough oil to produce 2.5 million barrels per day for 186 years.

57.020000°, -111.650000°

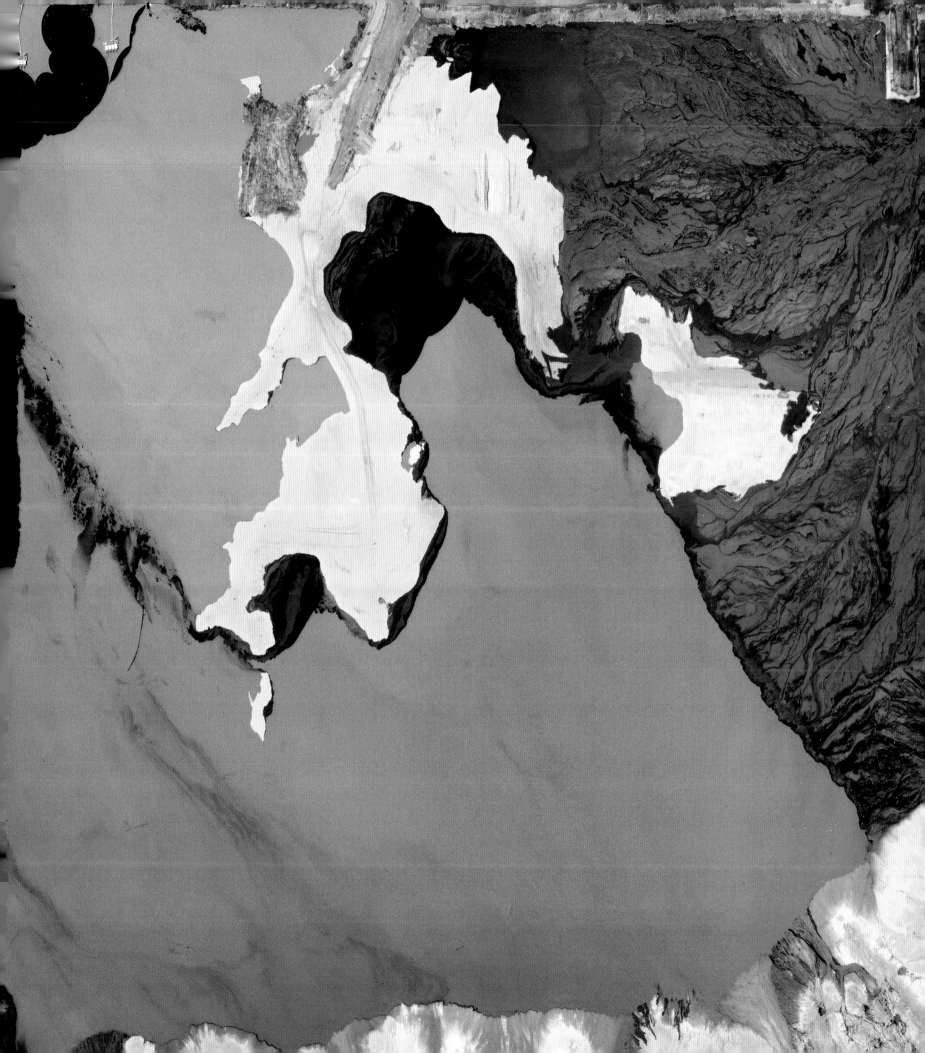

"We have forgotten that we are wholly embedded in a much older, more powerful world whose constancy we take for granted ... Averse to even the smallest changes, we have now set the stage for environmental deviations that will be larger and less predictable than any we have faced before."

— Marcia Bjornerud

PREVIOUS SPREAD
**Hurricane Michael Damage**
2018

On October 10, 2018, Hurricane Michael made landfall and caused catastrophic damage in Mexico Beach, Florida, with sustained winds of 155 miles per hour (249 kilometers per hour). This Overview was captured two days later. The Category 4 storm made history as the third strongest by pressure and fourth strongest by wind speed to make landfall in the United States. In the future, scientists predict that there may not necessarily be more hurricanes, but there will likely be more Category 4 and 5 hurricanes that carry higher wind speeds and more precipitation as a result of global warming.

29.941389°, -85.406389°

OPPOSITE
**Great Barrier Reef Coral Bleaching**
2018

The Great Barrier Reef is Earth's largest structure composed of living things, made of more than 2,900 individual reefs stretching roughly 1,400 miles (2,253 kilometers) offshore of Australia. Perhaps there is no better "canary in the coal mine" for nature's reaction to a warming planet than the recent coral bleaching events at the reef. Ninety-three percent of the increase in global temperatures has been absorbed by the oceans, raising water temperatures and causing ocean acidification. As a reaction to the warmer waters, coral expel the algae living inside their tissues, which give the coral necessary nutrients that provide up to 90 percent of their energy. Corals can continue to live after bleaching, but often they begin to starve soon thereafter. In 2016, a bleaching event killed approximately 30 percent of the Great Barrier Reef's coral, and overall, the average time between bleaching events has halved between 1980 and 2016.

-21.666530°, 152.235135°

# Nature

The relatively recent explosion of our civilization—visible in the dramatic growth of our cities, transportation, consumption, utilization of natural resources, and waste—has pushed the planet's ecosystem out of balance. All of our action is causing a reaction. Historically, Earth has gone through many periods of warming and cooling. However, for the first time, one species—humans—is single-handedly influencing that cycle. While extreme weather anomalies have always occurred to some extent, it is becoming frighteningly clear that our activity has influenced their intensity and frequency. Unusually extreme temperatures, severe floods, longer droughts, inflamed wildfire seasons, and the extinction of entire species remind us that there are still some processes on Earth that remain far beyond our control.

The burning of carbon-rich materials for energy and the far-reaching exploitation of land to grow crops and raise animals has released an unprecedented amount of carbon dioxide, methane, and nitrous oxide into the air. In a somewhat ironic twist, the presence of these greenhouse gases is what created the livable temperatures in which our civilization developed, but now, in greater quantities, they pose a direct external threat to our long-term safety on Earth. As sunlight hits the earth, some of the heat is absorbed by the land and the water on the planet's surface. The remainder of the sunlight is reflected back into the atmosphere. The greenhouse gases—that we have been releasing into the atmosphere at alarming rates for decades—trap some of the heat being reflected. When heat is trapped it leads to warmer land and ocean temperatures on earth.

The evidence of this warming has been most obvious in the behavior of our most important resource: water. As water on the surface of the planet absorbs excess heat, water temperatures rise and increase the melting of ice (which has often been frozen for thousands of years). As sea ice melts, or ice on land melts and flows into the sea, water levels rise and threaten the coastal areas, where 90 percent of our settlements have been built. Warmer air temperatures also cause clouds to retain more moisture, leading to more dramatic rainfall events and storms, then subsequent floods and landslides. Warmer air, on the other hand, also leads to droughts that pose a threat to our health, food supplies, and the most vital systems of our civilization. The planet's ecosystems and animals, us included, are incredibly resilient, but there is not enough time for natural adaptation to keep up with the pace at which we are currently transforming the planet and its climate. We need to rapidly and drastically decrease our impact and dedicate more resources to the technologies that emit less carbon or remove it from the air. As we continue to forecast or debate just how serious the repercussions of our actions will be, the planet will continue to react.

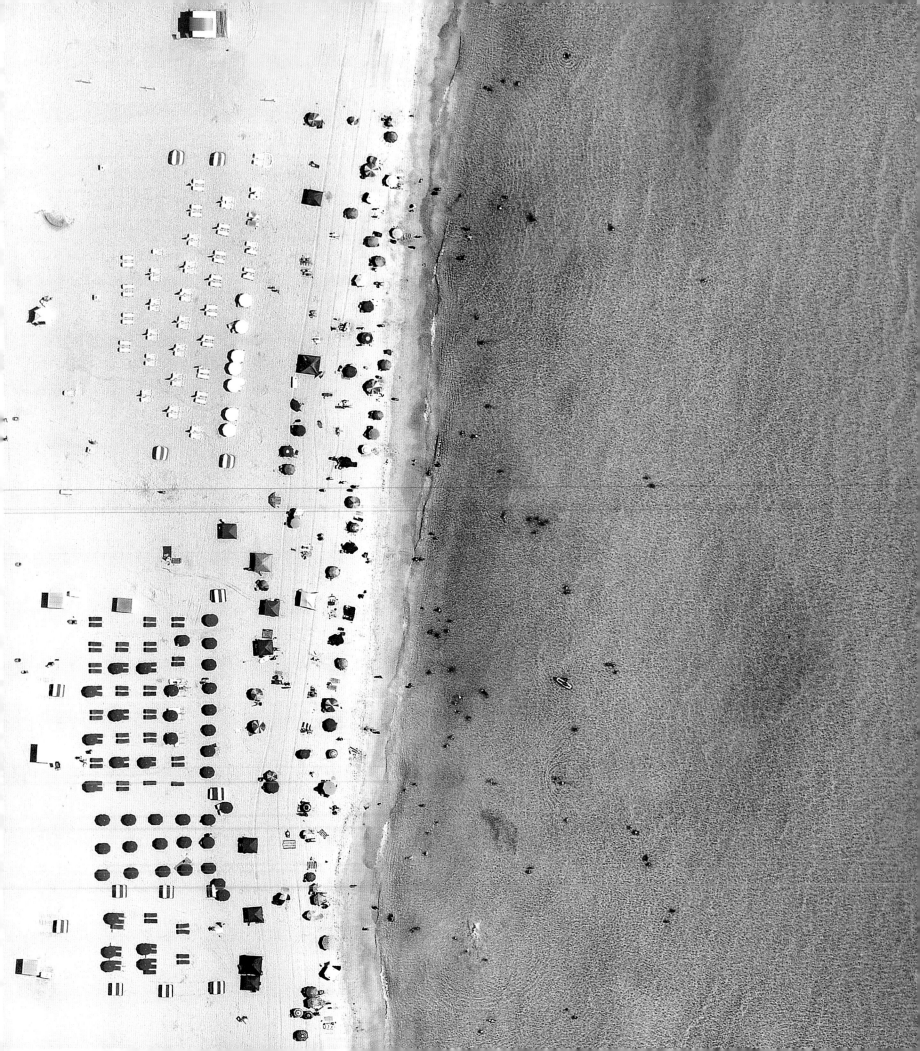

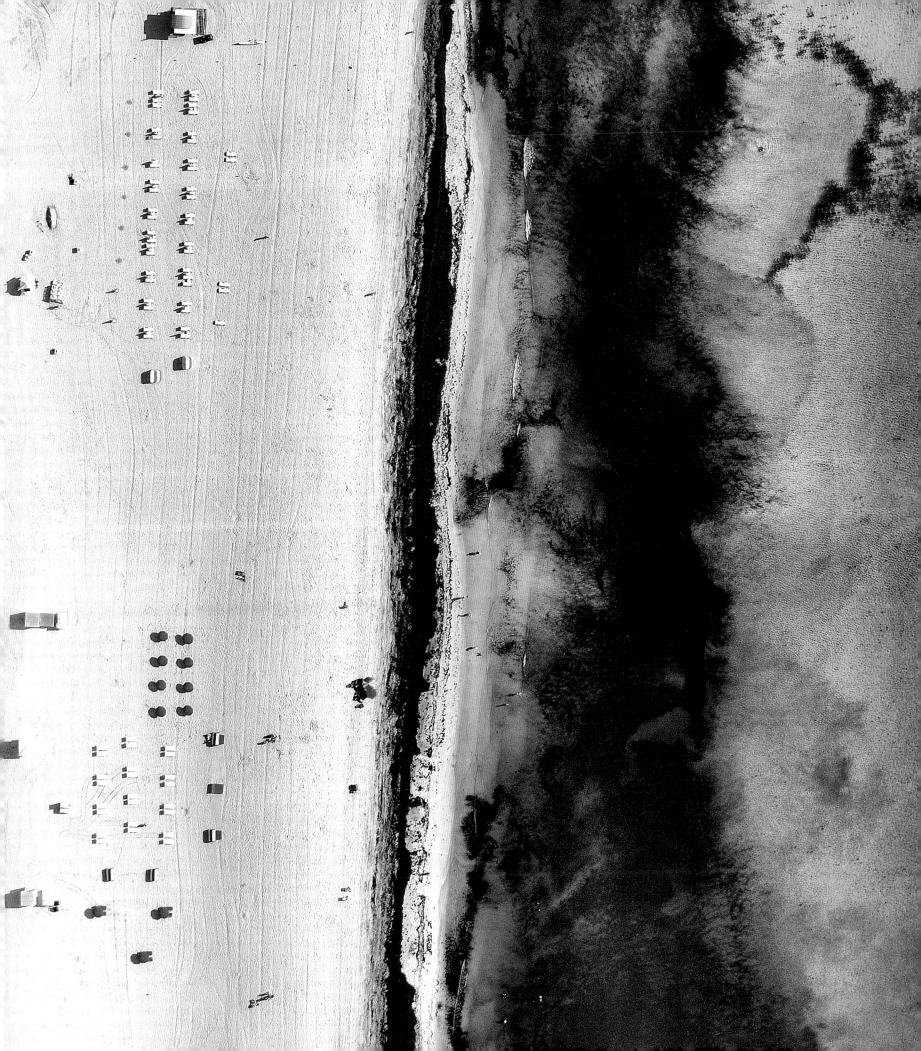

**Miami Red Tide**
May 2017 / June 2018

In 2018, tides of harmful algae blooms overtook the waters surrounding Miami, Florida, forcing the closure of at least six public beaches. The increased growth of dark algae discolors the typically clear waters, hence the "red tide" name. While it is difficult to pinpoint the exact cause of this phenomenon, red tides tend to follow intense storm seasons, and they may also be fueled by agricultural runoff bringing large amounts of unnatural fertilizers into the ocean. This specific algae, *Karenia brevis*, produces toxic chemicals that can affect fish and beachgoers alike due to its neurotoxicity and irritative respiratory properties. Red tides can last anywhere from a few weeks to more than a year depending on ocean temperatures, sunlight, salinity, winds, and currents.

25.793326°, -80.126459°

RIGHT, TOP AND BOTTOM

**Chicago Polar Vortex**
Before / During

A polar vortex is a large mass of cold, dense air that typically sits over one of the earth's two poles. Due to recent warming in the Arctic, in 2019, the jet stream pushed this frigid air as far south as Chicago, Illinois, resulting in some of the coldest temperatures there in more than three decades. During the event, the town of Mount Carroll, Illinois, experienced the state's coldest recorded temperature of all time at -38°F (-39°C). In Chicago, massive chunks of ice could be seen floating offshore in Lake Michigan, as shown here. As temperatures in the Arctic continue to rise, polar vortex intrusions could become more common in the Midwest and the northeastern United States.

41.833392°, -88.012140°

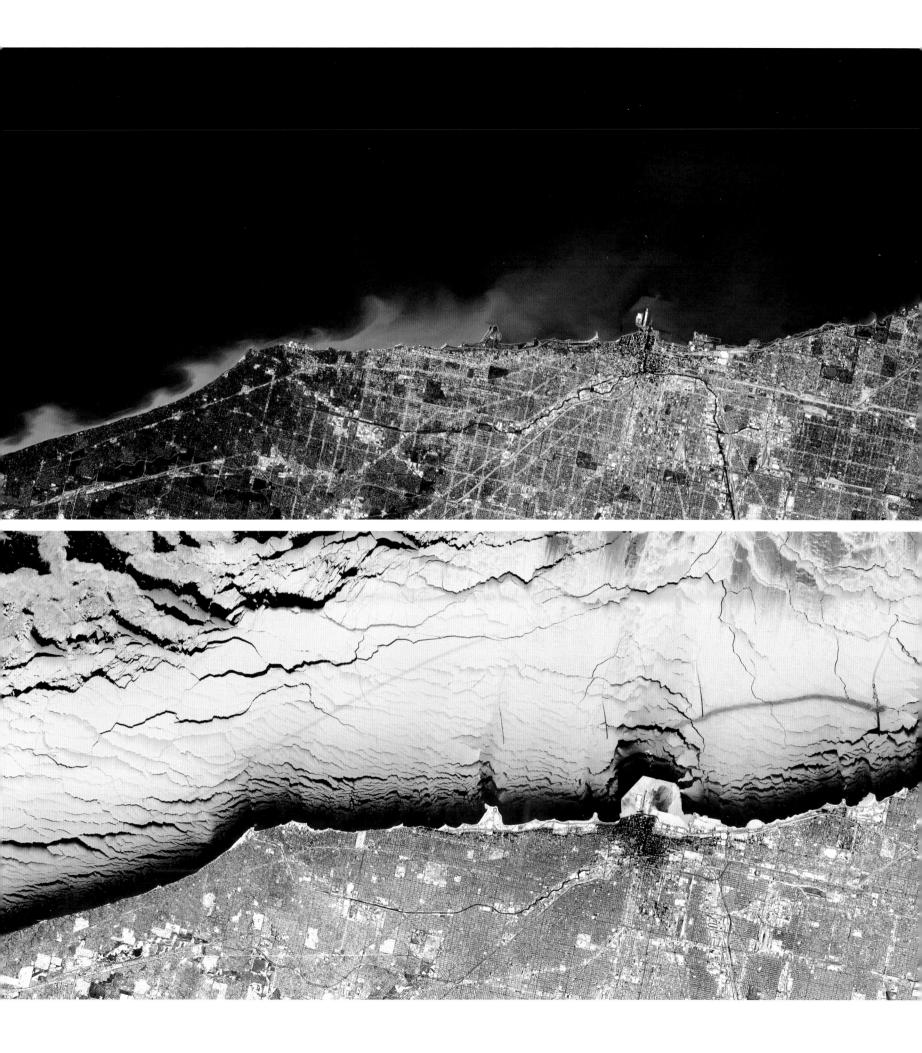

**Camp Fire**
November 8, 2018

The Camp Fire was one of the most destructive and deadliest wildfires in American history. From November 8, 2018 until November 25, 2018, the fire burned more than 153,000 acres (almost 240 square miles/620 square kilometers) of Northern California, destroyed more than 18,000 structures, and caused 86 fatalities. Fueled by high winds, the peak speed of the fire burned at 44 acres (18 hectares) per minute, or about one football field (100 yards/91 meters) every two seconds.

39.654918°, -121.456205°

**Camp Fire Aftermath**
Before / After

The town of Paradise, California, suffered sweeping devastation during the Camp Fire. Before-and-after imagery of this mobile home park shows the consequences of the rapidly moving flames. Paradise typically receives five inches (12.7 centimeters) of rain each summer; yet in 2018, the town only received one-seventh of an inch (3.6 millimeters) between May and November, creating extremely dry conditions that, combined with high winds, fueled the fast-spreading destruction.

39.783549°, -121.591681°

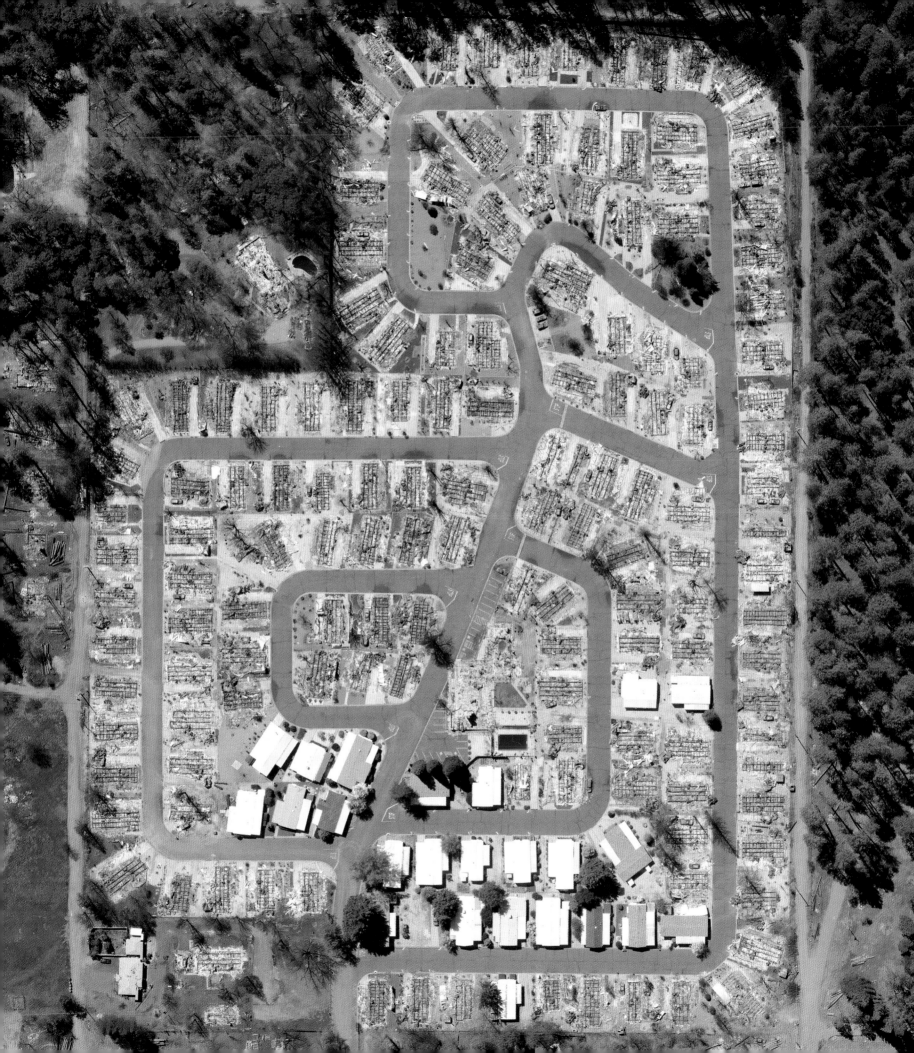

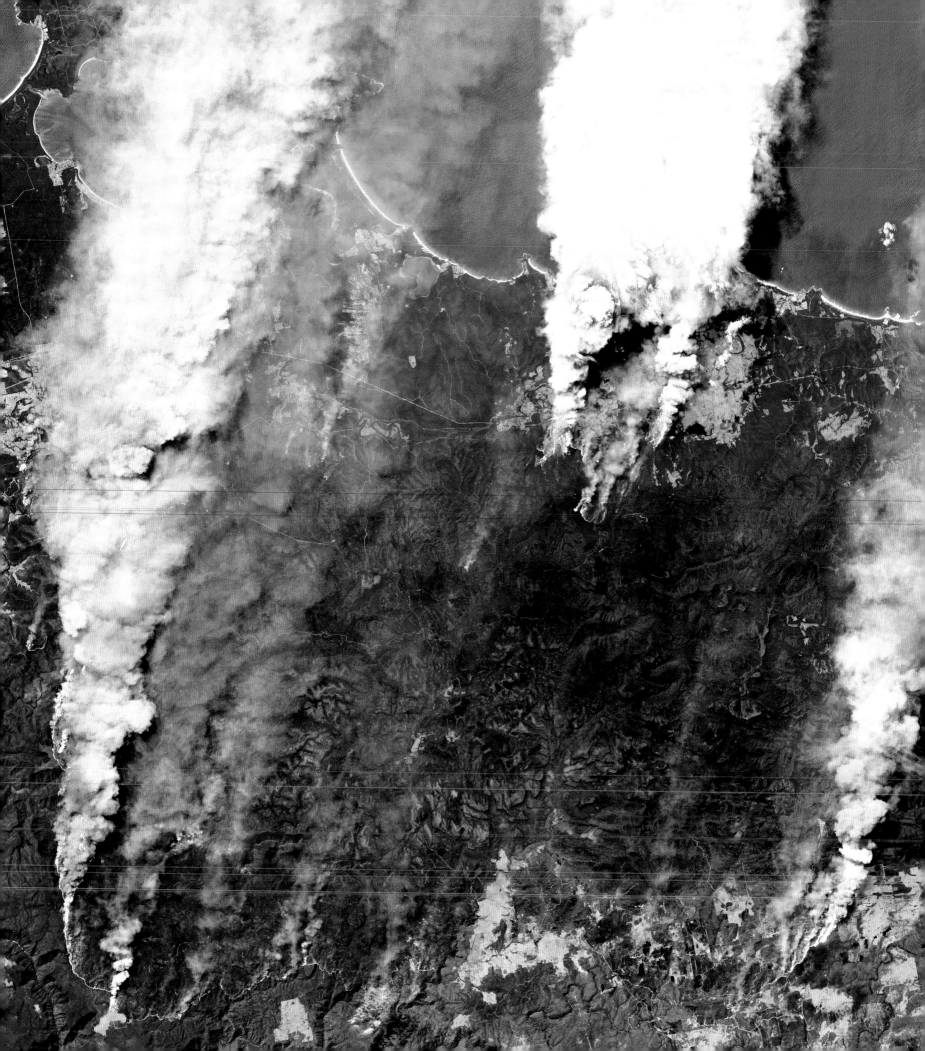

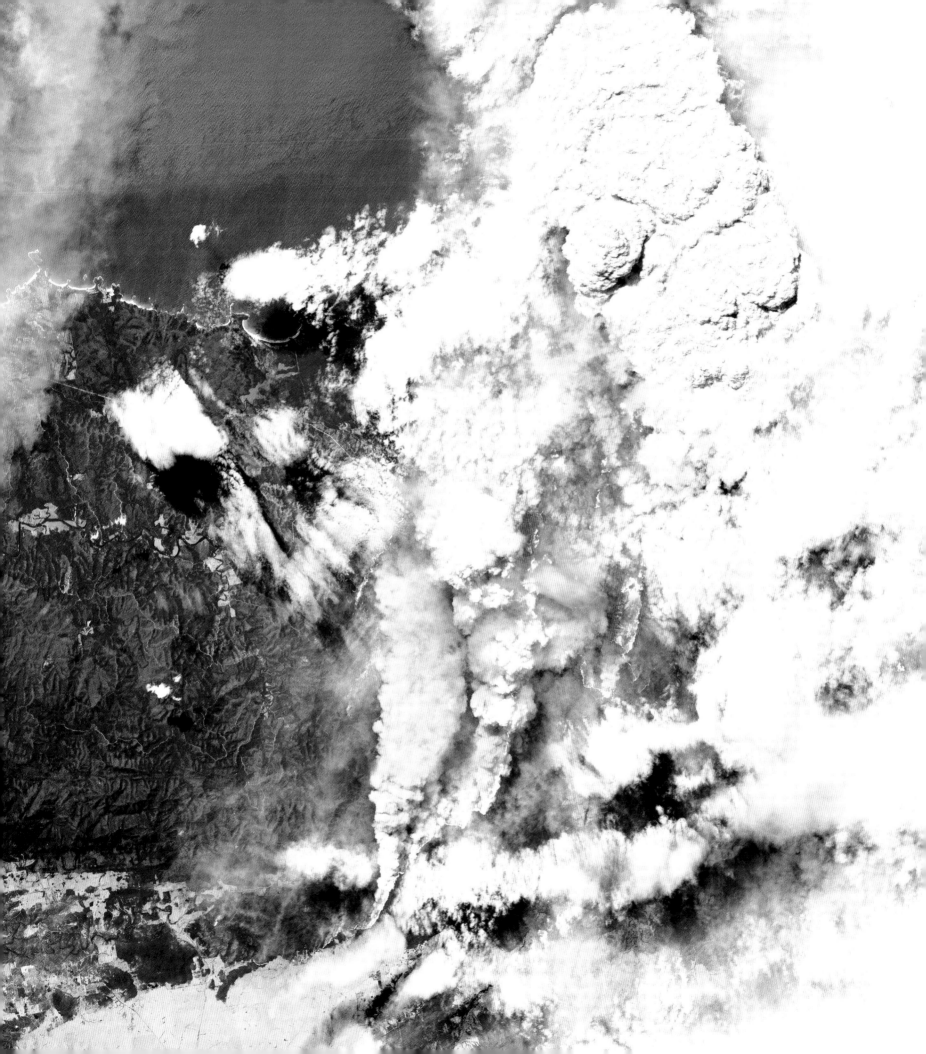

PREVIOUS PAGE

**Australian Bushfires**
December 31, 2019

Active bushfires affecting a 5,000-square-mile (12,950-square-kilometer) area of New South Wales, Australia are shown in the Overview on the previous page. At the time of this photograph, this massive burn accounted for just a portion of the 38,000 square miles (98,420 square kilometers) that had already been torched by the fires that started in September 2019. This coastal area of the country contains eucalyptus trees, which release volatile oils when burned and thereby create massive embers than can quickly jump to other areas of the forest. Climate conditions have not helped matters—the warmest year in Australian history combined with the lowest rainfall since 1900 created the dry conditions for the blaze. After 240 straight days of fire on the continent, torrential rains came in February 2020 and ended the fire season.

-35.336600°, 150.470500°

RIGHT

**Bushfires from Outer Space**
January 1, 2020

The Himawari-8 satellite, which photographs the earth every 10 minutes from 22,000 miles (35,406 kilometers) away, captured a massive plume of smoke coming from Australia on January 1, 2020. Smoke from the blaze was observed crossing the Pacific Ocean all the way to South America.

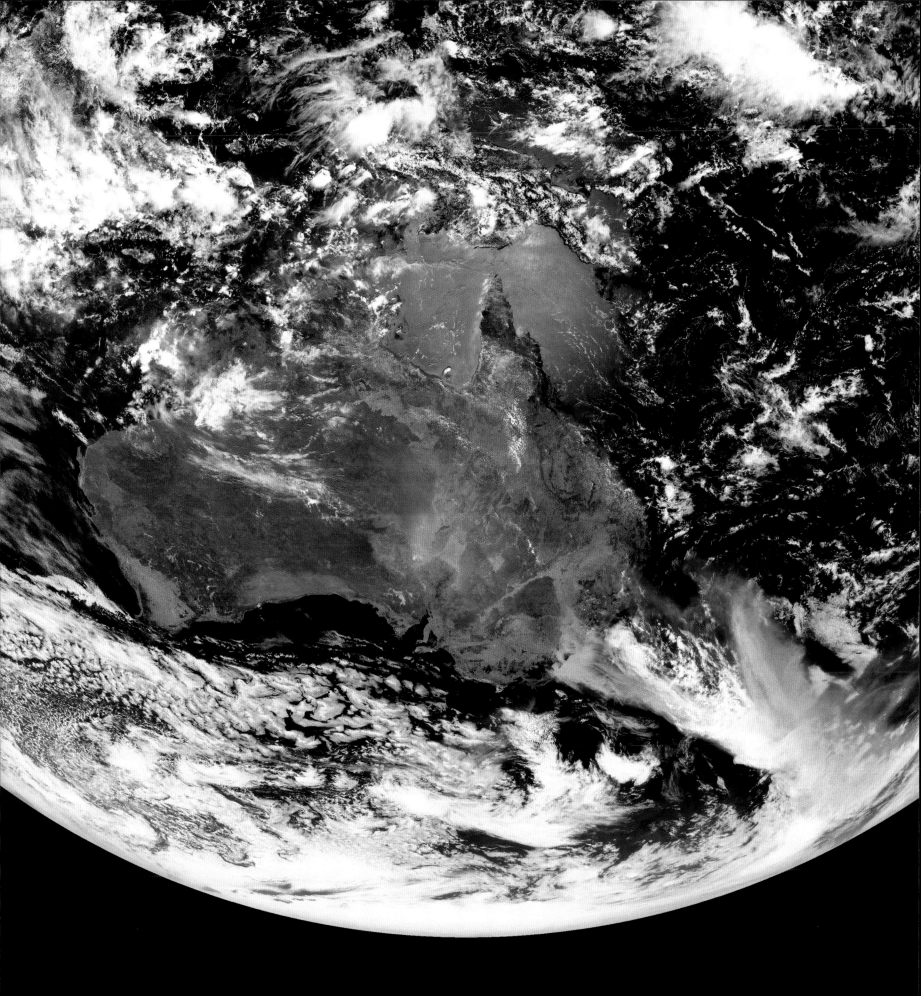

PREVIOUS PAGE AND RIGHT

**Cape Town Water Crisis**
April 2014 / April 2018

In 2018, the city of Cape Town, South Africa, home to 4 million people in its metro area, nearly became the first major city to run out of water. To get a sense of how serious the crisis became, the before-and-after Overviews on the previous pages show the parched Theewaterskloof Dam—the city's largest reservoir, which holds nearly half of its water supply. The zoomed-out Overview at right gives a macro look at the reservoir to see the dangerously low water levels.

Reports suggest that the crisis was caused by the combination of an unprecedented three-year drought that diminished the city's reserves, increased demand from a growing population, and ongoing mismanagement of the city's water resources. If this "Day Zero" had occurred, all taps in the city would have been turned off, and residents would have been forced to travel to roughly 200 collection sites within the city to collect a maximum of 6.6 gallons (25 liters) of water per person per day. Fortunately, the winter rains that came later in the year provided much-needed relief.

-34.078056°, 19.286978°

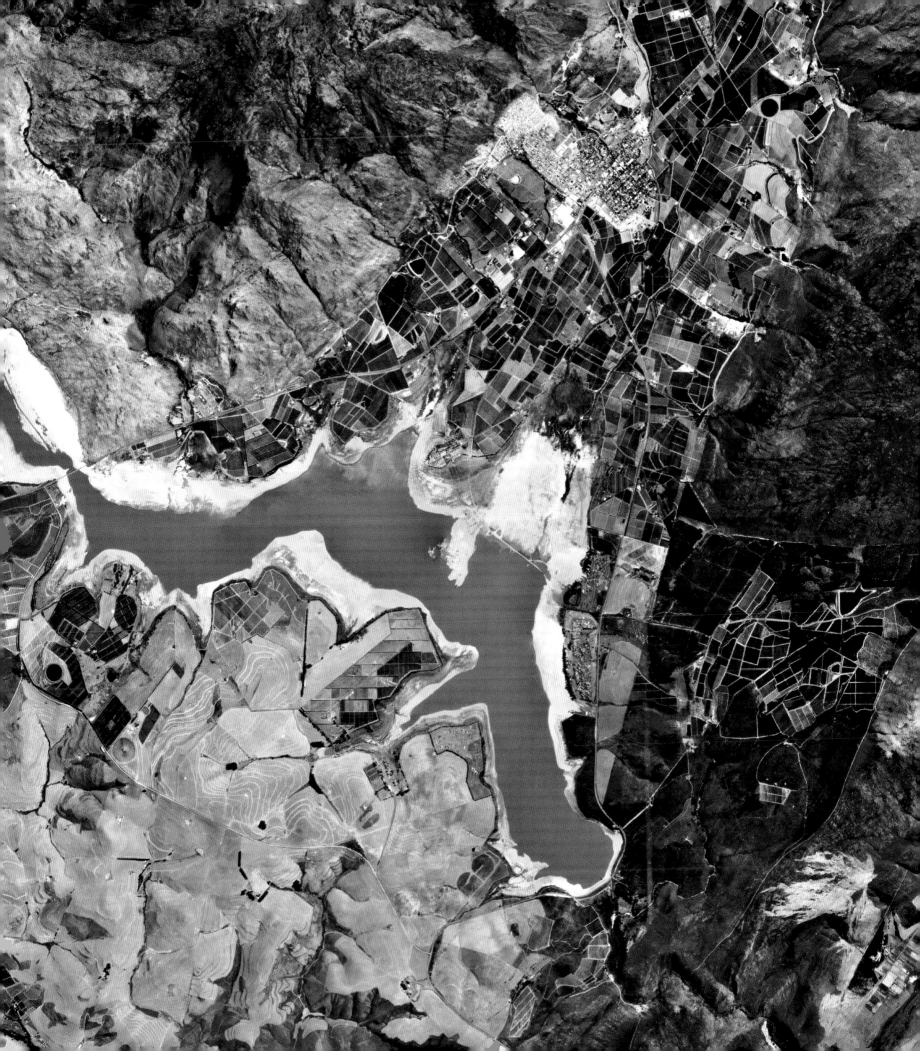

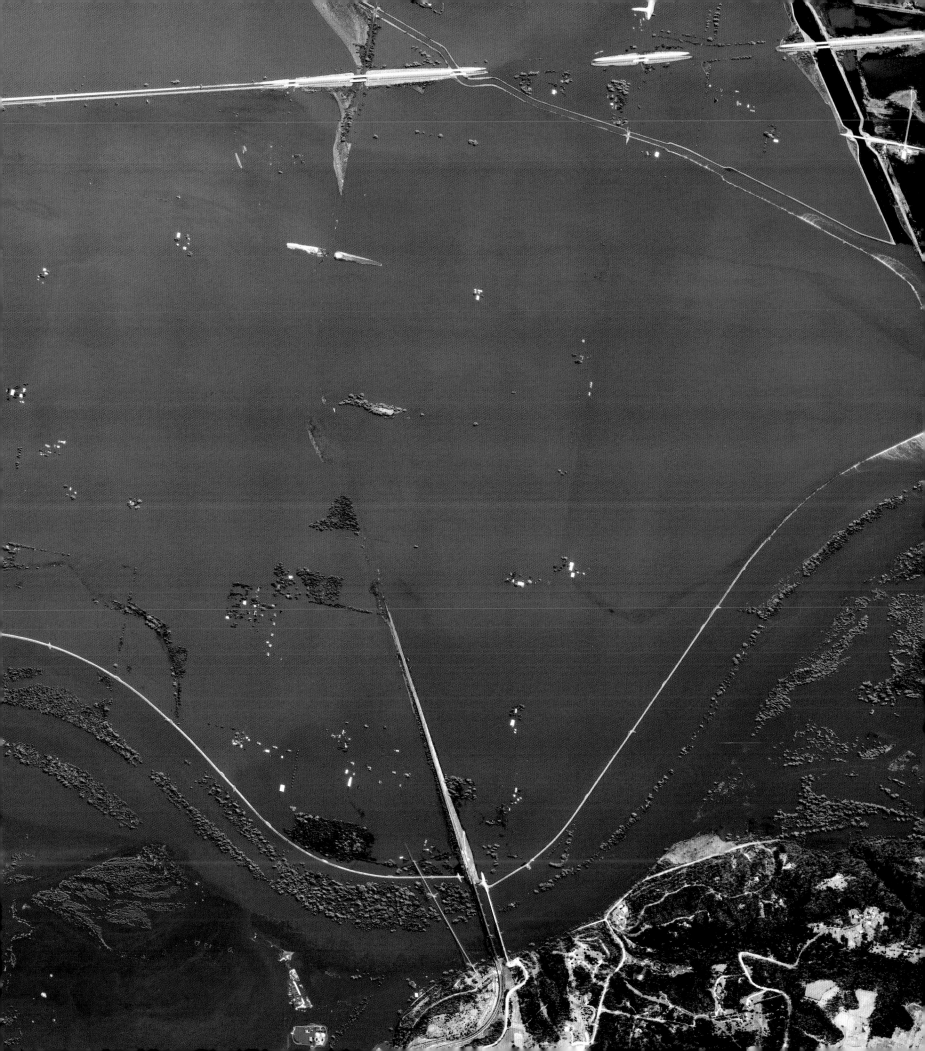

**Nebraska / Iowa Flooding**
August 2018 / March 2019

Farmland at the state border of Nebraska and Iowa experienced catastrophic floods in March 2019. Flooding across the Missouri River basin was caused by the cascade of a record snowfall, then rapid snow-melt, followed by heavy rainfall. The January-to-May period of 2019 was the wettest on record for the United States and destroyed at least 2,000 homes, 340 businesses, and a vast acreage of crops in this region. Across the Midwest, record-high river levels were set at 42 different locations and more than 1 million acres (404,686 hectares) of crops were destroyed. In the past century, annual precipitation has risen by 10 percent across the Midwest (the overall average for the country has gone up 7 percent). As temperatures rise, warmer air can hold more moisture and suddenly release it, leading to more volatile and unpredictable weather events.

41.021611°, -95.849611°

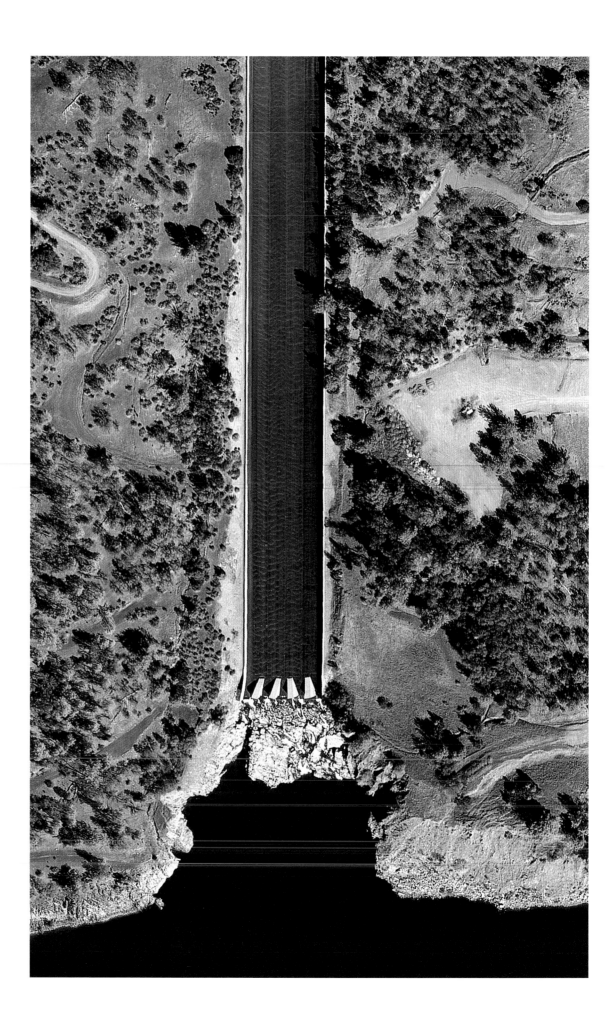

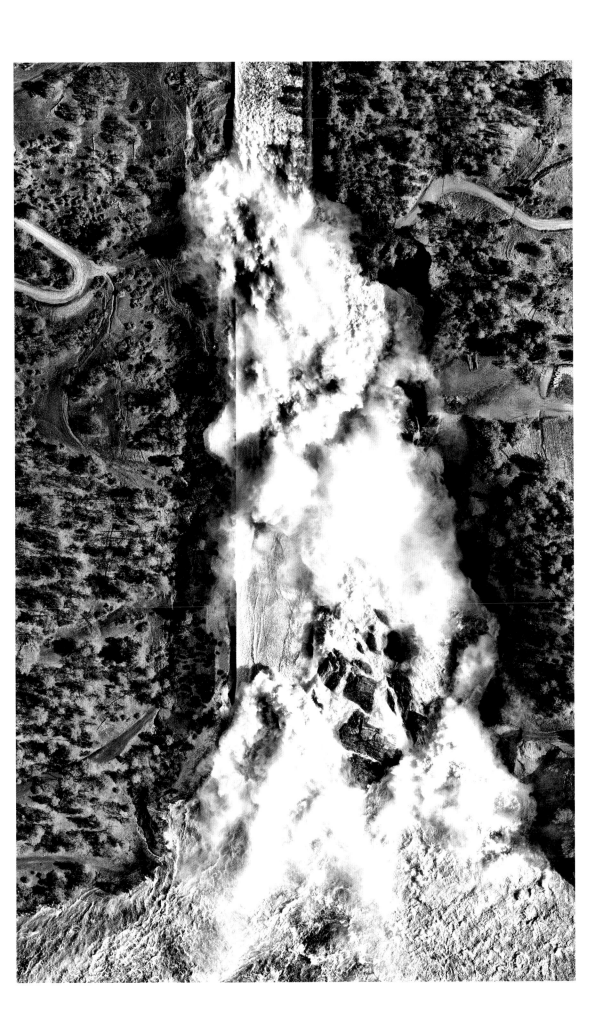

**Oroville Dam Spillway Rupture**
2012 / 2017

In February 2017, the Oroville Dam spillway—a structure used to provide the controlled release of flows from the reservoir above the dam—was severely damaged. Following the wettest winter in the history of Northern California, with record rainfall, water levels at the dam rose so quickly that the facility operators were forced to keep the spillway active even though its structure had been damaged under the pressure of huge volumes of water. What started as a small crater in the spillway's concrete expanded significantly, until the lower half of the chute was utterly destroyed. Downstream riverbanks collapsed, significant areas of farmland were flooded, and over 188,000 people in the Feather River valley were evacuated as officials feared the complete collapse of the dam's other emergency spillway. As of September 2018, the cost of repairs at Oroville was estimated at $1.1 billion.

39.539222°, -121.496833°

**Yakutia Permafrost Melt**
2018

———

Vibrantly colored lichens and mosses can be seen here alongside frost-covered ground in Yakutia, Russia. The Yakutia region is one of the coldest inhabited places on Earth with an average January temperature of -41.3°F (-40.7°C). However, annual temperatures here have risen more than four degrees, to 18.5°F (-7.5°C) from 14°F (-10°C), over several decades. This warming has led to increased melting of the region's permafrost—a thick subsurface layer of soil that remains frozen throughout the year. As permafrost thaws across Yakutia and other arctic areas, stored methane is released into the atmosphere, which warms the planet 84 times more than carbon dioxide over a 20-year period. In 2013 alone, melting of permafrost is believed to have released 18.7 million tons (17 million metric tons) of methane—a significant increase on the 4.2 million tons (3.8 million metric tons) estimated to be released in 2006.

67.918400°, 147.060800°

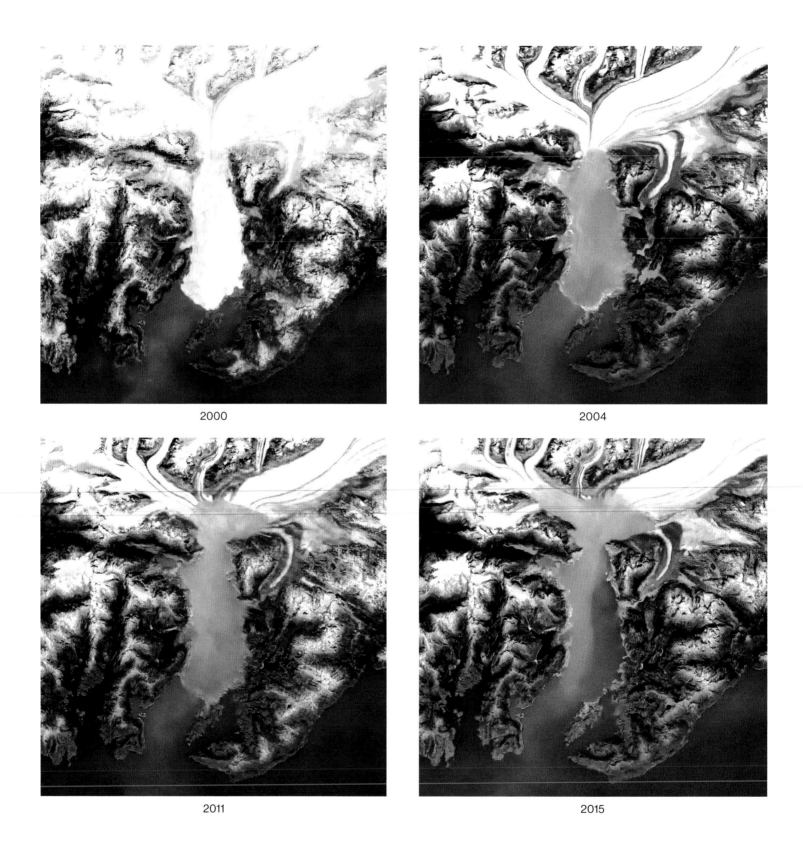

2000

2004

2011

2015

PREVIOUS PAGE, ABOVE, AND OPPOSITE

**Columbia Glacier Recession**
2019 / 2000–2019

The Columbia Glacier in southeastern Alaska is one of the most rapidly receding ice floes in the world. Since the 1980s, the glacier has lost more than half its total volume, which has led to a retreat of the ice more than 12 miles (19 kilometers) to the north. By 2008, the glacier had retreated back to the top of the surrounding inlet and split into separate glaciers that have continued to calve (break off at the end) on various fronts since. While rising air and water temperatures are believed to have played a role in starting the glacier's recession, the melting of the glacier at its terminus (ending point) has contributed greatly to its instability and the accelerated ice loss that has followed.

61.219722°, -146.895278°

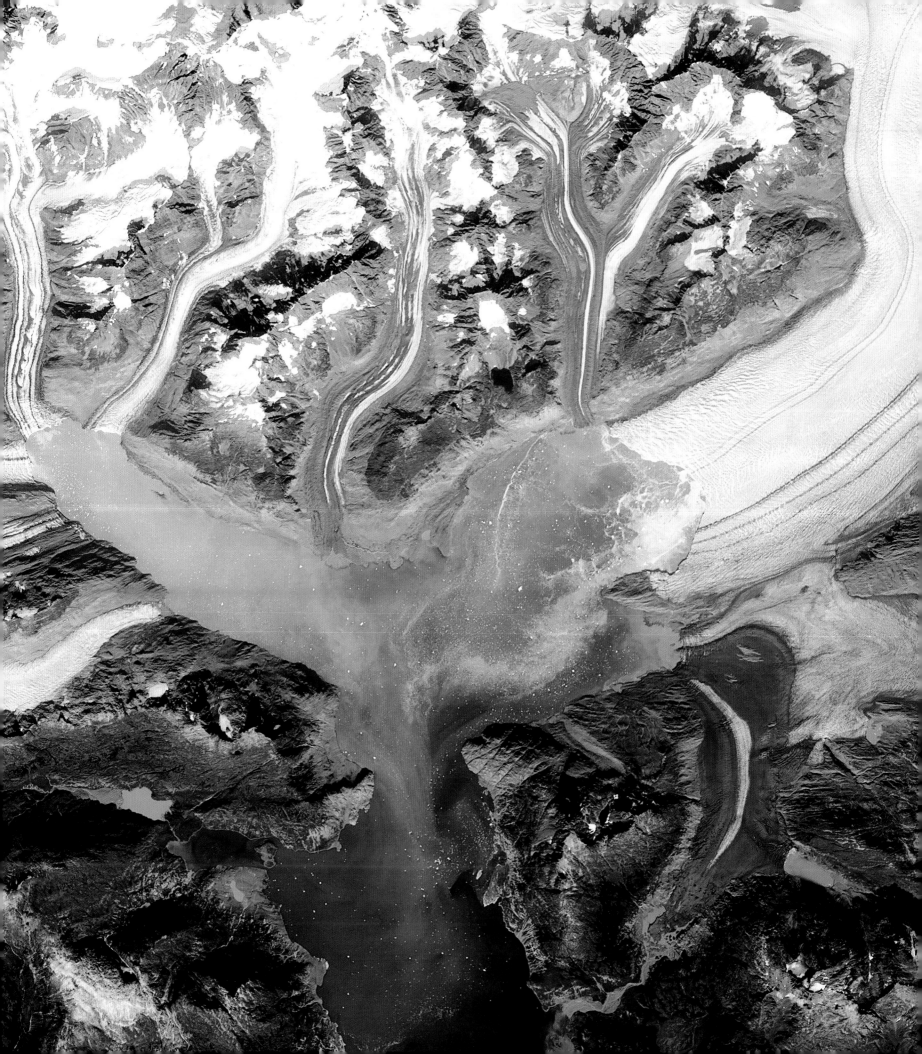

**Greenland Ice Sheet Early Melting**
June 8, 2019 / June 10, 2014 / June 15, 2016

———

Greenland's ice sheet is melting seven times faster than it was in the 1990s—averages of 33 billion tons (29.9 billion metric tons) of melt have risen to 254 billion tons (230 billion metric tons) in recent years. During the spring and summer, the surface of Greenland transforms from a solid white to one where blue streams and lakes emerge. This melting contributes directly to sea level rise because the water that is frozen here is situated on top of a large land mass (in contrast to floating sea ice that makes up much of the rest of Arctic ice).

In 2016, Greenland's melting accelerated with unusually high temperatures; for example the capital city of Nuuk recorded a 75°F (23.8°C) day on June 9, 2016—the highest temperature ever recorded there in June. In these images from the ice sheet in June 2014 (above) and June 2016 (opposite), clear differences in ice coverage and melting can be observed. In total, scientists estimate that half of the ice loss from Greenland was caused by increased air and surface temperatures (which have risen much faster in the Arctic than the global average) and the other half was from the speeding up of the flow of ice into the sea from glaciers, driven by a warmer ocean.

69.621400°, -49.758500°

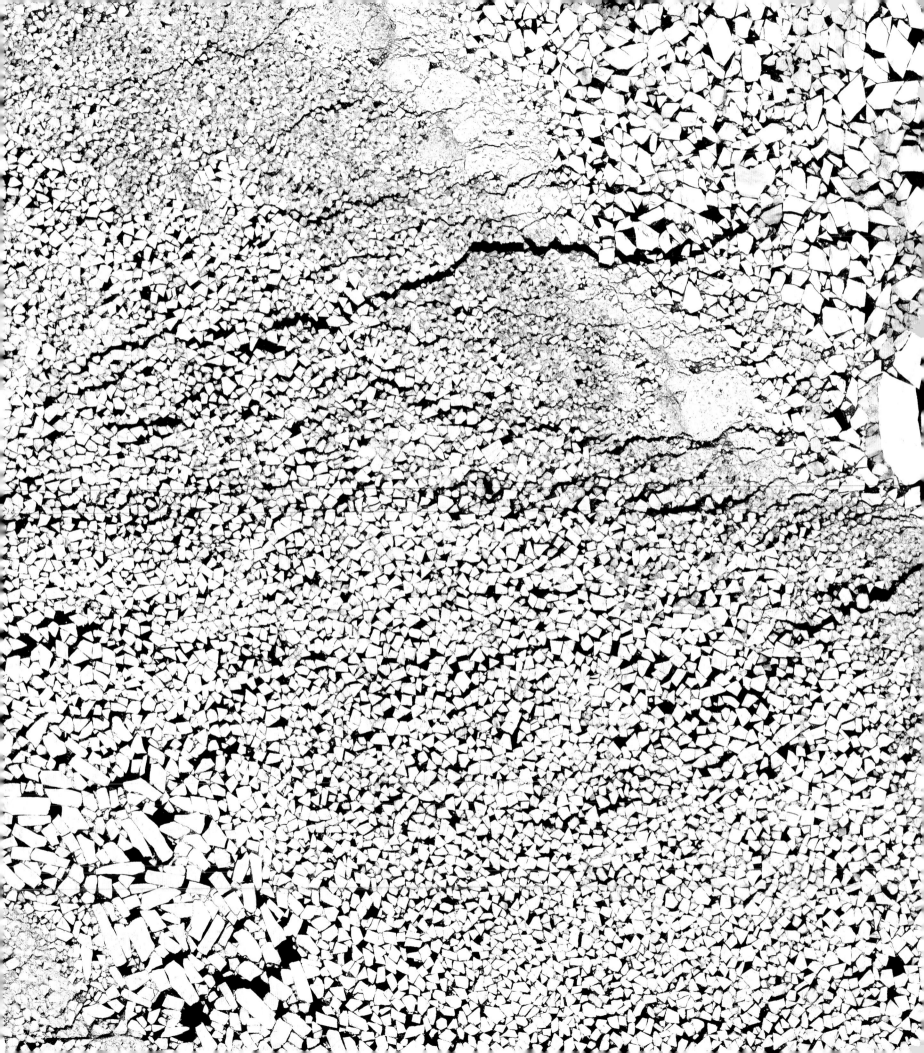

**Antarctic Sea Ice Melt**
2019

———

Sea ice is seen on the previous page broken apart in various block sizes roughly 40 miles (64 kilometers) off the coast of Antarctica. Antarctic sea ice extends far north in the winter and retreats almost to the coastline every summer. The ice is frozen seawater that is usually less than 3 to 6 feet (0.9 to 1.8 meters) in thickness. Sea ice is significantly thinner than ice shelves, which are formed by glaciers, float in the sea, and are up to 3,280 feet (1 kilometer) thick. In the 1980s, Antarctica lost 40 billion tons (36.3 billion metric tons) of ice every year. In the last decade, that figure was estimated at a staggering 252 billion tons (229 billion metric tons) per year. When ice melts, it often exposes a darker area of soot and dirt beneath its surface and turns into darker, liquid water once it is fully melted. Dark surfaces absorb more heat, and thus the accelerated melting of the world's ice could initiate a feedback loop that further speeds up the warming process that is causing the melting in the first place.

-65.539300°, 101.884100°

RIGHT, TOP AND BOTTOM

**Melting at Esperanza Base**
September 2019 / February 2020

———

Visible melting of ice and snow can be seen at Esperanza Base, a Chilean research station in Antarctica. On February 6, 2020, the day before this second Overview was captured, the base recorded high temperatures of 64.9°F (18.3°C)—the hottest temperature ever recorded in Antarctica. Roughly the same temperature in Los Angeles that day. The Antarctic Peninsula is one of the fastest-warming regions on Earth, with average temperatures rising almost 5.4°F (3°C) over the past 50 years.

-63.398131°, -56.997277°

> "The climate crisis has already been solved. We already have the facts and the solutions. All we have to do is wake up and change."
>
> — Greta Thunberg

# Human

The earliest human civilizations could never have anticipated how quickly or significantly we would transform the earth. Until relatively recently, the majority of humans had no reason to believe that our activity could affect the balance of the climate. Regardless of what we have believed or ignored, it is now clear that our combined, continued action is indeed causing a reaction by some of Earth's natural forces. In the past decade, we have observed numerous large-scale catastrophes and migrations related to the climate. And while some of us have not experienced such events firsthand, global crises like the COVID-19 pandemic of 2020 remind us that certain phenomena have the power to threaten our collective stability, not just that of certain people or areas of the planet.

The examples in this chapter represent how our species has chosen to react to the backlash of an environment we helped shape. From greater adoption of low-carbon energy sources to building environmentally conscious architecture, we can address the current reality and future of our civilization's effect on the planet. We have seen collaborative efforts between nations to combat major environmental issues from desertification to sea-level rise—evidence of our willingness to work together when it comes to solving problems that transcend borders. Perhaps the climate crisis will spur the most important international collaborations to date. It will take time for many of these projects to be designed, for agreements to form, and to hopefully see results. Therefore, we must simultaneously react to the problems we have already created, do our best to prepare for future climate events, and push for large-scale shifts in energy production to quickly and conscientiously move away from fossil fuels—the most crucial step to stop warming. The time to create the interest and momentum for these actions is now. It is clear that when we have a unified purpose, we can collectively take unprecedented action.

As we reflect on a time when a global pandemic put much of our activity on hold, briefly slowing rates of emissions, we are still faced with unprecedented urgency to prevent as much further warming as we can. There is technology that we already know of that removes carbon from the atmosphere—trees—and hopefully we will focus our attention on conservation as well as developing new technologies that mimic that process with efficient carbon capture and storage. If adaptation is defined as the "successful interaction between a population and its environment," we will need to update much of our civilization and systems in order to have success in our story on this planet. The shift to a world where humans live sustainably with the earth would be our greatest adaptation yet.

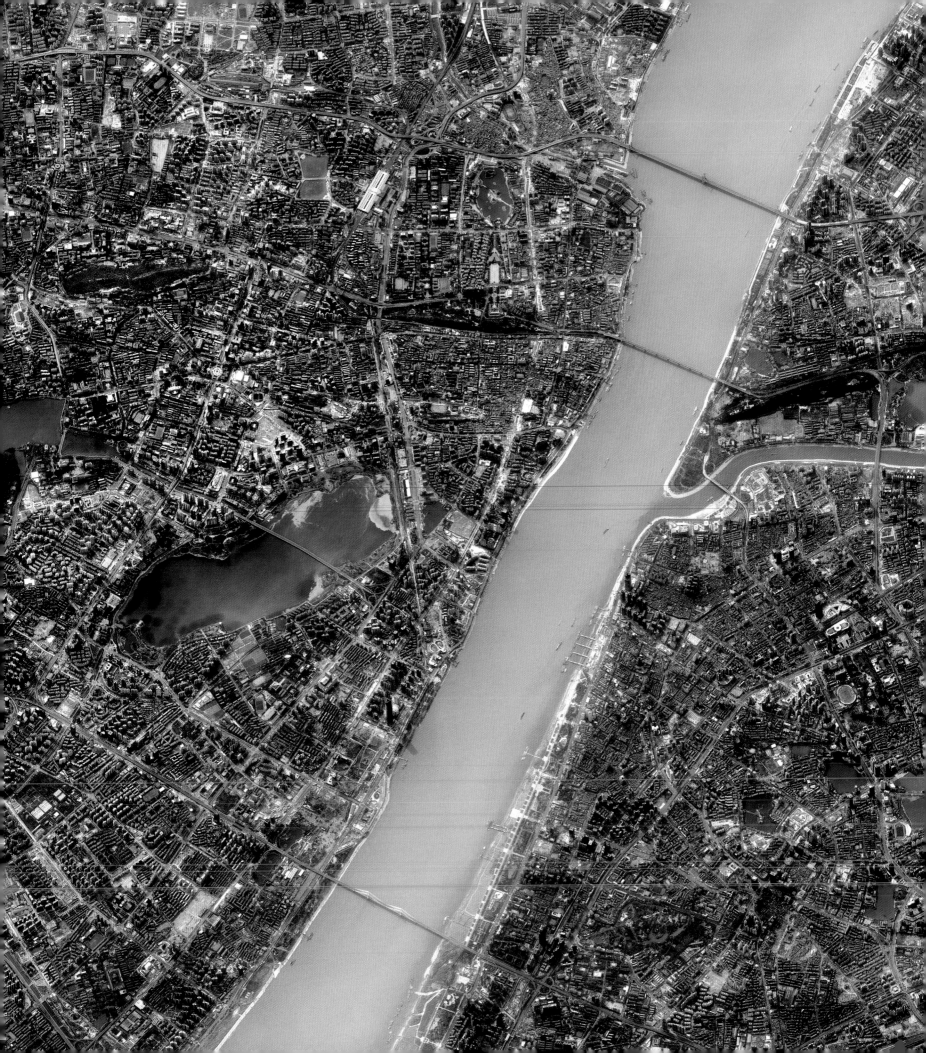

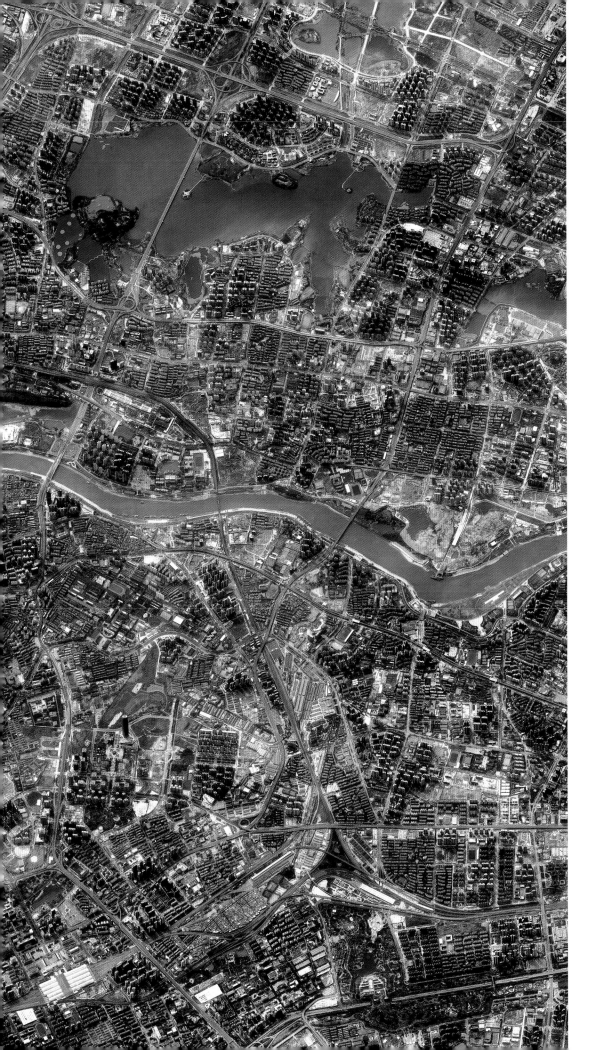

## COVID-19 Pandemic

**Wuhan Lockdown**
February 2020

Wuhan is the capital of Hubei province in China, and home to roughly 11 million people. In December 2019, the outbreak of COVID-19, also known as the coronavirus, began in Wuhan. It is believed that the virus originated from the sale and ingestion of contaminated meat products sold at a market in the city. In an unprecedented reaction to the crisis, the Chinese government restricted the movement of Wuhan residents and closed off the city on January 23, 2020. The entirety of Hubei province was subsequently quarantined for two months to limit the spread of the virus. During the lockdown, China experienced a 25 percent decrease in emissions as many industrial production factories in the Hubei region were forced to close.

Despite the extreme quarantine measures, the coronavirus rapidly spread from Wuhan to other cities and countries around the world due to its highly contagious nature and the delay between an individual's exposure and first symptoms. The far-reaching spread was in part enabled by the urbanization and transportation that our civilization is built upon. Densely populated cities such as Madrid, Milan, and New York City saw rapid transmission between residents living and working in close proximity. Moreover, global transit networks enabled the virus to easily move across borders, often undetected for many days.

30.532413°, 114.277261°

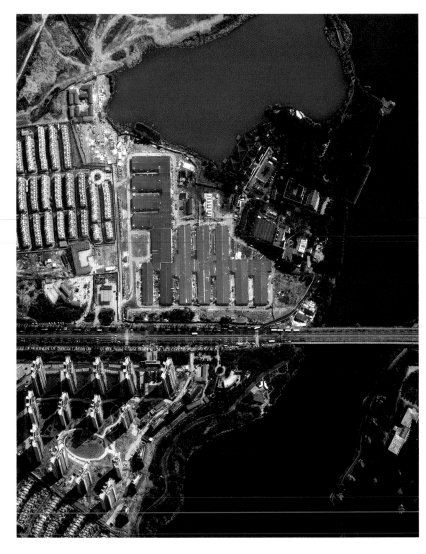

**Wuhan Hospital Construction**
Before / After

———

Huoshenshan Field Hospital in Wuhan, China, was built over a ten-day period between January 23 and February 2, 2020. Constructed by more than 7,000 people working around the clock, the facility was a major initiative in the Chinese government's response to slow the spread of COVID-19. The hospital included 1,000 beds with 30 intensive care units, medical equipment rooms, and quarantine wards.

30.529100°, 114.082200°

**Social Distancing Measures**
February 14, 2020 / March 9, 2020

———

In an effort to combat the spread of COVID-19, the Saudi Arabian government banned travel to the country and closed its holy sites for numerous days. The Grand Mosque of Mecca, which typically sees thousands of Muslim pilgrims each day can be seen with significantly less visitors upon reopening following a sterilization. Countries around the world engaged in large scale lockdowns in an attempt to slow the spread of the virus. In April 2020, more than 3 billion people across the world were under instruction to stay at home.

21.422523°, 39.826181°

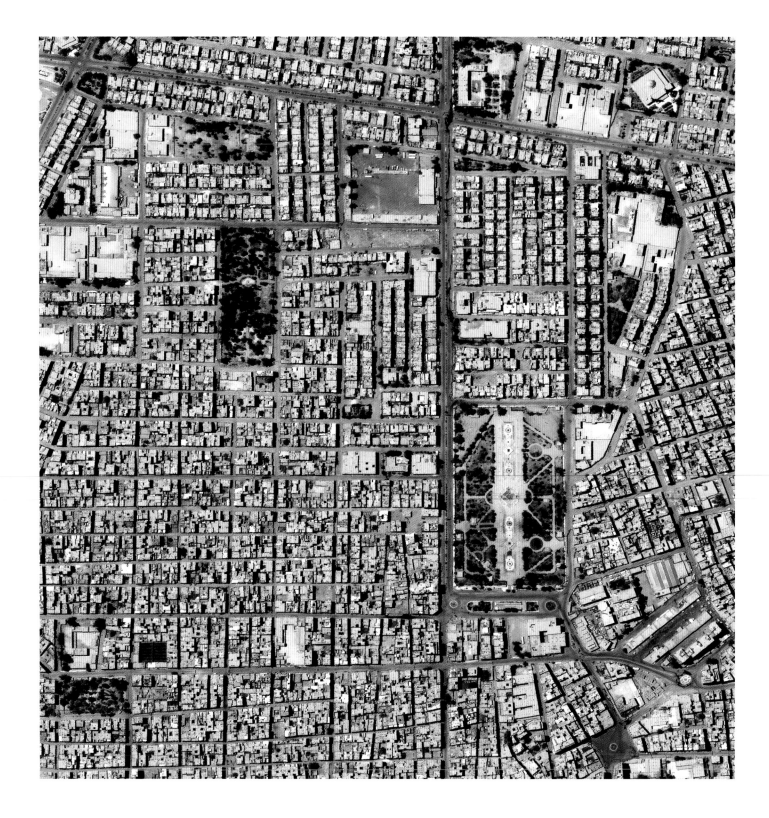

**Abandonment of Deir ez-Zor**
2012 / 2018

Deir ez-Zor is the largest city in eastern Syria. Here it is seen before and during the Syrian Civil War. Extended periods of drought in the late 2000s and early 2010s forced Syrian farmers and others dependent on the agriculture industry into cities like Deir ez-Zor, exacerbating existing political unrest. This tension is believed to be a major factor in setting off the Syrian Civil War, the ultimate cause of the world's largest refugee crisis, with over 5 million refugees fleeing to neighboring countries, Africa, and Europe to escape the conflict.

The World Bank estimates that climate change could create more than 140 million new refugees in Sub-Saharan Africa, South Asia, and Latin America by 2050. The vast majority of climate migrants are expected to move to new areas within their own countries, putting pressure on the resources of already stressed cities and rural communities.

35.333333°, 40.150000°

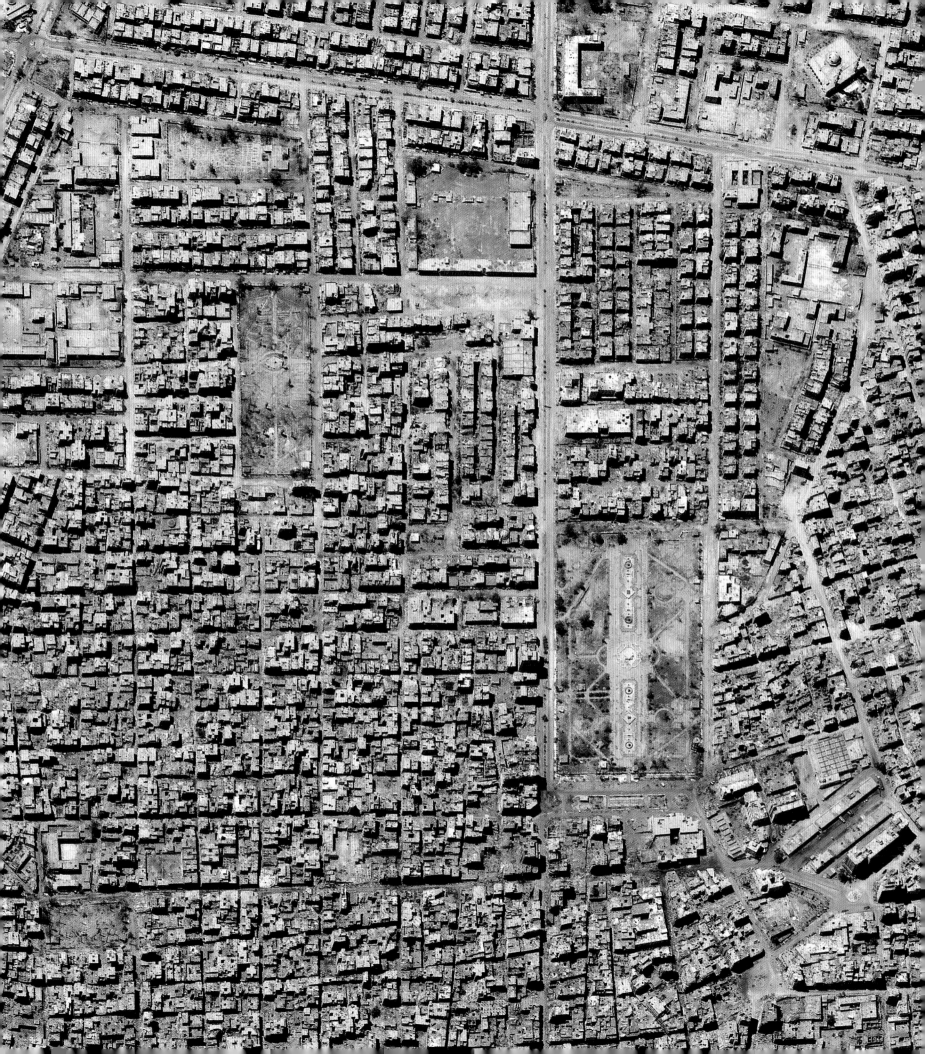

# Syrian Refugee Crisis

BELOW

## Zaatari – Jordan
2016

The Zaatari refugee camp is the world's largest facility for Syrian refugees. Originally built as a temporary solution in 2012, 15,000 people moved to the camp within the first month of it being open. By 2013, that number jumped as high as 156,000, despite official capacity listed as 60,000. The current population is estimated at 80,000. The main concerns with camps such as Zaatari are a lack of adequate food supplies and the poor quality of living conditions due to crowding.

32.295667°, 36.323750°

BELOW

## Kilis – Turkey
2018

The Kilis camp contains roughly 15,000 Syrian refugees. Overall, Turkey has taken in an estimated 3.4 million refugees since the beginning of the crisis. However, as early as mid-2016, they began disbanding these facilities, forcing thousands of Syrian refugees to return to active war zones.

36.646944°, 37.083056°

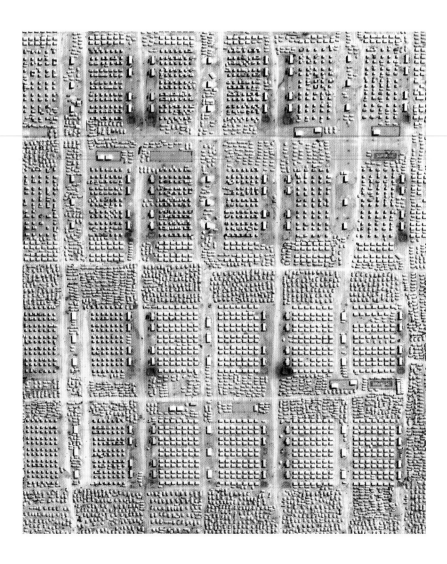

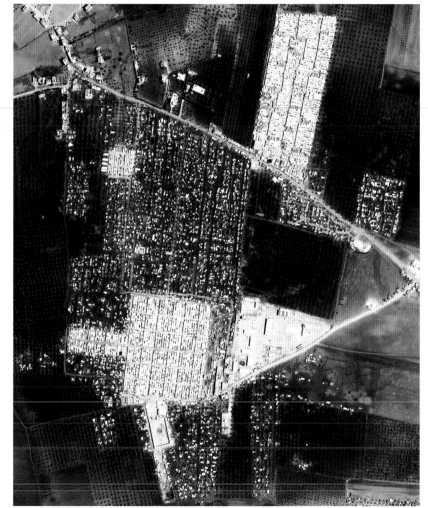

**Röszke – Hungary / Serbia Border**
2015

———

In 2015, hundreds of Syrian refugees set up temporary shelter with tents and buses at the Hungary–Serbia border by the Hungarian town of Röszke. This image was captured two days before Hungary closed its borders and forced those fleeing back into Serbia.

46.181700°, 20.010900°

**Moria – Greece**
2019

———

Originally built to house about 3,000 people, Moria is now home to more than 13,000 refugees. Many of the refugees who settled here live outside of the camp's walls, without electricity or running water.

9.134579°, 26.503564°

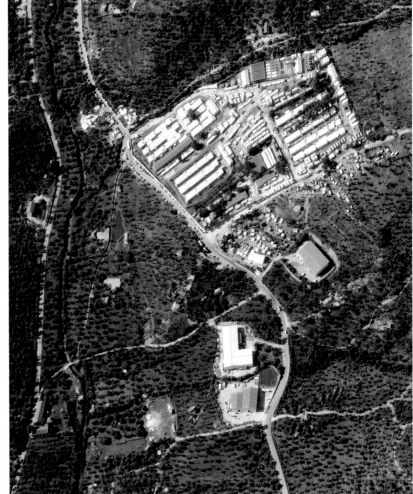

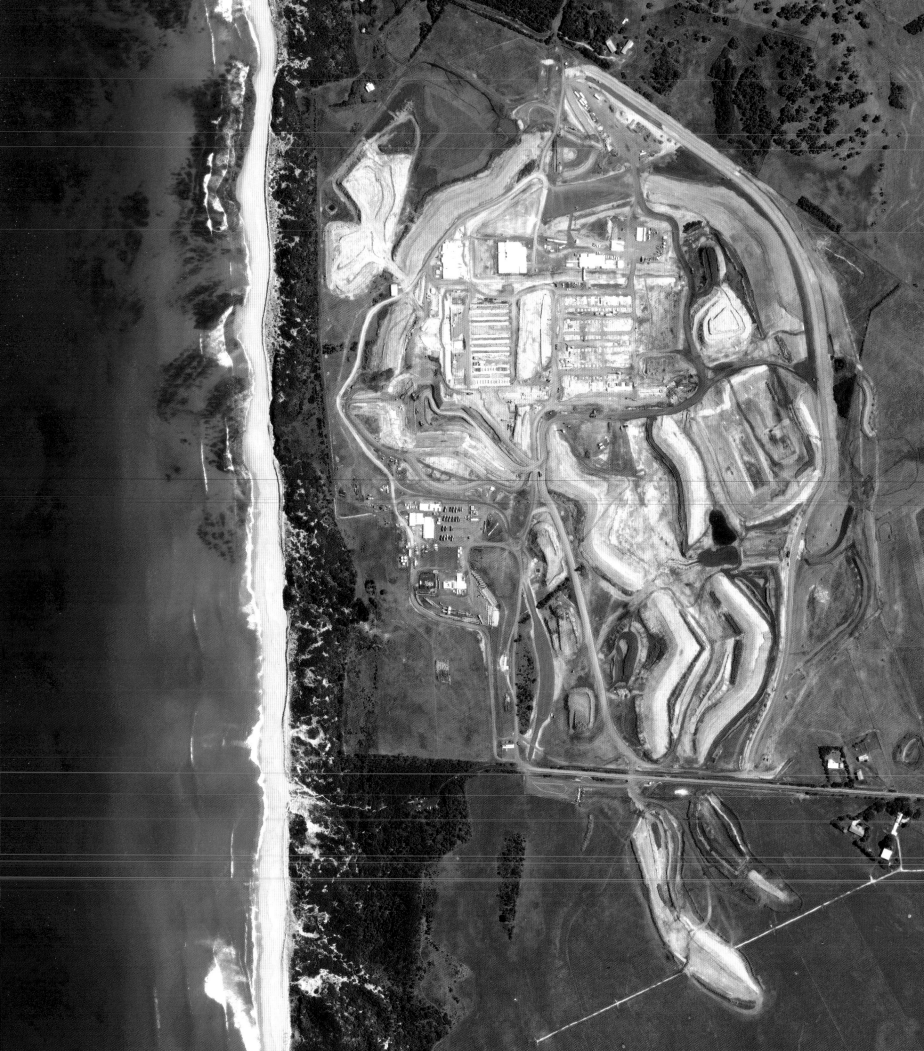

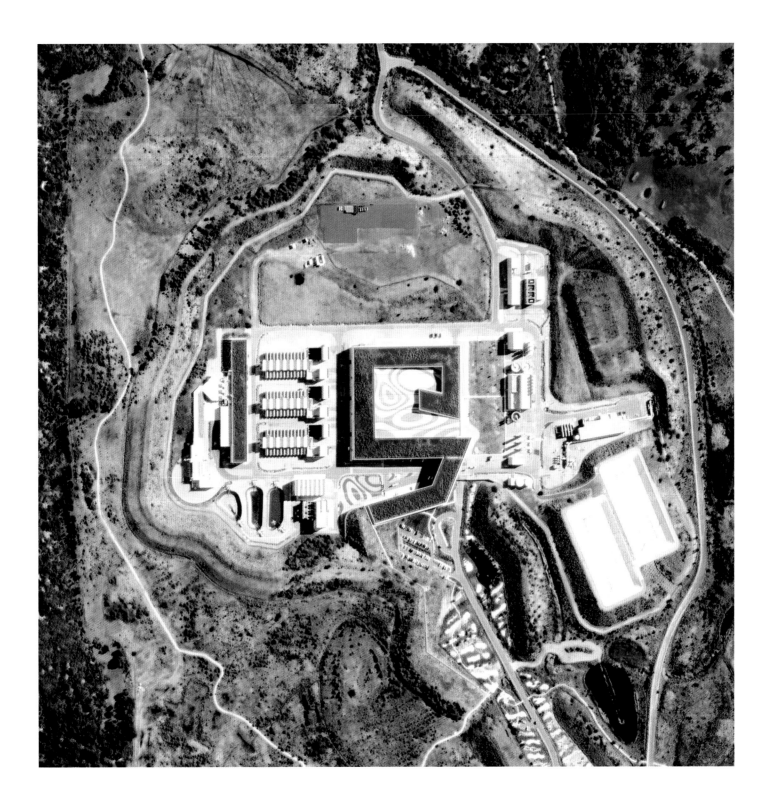

OPPOSITE AND ABOVE

**Victorian Desalination Plant**
2010 / 2019

The Victorian Desalination Plant was constructed over a four-year period to provide water stability to the city of Melbourne, Australia. In 2009, water levels decreased to 28.4 percent of what was normal due to the combination of drought, population growth, and pressure on reserve storage. Upon the completion of the project in 2012, the city no longer had a water shortage, and the factory sat on standby until it became operational in 2017. With estimated annual production of 150 gigaliters, this facility has the potential to provide up to a third of Melbourne's annual water consumption. While desalination plants increase access to usable water, their energy requirements remain a concern—separating salt from water requires approximately fifteen times the amount of energy as compared to using local freshwater supplies.

-38.588000°, 145.526000°

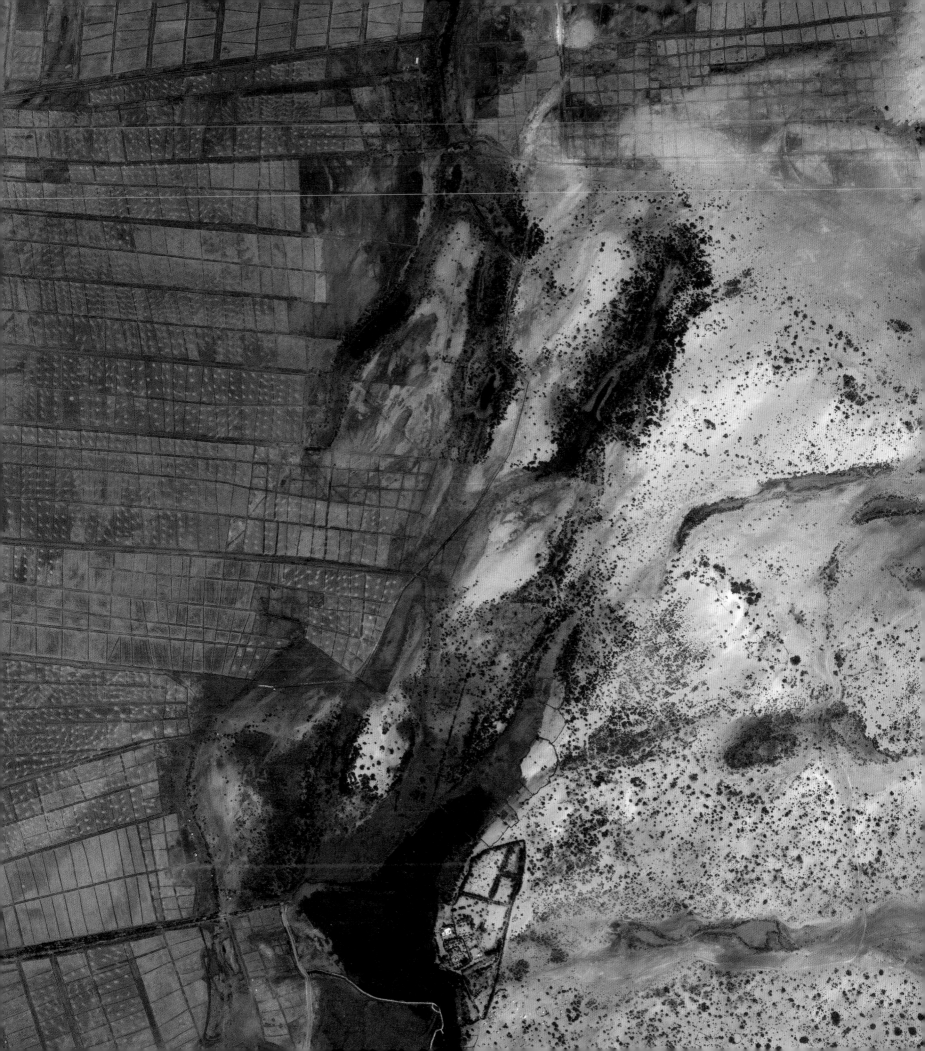

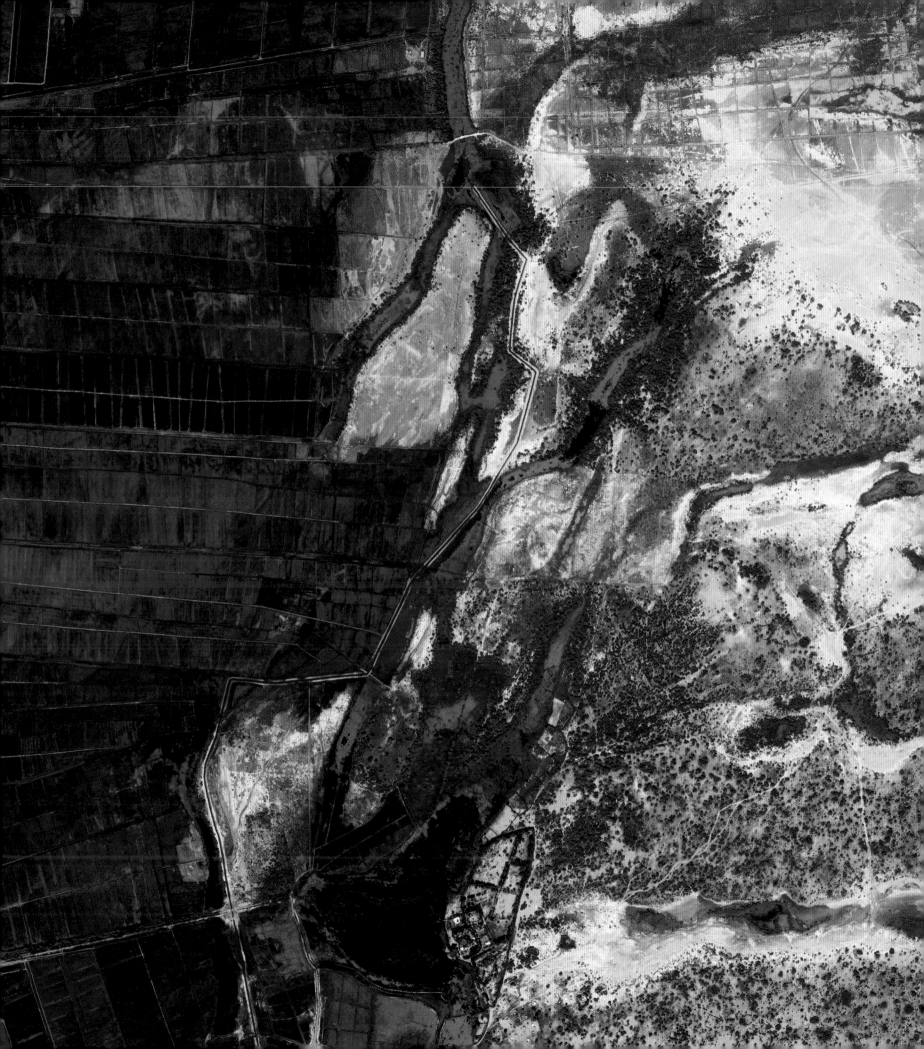

**Great Green Wall of Africa**
2018 / 2019

The Great Green Wall is an anti-desertification initiative underway in Africa's Sahel region, on the southern edge of the Sahara Desert. Desertification is a type of land degradation that occurs in dry regions, where a lack of water and expanding desert leads to a loss of biological and agricultural productivity. The project intends to restore 250 million acres (101.1 million hectares) of degraded land by 2030 by planting a 5,000-mile (8,047 kilometer) tree line. The section in these Overviews is located on the border of Mauritania and Senegal. If effective, the wall will stop the advancement of the desert, absorb 250 million tons (226.8 million metric tons) of carbon dioxide from the atmosphere, and create 350,000 rural jobs. The Sahel is on the front line of climate change, as millions of residents have already been impacted by droughts, lack of food, conflict over limited resources, and climate migration.

16.528218°, -16.091333°

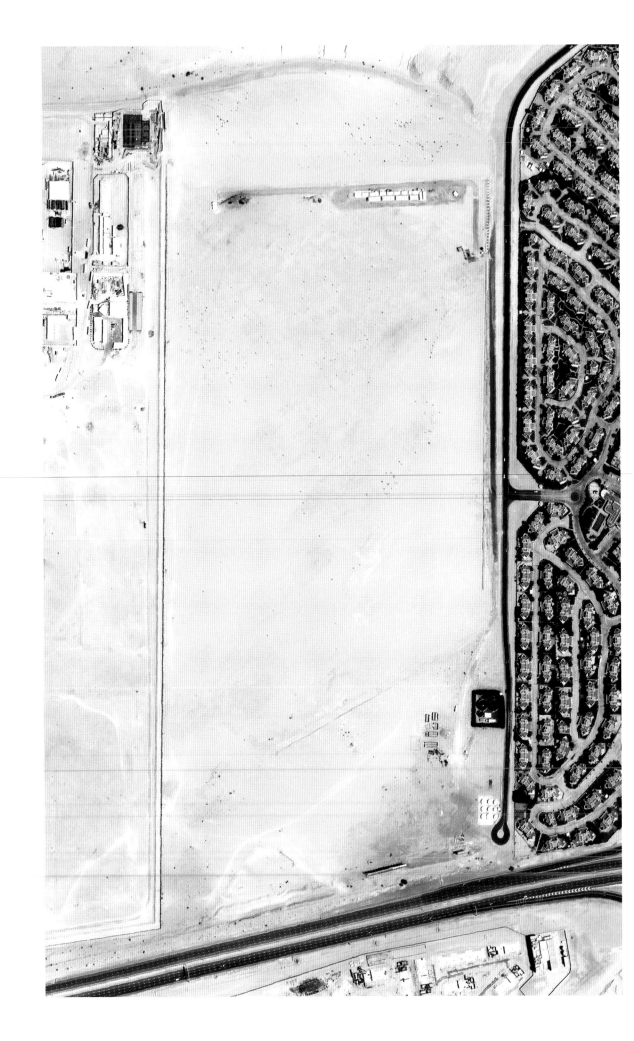

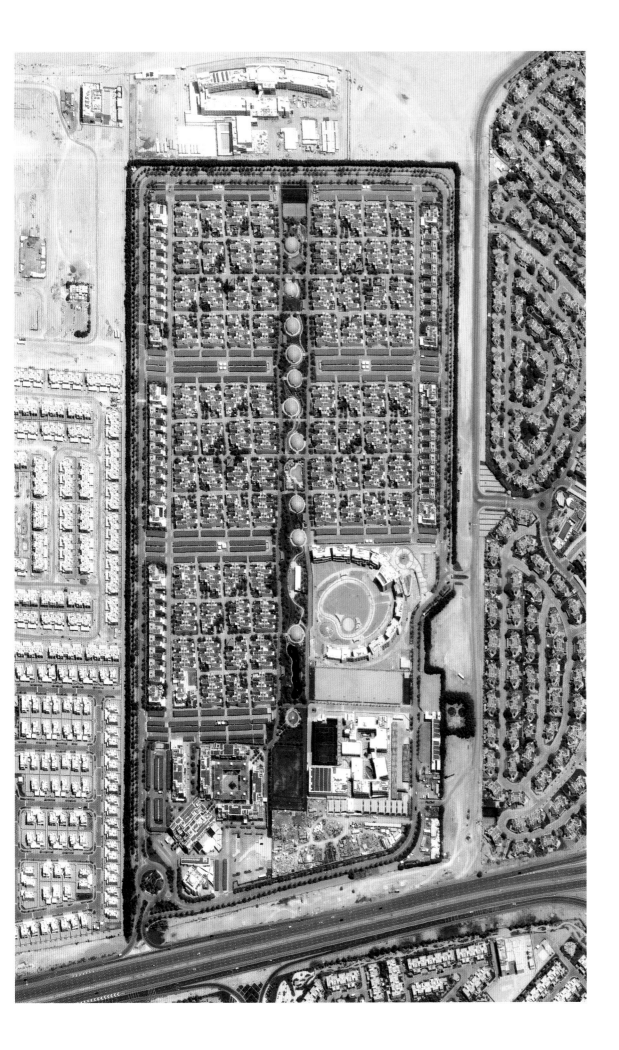

**The Sustainable City**
2012 / 2019

The Sustainable City is a complex in Dubai, United Arab Emirates, that was built to be the first net-zero-emissions energy development in the country. The area is home to roughly 2,700 people with 500 homes, 89 apartments, and additional areas for offices, retail, health care, and food shopping, all on-site. With 11 "biodome" greenhouses (seen middle), much of the produce for residents is grown within the "city," using a passive cooling system that keeps energy requirements low. All houses come equipped with solar panels on the roof and are painted with a UV-reflective paint to reduce thermal heat buildup inside homes. The United Arab Emirates aims to generate 75 percent of the Dubai's energy from renewable sources by 2050.

25.029694°, 55.278103°

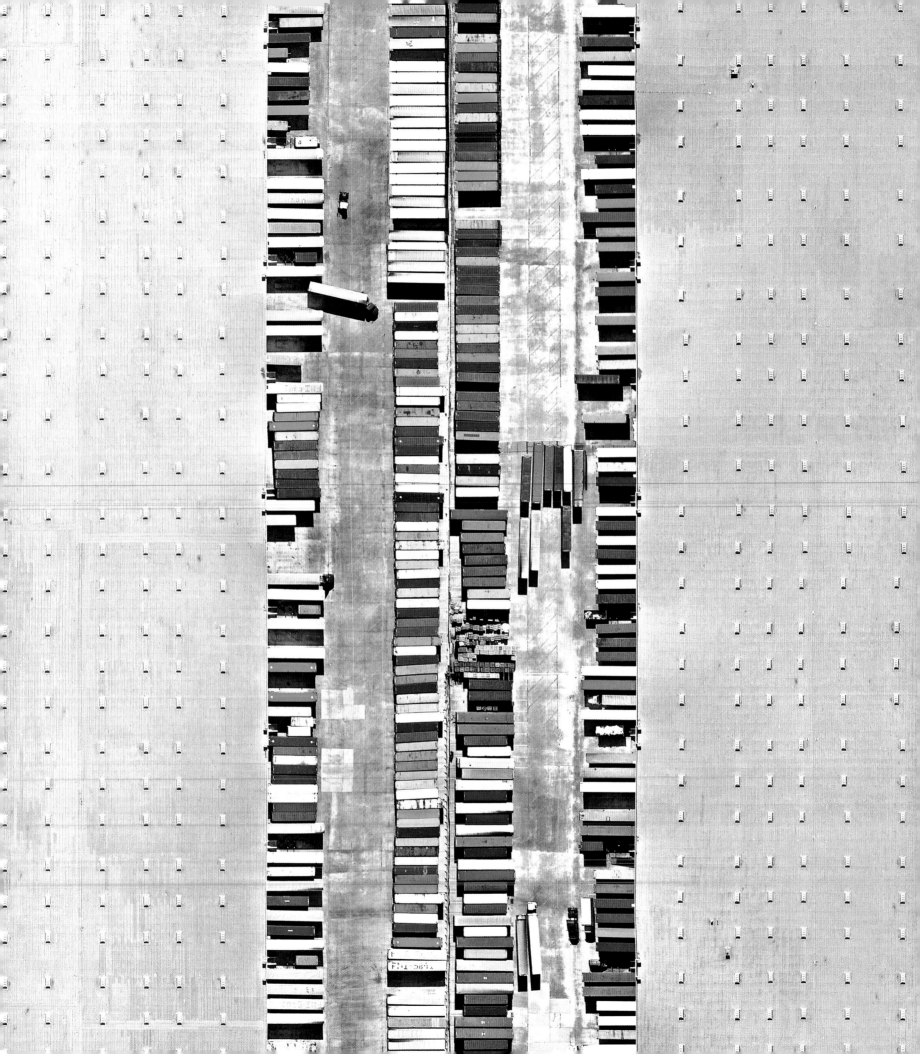

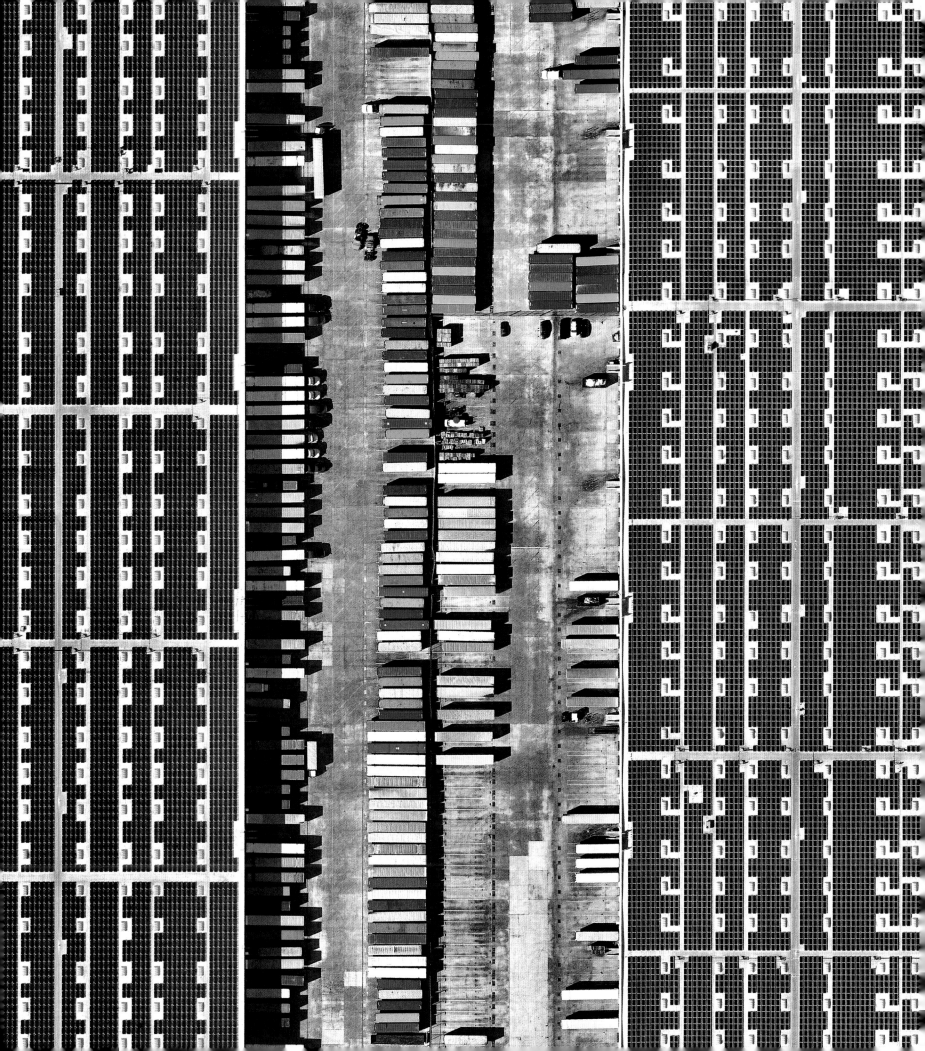

PREVIOUS PAGE

**Westmont Rooftop Solar Project**
2014 / 2017

The Westmont Distribution Center, with its rooftop solar project, is located in San Pedro, California. At the time of its installation in 2017, Westmont was the most powerful rooftop solar project in the nation, with the exception of Apple's new headquarters (see page 244). The 2 million square feet (185,806 square meters) of panels have a bifacial design, meaning they can collect reflected light from the surface of the roof in addition to direct sunlight. This enables the panels to generate up to 45 percent more power than traditional rooftop solar panels and power 5,000 nearby homes.

33.764494°, -118.286483°

RIGHT

**Carbon Capture / Sequestration**
2019

The Illinois Basin–Decatur Project (IBDP) in Decatur, Illinois is a large carbon sequestration that captures 1 million tons (907, 185 metric tons) of carbon dioxide every year. The neighboring biofuel production plant captures carbon dioxide emissions that result from the production of corn ethanol. The captured $CO_2$ is then dehydrated and compressed for injection into a well (seen here next to three circular cylinders) that is 7,000 feet (2,134 meters) deep. The well is built into the sandstone of Mount Simon, an ideal place for $CO_2$ storage due to the properties of sandstone that allow for significant absorption of carbon. At that depth, there is also a saline solution that reacts with the injected $CO_2$ to create a solid that does not rise back toward the surface.

Storage underground, or "geological" storage of carbon dioxide is one means of removing $CO_2$ from the earth's atmosphere. Reducing the amount of $CO_2$ in the atmosphere has the potential to slow the global warming trend. Geological storage like the Decatur project demonstrates the promising potential for this technology.

39.875668°, -88.889269°

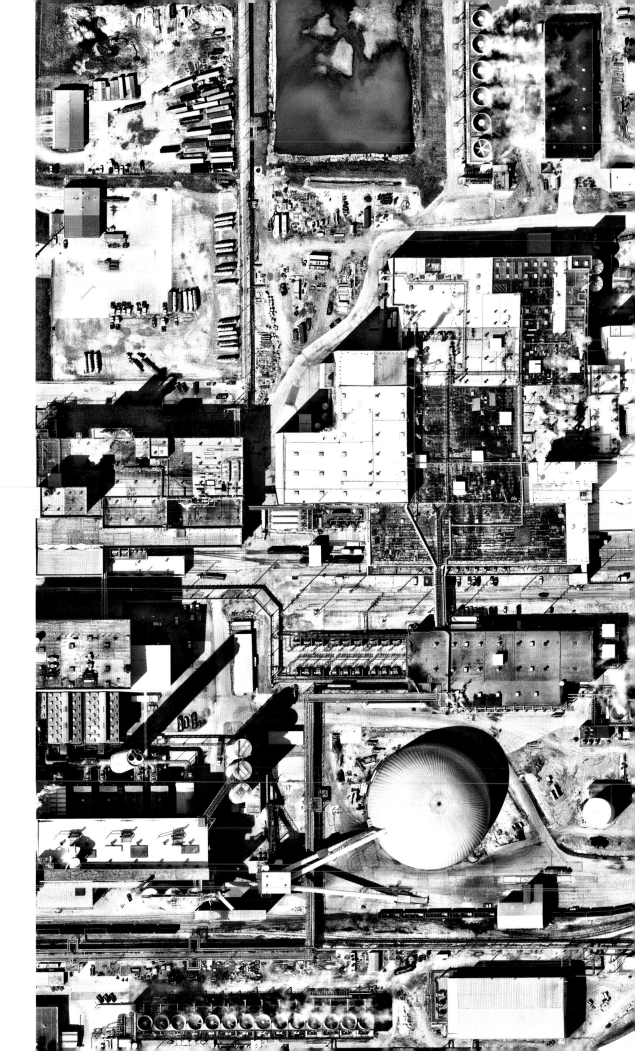

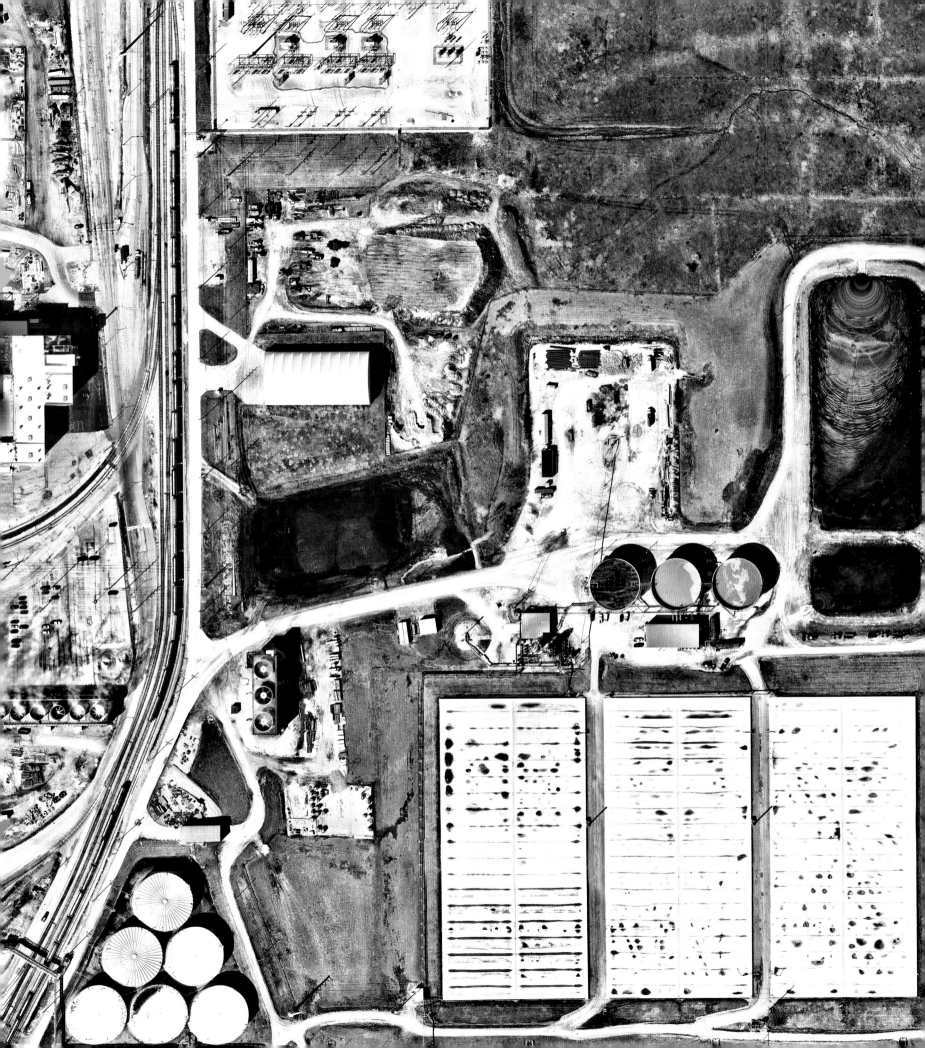

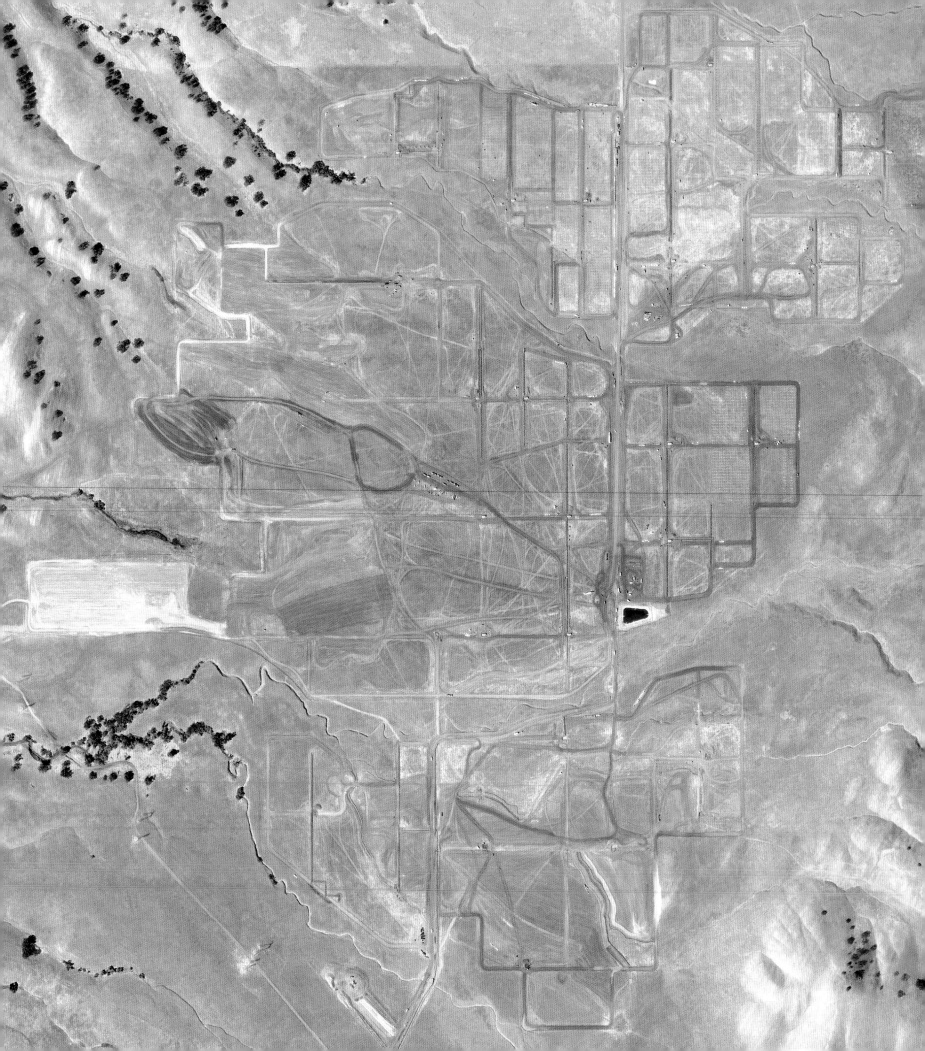

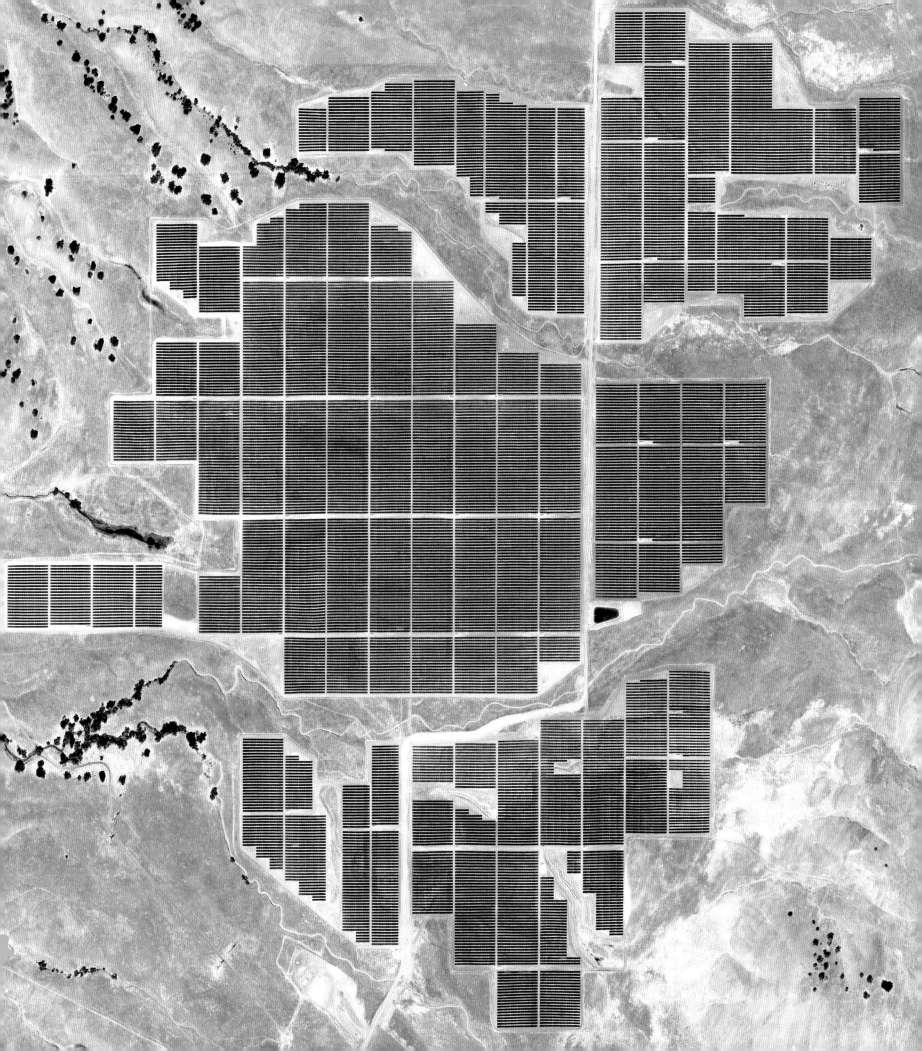

2010

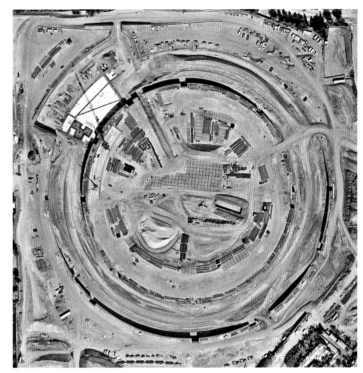

2014

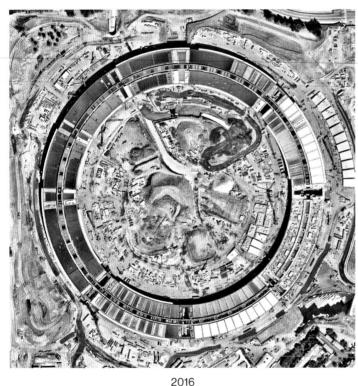

2016

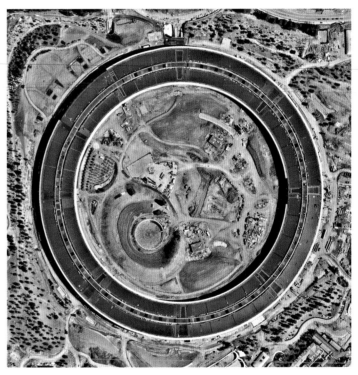

2017

PREVIOUS PAGE

**California Flats Solar Project**
2016 / 2017

The California Flats solar project, built in 2017, generates enough electricity to provide clean energy to power 116,000 California households, as well as to displace more than 120,152 tons (109,000 metric tons) of carbon dioxide annually. That energy accounts for 55 percent of the facility's total capacity. The other 45 percent of the electricity generated here is used to power Apple Park (seen here).

35.883333°, -120.400000°

ABOVE AND OPPOSITE

**Apple Park**
2010–2019

Apple Park, in Cupertino, California, is the corporate headquarters of Apple Inc. Opened to employees in April 2017, the facility replaced the original Apple Campus, which opened in 1993. The building is one of the most environmentally friendly in the world, with power coming from the world's largest rooftop solar installation as well as from the California Flats solar project (see previous pages). Air flows freely between the inside and outside of the building, providing natural ventilation and alleviating the need for HVAC systems during nine months of the year. The central campus also contains many drought-tolerant plants, and reusable water is used throughout the building.

37.334185°, -122.009930°

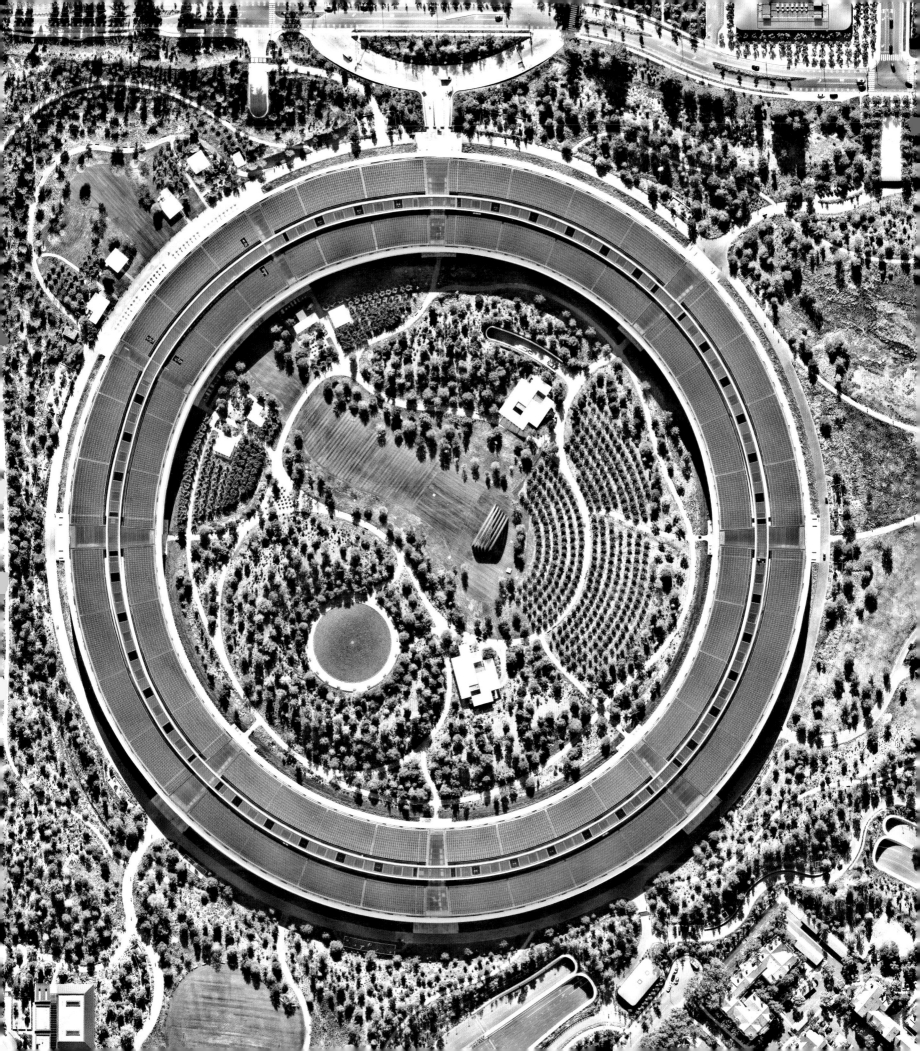

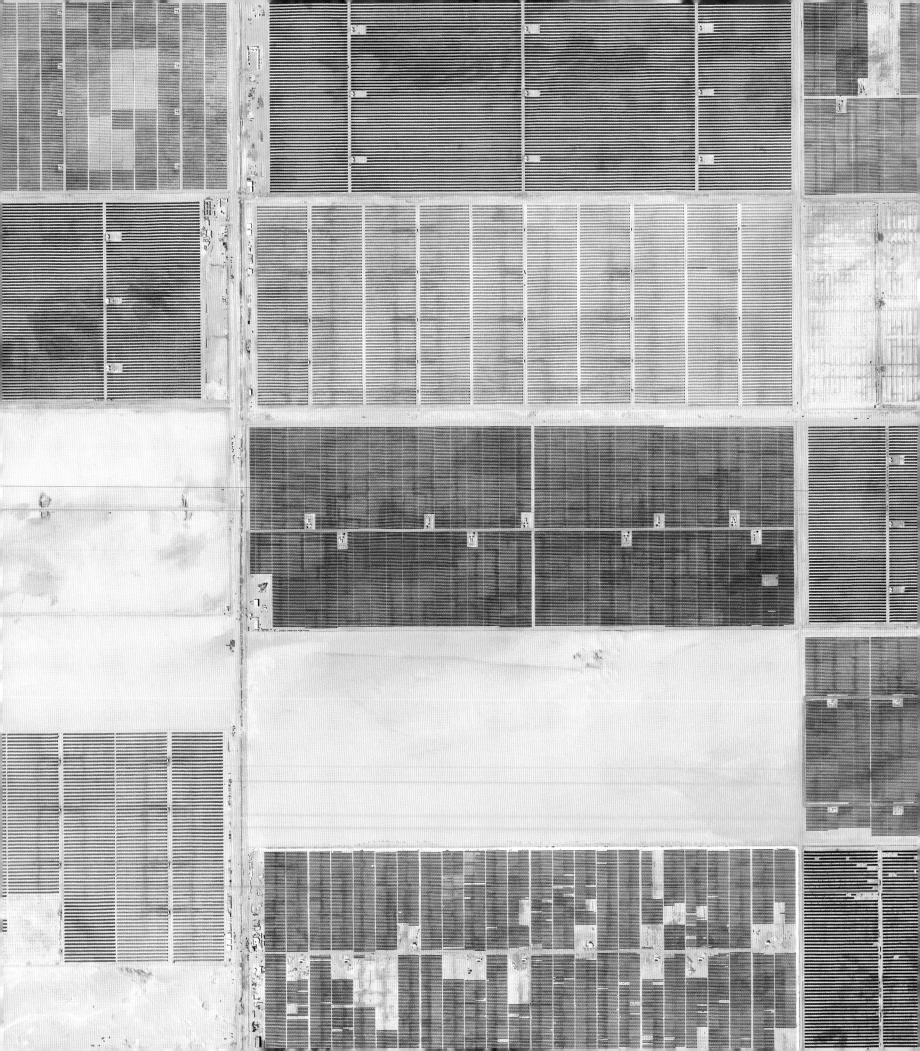

EPILOGUE

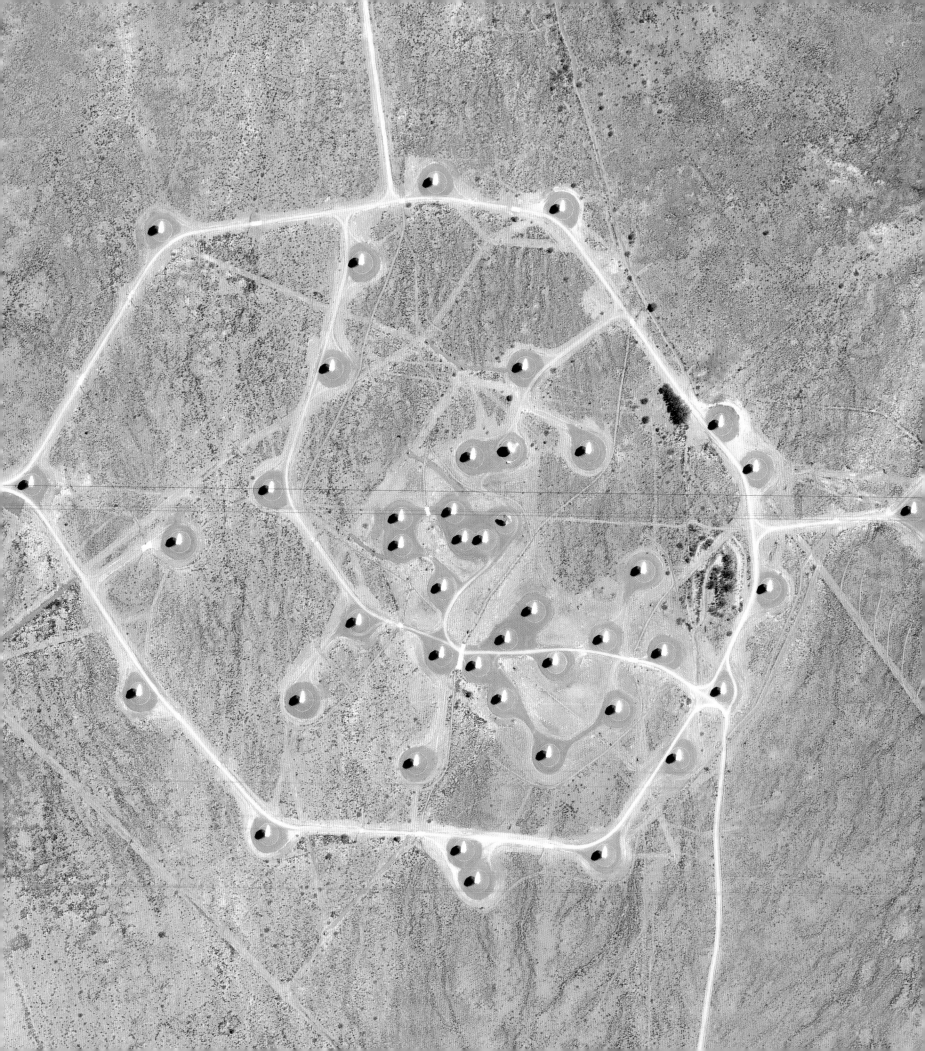

# The Future

The story of the planet and how we impact it is ever changing. That conversation is often focused on projections of what is yet to come. However, only by deeply understanding the past can we have any hope to plan and create a sustainable future. In this book, you have seen evidence of some of our most glaring impacts—a visual history of what has happened, what we can already see *now*. We have focused on the locations that come together to tell a story, a story of the unfolding human era on Earth. While everything to this point has focused on the past, this epilogue features Overviews of large-scale human projects currently under construction, with the predicted date at which they will come into full operation.

Some of the solutions to help move us toward a better future are already being utilized. Technology by itself cannot solve every challenge posed by a changing climate, especially as weather events become increasingly more intense and unpredictable in their form. Nevertheless, the ability of humans to inspire one another, and to work together to build and solve problems, never ceases to amaze—as evidenced by much of the content in this book. By bringing attention to these future developments, we hope to see many, many similarly compelling ideas come to fruition in the years ahead.

We hope the stories in this book inspire urgency and action. It is clear that we have already tipped the balance of Earth's ecosystems—we are putting more carbon into the atmosphere than natural forces can absorb, or technologies we have not yet invented or scaled can remove. While civilization is endlessly fascinating and expansive, it has been built with convenience and money in mind, very rarely considering the ultimate costs to, or repercussions from,

**Venice MOSE**
Estimated Completion: 2022

The city of Venice, Italy, is situated on, and surrounded by, water. Venice already experiences regular flooding as high tides bring water into the city's streets. With tidewaters expected to rise to even more perilous levels in the coming decades, the city is nearing the completion of its construction of 78 giant steel gates across the three inlets through which water from the Adriatic Sea could surge into Venice's lagoon. The project, known as MOSE, is designed to protect Venice from flooding of tides up to 9.8 feet (3 meters). The massive gates at the Lido inlet are seen on the previous spread. After multiple delays and cost overruns, the project is expected to be fully finished by 2022, at a total cost of more than $6 billion.

45.437500°, 12.335833°

**DevLoop**
Estimated Completion: 2030

The DevLoop test site outside of Las Vegas, Nevada was constructed to test the aerodynamics of the Hyperloop—a futuristic mode of passenger and/or freight transport that operates through sealed vacuum tubes pushing pods free of air resistance or friction at high speeds. Theoretical speeds of the Hyperloop have been estimated up to 760 miles per hour (1,223 kilometers per hour), allowing for a 35-minute transit time between Los Angeles and San Francisco. Traveling at these speeds, the Hyperloop would have routes that are faster than short-haul air travel, thereby significantly reducing the amount of emissions when an individual travels these distances. The Hyperloop designs have been made open-source by the entrepreneur Elon Musk, allowing companies and organizations to work collaboratively on the project.

36.432023°, -114.962475°

the environment. Science makes it abundantly clear that we no longer have the luxury of time on our side to debate how soon we need to make changes. We must adopt a more long-term perspective if we are to continue existing on Earth 100, 500, or 1,000 years from now.

With certain behaviors and systems so ingrained in our world, change will be not easy. However, change is inevitable, and if we want to shape it for the better, we must become informed and move in the best possible direction. There are things we can do on an individual level, and there are things we can do together that have an impact. The next car ride, the next election, the next meal you eat, the next item you order online, and the next time you discard your trash are all opportunities to act with greater consideration of how those things impact the planet. It is the totality of our individual actions that have the potential to bring about the sweeping changes we so urgently need. With greater collective awareness and effort, who knows what we might do, what we might create, and what the future might hold.

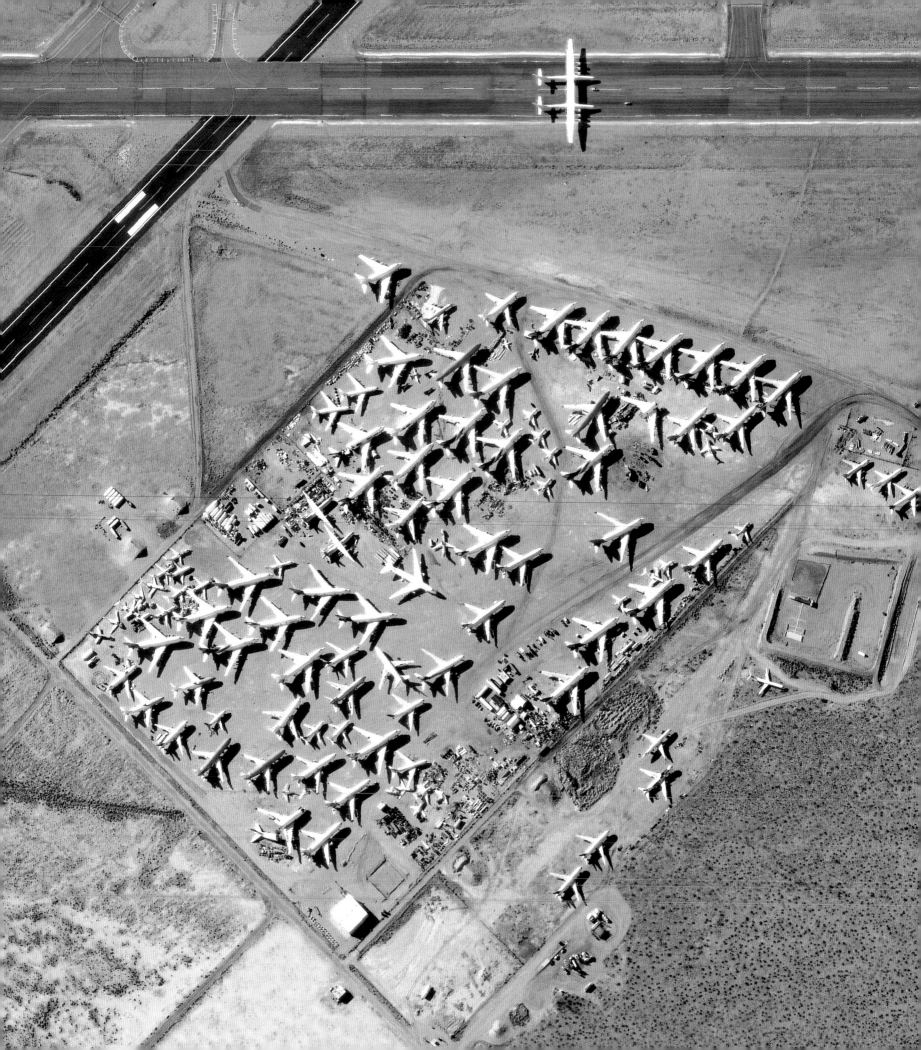

**Hornsea Wind Farm**
Estimated Completion: 2025

———

The waters around Great Britain are some of the best in the world for generating wind power, estimated to have over a third of Europe's total offshore wind capacity. Accordingly, Great Britain now has the largest offshore wind power operation, surpassing Denmark in 2008. The Hornsea Wind Farm project aims to take advantage of the abundance of potential energy off the coast of England in the North Sea. Development has been broken down into three different zones, with plans to increase capacity over time and move the United Kingdom toward greater use of renewable power. The project is expected to be the highest capacity wind farm in the world when the final construction phase is completed in 2025.

53.885000°, 1.790000°

**Virgin Galactic Spaceflight**
Estimated Completion: 2021

———

Virgin Galactic's *White Knight Two* (pictured on runway at top) is seen passing retired planes at Spaceport America in the Mojave Desert of Nevada. The spaceplane is a launch platform for smaller commercial spacecrafts. The *White Knight* takes off with a smaller plane attached under its wings. At an altitude of 60,000 feet (18,288 meters), the smaller plane is released, fires its thrusters, and rises until it crosses the Kármán line—defined as the altitude of 62 miles (100 kilometers) where "space" begins. Customers on board will be able to briefly experience the Overview Effect and the weightlessness of space in zero gravity. As the space industry continues to mature in the coming years, development of space infrastructure, tourism, and imaging is expected to increase significantly.

32.991387°, -106.978474°

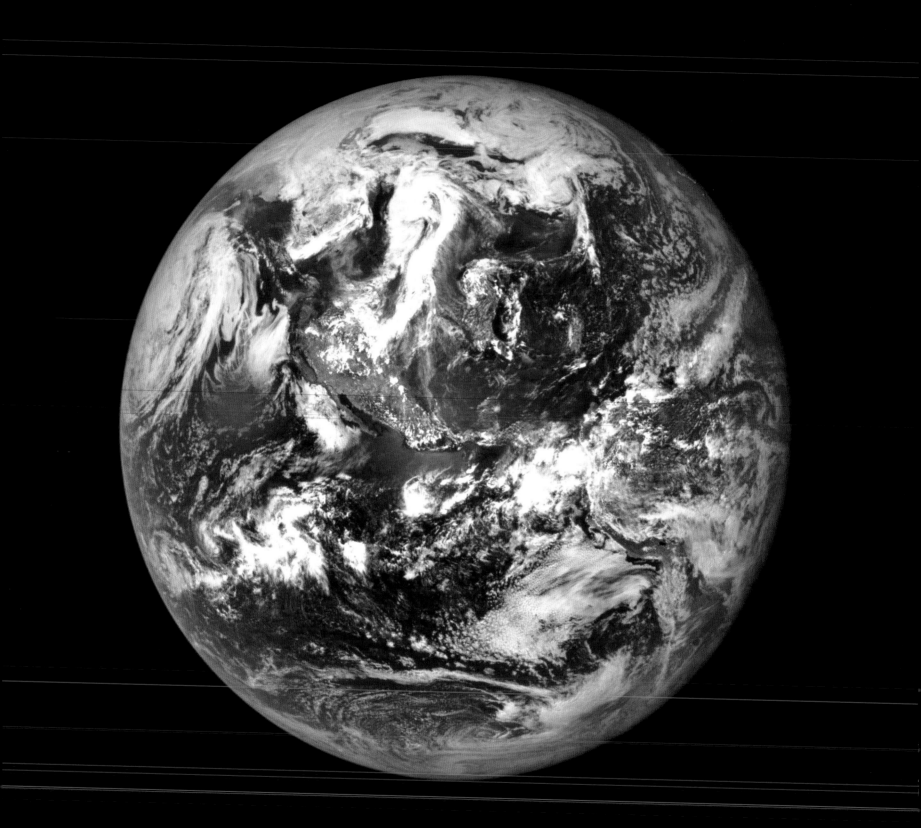

# About Overview

Overview uses satellite and aerial imagery to demonstrate how human activity and natural forces shape our Earth. This perspective provides a powerful look at the planet where we live and the civilization we are creating. Through our books, products, and collaborations, we aim to inspire the Overview Effect—the cognitive shift experienced by astronauts who look back at Earth and report feelings of overwhelming awe and amplified appreciation for the planet we call home.

Check out our other books:

**Overview: A New Perspective of Earth**

**Overview: Young Explorer's Edition**

Follow along @dailyoverview on Instagram, where new images are posted daily.

To subscribe to our daily post, order prints, or license imagery, visit over-view.com

OPPOSITE

**The Blue Marble**
July 6, 2015

The first photograph captured by the camera onboard the Deep Space Climate Observatory (DSCVR) satellite, which orbits approximately 1 million miles (1.6 million kilometers) away from Earth. This image was made by combining three separate photos to get a full picture of the planet. DSCVR's camera will continue to provide a daily stream of Earth images, allowing for both real-time and ongoing observation of the planet. In this image, North and Central America are visible, along with the centrally-located shallow, turquoise waters of the Caribbean Sea.

# About the Authors

**Benjamin Grant** is the author of *Overview: A New Perspective of Earth* and *Overview: Young Explorer's Edition.* Those books and this one take their inspiration from the project Overview, which he founded in 2013. Large-format prints from the project have been displayed around the world with noteworthy exhibitions in Munich, San Francisco, New York, Tel Aviv, Los Angeles, Barcelona, and Sweden. Benjamin graduated from Yale University, where he studied history and art history and rowed on the heavyweight crew team. He lives and rides his bike in San Francisco.

**Timothy Dougherty** started working with Overview in 2016, focusing on partnerships and content strategy. He has contributed writing on urbanization from the Overview perspective for the *Breakthrough Journal.* He graduated from Georgetown University, where he studied finance at the McDonough School of Business. Originally from Philadelphia, Tim currently resides in San Francisco where he enjoys the outdoors.

# Acknowledgments

The authors would like to thank . . .

Hannah, Kaitlin, Betsy, Ashley, Jane, Mari, and everyone at Ten Speed Press—for your continued confidence in the power of this perspective.

Kirsten and Maxar Technologies—for being our first partners on this project and for all of the ways you help us provide a new vantage point.

Tony and Nearmap—for your willingness to help us tell the best story possible.

Manos, Erwan, and ESA—for all the research you have done to help us bring the power of time into these images.

Robbie, Trevor, and Planet—for providing the bigger picture that helped us complete this story.

Gopal, Chris, and the Google Earth team—for creating an incredible tool to bring this medium to many more people.

Trevor—for teaching us how to bring these stories to life.

Eli and Kira—for your collaboration, which helps to keep this project going.

Ben would like to thank . . .

My parents and family—for your ongoing support and love. Without you, none of this would be possible.

Tim—for believing in this project and for joining me to create and tell this story.

Pat—for the brainstorms and endless inspiration.

Patrick and Katya—for helping me find a home.

Graham—for your unwavering criticism and mentorship.

Anna—for helping me realize that time is all we have.

The Pasternaks—for the home away from home.

Tim would like to thank . . .

Kelly—for taking an interest in everything I do.

Nathan—for your sensibility and uncanny ability to help clarify thoughts.

Hannah—for your spirit, support, and patience over the years.

Ben A.—for being a voice of reason in this world.

Colton and Joe—for laying the foundation to pursue the unknown.

Pete and Tim—for listening to any and all ideas and providing the critique only possible from great friends.

# Image Credits

**MAXAR**

## Westminster, Colorado, USA
Source imagery © Maxar Technologies

Maxar Technologies is the provider of the world's highest-resolution satellite imagery. They operate a constellation of four satellites that have a maximum resolution of 30cm, meaning 1 pixel in the image equals 30 centimeters square on the ground. The approximate altitude of their satellites is 383 miles (617 kilometers) above the earth.

39.912597°, -105.002713°

Cover: Occidental Glacier
Page vi: Bingham Canyon Mine
Pages x–xi: Colorado River
Page xiv: Lake Natron
Page xiii: Hunga Tonga–Hunga Ha'apai Formation
Pages vi–1: Boca Raton
Page 2: Eixample District, Barcelona
Pages 4–5: Shanghai City Center
Pages 8–9: Delhi Neighborhoods
Pages 12–13: New York City
Page 14: Central Park
Page 17: Bahrain Land and Waterway Development
Page 19: Kibera
Pages 20–21: Venice
Pages 26–27: Playa del Carmen Seafront
Page 30: Tappan Zee Bridge
Pages 36–37: Beijing Daxing International Airport (PKX)
Page 40: Volkswagen Wolfsburg Plant
Page 41: Port of Bremerhaven
Pages 42–43: Suez Canal
Pages 44–45: Port of Singapore
Pages 50–51: Qatar Interchange Redesign
Pages 54–55: Train Stations Along Thalys 9424
Page 58: Central de Abasto
Pages 66–67: Rimini Beach Umbrellas
Pages 68–71: Glastonbury Festival
Pages 72–73: Burning Man
Page 74: Shopping Mall Conversion into Fulfillment Center
Pages 82–83: Sudokwon Landfill Buildup
Pages 86–87: Bingham Canyon Mine
Page 88: The Blue Lagoon
Pages 90–91: Pivot Irrigation Sprinkler
Page 93: Saudi Arabia Pivot Irrigation Expansion
Pages 94–95: San Francisco Bay Area
Page 96: San Francisco Bay Salt Ponds
Pages 98–99: Nanri Island Aquaculture / Offshore Wind Farm
Pages 102–103: Aral Sea Basin
Pages 106–107: Kazakhstan Cotton Farming
Pages 108–109: New Bullards Bar Reservoir Drought Recovery
Page 113: Merowe Dam
Page 114: Deforestation in Bolivia
Pages 116–119: Blooming Dutch Tulips
Pages 122–123: Spanish Greenhouse Construction
Page 127: Fântânele-Cogealac Wind Farm
Page 128: Ouarzazate Solar Power Station Construction
Page 129: Noor III Solar Concentrator

Pages 130–133: Cattle Feedlot Expansion
Pages 134–135: Amazon Slash and Burn
Pages 138–139: Rondônia Deforestation Pattern
Pages 140–141: Sumatra Deforestation
Pages 142–143: Sumatra Palm Oil Plantation
Pages 144–145: Oregon Clearcutting
Page 148: Qinhuangdao Coal Terminal
Pages 150–151: Salar de Uyuni
Page 153: Gigafactory 1
Pages 154–155: Olympic Dam Mine
Page 157: Palo Verde Nuclear Generating Station
Page 158: Jänschwalde Surface Mine
Page 159: Jänschwalde Power Station
Page 160: Florida Phosphate Mine
Page 161: Kansas Wheat Production
Pages 162–163: Paragominas Bauxite Mine
Page 164: Binzhou Aluminum Factory
Page 165: Aluminum Roofing in Ansan
Pages 166–167: Brumadinho Dam Collapse
Pages 168–169: Paraopeba River Contamination
Pages 170–171: Distant Contamination
Page 172: Wisconsin Sand Mine
Page 173: Oklahoma Fracking Wells
Page 174: Petrochemical Factory and Plastics Production
Page 179: Athabasca Oil Sands Expansion
Pages 190–191: Camp Fire Aftermath
Pages 196–197: Cape Town Water Crisis
Pages 200–203: Nebraska / Iowa Flooding
Page 204: Oroville Dam Spillway Rupture
Pages 206–207: Yakutia Permafrost Melt
Pages 208–209: Columbia Glacier Recession
Pages 212–215: Greenland Ice Sheet Early Melting
Pages 216–217: Antarctic Sea Ice Melt
Pages 218–219: Esperanza Base
Page 220: Oosterscheldekering
Pages 222–223: Wuhan Lockdown
Page 224: Wuhan Hospital Construction
Page 225: Social Distancing Measures
Pages 226–227: Abandonment of Deir ez-Zor
Page 228: Zaatari – Jordan
Page 228: Kilis – Turkey
Page 229: Röszke – Hungary / Serbia Border
Page 229: Moria – Greece
Pages 230–231: Victorian Desalination Plant
Pages 232–235: Great Green Wall of Africa
Pages 236–237: The Sustainable City
Pages 242–243: California Flats Solar Project
Page 244: Apple Park (1/4)
Pages 246–247: Benban Solar Park
Page 248: Square Kilometre Array
Pages 250–251: Venice MOSE
Page 252: DevLoop
Page 256: Virgin Galactic Spaceflight

## Barangaroo, Australia
Source imagery © Nearmap

Nearmap operates small aircraft out of Australia, Canada, New Zealand, and the United States. Using a patented airplane-mounted camera system, they are able to cover wide areas in a short amount of time and capture imagery at an extremely high resolution of 7.5cm. Nearmap planes fly at an altitude of approximately 18,000 feet (5,486 meters).

-33.863704°,151.199950°

Page xvi: Niagara Falls
Page 15: Sheep Meadow
Pages 24-25: Las Vegas Residential Development
Pages 32-33: Hartsfield Jackson Atlanta International Airport (ATL)
Pages 34-35: Hartsfield-Jackson Takeoff
Pages 38-39: Grounded 737MAX Airplanes
Pages 46-47: Port of Los Angeles Trucks
Pages 48-49: Holland Tunnel Traffic
Pages 52-53: Diesel Volkswagen Parking Lot
Page 56: PortMiami
Page 57: Navigator of the Seas
Pages 62-63: Esplanade Reserve / Elizabeth Quay Conversion
Pages 64-65: Arrowhead Stadium
Page 75: Shopping Mall Conversion into Fulfillment Center
Pages 76-79: Tire Graveyard
Pages 80-81: NYC Recycling Process
Pages 84-85: Wastewater Treatment
Page 97: San Francisco Bay Salt Ponds
Pages 124-125: Blooming Canola Flowers
Page 126: Wind Farm Turbine Factory
Pages 146-147: Washington Sawmill
Page 156: Port Adelaide
Page 175: Petrochemical Factory and Plastics Production
Pages 180-181: Hurricane Michael Damage
Page 182: Great Barrier Reef Coral Bleaching
Pages 184-185: Miami Red Tide
Page 205: Oroville Dam Spillway Rupture
Pages 238-239: Westmont Rooftop Solar Project
Pages 240-241: Carbon Capture / Sequestration
Pages 244-245: Apple Park

**Washington, D.C., USA**
Source imagery courtesy of NASA

The National Aeronautics and Space Administration (NASA) is an independent agency of the US government responsible for the civilian space program, as well as aeronautics and aerospace research. Through its Earth Observatory programs, NASA uses current and historical satellite imagery to monitor the planet at an altitude of approximately 435 miles (700 kilometers). Images noted with an asterisk (*) below were processed for color and cloud removal by the team at Google Earth Timelapse.

38.883055°, -77.016388°

Pages 6–7: Shanghai Expansion
Pages 10–11: Delhi Expansion
Page 16: Bahrain Land Reclamation
Page 18: Nairobi Expansion
Pages 28–29: Playa del Carmen Expansion*
Page 61: The Lights of Paris
Page 92: Saudi Arabia Pivot Irrigation Expansion*
Pages 104–105: Aral Sea Diversion
Page 112: Merowe Dam
Page 152: Salar de Uyuni Lithium Mines
Page 178: Athabasca Oil Sands Expansion
Pages 188–189: Camp Fire
Page 210: Columbia Glacier Recession*
Pages 214–215: Greenland Ice Sheet Early Melting
Page 258: The Blue Marble

**San Francisco, CA, USA**
Source imagery © Planet

Planet utilizes a constellation of small satellites to image the entire Earth daily, making global change visible, accessible, and actionable. With more than 150 satellites, Planet owns the largest earth observation constellation. Their imagery is typically 3–5m resolution (some satellites go up to 80cm resolution) and is captured from altitudes between 260 to 420 miles (418 to 676 kilometers).

37.783437°, -122.396258°

Page 60: The Lights of Paris
Pages 100–101: Nanri Island Aquaculture / Offshore Wind Farm
Pages 110–111: Sierra Nevada Mountain Range Snowpack
Pages 120–121: Spanish Greenhouse Construction
Pages 176–177: Athabasca Oil Sands Expansion
Pages 198–199: Cape Town Water Crisis
Pages 254–255: Hornsea Wind Farm

**Paris, France**
Source imagery courtesy of ESA

The European Space Agency (ESA) is an intergovernmental organization of 22 member states dedicated to the exploration of space. ESA conducts Earth observation primarily through its Copernicus (Sentinel) program which aims to achieve global, continuous, autonomous, and high-quality observation of the planet. Through its efforts, ESA aims to improve the management of the environment as well as understand and mitigate the effects of climate change. Sentinel satellites orbit at an altitude of roughly 488 miles (785 kilometers).

48.848336°, 2.301978°

Page xii: Andes Mountains
Pages 22–23: Las Vegas Expansion
Pages 136–137: Amazon Deforestation
Pages 186–187: Chicago Polar Vortex
Page 211: Columbia Glacier Recession

**Graz, Austria**
Source imagery © Vexcel

Vexcel uses airplanes coupled with a unique lens to capture detailed views of locations across the planet. Flying at altitudes between 6,500 to 17,250 feet (1,980 to 5,258 meters), their images have a resolution of 7.5cm.

47.066667°, 15.433333°

Page 191: Camp Fire Aftermath

Japan Meteorological Agency

**Tokyo, Japan**
Source imagery courtesy of JMA

The Japan Meteorological Agency (JMA) operates satellites for the purpose of weather research. The Himawari-8 satellite that captured the Overview in this book is positioned 22,239 miles (35,786 kilometers) away from the Earth, giving its camera the ability to photograph the entirety of the planet in one frame. For this image, initial processing was completed by RAMMB/CIRA/CSU and additional black space was included in the image.

35.689662°, 139.744365°

Pages 194–195: Bushfires from Outer Space

# Index

Published in the United States by Ten Speed Press, an imprint of Random House, a division of Penguin Random House LLC, New York.
www.tenspeed.com

Ten Speed Press and the Ten Speed Press colophon are registered trademarks of Penguin Random House LLC.

Library of Congress Control Number: 2020936903

Hardcover ISBN: 978-1-9848-5865-8
eBook ISBN: 978-1-9848-5866-5

Printed in Italy

Design by Betsy Stromberg

10 9 8 7 6 5 4 3 2 1

First Edition

COVER

**Occidental Glacier**
2019

———

The Occidental Glacier is located in the Southern Patagonian Ice Field of Chile. In this image from May 2019, massive icebergs and an ice mélange fill the lake at the toe of the glacier. Recent measurements of the Patagonian ice fields (taken using satellite photography) show that they have been receding and thinning at an accelerating rate in recent years. Between 2002 and 2017, the ice shrank by roughly 23 gigatons per year—a volume of water equivalent to roughly ten Olympic-size swimming pools.

-48.850300°, -74.064300°